DATE DUE

SE 14 '98		
OC 2 0		

Demco, Inc. 38-293

BHUTAN

Mountain Fortress of the Gods

LENDERS TO THE EXHIBITION

Anthony Aris

Kunzang Chöden

Penjo Dasang Dorji

Christoph and Marie Noel Frei-Pont

Melchart Collection

Ugyen and Norzom Namgyel

National Museum of Bhutan, Paro

National Museums & Galleries on Merseyside

Liverpool Museum

Dasho Sangye Ngedup

Paro Dzong

Gap Pasang

Helga Paul

Françoise Pommaret

Punakha Dzong

Michael Rutland

Sammlung für Völkerkunde St. Gallen

Christian Schicklgruber

Josette Schulmann

Estate of Fritz and Monica von Schulthess

Anton Subal

Thimphu Dzong

Guy Van Strydonck

Völkerkundemuseum der Universität Zurich

and other private collectors in Bhutan and Europe

BHUTAN

Mountain Fortress of the Gods

General Editors
Christian Schicklgruber & Françoise Pommaret

Shambhala

Boston
1998

Shambhala Publications, Inc.
Horticultural Hall
300 Massachusetts Avenue
Boston, MA 02115
http://www.shambhala.com

9 8 7 6 5 4 3 2 1

Printed in the United Kingdom

Distributed in the United States by Random House, Inc.,
and in Canada by Random House of Canada Ltd

Translations from German by Stefan B. Polter

Library of Congress Cataloging-in-Publication Data
Bhutan : mountain fortress of the gods / edited by Christian
Schicklgruber and Françoise Pommaret. — 1st ed.
 p. cm.
 Includes bibliographical reference and index.
 ISBN 1–57062–352–X (cloth)
 1. Bhutan—Description and travel. I. Schicklgruber, Christian.
II. Pommaret-Imaeda, Françoise.
DS491.5
954.98—dc21

Endpapers:
The dance of Shinje Yabyum (Lords of Death) at Kuje Lhakang, Bumthang (A.A. 1970).

Contents

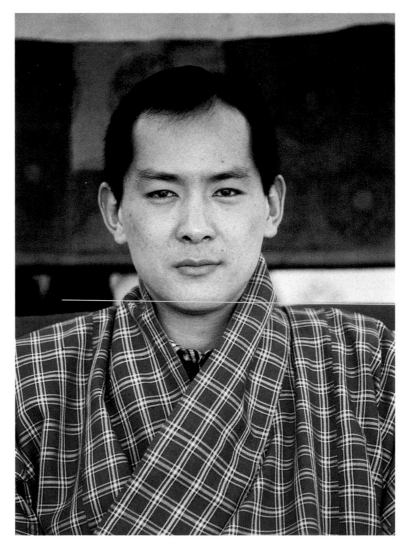

The Fourth King of Bhutan, Jigme Singye Wangchuck, was born on November 11th, 1955, ascended the throne in 1972 and was crowned on June 2nd, 1974.

I am pleased that the Vienna Museum für Völkerkunde and the Government of Austria are organizing an exhibition on the Kingdom of Bhutan from November 1997 to March 1998 to which the National Museum of Bhutan has been able to lend some of its valuable articles. This exhibition which will also be hosted in Switzerland from May 1998 and in other parts of Europe is the largest exhibition on Bhutan ever held outside the country. It is a shining example of the close cooperation between Austria and Bhutan in learning about and appreciating each other's cultural heritage, while working together as partners in development. The exhibition is also a reflection of the increasing recognition in today's fast changing world that preservation and promotion of culture should complement economic development. I am confident that this exhibition will go a long way in fostering a better understanding of the culture and people of Bhutan among the friendly peoples of Austria, Europe and elsewhere.

Although Bhutan's recorded history begins only from the seventh century when Buddhism was first introduced in the country, ancient stone tools like the adze, locally known as *namcha tarey*, and megaliths found in parts of the kingdom indicate that Bhutan was populated as far back as 2000 BC. A distinctive feature of Bhutan's history is that it has never been occupied by invading forces and that Mahayana Buddhism has played a central role in shaping the country's destiny. Against this backdrop, a rich and unique culture marked by the abiding faith and belief of the people in the teachings and values of Mahayana Buddhism evolved through the centuries. The culture and value system that the people of Bhutan have inherited today embodies the collective memories of communities across the kingdom, and their pride in this rich heritage has instilled a sense of distinctive identity in our people as citizens of a unique sovereign and independent nation in the Himalayas.

Standing on the threshold of the next millennium Bhutan is poised to launch its eighth Five Year Development Plan in July 1997. In the process of implementing thirty-six years of planned economic development, we have come to realize that economic criteria alone could not provide a programme for human dignity and well-being. In the march of economic development, people need to reinforce their belief in meaningful values and their sense of identity as responsible members of society. We in Bhutan, therefore, consciously endeavour to balance our development with the promotion of the most valuable and relevant elements of our rich cultural heritage.

I sincerely hope that this publication and the exhibition on Bhutan will contribute towards a greater understanding about a tiny kingdom in the Himalayas which had, until 1961, followed a policy of self-imposed isolation to safeguard its sovereignty, and is today striving to emerge as a modern nation committed to achieving economic development and prosperity for its people while preserving its pristine environment and rich cultural heritage.

May 23, 1997

Jigme Singye Wangchuck, King of Bhutan

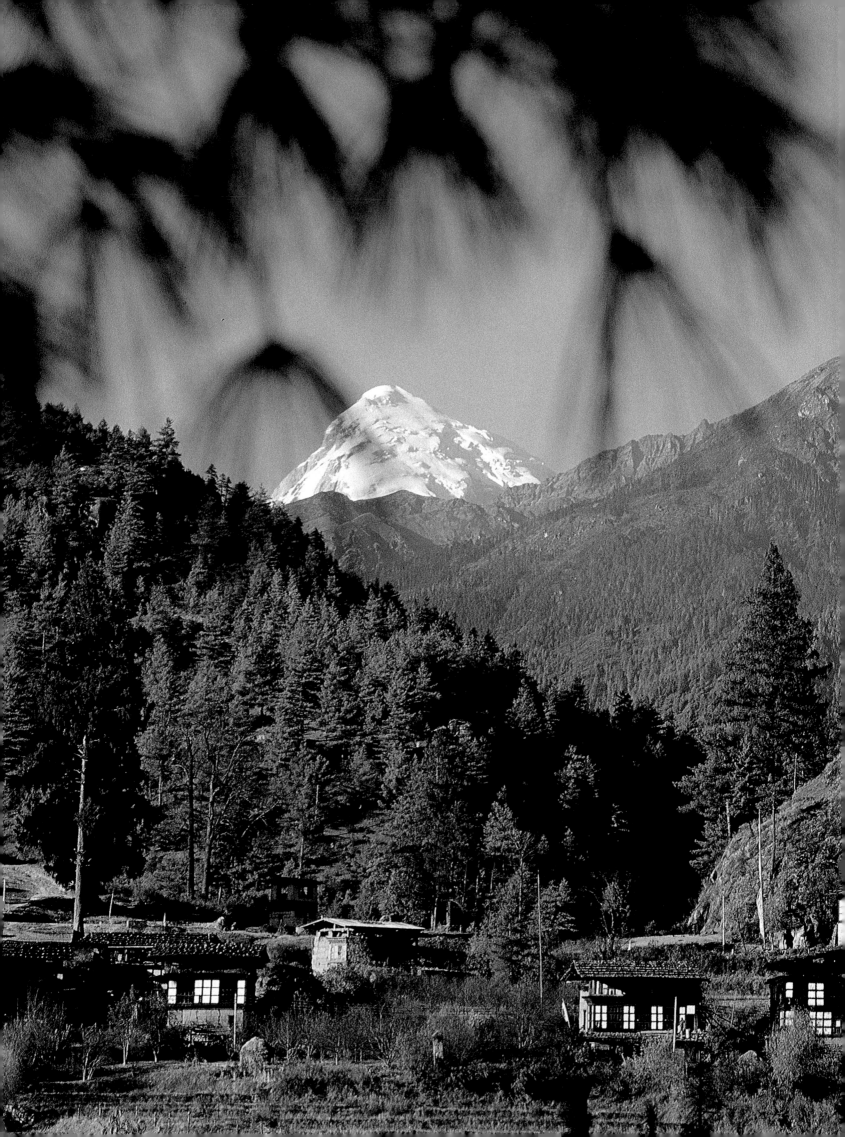

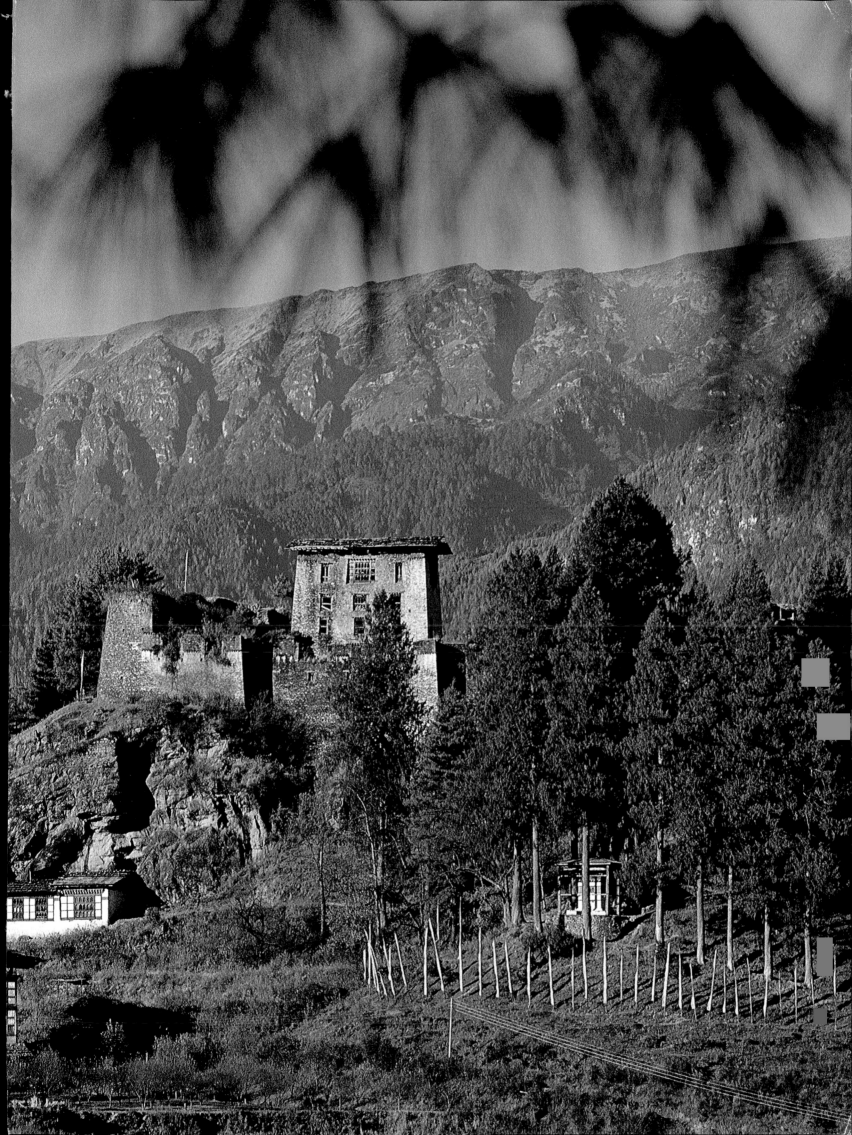

Acknowledgements

The child of many mothers and fathers, the idea for this exhibition and publication *Bhutan: Mountain Fortress of the Gods* was actually born three years ago at the Museum für Völkerkunde in Vienna. By good fortune the Royal Government of Bhutan offered its full support from the outset. So many outstanding objects would not have travelled from Bhutan to Europe without the enthusiasm of H.E. Lyonpo Dago Tshering, Minister of Home Affairs, H.E. Lyonpo Dawa Tsering, Minister of Foreign Affairs, and Sangye Wangchuk, Secretary of the Special Commission for Cultural Affairs, to whom we here express our deep appreciation. H.E. Dasho Jigmi Thinley, Permanent Representative of the Kingdom of Bhutan at the United Nations in Geneva, not only provided official support, but also offered deep insight and guidance into his culture. Our special thanks go to Mynak Tulku, Director of the National Museum in Bhutan; without his untiring efforts many visitors would have no access to this unique culture.

In Bhutan Vladimir Stehlik provided efficient logistic and administrative support. We wish to thank him as well as his most efficient Bhutanese staff. In Central Bhutan, our hosts Kunzang Chöden and her husband Walter Roder were wonderful company, sharing with us their deep cultural sensitivity. With great kindness, Ugyen Norzom and Ugyen Namgyel provided us with traditional Bhutanese hospitality in Thimphu and Prakhar. Lopön Tsip Phub Tshering, the village priest of Gunitsawa, introduced us to his mountains and their gods with a fine sense of humour. In spite of frequent changes of travel plans, Dago Beda kept her winning smile and efficiently organized all our field trips.

As an essential link between Austria and Bhutan, our thanks go to the Austrian Embassy in New Delhi and especially to H.E. Karl Peterlik, Ambassador to India and Bhutan.

The book accompanying this exhibition was the endeavour of Anthony Aris of Serindia Publications in London. Maria Phylactou, Stefan B. Polter and Johann Lehner were assigned the difficult tasks of translating and editing the English and German texts from many different sources. Howard Solverson compiled the index. We are deeply indebted to them for their talent and patience.

We thank our authors, who are presented to the reader in the introduction, for sharing their insights, opinions and specialized knowlege of the country.

Peter Kann, Director of the Vienna Museum für Völkerkunde, gave us his full confidence and administrative support. Arno Grünberger and Reinhard Mittersteiner shaped the design of the exhibition and coveyed our ideas into reality. The restoration departments and the workshops of the museum made it a reality. Our thanks are due to Barbara Matuella, Walter Baumgartner, Helmut Behavy, Norbert Kirchner, Florian Rainer. Christine Kreutzer deserves a special mention for her skills in publicizing the exhibition.

Thanks are also due to our photographers, especially to Erich Lessing who cast a highly sensitive light on the exhibition objects, while Robert Dompnier, Gerald Navara, Guy van Strydonck and Jon Warren, with their strong affection for Bhutan, convey the spirit of the culture and the lay of the land.

We are very grateful to all the private and institutional lenders in Bhutan and Europe who agreed to part with their objects for so long. Without their support and trust this exhibition would never have materialized.

Financial support was granted by the Austrian Ministry of Education and the Ministry of Foreign Affairs, who thus made this exhibition possible.

Finally, our deepest gratitude is offered to those anonymous Bhutanese artists and craftspersons whose hands actually shaped these objects and who empowered them with such a resonance of meaning. This exhibition is after all their creation and, we trust, faithfully mirrors and celebrates their unique culture.

Françoise Pommaret

CENTRE NATIONAL DE LA
RECHERCHE SCIENTIQUE, PARIS

Christian Schicklgruber

MUSEUM FÜR VÖLKERKUNDE
VIENNA

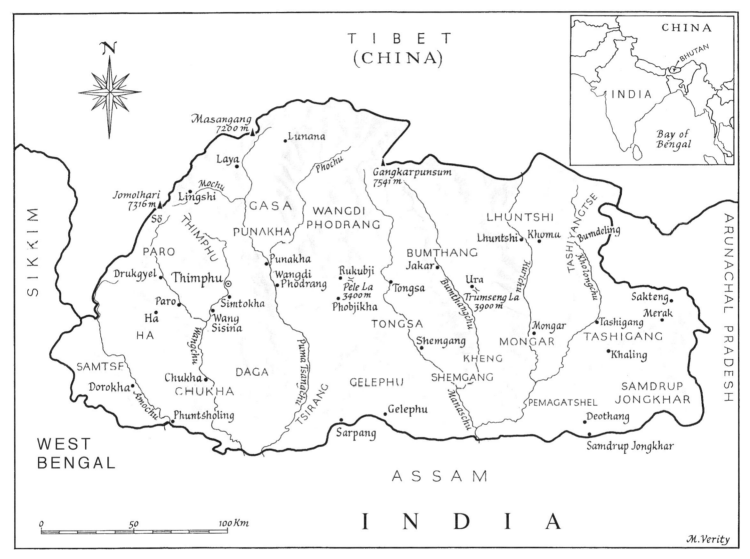

TIBET
(CHINA)

CHINA

BHUTAN

INDIA

Bay of
Bengal

Masangang
7200 m

Lunana

Laya

Phochu

Gangkarpunsum
7541 m

Jomolhari
7316 m

Mochu

Lingshi

GASA

WANGDI
PHODRANG

LHUNTSHI

Sö

THIMPHU

PUNAKHA

Lhuntshi

Khoma

Bumdeling

PARO

Punakha

Drukgyel

Thimphu

Wangdi
Phodrang

Rukubji

BUMTHANG
Jakar

Paro

Simtokha

Pele La
3400 m

Tongsa

Ura

Trumseng La
3900 m

Sakteng

Merak

Hã

Wang
Sisina

Phobjikha

Mongar

Tashigang

HA

DAGA

TONGSA

Shemgang

MONGAR

TASHIGANG

SAMTSF

Chukha

GELEPHU

KHENG

Khaling

Dorokha

CHUKHA

SHEMGANG

PEMAGATSHEL

SAMDRUP
JONGKHAR

Phuntsholing

Gelephu

Deothang

Sarpang

Samdrup Jongkhar

WEST
BENGAL

ASSAM

INDIA

SIKKIM

ARUNACHAL PRADESH

TASHIYANGTSE

0 50 100 Km

M. Verity

International boundaries are derived from available sources and should not be taken as authoritative.

Map of Bhutan

*Preceding pages: Drukgyel Dzong at the northwest of Paro valley
was built in 1647 by the Shabdrung Ngawang Namgyel to com-
memorate a famous victory over Tibetan forces. Beyond on the
border stands Mt Jomolhari (7,316 m). (J.W. 1994)*

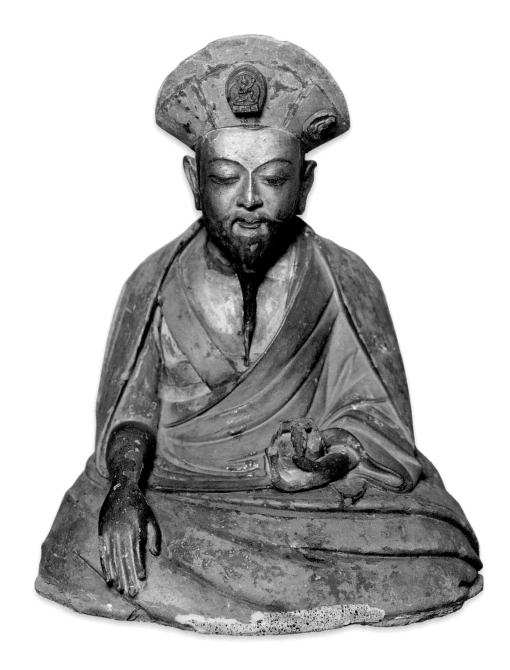

Introduction

Christian Schicklgruber

The title of this book, "Bhutan – Mountain Fortress of the Gods", describes the last surviving Buddhist kingdom along the slopes of the Himalayas. It also reflects the view most Bhutanese have of their own country – a small independent nation between powerful neighbours, where Buddhist values guide everyday life, and those in power have a special relationship with gods and saints.

Fortresses which guard against internal and external enemies dominate the landscape. A fortress-monastery – a manifestation of combined religious and secular power – commands each valley. Until the very recent past the lords of these forts looked after the preservation of the religious organization which was charged with assuaging the spiritual sources of human unhappiness. The lords also had the duty of alleviating material hardship. There was never any conflict with the legacy of the past.

Less than three decades ago, after centuries of self-imposed isolation, the country began to open itself to the West. Carefully chosen Western countries were asked to help the government to eliminate the material sources of human unhappiness, and to link the valleys divided by high mountain ranges with modern communication systems. Fully aware that all other Himalayan Buddhist states had lost their political independence, Bhutan decided to join the international community of nations as a means of forestalling threats

Clay statue of Shabdrung Ngawang Namgyel who unified Bhutan in the 17th century. (S.F.K.)

of losing its unique idenity as a sovereign, independent Buddhist kingdom in the Himalayas.

This meant that Bhutan had to open the fortress gates. Modernization has its blessings but may also undermine cultural cohesion. The country tries not to violate traditional values; harmony and compassion, the basis of Buddhist ethics, continue to guide every action even while the country cautiously catches up with modern times. Given the worldwide tendencies towards cultural homogenization and the evolution of the 'global village', will Bhutan be able to remain a fortress of the gods?

No bigger than Switzerland and with a population of just 600,000, Bhutan is the last Buddhist kingdom of the Himalayas; it was the only one to successfully retain its independence against its powerful neighbours – China in the north and India in the south. All other Himalayan states – for example Ladakh, Sikkim, Mustang – have been absorbed by foreign powers. Until the late nineteenth century, invasions were repelled or forestalled by means of shrewd tactics, perhaps also through the benevolence of protecting deities. Since the turn of the century Bhutan's situation as a sovereign buffer state between much bigger political entities has been safeguarded by the diplomatic abilities of its rulers. Bhutan has never been colonized.

Bhutan is a fortress not only in the military sense, but also a bastion in time. The third king, Jigme Dorje Wangchuck (r. 1952–72), realized that he could not keep Bhutan isolated from the world around as his predecessors had managed to do.

Although the country's insularity served to protect an entirely unique cultural legacy, the time came to partake of the technological achievements of the West. This technology is employed for the material improvement of living conditions and the strengthening of the communication network. Building and maintaining social services like schools and hospitals still depend on development aid.

Westerners and Bhutanese often like to say that the country is making a leap from the Middle Ages into the modern world. But is it meaningful to apply a term from European history with apparent ease to an Asian country of the twentieth century? It is probably as unhelpful as defining 'modernity' simply in terms of cars, computers and telephones. In the West, a country where there are no political parties, and where public opinion is represented by a single national newspaper, would not usually be regarded as 'modern'.

We should, however, beware of judging foreign cultures by the standards of our own. The people in charge of Bhutan's modernization proceed very cautiously and selectively. 'Modernization' is not imported wholesale. It may at first sight seem surprising, and hardly 'modern', that men and women who operate computers all wear national dress – apparel that goes back to a Buddhist cleric of the early seventeenth century, and which was made obligatory in offices and on official occasions some years ago.

Bhutan is so very different in many other, less obvious, respects. It has already decided that the protection of nature is more important than economic growth at all costs. Many people in the West believe that such a stance is necessary for survival in the future. Bhutan has not yet followed the course of the West where the economy has become dissociated from tradition, family relationships, rural social structures and respect for nature, and dominates all other aspects of human culture through the mechanism of self-regulating markets. As yet a monarch rules the country together with an elite; the peasants present offerings to the mountain gods for a good harvest; monks take part in decisions about suitable development projects and men's relationship with nature is determined by Buddhist ethics – as yet Bhutan is not modern. Is Bhutan a bastion on the fringes of time?

The first traces of Buddhism in Bhutan go back to the seventh century; at the time pre-Buddhist religious practices still persisted. During the next centuries, famous lamas arrived from Tibet in the north, and succeeded in establishing a firm foothold among the indigenous kingdoms of the valleys.

Only in the seventeenth century did Bhutan become a unified Buddhist state. The protecting deity, Mahakala, guided Lama Ngawang Namgyel (1594–1651), the future Shabdrung, from Tibet to the region of present-day Bhutan, where he was destined to create a realm for the peaceful flowering of Buddhism. The country was conceived as a fortress to ward off external enemies bent on destroying the religion by force, and also those 'internal enemies' – hate, greed and ignorance – that obstructed the path to enlightenment.

The religious traditions established by the great masters form the basis of a system of meditative and ritual practices which aim at release from the cycle of rebirths. However the elaboration of such practices, as well as knowledge of the philosophic texts, is reserved for the monks in the monasteries. The mainly rural population also regards entering nirvana as the great goal of their religious activities, but for its daily survival needs divine support. Such assistance comes both from the protecting gods of monastic Buddhism and from the 'gods of the landscape' – the mountain gods and a host of local protectors who either have their abode in, or are represented by, such natural features as mountains, trees, lakes and rivers. These much older gods have been integrated into the Buddhist pantheon. Receiving worship and sacrifices, they guarantee fruitfulness and protection against all wrathful demons and hindrances. At the village level, these gods also watch over social norms. If any member of the community breaks the rules, all will suffer. There is great social pressure to conform.

The gods also support all types of rule in Bhutan. The chief of a clan in pre-Buddhist times, the head of a Buddhist school wielding secular power, the monarch of our times – all can legitimize their power by way of a direct relationship to a god, or as the recipient of his or her benevolence.

* * *

Bhutan is often referred to as a paradise, the last Shangri-la, and not only by clever travel agents playing on the longing for a paradisial ambience; it seems that Bhutan is ideally suited to fulfil these fantasies. But a country where people have to work as hard as they do in Bhutan, where wild animals threaten the crops, where parents in remote rural areas cannot immediately get hold of a doctor for their sick child, where national unity and independence have to be defended, and where throughout history wars costing many lives were

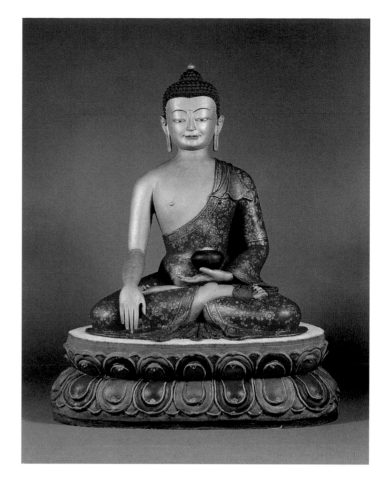

These three images are found together in most altar rooms in Bhutan. Right: The historical Buddha Sakyamuni makes the earth-witness gesture with his right hand. Below left: the Shabdrung Ngawang Namgyel. Below right: the Indian mystic known as Guru Rinpoche (Padmasambhava), who is reputed to have introduced Tantric Buddhism to the country in the 8th century. (E.L.)

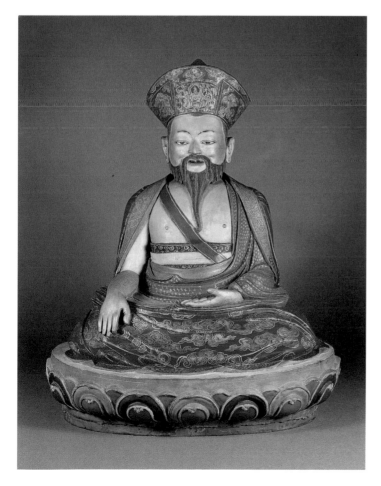

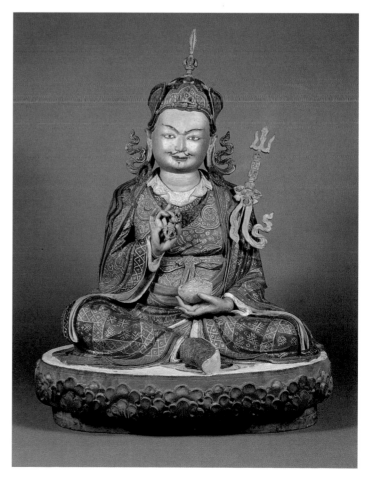

fought, is hardly a paradise. If this were a paradise the endeavours of the Bhutanese government to develop the country in the best interests of the broad majority would be without meaning. If this were a paradise it would be natural and hardly remarkable that despite all their toil and troubles the Bhutanese are often laughing and know how to celebrate.

Certain recent Western press reports about Bhutan suggest that it is an unlikely paradise. Since the early 1990s well-organized political groups among the Nepali minority have promoted their view of the ethnic Nepali–Bhutanese conflict in the international media. The outsider is faced with two interpretations – the Nepali and the Bhutanese – of a problem whose existence nobody denies. From early this century the Bhutanese government offered people of Nepali extraction work on the land along the Indian border, where the climate was traditionally regarded as unwholesome by the indigenous high-altitude population. Until very recently there was a continuous influx of Nepalis, for whom living conditions in Bhutan were much better than at home. In the mid 1980s, the Bhutanese government became aware of an unprecedented expansion in the size of this minority and regarded the unchecked influence of Nepalis as a threat to national sovereignty. To understand such fears one need only look at neighbouring Sikkim. Nepali immigration there reached such proportions that the original inhabitants came to constitute a minority in this once independent Buddhist kingdom, and this subsequently led to the fall of the monarchy. Today Sikkim is a state of the Republic of India.

A subsequent measure of the Bhutanese government was the implementation of the 1958 and 1985 Citizenship Acts; all Nepalis who were unable to produce evidence based on records held by the Ministry of Home Affairs that they or their ancestors had settled in Bhutan before 1958 were not recognized as citizens. Many of them now live in refugee camps in Nepal.

The opposition groups in Nepal also criticize the system of government, calling it 'feudalistic'. As head of both state and government, King Jigme Singye Wangchuck rules the country. He is assisted by a cabinet, a National Assembly and the civil service. A nine-member Royal Advisory Council functions mainly as a consultative organ. Laws can be initiated both by the king and members of the National Assembly. The National Assembly meets once or twice a year for approximately three weeks to examine all kinds of issues and pass the laws. Out of 150 members, 10 are from the clergy, 35 are government representatives nominated by the king,

and the rest are elected by the rural population.

Against the argument that this system does not accord with Western concepts of democracy, it should be pointed out that it may be slightly incongruous to graft a system of government developed in Europe over a period of two thousand years onto a Buddhist kingdom with a completely different history and world-view.

Since the first unifier and theocratic ruler the Shabdrung Ngawang Namgyel created something akin to a 'Bhutanese culture' in the seventeenth century, successive rulers have made attempts to induce the many different groups of Bhutanese to accede to a common cultural legacy and tradition. For almost as swiftly as the Shabdrung managed to unite the various local principalities which had previously fought each other, the country reverted after his death to ethnically and religiously based particularism. It was only in the present century that the first king of Bhutan and his successors achieved the spiritual and political consolidation we witness today. This 'Bhutanization' of the public and private life of all inhabitants is based on the traditional values of Buddhism – compassion and harmony. A state subscribing to these principles has to ensure that all obstacles to the happiness of each individual are removed. A number of cultural values designed to produce such a result were made mandatory throughout Bhutan in 1989. These laws define culture and national identity and regulate all aspects of visible lifestyle for the citizen. These 'Basic Rules of Disciplined Behaviour' (*driglam namzha*; sgrig lam rnam bzhag) are based on religious ideas and legitimized through the authority of the founding monk and theocrat, the Shabdrung Ngawang Namgyel.

These values and code of behaviour are not only important for the consolidation of the domestic scene, but also have repercussions on Bhutan's value system and its contacts with the West. The Bhutanese leadership is convinced that in order to hold its own against Western influences, the kingdom

Masks are worn during religious dances, when the dancer incarnates a deity. 1. Mask of a ging (a celestial being who guards the paradise of Guru Rinpoche) identifiable by the protruding fangs. 2 & 3. Masks of wrathful deities. Peaceful deities adopt a wrathful aspect to subdue malevolent forces. 4. Most probably Pema Gyelpo, one of the eight aspects of Guru Rinpoche. (E.L.)

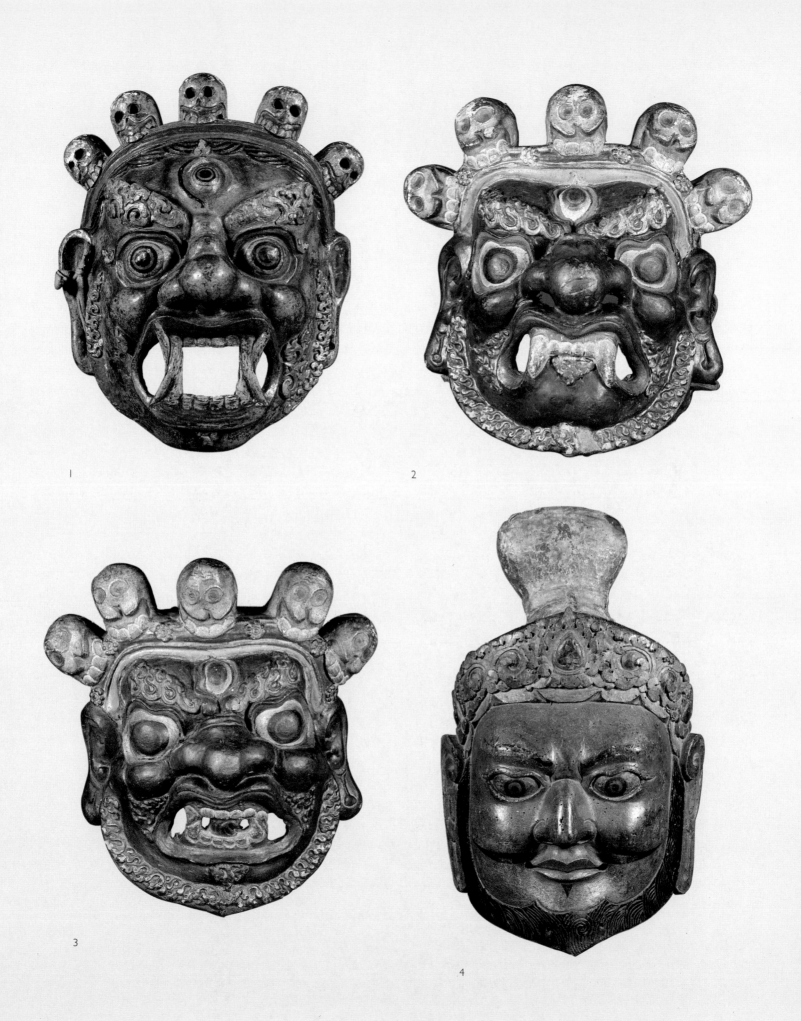

1

2

3

4

has to harmonize all development activities with the best aspects of indigenous cultural values. The paternalistic leadership of King and Government acts as a guarantee.

Only time will tell whether the attempt to provide a harmonious balance between both ethnic diversity and a Bhutanese national identity, and between the claims of tradition and the aspirations to modernity, will prove successful. As far as the Bhutanese are concerned, the relevant structures seem to be in place.

* * *

In this book, eight authors describe different aspects of the country. A very special view of Bhutan is provided by three contributions from Bhutanese authors – a high cleric, a female writer and an intellectual and eminent figure in the shaping of the country's future.

The sequence of the essays is meant to mirror the successive impressions of a foreigner on his first visit. Our trip begins with visual impressions, with the lay of the land, its flora and fauna, architecture and the various peoples with their distinctive regional dress. Next we turn to the everyday life of the people, followed by a meeting with the gods. Then comes history, and here the past helps to explain the present just as a close view of the present throws light on historical matters.

Each essay places its specific subject within a wider context where all spheres of life interconnect, and does not confine itself to one single aspect.

The Viennese botanist Gerald Navara sees the country as a landscape of great beauty and an ecological treasure-house with its snow-capped mountains, snow leopards and yaks, dense jungles and roaring streams, elephants and red pandas and terraced mountain slopes dazzling with lush green rice paddies. Of the total area only 8% is under cultivation, 20% has been declared nature conservation areas, and 60% is to remain forested. Buddhism prohibits hunting and fishing. The distance from the lowest point in the country (150 m) to the high mountain-tops at 7,000 m and above, is only between 90 and 150 kilometres as the crow flies. That explains, for instance, why Bhutan boasts fifty varieties of rhododendron, while west Nepal has 'only' ten. This astounding diversity of habitats is multiplied on account of the high north–south mountain ranges, which separate seven deep river valleys and prove an insurmountable barrier for many kinds of flora and fauna.

Traditional knowledge about the multifarious uses of wild plants remains alive to the present day. So we find that with the correct preparation, wild poisonous plants land in the cooking pot, and that an interest in herbal remedies provided one of the original names for Bhutan – 'the southern valley of medicinal plants' (*Lho Jong Men Jong*).

The riches of Bhutan's flora are matched in its fauna. So the traveller who encounters rain-drenched virgin jungles or glistening snow mountains will not be surprised if the stories he hears include an occasional mythical animal.

Into this picture of landscapes, animals and plants the French ethnohistorian and Tibetologist Françoise Pommaret introduces the people. She, too, takes the distinctive landscape as her starting-point to emphasize the different cultural and religious identities of the various valleys, and proceeds to give an overview from north to south and west to east. The valleys were settled by several ethnic groups during waves of immigration for which there is circumstantial evidence. In western Bhutan we find the Ngalongs, whose culture in many ways resembles that of 'old Tibet'. As for central Bhutan, and especially Bumthang district, many elements of its cultural and religious history form the basis of present-day modern Bhutan. The origins of the population of eastern Bhutan seem to be lost in proto-historic times.

After a journey across the high mountain crests, Pommaret traces the course of the north–south river valleys as they plunge over the shortest possible distance from the alpine regions of the Himalayas to the tropical lowlands. Before the building of metalled roads across the mountain ranges, trade consisted mainly in the exchange of goods between the different altitudes of a valley. Various ethnic communities gained their livelihood by optimal adaptation to their natural surroundings. In the northern high alpine regions cattle-herding is only possible during the summer months, while at moderate altitudes various crops like cereals, corn, rice and potatoes are grown, and in the subtropical south mainly cash crops such as oranges and cardamom.

Bhutan appears remarkable not only to the traveller, but also to the linguist. There are few regions in the world where

Situated at 3,000 m in a dramatic landscape on the way to Laya in the northwest, Gasa Dzong is today the only district headquarters which cannot be reached by a motorable road. Built at the foot of a 6,000 m mountain, the embodiment of the local guardian deity, Gasa dominates the whole gorge of the upper Mochu river and has the distinction of having curved external walls. (R.D.)

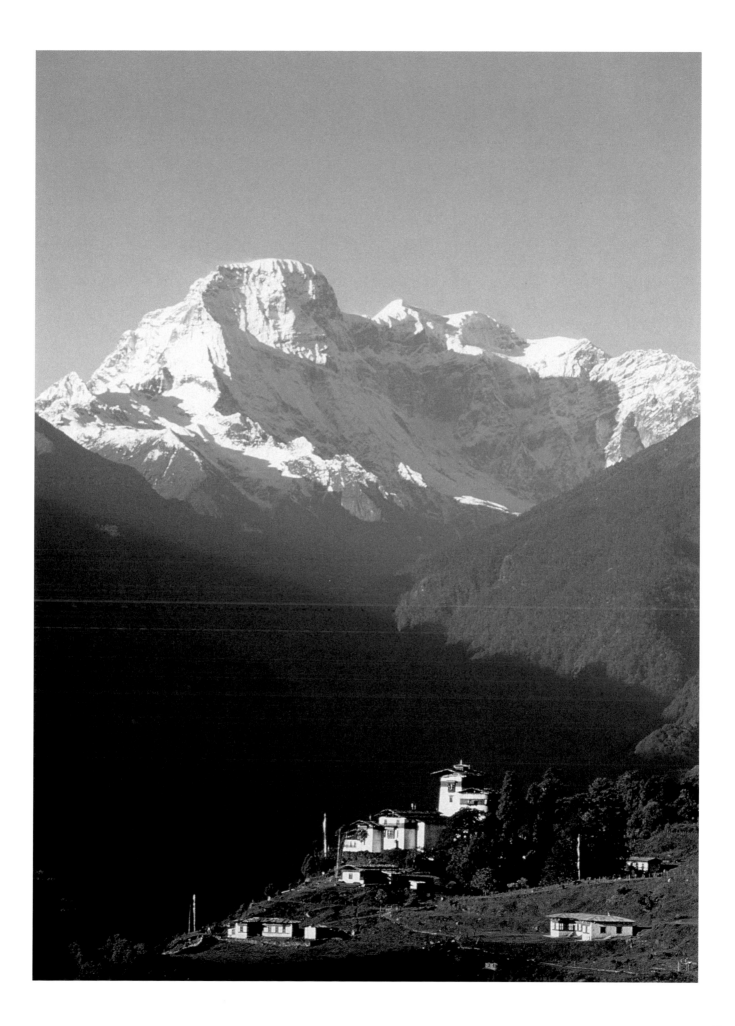

so many languages are spoken within such a small compass. Because of this linguistic diversity, communication across the valleys and the region became possible only after the introduction of a national language, Dzongkha. 'Dzongkha' means 'the language of the *dzong* (fortress-monastery)' and is based on a language spoken in western Bhutan. It is vigorously promoted as a means to foster national unity and identity.

Against this background of geographical, climatic and ethnic diversity, the Belgian architect Marc Dujardin discusses the richness of the building traditions of Bhutan's mainstream culture. He goes much further than providing a description of the visual aspects to illustrate the function of architecture as an integrating and creative force within the culture as a whole.

The basic structure of all Bhutanese building types was laid down by the country's unifier, the Shabdrung Ngawang Namgyel. The design of his fortresses aimed for a distinctive Bhutanese building style set off from Tibetan traditions, and contributing to an independent Bhutanese cultural identity. The fortress-monasteries represent the dual rule of religious and secular power. This type of construction combining the sacred and profane 'under one roof' was also used for traditional farmhouses and, more than three hundred years after the Shabdrung's death, made compulsory for new urban buildings.

In his analysis of a village settlement, Dujardin discusses traditional conceptions of built-up spaces in all their manifestations from village temples, via spirits' abodes, to farmhouses. The siting of specific buildings in a village is dictated by religious considerations. Thus, for example, the entire valley is regarded as a huge snake whose head is literally nailed down by the village temple. Every farmhouse with its social interaction is the place wherein, and by which, society is constantly recreated. The reconstruction of houses at regular intervals indicates cycles of inheritance in the same way that sacred areas of the house express the religious life of the individual. Dujardin gives several examples of the dynamic interaction between architecture and the traditional order over a historical period.

The Swiss ethnologist Martin Brauen introduces us to a village "somewhere in central Bhutan". It is the type of setting where 80% of Bhutanese live, where they cultivate their fields, tend their flocks, celebrate rural religious ceremonies – where, in short, traditional Bhutanese society is alive.

Since olden days taxes in kind, in money or in labour have tied the rural communities to the centres of power. The Bhutanese were much burdened by such contributions and only recently has the compulsory labour system been revoked. In 1993, the labour wage for men and women was equalized.

The organization of rural village life described here gives women a highly advantageous position since property is generally inherited through the female line (although Bhutanese law promotes equal rights for male and female children). This arrangement provides women with a strong domestic position; they decide about the budget and the buying and selling of goods, they divide the work-load among family members, they are active and highly vocal in any important decisions made at the local level, and they concern themselves with the staging of religious ceremonies. Brauen cites family histories which poignantly illustrate how social norms and actual behaviour are brought into harmony through the social process.

The extent of a woman's freedom in her dealings with men – illegitimate children are freely talked about – depends greatly on whether she is a rich landowner, landless without anything to bequeath to her daughters, or the wife of an artisan. In the latter case it is the man who owns the means of production.

Women's highly favourable position is restricted to the village level. On the next higher level all power rests with men. They have always been the only ones allowed to interpret Buddhist scriptures and formerly relegated woman to an inferior position, removing her from the public to the private sphere, even though this was contrary to early Buddhist teachings which proclaimed the equality of all living beings.

The Australian economic expert Barry Ison writes about traditional crafts and the craftsmen's lives. The crafts he discusses are carpentry, stone-masonry, carving (both in stone and wood), painting, pottery, metal-casting, wood-turning, smithing, jewellery in gold, silver and copper, bamboo and cane-work, paper manufacture, needlework and weaving. These so-called 'thirteen traditional crafts' (*zorig chusum*; bzo rigs bcu gsum) form part of a general system regulating all secular and religious aspects of Bhutanese culture. It originated with the founder of Bhutan, the Shabdrung Ngawang Namgyel. Since the 1990s the government is again promoting the thirteen crafts to create employment and strengthen cultural identity.

For each craft, Ison focuses on a particular craftsman and

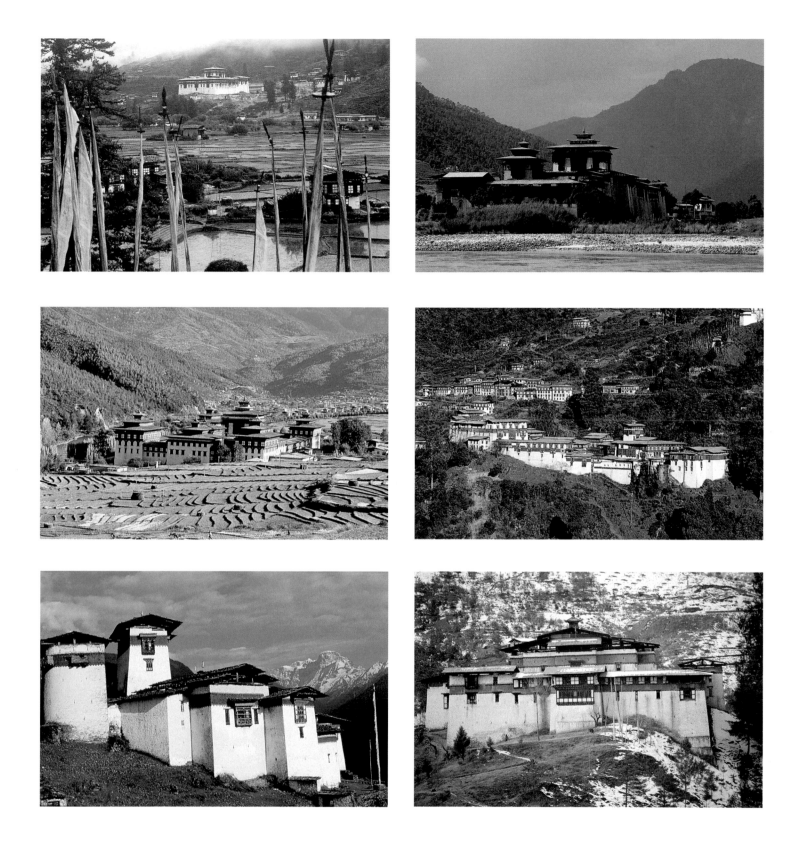

1. *Paro Dzong.* (G.V.S.) 2. *Punakha Dzong.* (J.P.) 3. *Tashichödzong (Thimphu).* (R.D.) 4. *Tongsa Dzong.* (J.W.) 5. *Gasa Dzong.* (R.D.) 6. *Simtokha Dzong.* (C.S.) *Architecturally striking, these dzongs (fortress-monasteries) were built in the 17th century in each valley to house the Drukpa monk-body and the civil administration, a role which most of them still possess today. Except for Simtokha Dzong, which retains its original form, all have been rebuilt at different stages.*

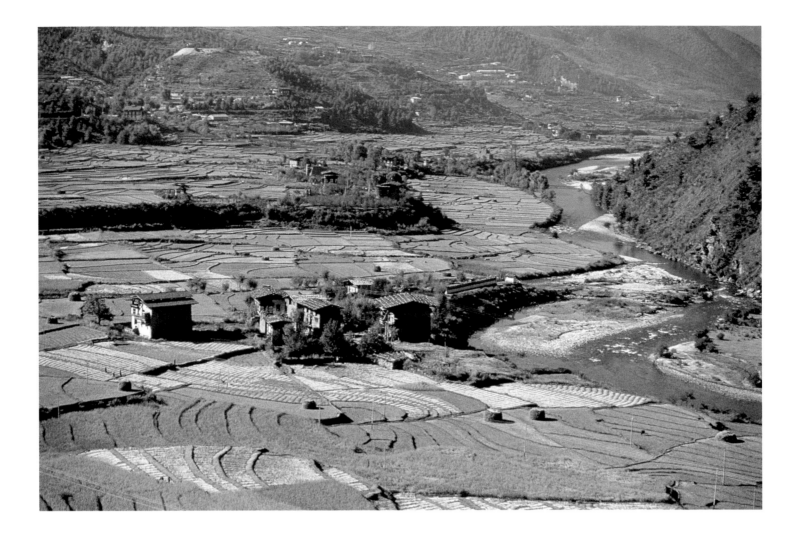

The valley of Thimphu at 2,300 m in the west of the country is one of the most fertile in Bhutan and was extensively devoted to agriculture until the rapid urbanization of the capital over the past fifteen years. (R.D.)

provides a description of the special tools, the gathering and preparation of the raw material and the methods of production, and also indicates the value and worth of the finished product in its overall cultural context. Without this individualized approach we would never have learned, for instance, that after finishing a religious image the craftsman might be rewarded with auspicious dreams by the god in question.

The shape and decoration of religious images are strictly defined in Buddhist literature. The proficiency of an artist shows in his graceful brush-lines or the meticulous execution of a cast but never impinges on the deeper meaning of the work in question. As is so often the case in Bhutan, this is already supplied by the sacred canon.

The introduction to Bhutanese religion is written by Mynak Tulku, a Buddhist monk and high cleric. His selection of several Buddhist topics and their sequential arrangement provides insights into real-life practices which even the most erudite scholar would be unable to supply if he were not a highly advanced practising Buddhist.

Mynak Tulku first presents the immensely rich and well-ordered literature comprising the Buddha's teaching and its interpretation, and relates each religious text to one of the numerous Buddhist schools practising it. The state religion of Bhutan is the Buddhism of the Drukpa Kagyupa School, which gave its name to the country: Druk Yul, 'Land of the Thunder-Dragon'. The school is very tolerant towards the Nyingmapa School, the oldest Buddhist teaching tradition in the Himalayas and the second-largest denomination in Bhutan. The short discussion of the differences between the schools ends with the remark that despite all their divergences in matters of scripture and ritual, they share a common goal: Buddhist teachings should elevate men to a higher spiritual level and to enlightenment, which grants release

from the cycle of rebirths.

Buddhism was first introduced to Bhutan in the seventh century during the time of the Tibetan king Songtsen Gampo without greatly influencing the lives of the population. More important was the ground laid in the eighth century by the missionary work of Guru Rinpoche who, up to the present day, is regarded as a second Buddha. The final breakthrough for Buddhism came in the thirteenth century, when a great variety of Buddhist schools from Tibet founded branches in Bhutan. It remained for the country's unifier Ngawang Namgyel to codify the various teachings in the seventeenth century.

Since then the regular performance of Buddhist rituals has played an important part in the daily life of the Bhutanese. Mynak Tulku describes certain rituals and the relevant ritual objects and techniques according to specific occasions – be it the erection of a house, the empowerment to perform a ritual, the performance of a death ceremony, or

Dressed in their best clothes, this family is making a pilgrimage to the monastery where their young son is a monk. (G.V.S.)

the veneration of mountain gods. The fact that these gods originally predated Buddhism illustrates the tolerance and harmony suffusing the spiritual life of the Bhutanese.

The Viennese ethnologist Christian Schicklgruber guides us through 'deified nature', where mountains are gods. A great many gods either reside in, or are personified by, such natural features as mountains, trees, rocks and rivers. Their cult, which is found throughout the Buddhist regions of the Himalayas, dates from much earlier than the advent of Buddhism and has its origins in a mingling of animism and shamanistic practices.

Instead of outlawing these indigenous religious conceptions and practices, the Buddhist missionaries incorporated them into their own faith. With magical means they subdued the old gods and turned them into protectors of the new religion.

For the peasant population the protection of the mountain gods presents the most important spiritual underpinning of daily life. As long as they receive proper veneration and offerings, these deities guarantee fruitfulness and protection

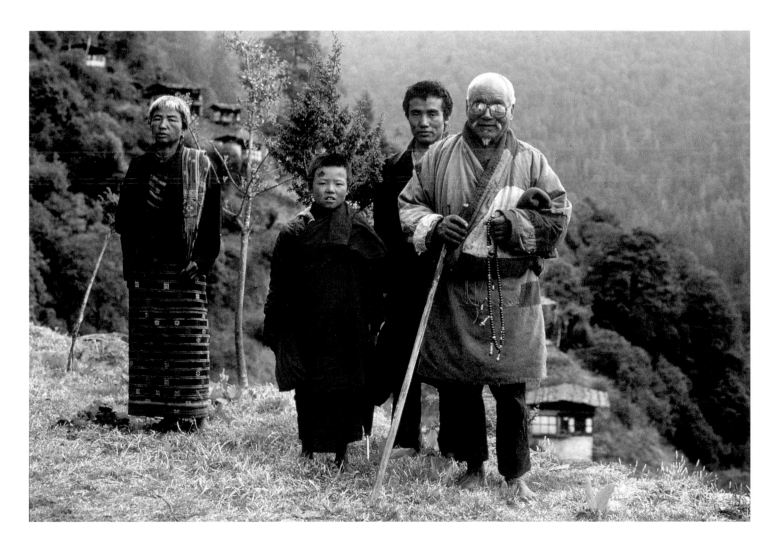

against the powers of evil and natural calamities. But should someone disturb their peace or the requisite offerings fail to appear, they may threaten the livelihood, and even the lives, of their believers.

These gods play a part in the relations not only between men and their habitat, but also between men themselves. They keep a watchful eye on compliance with social norms, just as they give legitimacy to the political power-holders. Usually only those with good relations with the gods have access to political power. Before the establishment of the centralized power of the state this relationship was based on kinship – the ruler being a 'son' of the gods; afterwards the same claim was put forward by those on the fringes of power. But even great Buddhist lamas with secular power would invoke their familiarity with the mountain gods, either because they had privileged knowledge of the correct rituals or because they had subdued them with magic and turned them into devout followers.

In every large monastery these gods have a chamber to themselves or are represented in wall-paintings. At village-level, regular observance is the duty of local priests who use Buddhist rituals to approach them and put them in favourable mood. For such rituals the whole village has to be present, and they are an occasion to strengthen the community spirit.

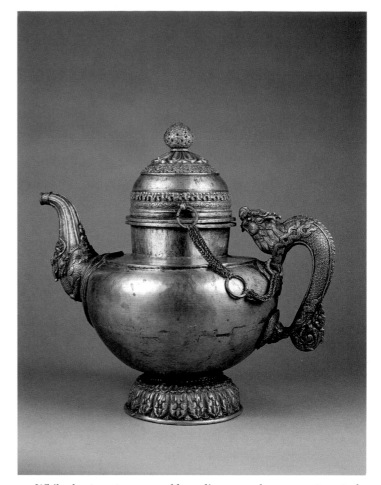

While clay teapots were used by ordinary people, a copper teapot of this quality would have been reserved for use by the nobility. (E.L.)

Two further contributions by Françoise Pommaret deal with Bhutan's development from pre-Buddhist times to the present monarchy. Because of the lack of documentary material, we can only speculate as to what happened in the region earlier, but with the advent of Buddhism documentation improves. There are Bhutanese sources on the lives and works of great men.

Before unification in the seventeenth century, the situation in each region differed. In eastern Bhutan political and social life was shaped by clans which claimed both the Tibetan king Trisong Detsen and the local gods as their ancestors. In central Bhutan the religious leadership formed an alliance with members of the pre-Buddhist order. Here the school of unreformed Buddhism, the Nyingmapa, was particularly prominent. Members of the religious nobility entered into diplomatic marriages with the local ruling families. The Bhutanese monarchs trace their ancestry back to one of the greatest saints of Bhutan, the 'treasure revealer' Pema Lingpa. The history of western Bhutan was largely shaped by the establishment of various religious schools from

Tibet. Even though the Drukpa Kagyupa School became increasingly important from the thirteenth century onward, it was unable to unite the various local principalities.

Unification had to wait for the arrival of the Shabdrung Ngawang Namgyel. Due to succession struggles in Tibet, he had to flee the country and was guided by the prophecies of the guardian deity Mahakala to the region of present-day Bhutan. In the early seventeenth century he succeeded in uniting the warring valley-based rulers under his command. This victory was due to his religious abilities and charisma, as well as to his superior military strategy. He laid the foundations upon which an all-Bhutanese society could be organized. In each valley he built *dzongs*, the fortress-monasteries so typical of Bhutan. There resided the high clergy and local leaders under the central power. The national consciousness of the modern Bhutanese derives much from institutions first established by the first Shabdrung. He was succeeded by six reincarnations, each of whom stood at the head of the country.

Yet soon after the first Shabdrung's death it became

evident that his charismatic personality was sorely missed. The power of the theocratic rulers diminished while local leaders attempted to take over the key position at the centre, and Bhutan became engulfed in civil war.

It was during this unsettled period that Bhutan made first contact with the British who saw the country as a trading-partner and useful buffer-state against China. Early good relations deteriorated until, in the 1860s, border incidents led to war, from which the British emerged victorious. In a treaty signed in 1865, Bhutan returned recently conquered areas along its southern border, and relations improved again.

The most powerful figure in Bhutan at the time was the governor of the Tongsa Dzong, Jigme Namgyel. The protective deity Mahakala, who had already appeared to the first Shabdrung, came to him in the form of a raven and called upon him to re-establish Bhutan's erstwhile unity. In this he succeeded through war, shrewd alliances and the placing of relatives in key positions. After a series of struggles, wars and assassinations he emerged as the most powerful regional leader. The first step towards the monarchy had been achieved. Soon after he had installed his son Ugyen Wangchuck as his successor, peace reigned in Bhutan for the first time since the end of the seventeenth century.

Finally, on 17 December 1907, the most influential figures in Bhutan as well as representatives of the monastic community and the people elected Ugyen Wangchuck (r. 1907–26) as the first king of the new hereditary monarchy. The spiritual and political consolidation was completed by the second king, Jigme Wangchuck (r. 1927–52). There were early conflicts between the king and the last active reincarnation of the Shabdrung. Following the death of the latter, the king was able to firmly hold the reigns of power. When India gained independence in 1947, Bhutan's previous relationship with Great Britain was transferred to the new republic. Today Bhutan is completely independent in her domestic affairs, while foreign policy is developed in consultation with India. Bhutan follows a cautious and pragmatic foreign policy reflected in its establishment of diplomatic relations with 18 countries including Austria, Switzerland, Denmark, Norway, Sweden, the Netherlands, Finland, Japan, the European Union and six other countries of South Asia.

The third king, Jigme Dorje Wangchuck (r. 1952–72), is regarded as the father of modern Bhutan. He ended Bhutan's self-isolation and built up international contacts. He also introduced important measures on the domestic front: the National Assembly was instituted in 1953, serfdom abolished in 1956, and in 1971 Bhutan took its place in the community of nations and became a member of the United Nations. Now the ruling monarch Jigme Singye Wangchuck has the task of continuing the political development and leading his country towards a new era.

Karma Ura, a young intellectual and civil servant at the Ministry of Planning in Thimphu, explains Bhutan's philosophy of development. The Bhutanese assume that the Western world understands development as the stimulation and satisfaction of material desires. In Bhutan the spiritual well-being of each individual is the supreme goal. The current king's formula, "gross national product comes second to gross national happiness", illustrates the attempt to harmonize the spiritual and material aspects of life.

Since 1961, material development policies are laid down in five-year plans with the main emphasis on road-building, communications, health, education and agriculture. Improvements of the social infrastructure are still largely financed through international development cooperation. To become self-sufficient, the government wants to increase agricultural and industrial output, and especially to exploit the tremendous water-power potential. As this involves greater exploitation of nature, stronger measures for conservation need to be put in place. The state policy regarding the protection of nature is based both on Buddhist ethics and indigenous practices of resource management. Local solutions to ecological situations are encouraged through a process of decentralization, with the central government only intervening if modern technologies overstrain traditional methods.

These approaches to planning and regulation are formulated in urban settings which themselves are products of the developmental process.

The Bhutanese writer Kunzang Chöden highlights the consequences of the most recent developments on the lives of five women living in the capital Thimphu. The city, the seat of both government and administration, has grown tremendously during the past thirty years and now has a population of over 35,000.

Kunzang Chöden believes that the position of women was stronger under the pre-Buddhist Bön religion. Monastic Buddhism banished women from public and religious life. Men ruled in the *dzong* and women in the household. Today women hold 16% of government jobs, mainly in lower positions. The well-educated young female civil servant that

Kunzang Chöden interviewed is an exception.

The new freedom of Bhutanese women has not come about through official efforts. Rather, new economic possibilities provide alternatives to traditional role models. A growing market for handicrafts allows a female weaver to earn her own living. Because civil servants are forbidden to engage in business, their wives are very active in the property and estate market. At private get-togethers women exchange important information. The old nun interviewed by Kunzang Chöden receives enough alms to devote herself to a religious life without recourse to monastic or family support. The new freedom is also changing traditional marriage patterns. Nowadays marriages are no longer strictly within the same social stratum, and less often arranged by parents. Furthermore, a certain measure of economic wealth gives people a better chance to marry for love and ignore the social position into which they were born.

For the first time in Bhutanese history, people perceive 'leisure' as a subject in its own right. One often hears complaints about the lack of facilities to make the most of one's free time. In the future, watching videos or playing cards may not prove sufficiently fulfilling. A woman from eastern Bhutan who spends much time with her daughter – a teacher in the city – voices regret that modern women show little interest in religion, and have little time for religious practice.

* * *

Do the developments referred to above present a far greater potential danger to the 'fortress of the gods' than all the problems with Bhutan's largest minority? Well-educated women and men who have seen the world still wear traditional dress. But for how much longer will its historical resonance remain relevant to their thoughts and actions? Soon this young urban population will want to satisfy new needs and desires – the fruits of a liberal economic policy – and not always in agreement with traditional values. A money economy is a modern phenomenon, and material aspirations have always been regarded as an 'inner enemy' of religious strivings.

Soon the sons and daughters of the great old families, together with members of a growing middle class, may want to direct the ship of state, or at least have a say in the shaping of the future. Whether they will do so in the spirit of their forbears, only the future can tell.

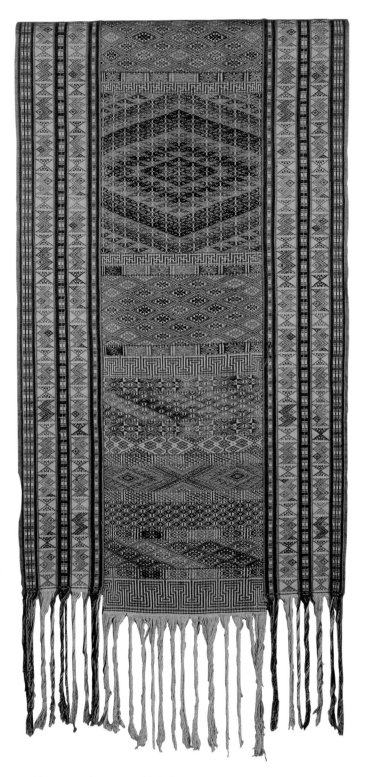

Known as chagsi pangkheb, *literally 'cloth to wash hands', this ceremonial cloth was seldom used as such except by the well-to-do and high clergy in rituals. See also p. 130.* (E.L.)

The king has directed his country's development till now. He believes that a strong sense of culture and national identity among his subjects are the key for survival for a diminutive country situated between towering neighbours to the north and south. A society imbued with strong religious values should also be able to counter the dangers arising from globalization.

How 'modern' is Bhutan? Will it reach the point where uncontrolled market forces rule the social sphere, where nature is exploited purely for profit, and the alliance between religion and power breaks down? One would naturally expect that clerics and religiously legitimized leaders in particular would attempt to forestall developments that might threaten their world-view. This may have been true for many parts of the world, but not for Bhutan. In this book the subject repeatedly arises of how harmoniously the past influenced the present during Bhutan's history, how older values and conceptions fruitfully developed under changing circumstances. Thus, for example, were the indigenous gods of earlier times adopted into the Buddhist pantheon, and thus the seemingly rigid structures of Bhutanese architecture showed themselves highly adaptable to new developments. This sense of harmony should prove capable of linking the present with the future without discarding the moral values of the past.

May tolerance and compassion, the root of all actions in Buddhist philosophy, protect Bhutan, mountain fortress of the gods.

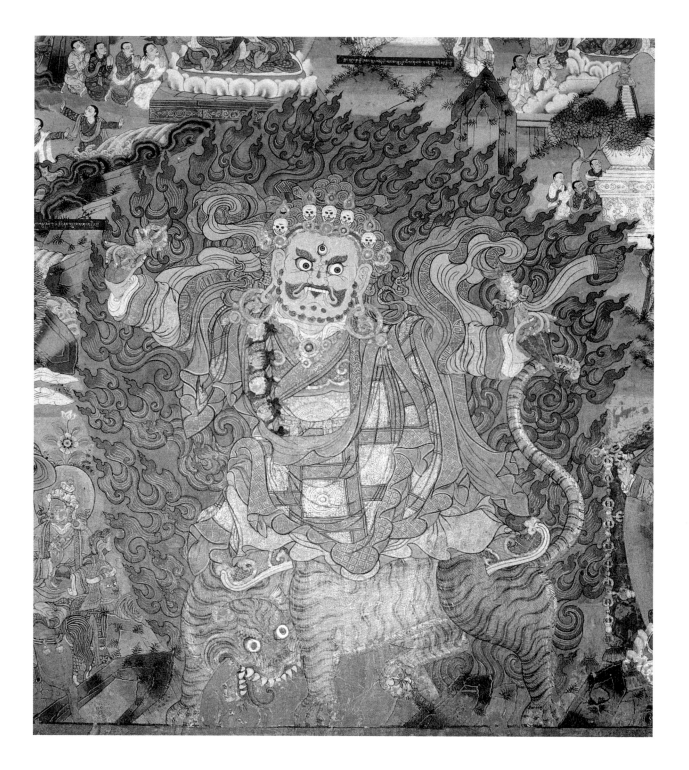

The Country and its Heritage

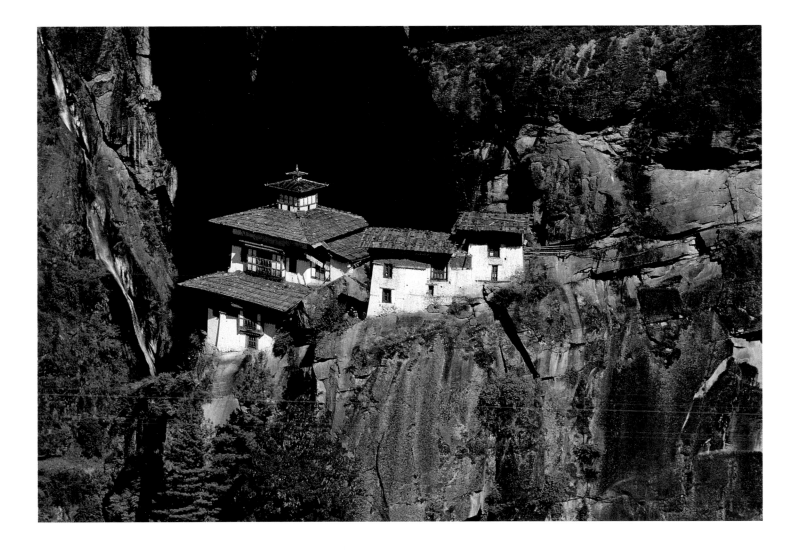

Left: Wall painting at Guru Tsengye Lhakhang representing Dorje Drolö, the wrathful aspect assumed by Guru Rinpoche to arrive at Taktsang mounted on his dakini-tigress. (F.P. 1982) Above: The temple complex of Taktsang (Tiger's Lair), clinging at 3,000 m to the side of a cliff high in the Paro valley, is one of the most sacred places of Bhutan. See also pp. 134–135. (G.N.)

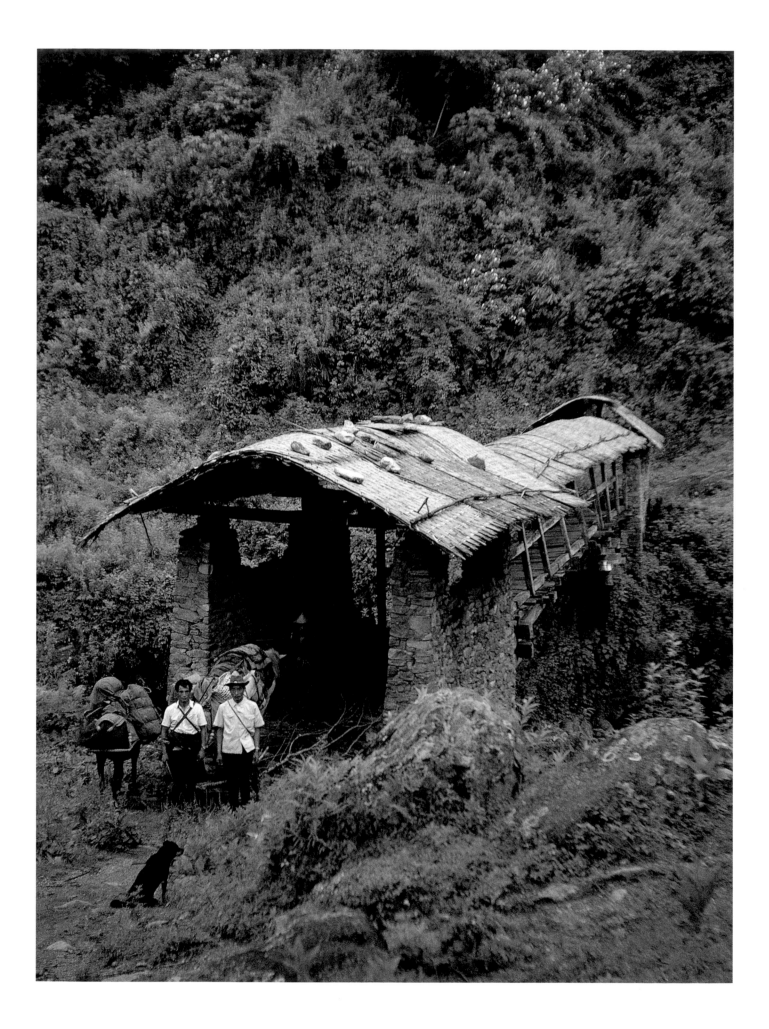

The Lay of the Land

Gerald Navara

Reports about Bhutan invariably mention that it is a country with the most varied habitats and a rich array of animal and plant species, and that is almost unbelievably unspoilt. Authors also acknowledge that there has been little research on the subject. Indeed, Bhutan can be compared to those large empty spaces on old maps indicating unexplored territory; it is a veritable *terra incognita*. It presents a great ecological treasure-house whose significance for scholarly research, and for our world heritage, is only slowly being recognized and is, as yet, little appreciated. The small kingdom in the eastern Himalayas was closed for a long time, which has also spared it until now from the ravages of untrammelled development encountered in comparable regions.

More than half the country is still covered with forests. One tenth of the area is covered by glaciers and, together with rocky ranges, heathlands of alpine dwarf bushes and pastures, makes up a quarter of Bhutan's total area. No more than 8% is under cultivation to feed some 600,000 persons.

The country's geographical situation and topographical extremes, along with its long isolation, are responsible for its extraordinary flora and fauna. If one thinks of Bhutan as a country of high mountains and alpine conditions, one will be surprised by its subtropical climate and dense jungles. A glance at a world map will show that it shares its position along the 27th latitude with Cairo and New Orleans, though

A traditional bamboo-covered cantilever bridge in Lhuntshi in the northeast. Rifles may be carried against attack from bears, abundant in the region, although hunting is banned in Bhutan. (A.A. 1970)

its situation on the southern border of the Tibetan plateau accounts for its many peculiarities, of which the summer monsoon blowing in from the Bay of Bengal is only one.

With an area of 46,500 km² – almost exactly the size of Switzerland – Bhutan extends across 3° of longitude and almost 1.5° of latitude. Its lowest point, 150 m above sea-level, lies on the Indian border. To the north, the country is framed by the main Himalayan mountain range with several peaks above 7,000 m, the highest being the Gangkar Pünsum (7,497 m). The distance from the lowlands to the snow-covered peaks varies between 90 and 150 km, as the crow flies. These two extremes frame a landscape which stretches from the subtropics to perennially frozen regions. Naturalists delight in the idea of Bhutan with its rich variety of species found within a small area, since there are few places on earth where it is possible to experience such contrasts within so small a compass. A further factor are the seven great rivers running north–south. Ravines with depths of up to 3,000 m present insurmountable barriers for many plants and some animals. The grid produced by the valleys and the different climatic zones provides for a great variety of habitats.

The south, with its lowlands and promontories, has a subtropical climate with warm winters and hot and very humid summers. From June to September the monsoon brings precipitation totals of five metres, rising in certain parts of the country to seven metres. The resulting landslides, washouts and erosion can easily be imagined.

In the central area, at heights between 1,500 m and 3,000 m, the climate is temperate. During the winter it is cool to cold

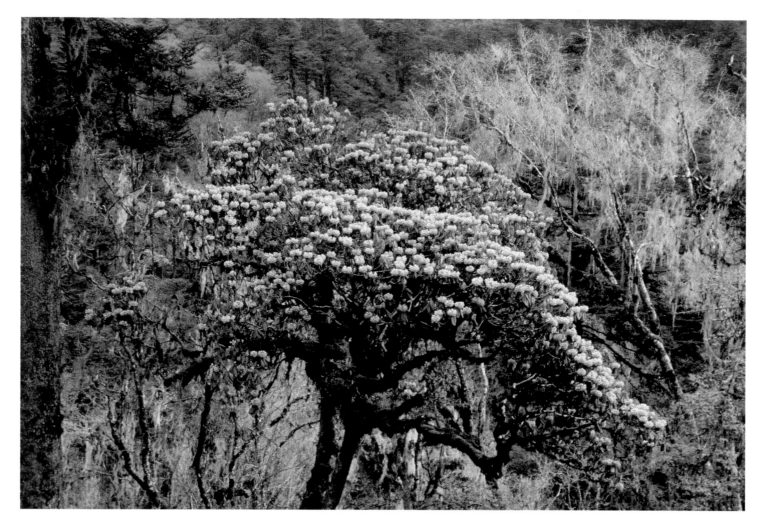

Rhododendron tree in full bloom in the month of April. (F.P.)

and dry. In March the temperature begins to rise, but there is still no rain. Thus June is already quite hot and dry, while the monsoon approaches from the south, each day moving a couple of kilometres further north. In this region the rainfall is also very heavy and comes down in torrents the likes of which are unknown in Europe. The heaviest rains fall in the side valleys where the mountain ridges drain the clouds. Thick cloud-banks lie low across the country, and the mighty thunderstorms in July and August lend a vivid dimension to Bhutan as the 'land of the thunder-dragon'.

By the end of September the rains slowly lose their ferocity, ending quite abruptly in early October, when the temperature starts to drop. The air is clear, and the visitor approaching Paro by plane at this time of year is highly likely to see the Himalayan range before him, with Mt Everest seeming impossibly close, being in fact some hundreds of kilometres away.

In the main valleys running north–south the summer progresses slightly differently. The rains are not as copious because strong southerly winds drive the clouds further north. The temperature differences over the year can reach extremes. In the Paro valley (2,200 m) the temperature in summer sometimes rises to 30°c, while in winter it can drop to minus 7°c. The lowest temperatures occur at the end of January and in February. Around this time it can be definitely chilly in the capital Thimphu, 2,330 m above sea-level.

The climate of the high mountain regions is characterized by short, cool summers and cold winters with much snow. The climate is a major influence on the vegetation and the main cause of certain special features.

When attempting to find out more about the natural history of Bhutan, one usually gets a somewhat fragmented picture since few people have managed to visit all parts of the country. Writers therefore fall back on the reports produced in the nineteenth century by the earliest expeditions. There is speculation about the existence of many species. In a side valley of the Sankosh, the author himself was treated to the story of a giant twenty-metre-long snake whose looks could kill.

1

2

3

4

5

6

Some flowers of Bhutan:
1. *Zingiberaceae;* 2. *Dendrobium densiflorum;* 3. *Rhododendron sp.;*
4. *Meconopsis sp.;* 5. *Cymbidium grandiflorum;* 6. *Pelargonum sp.* (G.N.)

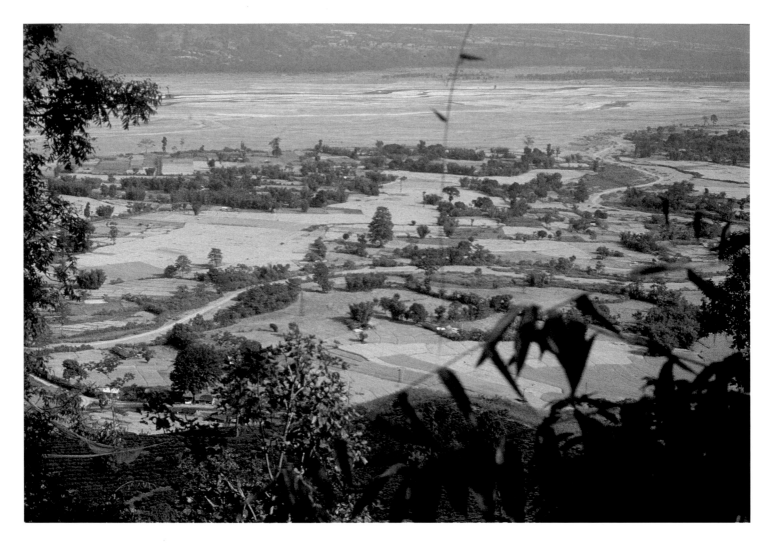

Less than 100 km south of the high Himalayas, the foothills meet the fertile plains of Bengal near the border town of Phuntsholing. (G.V.S.)

Bhutan is situated in the eastern Himalayas at the interface of several floral and faunal regions. On the one hand it presents a continuation of the Himalayas in the west, but on the other partakes of influences from the Indo-Malayan region in the southeast, and from the Indian subcontinent in the south. In the north, species arrived from China and Tibet. This also explains why Bhutan is much richer in plant and animal varieties than any of its neighbours. To take rhododendrons as an example: in western Nepal there are only some ten different species, in eastern Nepal already twenty-nine, while in the 'land of the thunder-dragon' we find more than fifty.

VEGETATION

A comprehensive account of Bhutan's flora must wait until enough data on all the country's regions has been collected.

In the south the mountains give way to lowlands along the Bhutanese–Indian border. This narrow strip is covered with subtropical forests with a number of evergreen trees. What appears on first sight as a rain forest, is in fact a vegetation clearly defined by changes between dry and wet seasons. Noticeable are wild banana plants (*Musa sp.*), pandanus (*Pandanus tectorius*), wool-trees (*Bombax ceiba*), fig trees (*Ficus sp.*) and the sal-tree (*Shorea robusta*).

The transition to the next vegetation zone is rapid and depends on the amount of precipitation. Various species of

Opposite: A dense subtropical mixed forest is found in a gorge to the north of the Punakha valley. (F.P. 1982)

An aerial view of the region south of Wangdi Phodrang with fields providing a clearing in the forest. (G.N./T.B.W.)

oak like *Castanopsis indica* and *Engelhardtia spicata* increasingly characterize the summer-green forests. Climbing plants, tree ferns and numerous epiphytic orchids like *Cymbidium grandiflorum* and *Dendrobium fimbriatum* grow on the mighty trunks. On slopes exposed to the south and southeast, at altitudes of 1,500 m, one encounters the first rhododendrons of treelike appearance with a height of up to ten metres and flowering before the onset of the monsoon.

In the dry central valleys with their north–south orientation the vegetation is completely different. The chir pine (*Pinus roxburghii*) grows in clusters and is highly valued as timber; sometimes beams of 15 m can be hewn straight from the trunk. Between 1,800 m and 2,000 m one increasingly finds maples, beeches, evergreen oaks and more and more rhododendrons.

In drier habitats grow entire forests of blue pine (*Pinus wallichiana*); an important source for timber. The undergrowth here consists of roses (*Rosa sericea*), berberis (*Berberis asiatica*) and jasmine (*Jasminum humile*). Above 2,500 m other conifers appear, like Tsuga (*Himalayan hemlock*), Sikkim larch (*Larix griffithiana*) and East Himalayan fir (*Abies densa*). Above 3,700 m the most common shrubs are Weeping blue juniper (*Juniperus recurva*) and *Rhododendron lepidotum*, and we also find more and more flowers such as globe flowers (*Trollius pumilus*) and many kinds of Himalayan poppy (*Meconopsis sp.*) indicating the transition to heights above 4,000 m, where alpine shrub-heaths predominate. Little is known about this high-altitude vegetation.

Useful plants

Bhutanese medicine is dependent on natural products. A survey of medical practices has shown that more than three hundred wild plants are used. Plants from the highlands and the lowlands are distinguished. Many plants are also used for cooking, even poisonous ones, following careful preparation. Thus a fern (*Angiopteris lygodiifolia*) is turned into a

vegetable. Once the leaves reach their full size of up to three metres, they become poisonous. But the Bhutanese have found a way to solve this problem. They cut the leafstalk, which is several centimetres thick, into small slices and soak them in a brook for several days. The poison is thus washed out or neutralized, and the fern slices are ready for cooking. The buds of a large-blossomed orchid (*Cymbidium grandiflorum*) are a popular vegetable served with meat. Being rare, the plant fetches a high price at the market. Here necessity seems to have been the mother of invention, making people resourceful in discovering unusual edible plants. At least in the mountain regions there is scarcely a plant, whether herbage, shrub or tree, for which the inhabitants do not find some use. The bark of a certain shrub (*Daphne sp.*) is made into high-quality paper. These are only a few examples to show how much useful knowledge can be found in traditional undisturbed lore.

An aerial view of terraced fields in Paro valley in October when chillies are set out to dry. (G.N./T.B.W.)

FISH

The lakes and rivers of Bhutan present another interesting habitat. No survey of the types of fish has yet been undertaken. Forty-two species have been recorded but potentially there may be an additional two hundred, because the rivers all join the Brahmaputra beyond the border in Assam and are enriched by the stocks of that river. The greatest variety is found in the lower-lying river sections. Mainly in the winter months, when the water level is low, some fish migrate from the Brahmaputra to the higher sections of the Bhutanese rivers in order to spawn.

The snow trout (*Schizothraichthys progastus*) is very common and popular. It is not a trout at all but belongs to the carp family, can grow up to fifty centimetres and loves swift waters. It migrates to the highest regions for spawning, afterwards returning to lower areas. In the swift brooks of the high mountains up to an altitude of 2,770 m brown trout

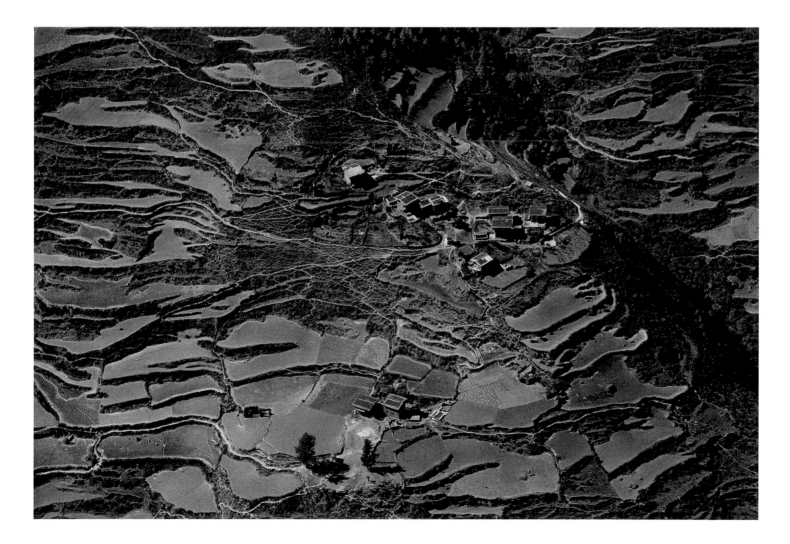

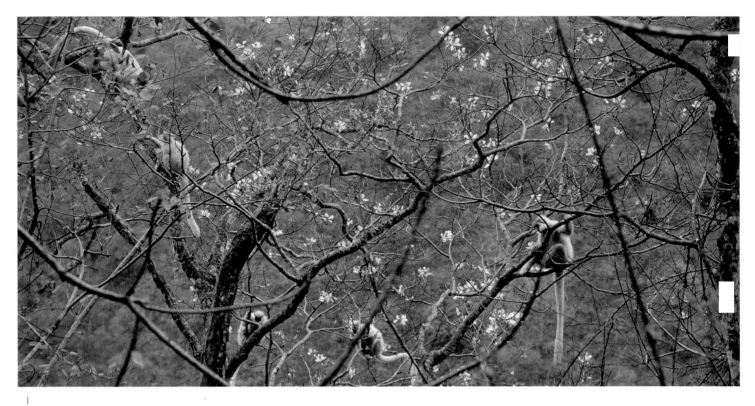

1

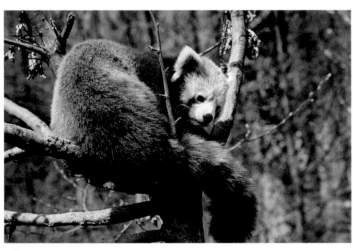

2

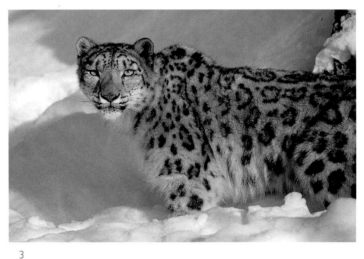

3

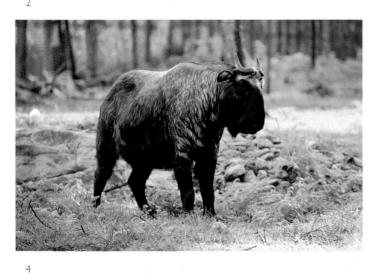

4

Some mammals of Bhutan:
1. Langur monkeys (Presbytis geei) are a common sight in central and south Bhutan. (F.P. 1991)
2. Red panda (Ailurus fulgens). (WWF/H.A.)
3. The elusive snow leopard (Panthera uncia) lives above 4,000 m in the north of the country. (WWF/P.W.)
4. The takin (Budorcas taxicolor), the national animal of Bhutan, lives in herds at 4,000 m and is a protected species. (F.P. 1994)

(*Salmo trutta*) can be found; they are not indigenous, but seem to have been released. These fast-flowing rivers have produced a fish that is ideally adapted to high flux. The barbs (*Garra gotyla gotyla*) have a sucking disc on their underside which enables them to attach themselves to stones. They feed on algae and attain a length of 15 cm. Dried so-called knife-fish (*Notopteridae*) are often brought from the south to the markets of larger towns.

Plans exist to build hydro-electric power stations along several large rivers over the next few years. They use water diverted from rivers through tunnels and pipes, which has a drying out effect.

BIRDS

Bhutan's wealth of bird varieties is truly extraordinary. Some 580 species have been recorded within its small territory, some of which are even of historical significance. The tutelary god Mahakala took the form of a raven to guide the country's unifier, the Shabdrung Ngawang Namgyel, to Bhutan. The Common raven (*Corvus corax*) lent its name and features to the crown of the king of Bhutan. The almost seventy-centimetre-high black bird is usually found at altitudes between 4,000 and 5,000 m. The national bird circles above the country in pairs or groups, and follows vultures on their flights to share in the carrion. Watching them roll and tumble in flight or do a nose-dive is a fascinating spectacle.

A frequent inhabitant of the same altitude is the Himalayan impeyan (*Lophophorus impejanus*), a member of the pheasant family. In its search for food, this colourful bird often digs deep holes in the snow. There is another bird with auspicious connotations for the country. A herd of some two hundred black-necked cranes (*Grus nigricollis*) winter in Bhutan. The arrival of the birds is noted in the country's only newspaper and they receive a big welcome. In summer, they migrate to Tibet to breed. From the evergreen mountain forests up to the summer-green forests one can find the Rufous-necked hornbill (*Aceros nipalensis*) living either in pairs or in small groups. The large-billed bird grows up to 120 cm and feeds mainly on fruit and seeds. Also very colourful are nectar-birds such as Mrs Gould's sunbird (*Aethopyga gouldiae*) which feeds mainly on nectar and occasionally on insects. Depending on the season it can be found at altitudes between 1,000 and 3,200 m. The Satyr Tragopan (*Tragopan satyra*) lives in the central and eastern Himalayas and is particularly common in Bhutan. This pheasant, found at altitudes between 2,000 and 4,300 m, feeds on fern leaves and other wild vegetables and is especially valued for its colourful plumage.

MAMMALS

Buddhism has spared the animal kingdom from the hunt. Any kind of chase, even of small animals, is strictly forbidden. Measures can be taken against such harvest scourges as wild boars (*Sus scofra*), which often come in sounders and do terrible damage. Self-defence against the Himalayan black bear (*Selenarctos thibetanus*), a protected animal, is often necessary as it is common in certain regions and is known to attack men.

In the south, however, in the vicinity of densely populated areas, poachers do present a danger to the unique wildlife of Bhutan's low-lying wooded regions. One of the casualties, which may have disappeared forever, is the Indian rhinoceros (*Rhinocerus unicornis*). There are no recent reports about the continuing existence of this unique animal in the Manas National Park. Its horn was eagerly sought by unscrupulous dealers who sold it to the East Asian medicine trade. This rhino is usually solitary and only joins partners for mating, or when it is parenting young calves. In the same region we find the Asiatic elephant (*Elephas maximus*).

The tiger (*Panthera tigris*), on the other hand, is found in many parts of the country, but again it is only infrequently met because this largest of cats of prey requires open spaces. It feeds mainly on deer, and occasionally on other large and small mammals. It shuns men. The leopard (*Panthera pardus*) inhabits dense forests. Its survival is regarded as less threatened, so it seems that this retiring animal finds sufficient space in the forests. The dense forests between 2,000 and 3,500 m are the home of the red panda (*Ailurus fulgens*). This long-tailed small bear, looking rather more like a red-haired raccoon, is normally a harmless herbivore living either in pairs or in groups. It shares its habitat with the takin (*Budorcas taxicolor*). This horned ungulate is a strange bull-like animal suggesting an ill-shaped cow. The species, also found in northern Sichuan, is the national animal of Bhutan.

The musk deer (*Moschus chrysogaster*) is something of a special case. It does not have antlers, but well-developed canine teeth, which lend it an unusual appearance. The musk deer is a threatened species because of its odorous musk produced by a gland. In Southeast Asia a litre of musk-oil

sells for $60,000. Synthetic production of the substance has so far been unsuccessful, and poaching can be quite common.

In the mountains, a number of horned animals can be found such as the serow (*Capricornis sumatraensis*), the goral (*Naemorhedus goral*) and the blue sheep (*Pseudonis nayaur*). Their predators include the grey wolf (*Canis lupus*), living predominantly in alpine regions. While most of these animals are not deliberately hunted, their population is nevertheless regarded as threatened because their habitat is continually encroached on.

Probably one of the most mysterious animals of Bhutan is the snow leopard (*Panthera uncia*), which occurs throughout the Himalayas but is very rarely sighted, no doubt partly because it is a solitary animal. In summer this wildcat roams beyond the tree-line into the regions of eternal ice and has been seen at altitudes above 5,500 m. It preys mainly on blue sheep, occasionally also on marmots (*Marmota bobak*) and domestic yaks, in winter following its prey into the mountain forests. Some individuals are known, however, to remain within their range all year long. Very little is as yet known of this animal.

AGRICULTURE

A visitor to Bhutan who goes to the market will be struck by the impressive array of fruit and vegetables, especially in the larger towns. The great variety results from the country's topographical and climatic diversity, which allows the planting of many different crops.

Rice is grown to an altitude of about 2,000 m. Terraces are laid out even on the steepest slopes and offer a sight the beauty of which is quite overwhelming. With the simplest of tools stepped fields are constructed along entire mountain slopes. In the more developed areas ploughing is done with motorized ploughs, but the *dzo* or cross between yak and cow, as well as other cross-breeds, are still far from obsolete. Particularly in remote areas, peasants will remain dependent on these draught-animals for the foreseeable future. Some peasants practise a type of crop rotation. After rice, potatoes or wheat may be planted. The fertilizer commonly used is the dung of domestic animals. It is usually distributed across the fields from a pannier. During harvest time, a major problem facing the peasants are the wild animals, mainly boars, which can destroy several fields overnight. Every farm has a small private garden where many different vegetables are grown. Fruit trees complement the picture. While the income of the peasants cannot be measured in monetary terms – as deals are often arranged in non-monetary ways – one gets the impression that self-sufficiency is the rule.

In the higher regions the vegetation becomes increasingly alpine, and cattle-herding becomes more important. In summer the cattle are driven to higher pastures at an altitude of over 4,000 m. In the highest regions people keep yaks (*Bos gruniens*). Everywhere one gains the impression of men being very conscious of the environment. Their work is closely attuned to nature's course. All needs can be satisfied from the surrounding forests.

Now Bhutan's population is rising, and everyone realizes that agriculture has to be strengthened and developed. There are good reasons to hope, however, that this small country in the eastern Himalayas is well-prepared for the challenges of the future. Political leaders are very cautious in developing the country, being particularly anxious about the proper use of ecological resources. After all, some 20% of the country's total area has been officially put under conservation. The countries of the so-called First World would do well to take one of the poorest nations of the globe as a model.

REFERENCES

Griffiths, William. [1865]. 'Journal of the Mission to Bootan in 1837–38', in *Political Missions to Bootan*. [Calcutta: Bengal Secretariat Office.] Repr. New Delhi: Manjusri, 1972, pp. 276–336.

Karan, Pradyuma. 1967. *Bhutan: A Physical and Cultural Geography*. Lexington, University of Kentucky Press.

Sargent, Caroline. 1985. 'The Forests of Bhutan'. *Ambio*, vol. 14, no. 2.

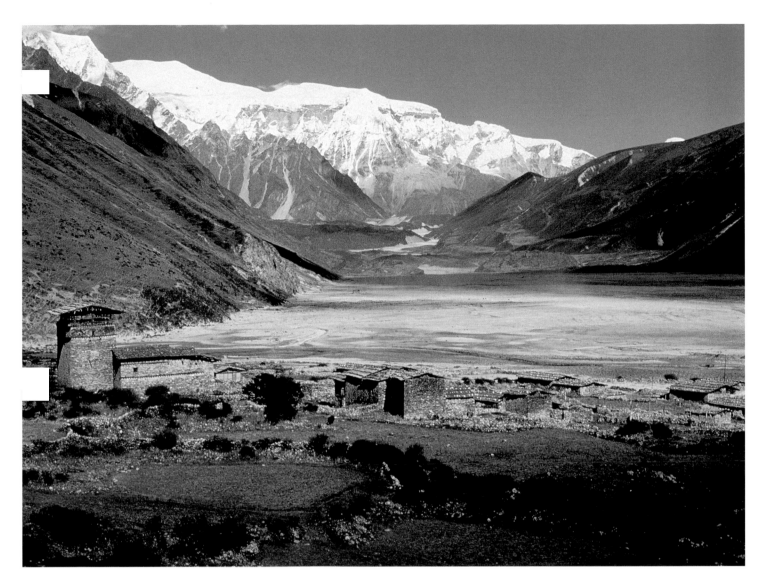

The village of Thanza in Lunana is built in a desolate and spectacular landscape, at an altitude above 4,000 m, where the main livelihood is raising yaks. (R.D.)

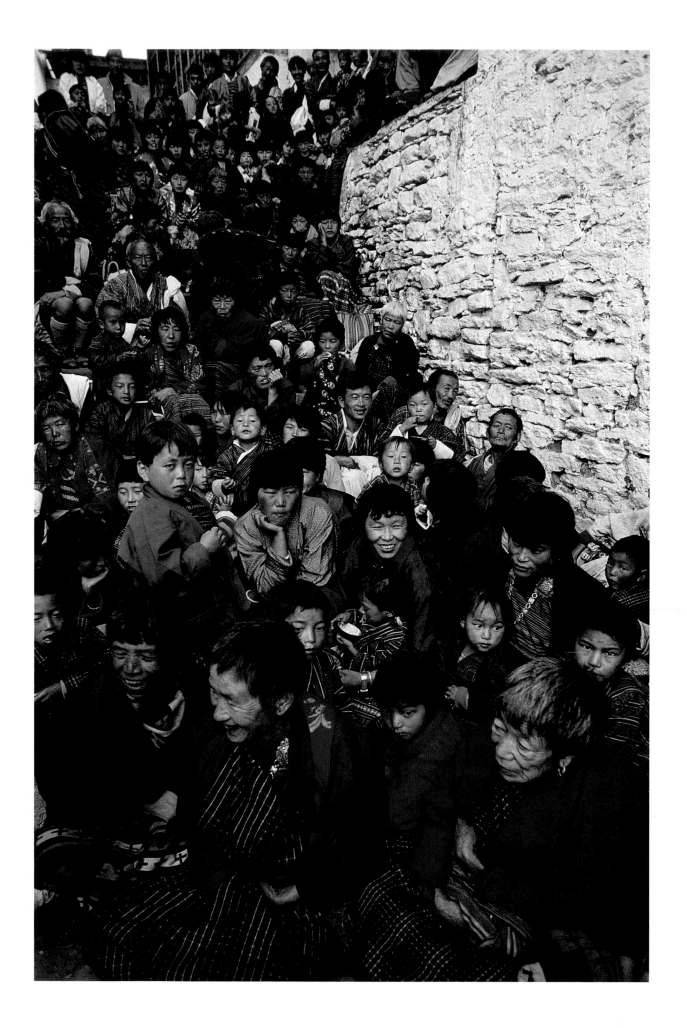

Ethnic Mosaic: Peoples of Bhutan

Françoise Pommaret

Bhutan has long been regarded as a mysterious and elusive country by the Western world. With a population of 600,000, and roughly the size of Switzerland (46,500 km²), it is a small and underpopulated country, especially when compared with its giant neighbours China and India. However, this does not do justice to the ethnic mosaic and variety of populations that make up the country. From the yak herders of the north to the orange growers of the south, Bhutan can boast of a fascinating kaleidoscope of populations. Most of the population is of Mongoloid stock and speaks languages of the Tibeto-Burman family; in the south there are also people of Indo-Aryan stock who speak languages of the Indo-European family.

The people of Bhutan are known as Drukpas, a term which derives from Druk Yul, the name of the country in Dzongkha, the national language. The following story explains the origin of the name Druk Yul:

It is said that in the twelfth century in Tibet, a monk called Tsangpa Gyare Yeshe Dorje wanted to build a monastery. At the chosen spot, he heard the sound of thunder which is believed to be the roar of a dragon. Taking this as a good omen, he decided to call his monastery Druk, which means thunder/dragon. As often in Tibet, the name of the religious school he founded took the name of the monastery, and his

Opposite: Families from the whole region attend the tshechu, an annual festival which is held in each valley with religious dances in honour of Guru Rinpoche. (J.W. 1994)

followers were called Drukpas. Much later, in the seventeenth century, the Drukpa religious figure, the Shabdrung Ngawang Namgyel, unified Bhutan. The country was then known as Druk Yul, its inhabitants as Drukpas.[1]

Stone tools retrieved from the ground suggest that Bhutan was inhabited since 2,000 BC at least, but to date the absence of archaeological excavations or extensive linguistic survey make it difficult to know which populations inhabited Bhutan, and in what order.[2] It would therefore be premature to give a scientific chronological account of the settlement of Bhutan. However, for some populations we can provide some linguistic or historical clues. In this paper, the population of Bhutan is considered in terms of three main geographical zones each stretching from west to east: the high northern belt, the broad central belt and the narrow southern belt.

THE NORTHERN BELT

The northern belt is situated on the slopes of the highest range of the Great Himalaya which forms the border with Tibet. A high altitude region, separated from the central valleys by high passes, it is inhabited between 3,500 and 5,000 m, and is characterized by a harsh climate with snow in winter and abundant rain in summer. This whole area is not suitable for rice cultivation; it is only possible to grow barley and high-altitude wheat. Vegetables are scarce; there are turnips and parsnips (the leaves of which are dried and eaten during the

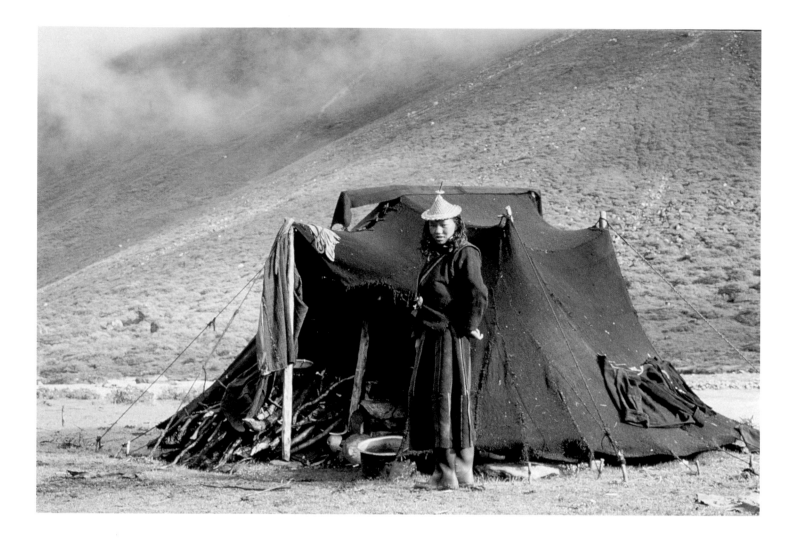

winter), and recently potatoes. This is mainly the domain of yaks which feed on the grass and flowers of the pastures and on high altitude dwarf bamboo (*Yushania microphylla*).

Three main areas make up the northern belt: Lingshi, Laya and Lunana, with predominantly pastoralist communities. Yak herders live partly in black yak hair tents, and partly in houses (which double as stores). In summer, the younger members of the family move to yet higher altitudes with their herds. This is the season when butter and hard cheese are prepared. These are then traded in the central valleys against rice and other cereals. In October, before the passes are closed by snow, the herders come down to the central valleys to sell their dairy products along with one or two yaks whose meat fetches a high price in these lower regions. In the olden days the barter system was practised by all, but nowadays cash is replacing barter. With money the pastoralists buy cereals, cutlery and salt, and then return before the onset of winter. Before 1959, they traded and bartered extensively with Tibet (especially salt), but with the closure of the border

A woman from the high valley of Laya (4,000 m) stands in front of her summer tent woven of yak hair. The Laya women's dress (opposite) consists of a black yak hair skirt with light vertical stripes, a blouse and a black woollen jacket. Heavy felt boots, a distictive conical bamboo hat and lots of silver jewellery worn on the back complete their outfit. Below: Laya girl and child. (R.D.)

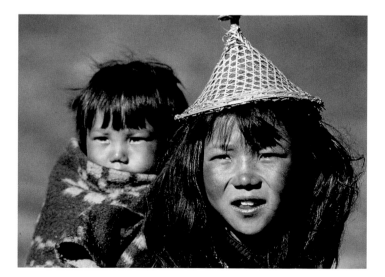

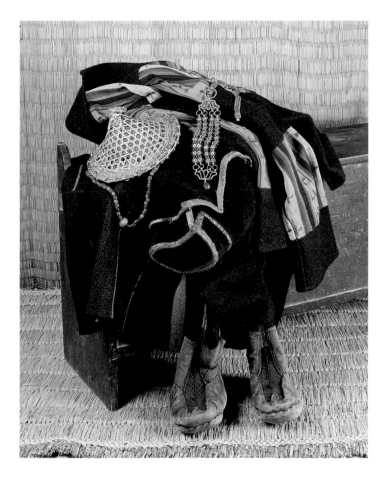

they have now turned for their supply towards Bhutan's central valleys. Most of these pastoralists own their herds though some are sharecroppers (especially in Lingshi), and look after a herd belonging to someone in the central valleys.

The people of Lingshi speak a language which is a slight variation of Dzongkha, a kind of 'patois'; the people of Laya and Lunana speak dialects of Dzongkha which are, nevertheless, far enough from it to be barely intelligible to mainstream Dzongkha speakers. The Lingshi and Lunana people now wear the standard Bhutanese dress, while those of Laya, especially the women, retain their distinctive dress made partly of yak hair fabric, partly of sheep's wool, and woven on a long horizontal backstrap loom. It is a black skirt with brown vertical stripes, a black jacket, a distinctive conical bamboo hat perched on the top of the head and much silver jewellery, including spoons, hanging at the back. The hair is kept at shoulder-length, which is not usual in Bhutan where in the countryside women have short hair.

Above: Laya woman's dress. Right: Made of wood and bamboo, butter tea churns and containers from the eastern valley of Sakteng are watertight and still in daily use. Below: The zem is a bamboo basket covered with leather to protect against rain or snow; it is used to carry or store all kinds of goods and food. Two of these baskets attached on a pack horse balance its load. They are made mostly in the south-central region of Shemgang (E.L.).

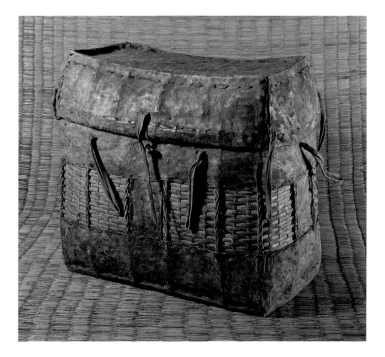

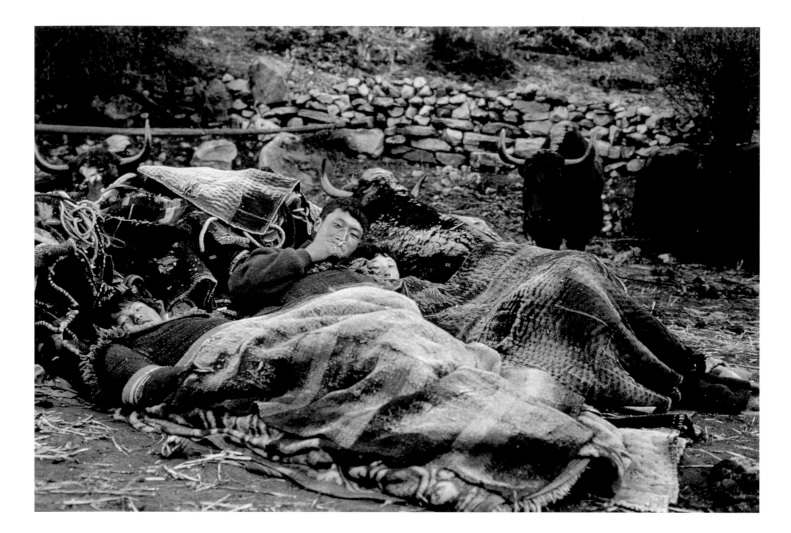

Above: While travelling, muleteers and yak herders sleep in the open near their animals. Striped blankets provide a minimum of protection against the biting cold. (R.D.) *Below: At dawn on a high pasture, a caravan's lead yak is ready to set off. Its trappings show that it is dedicated to a local mountain deity.* (C.S. 1996)

THE CENTRAL VALLEYS

These valleys are located at altitudes between 1,000 m (Tashigang) and 2,800 m (Bumthang and Ha). Their climate is therefore very diverse, ranging from subtropical to alpine with monsoon. The central valleys were traditionally divided along historical and linguistic lines into three regions: west, centre and east. The reality, however, seems rather more complex.

In the past these valleys constituted 'microworlds' in themselves, a feature reinforced by the fact that they are separated from each other by mountains which run north–south, with passes over 3,000 m. Most of these regions traded either with the north (Tibet) or with the south (India), but communications between them, across the width of Bhutan,

were few. Today, with the development of roads and other infrastructure, communications are good across the whole country, and exchanges of goods have become common. Nonetheless many of the patterns of the past still persist.

The western region

The western region comprises the valleys of Ha, Paro, Thimphu and Punakha / Wangdi Phodrang, the last two being located on the same river. The people of these valleys are called Ngalong, which means the 'first risen'. This refers to the conversion to Buddhism which, according to Bhutanese popular tradition, first took place in this western region. Another etymology for Ngalong suggests the term is a corruption of *ngonlung,* which means 'ancient region' and which, according to the religious figure Longchen Rabjampa (1308–63), was the name given to the regions of Shar (Wangdi Phodrang) and Paro.[3] In fact, in preference to the term Ngalong, the people of western Bhutan refer to themselves by their valley of origin: Ha, Wang, Paro or Shar.

The region of origin of the western Bhutanese is not yet known precisely. However, it seems likely that they migrated from Tibet in different waves, perhaps from the sixth or seventh century onwards, though the date is still not known. In this region Dzongkha, 'the language of the fortresses', is spoken, which belongs to a branch of the Tibeto-Burman family. It is intelligible all over western Bhutan, differing only slightly from valley to valley, the most divergent form being spoken in Ha. For economic reasons relating to the different ecological conditions, each valley in the region was traditionally coupled with another, and also with the southern belt; nonetheless each valley also retained its distinctive features.

Ha, a valley at 2,800 m and above, could not grow rice but only buckwheat, barley and winter wheat. It therefore depended on Paro for rice, and the sturdy women from Ha used to, and still do, come to Paro to help the richer 'Parops' at the time of rice transplantation and harvest. In exchange, they were fed and paid in rice grains which they brought back to Ha. On the other hand, 'Haps' bred cattle which they kept in the high pastures of Ha during the summer, while in winter they went down to the low and forested areas of the southwestern region of Samtse. This migratory pattern extended to all three zones from north to south, highlands to lowlands, and in the winter is still common in Bhutan, as we shall see. As for the 'Parops', whose valley is essentially devoted to rice cultivation, they sometimes obtain their yak meat and cheese from Ha, but mainly from the Lingshi area just north of Paro.

The Thimphu and Punakha people have a symbiotic relation, and in the historical texts they are known by the collective term Wang. They were thought to be the same people who, according to the season, migrated from one place to the other. A tradition from that time is for the state clergy to spend the winter months in Punakha which, at 1,200 m, is considerably warmer than Thimphu (2,330 m), where they spend the summer. Therefore people with properties in Thimphu often also own land and cattle in Punakha, which are looked after by sharecroppers. Rice from Punakha is highly rated and in winter, oranges are much sought after.

The region of Wangdi Phodrang, which is contiguous to Punakha and at the same elevation, is called Shar. Like Punakha it is an extremely fertile valley and its inhabitants used to trade with India following what is now the Wangdi–Tsirang highway as far as Kalikhola.

The central regions

To the east of Wangdi Phodrang, one reaches the Black Mountains with the Pelela pass (3,400 m), regarded as the border between the western and other regions of Bhutan, particularly the centre but also the east. In the nineteenth century the governor of Tongsa had jurisdiction over central and eastern Bhutan. Beyond is found an amazing and intricate network of languages, some spoken by only a few hundred people; they make Bhutan a paradise for linguists.

Close to the Pelela and almost at the same altitude but still on the western side of the Black Mountains, to the southeast of Wangdi Phodrang, there are a few high-altitude valleys over 3,000 m, of which Phobjika is the best known. There people speak a dialect of Nyenkha or Henkha, a language belonging to the Bumthang group of languages, which seems to be archaic Tibetan. In these valleys the land is not very favourable to cultivation and people have herds of cattle which, during the winter, they move to the forested areas two days' walk south of their valleys.

The area beyond the Pelela is known as Sephu; it extends northwards in the direction of Lunana, where the land is not favourable to cultivation. People keep yaks and sheep which, in the summer, they move from the Pelela slopes to higher altitudes. Known as Lap, 'people of the mountain passes', they speak a language called Lakha or Tshangkha, which belongs to the Dzongkha group. Yet very close to Sephu, at

the foot of the Pelela on its eastern side, in the large village of Rukubji famous for its superb flat land, people do not speak Lakha but a dialect of Nyenkha.

Moving east, one arrives in the valley of the Mangdechu river, where Nyenkha (also called Mangdekha in reference to the river) is spoken. This is Tongsa, a region of great importance in the history of Bhutan. Forested and endowed with good arable land, this region should not be considered on its own, but along with Bumthang. At a lower elevation than Bumthang (at 2,600 m and above), Tongsa (at 2,200 m) was the winter residence of the nobility of Bumthang, just as Thimphu and Punakha were complementary. South of Tongsa, mansions dominate the rice fields, and the lush forest served as the winter pasture of some of the cattle coming from Bumthang. The Yutola, the pass separating Tongsa from Bumthang, was never a problem for the sturdy cattle herders. While Tongsa had rice, Bumthang due to its elevation did not, and its rice supply came from Tongsa. The link between them was also reinforced by the proximity of the languages, Nubikha and Mangdekha, the dialects of the Tongsa region belonging to the Bumthang group. However, Bumthang also had links with the southern region of Kheng, and with Kurtö in the northeast, regions to which I shall return.

Bumthang is divided into four valleys: Chume, Chökhor, Tang and Ura, separated by dense coniferous forests, and each with a slightly different dialect. Bearing in mind the very early state of linguistic research, the Bumthang group of languages could be classified as part of the Proto-East Bodish branch of the Bodish section of the Bodic Division of the Tibeto-Burman family. B. Michailovsky writes: "The Bumthang languages are clearly closely related to Tibetan in addition to being heavily influenced by it, but we will show evidence that they are not Tibetan dialects, that is, unlike Dzongkha, they are not continuations of (roughly) the language reflected in the Tibetan writing system."[4]

At 2,800 m and 2,600 m, Chume and Chökhor are the lowest valleys of Bumthang. The main crops are winter wheat and buckwheat, the staple diet in Bumthang. The people of Tang and Ura, at 3,000 m and 3,400 m respectively, engage predominantly in animal husbandry with large flocks of

Archery is the national sport of Bhutan; the field between the targets of opposing teams measures more than 140 metres. Competitions, which involve the supplication of local deities, are fierce and can be enlivened by liberal quantities of alcohol. (j.w. 1994)

sheep reared mostly for their wool, and yak herds. The potato, which was introduced in Ura ten years ago, has considerably improved the living standards of this valley. Bumthang is famous for its *yathra*, coloured woollen fabrics woven, in the past, on a backstrap loom, but more recently on a pedal loom.

In the north of the Chökhor valley, in the area of Dur, one finds a small group of yak herders who call their language Brokkat, 'the language of the herders', which, according to van Driem, belongs to the Dzongkha group.[5]

The people of Bumthang consider their region to be blessed because, according to Bhutanese tradition, it was one of the first converted to Buddhism by the saint Padmasambhava in the eighth century. Bumthang boasts some of the oldest and most sacred temples in Bhutan, such as the Jampe and Kuje Lhakhangs. The origin of its inhabitants is still a mystery, although myths and linguistic and historical evidence seem to point to several waves of migration from Tibet from the seventh century and, perhaps more importantly, at the time of the collapse of the monarchy in Tibet in the ninth century.

Besides Tongsa, the Bumthang region can also be linked to Kheng, situated to the south and today divided between the districts of Shemgang and Mongar. Kheng is a large region stretching virtually to the Indian border in the south. While Chume and Chökhor were oriented towards Tongsa and the west of Kheng, Ura was closer to the east of Kheng via the high pass of Trumsengla (3,900 m). This association was economic through grazing lands, but also religious due to various lamas of Bumthang who were active in this region. Kheng enjoys a subtropical climate and has dense deciduous and subtropical forests. Rice cultivation, except in some pockets, was not practised much, the agricultural pattern being rather slash and burn for maize cultivation, and gathering of wild forest products. The forest undergrowth is of bamboo, cannabis and nettles (of which the cattle are very fond). Given the linguistic proximity between the language of Kheng and Bumthang, it seems likely that Kheng was partly populated by people who came from Bumthang.

A small group of people in Kheng are called Mönpas by the other Bhutanese, and are considered to be one of the aboriginal groups of Bhutan.[6] It is too early at this stage of research to know if they really were aboriginals, but their language and living patterns appear to suggest a very early migration. This seems to be corroborated by the fact that their migration is not recorded in the Bhutanese historical texts;

they could have arrived before the historical period. The Mönpas live on the west bank of the Mangdechu in the south of Tongsa district and also in Wangdi Phodrang district south of the Black Mountains. Their domain is the forest, from which they obtain a large part of their subsistence, and they speak a language known as Mönkha or Olekha, which belongs to the Tibeto-Burman group but has not been further classified by linguists.

If we go back to Bumthang and proceed east, we arrive in Lhuntshi district to the north and Mongar district to the south. Before the motorable road from Bumthang to Mongar was built, the most important trail went from Bumthang to Lhuntshi Dzong via the Rodungla pass. There were strong links between Bumthang and Kurtö, 'the upper Kurichu river' (i.e. the region from Lhuntshi Dzong and the west of the Kurichu river to the northern border). The language is a

dialect of the Bumthang group, and there were continuous religious and economic ties between Bumthang and Kurtö. Religious figures such as the descendants of Pema Lingpa established themselves in the Kurtö area, giving rise to a nobility which maintained marital relations with the nobility of Bumthang. Kurtö is lower than Bumthang and rice cultivation is possible. Rice could be exchanged with cattle products from Bumthang, or used to pay in kind the Bumthang religious specialists who, in winter, would perform rituals in Kurtö. Kurtö is known for the quality and complexity of its weaving tradition. A backstrap loom is used to produce a weave resembling chain-stitch embroidery. For certain festivals, women wear a special type of garment found nowhere else in Bhutan. Cut like a poncho, it can be of wool (when it is known as a *shingkha*) or of cotton with silk designs (when it is called a *kushung*).

The southern part of Lhuntshi and northern part of Mongar was called Kurme, 'the lower Kurichu river'. It is inhabited by people who, curiously in this environment

An old couple at Yaksa (3,800 m in Paro district) enjoy the last rays of sun while exchanging the latest news with a friend from the lower valleys. (c.s. 1996)

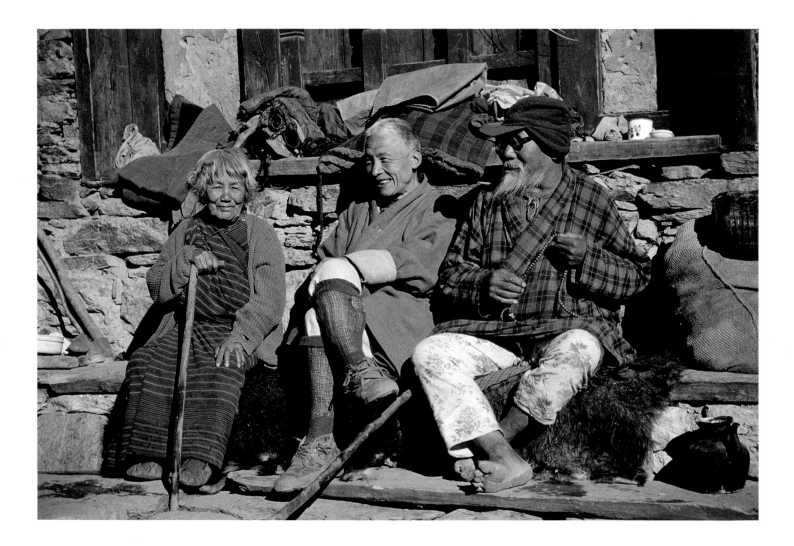

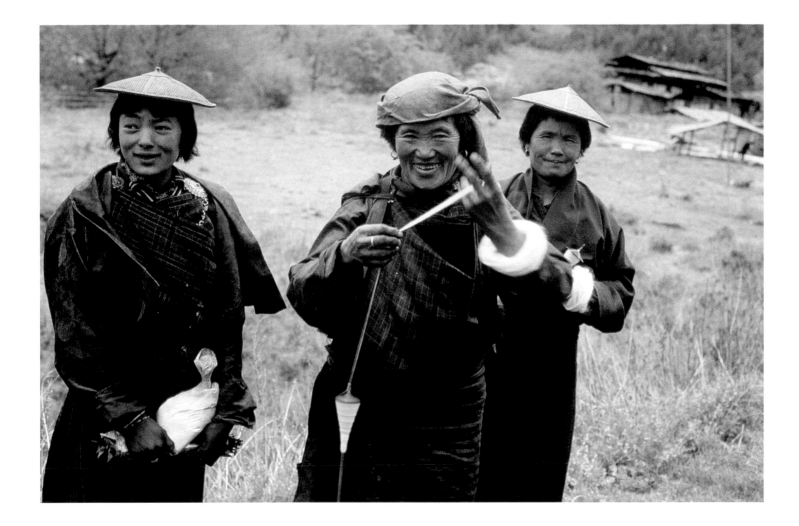

Three women with the typical Bumthang headdress spinning wool. Weaving is one of the most important economic activities in this central region. (G.V.S.)

of non-Dzongkha languages, speak a language related to Dzongkha which outsiders call Chöcha Ngachakha in reference to the way 'you' and 'I' are pronounced. In the region this language is known as Tsangmakha or Tsakalingkha (from the names of two villages) or Kurmekha, 'the language of Kurme'. The historical circumstances which allowed such a language to develop in this particular area are not yet known.

Close to this area and also north of Mongar are few villages where Chalikha (which takes its name from Chali village) is spoken. This language, too, belongs to the Bumthang group, which makes the problem of the Chöcha Ngacha language, unrelated to any of its neighbours and spoken by an isolated pocket of people, all the more puzzling.

Nowadays the motorable road from Ura in Bumthang to Mongar passes through what could be termed 'the great di-

vide'. After crossing the Trumsengla pass at 3,900 m, the road suddenly plunges through a dense forest which goes from coniferous to subtropical as the altitude decreases. Some three hours later it eventually reaches the Kurichu river at 600 m, the lowest point amongst the central valleys of Bhutan. To the south of Ura and to the east of the Trumsengla pass begins the region of Kheng where Bumthangkha is still spoken. It gives way to Khengkha only after the village of Senggor. From there Khengkha is spoken almost as far as the Indian border in the south. There is, however, one exception: the relatively inaccessible village of Gongdu in the south of the Mongar district, two days' walk from Gyepshing as well as from the Indian border. Along with a few other villages in the vicinity, this village is part of a small pocket of about 1,000 people who speak a totally different language, Gongdupekha. Although it belongs to the Tibeto-Burman family, like the language of the Mönpas, this language cannot yet be classified accurately, but certainly has no connection either with Khengkha or Tshangla (Sharchopkha).

The area east of the Trumsengla down to the Kurichu is

1

2

3

4

1. Boxes made of multicoloured bamboo strands and equipped with locks belong to well-off families and would contain precious clothes or objects; 2. This round container with a lid (dapa) is the speciality of the northeastern valley of Tashiyangtse. Made of wood and lacquered in a simple manner inside, it is used as a food container but also as a plate for the head of the family; 3. Small bamboo baskets of this shape are typical of Trimshing in southeast Bhutan and are used as food container and plate; 4. This type of conical bamboo basket was mainly used to store grains. (E.L.)

not very populated. The landscape of forest and gorges gives way to small parcels of cultivated land only fifteen kilometres before the Kurichu river. This river marks the boundary between the Khengkha-speaking and the Tshangla-(Sharchopkha-) speaking areas.

The eastern region

Although Lhuntshi district together with Kurtö and the east of Kheng are generally considered a part of eastern Bhutan, on linguistic and historical grounds Kurtö and Kheng are more closely linked to central Bhutan (which is why they have been discussed in the previous section).

Eastern Bhutan is lower and has a warmer climate than the rest of Bhutan, except the south. It is highly populated, which also means that it is more extensively cultivated – with rice but especially with maize, which is the staple diet of the eastern Bhutanese. In eastern Bhutan, there are few real valleys suitable for cultivation or habitation. Most of the valleys consist of a narrow river bed, and the villages are perched high up along the slopes. A popular description of a trail in eastern Bhutan is that it goes up, up, up and down, down, down, up, up and up … In the past, the eastern Bhutanese practised shifting cultivation but this is nowadays discouraged by the government. They also keep cattle, more for dairy products than for meat. Because the weather is not too severe in winter, the eastern Bhutanese do not migrate to the south with their cattle; but in winter they go to the marts near the Indian border or to Assam, in order to trade. Until ten years ago, many of the houses were made of bamboo and built on stilts, with roofing of bamboo mats, but nowadays, with higher living standards and easier means of communication, people like to build houses in the same style as the people of Bumthang or the west.

Most of eastern Bhutan, including the south, is populated by Sharchopas, 'people who live on the eastern side'. There is no trace of their migration to Bhutan in the historical texts, which means that they may have migrated in proto-historic times. Their language is known as Sharchopkha; they refer to it as Tshangla. It is spoken, with some variations, in Mongar, Tashigang, Pemagatshel (the ancient Dungsam) and Samdrupjongkhar districts, but also beyond the borders of Bhutan in the Dirang district of Arunachal Pradesh where it is known as Central Mönpa, as well as in Pemakö in southern Tibet, where the Chinese call it 'Cangluo Menba' or 'Motuo Menba'. This language still resists fine classification. It has been said that it belongs to the Bodish section of the Bodic division of the Tibeto-Burman family, but is outside the Bodish branch.[7] Like most of the languages of Bhutan, Tshangla also possesses a certain number of Tibetan loanwords, especially in the religious vocabulary. Devout Buddhists, the eastern Bhutanese are known for the quality of the cotton and silk weaving that women produce on the backstrap loom. Some of their weaving motifs as well as their supplementary-weft technique, present a striking similarity with those of the populations of Arunachal Pradesh, northern Burma and northern Laos, who also speak dialects of Tibeto-Burman.

However, the Sharchopas are not the only ethnic group in eastern Bhutan. The northeastern district of Tashiyangtse extends from the north of Tashigang to the Tibetan border. It is known for the fertile rice-growing valley of Yangtse, for the religious sites of Chörten Kora and Riksum Gompa, as well as for the beautiful valley of Bumdeling where black-necked cranes halt for the winter. This region is inhabited by people whose language is totally different from that of their Sharchopa neighbours. Known as Dzalakha, it is a Tibeto-Burman language which cannot be further defined, given the state of linguistic research. It is also spoken along the river Khoma in the east of Kurtö (Lhuntshi district) which is contiguous to Tashiyangtse. There it is known as Khomakha, the 'language of the village of Khoma'.

In the extreme east of Tashigang district, at the border with Indian Arunachal Pradesh, lie the two high valleys of Sakteng and Merak. These valleys form a cultural and ethnic entity as they are home to a particular people (who number around 5,000), who are not connected in any way to the Sharchopas. They are called Brokpas, a term which, in the context of Tibetan culture, simply means 'pastoralists' or 'herders'. However, in Bhutan in this form this term seems to be applied only to the people of Sakteng and Merak; other herders are referred to by the same term, but with its Dzongkha pronunciation 'Bjop'. The eastern Bhutanese call them Brami in Tshangla – which might mean 'the other people' – and their language Bramilo. Westerners have referred to them as 'northern Mönpa'.

The Sakteng and Merak people call their language Brokpake, and van Driem has classified it, like the Lakha of the Black Mountains and the Brokkat of Dur in Bumthang, as belonging to the Dzongkha group.[8] Yak and sheep herders, they also trade for commodities with Tawang in Arunachal Pradesh. In winter some of them also migrate with their flocks: the Saktengpas to the upper Tashigang region, the Merakpas to Khaling. Here we find another case of interdependence between valleys: the people of the high valleys come down for pasture in winter, and buy or trade grains while selling or bartering yak meat and dairy products with the inhabitants of the low valleys.

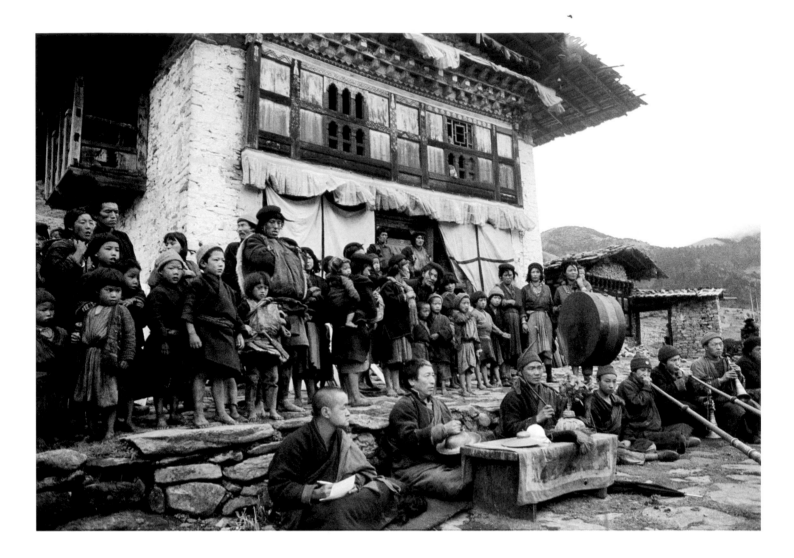

Open-air ritual outside a temple in the high eastern valley of
Sakteng inhabited by the Brokpas who are yak and sheep herders.
They wear distinctive clothing and headgear. (A.A. 1977)

The Saktengpas and Merakpas are famous for their distinctive dress. The women wear a short poncho-type dress and a red jacket woven in its lower part with geometric or animal designs. The men wear leather leggings and woollen trousers; their upper garment consists of sleeveless hide vests – worn with the fur on the inside – over long-sleeved woollen tunics. Both sexes wear a distinctive hat made of yak felt with long twisted tufts, said to keep the rain from running onto their faces.

Geographically and culturally very close to the Saktengpas and Merakpas are the Dakpas. Their dress is similar to that of the Saktengpas, and they speak a dialect of Brokpake.[9] A small group, they are herders who constitute part of the population of villages situated between Sakteng and Tashigang and south of Tashiyangtse district (Phongme, Chaleng, Yobinang, Dangpoleng and Lenkha near Radi) as well as near

Tawang in Arunachal Pradesh, where they are known as Mönpas, and the region of Tshona (mTsho sna) in southern Tibet. Further research is needed to ascertain whether they are a truly different group from the Sakteng and Merak people, or simply a branch of the same people.

Unlike van Driem, who thinks that Brokpake (also called 'northern Mönpa'), belongs to the Dzongkha groups, researchers such as Aris and Michailovsky seem inclined to think that it is the closest relative to Bumthangkha and belongs to the Proto-East Bodish branch of the Bodish section of the Bodic Division of the Tibeto-Burman family.[10]

Throughout the central valleys also live Tibetans who arrived in Bhutan in the 1950s in the aftermath of the upheaval in Tibet. They are mostly engaged in running small businesses and therefore live mainly in urban centres such as Paro, Thimphu, Tongsa, Jakar and Tashigang. While they speak the language of their adopted region as well as Dzongkha, at home they usually speak the dialect of their region of origin in Tibet. Now Bhutanese citizens, they are integrated into the society. Men wear the Bhutanese costume

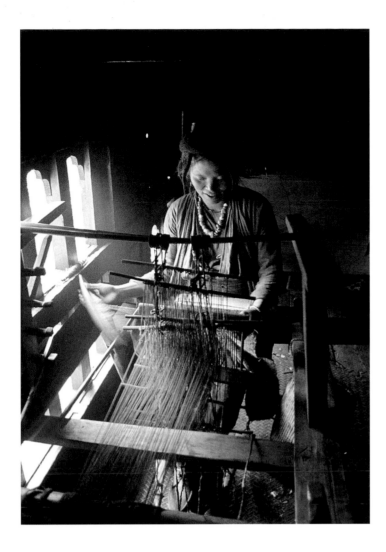

A Brokpa girl weaves woollen cloth on a pedal loom. (A.A. 1977)

go, which resembles the Tibetan *chuba*, while women still prefer to wear Tibetan-style dress: a sleeveless gown tied at the waist with two pleats at the back.

THE SOUTHERN BELT

From west to east the southern belt comprises the district of Samtse, the south of Chukha district, as well as Tsirang, Sarpang, and Samdrupjongkhar districts. It is a lowland region along the foothills of the Himalayas, with an elevation between 100 m and 1,000 m. Its southernmost part forms the border with the Indian states of West Bengal and Assam. Heavily forested in the past, with a subtropical and monsoon climate, this region was not much favoured by the people of the central valleys who feared the heat and malaria. However, as already mentioned, in western Bhutan there was a tradition for the people of Ha to take their cattle in winter to

the region of Samtse; in central Bhutan, the people of Kheng came down to 500 m in the south; and in eastern Bhutan, the Dungsampas had already settled in the lowlands of what is today Samdrupjongkhar district, where they built houses of bamboo with thatched roofs.

In Samtse district, there are some groups that the Bhutanese regard as aboriginals. Whether they are really so is a question that will need more anthropological and linguistic research. The first group of people discussed here are known in Dzongkha as Lhops or 'southerners'; they refer to themselves as Lhopus, and are known as Doyas by the Nepalis. They are a small group of a few hundred individuals who live in the hills to the north and northeast of Samtse, in Dorokha sub-district. According to the linguist van Driem, their language is more closely related to the eastern Kiranti languages of the Tibeto-Burman branch (such as Limbu) than to that of the Lepchas, their immediate neighbours to the west.[11] The term Doya used by Nepalis could be a corruption of '*daya*' meaning 'kind', as it seems they were welcoming to the migrants who came to settle in their region. The only study of this group has been carried out by a Bhutanese academic, Jagar Dorji.[12] Until now they have remained quite isolated from the changes which have touched most of Bhutan in the last twenty years. A motorable road is being constructed from Samtse to Dorokha, and no doubt this will have a great influence on the Lhopus' life. But still today, the Lhopus maintain their distinctive way of life. They live in close-knit communities, marry their cross-cousins and, by and large, are still animists worshipping local deities. They do not cremate their dead, but bury them in wood and stone-slab coffins that form a small mound. A hut erected on the mound protects it from the rain, and a fence is put up around the site. In the past, the personal belongings of the dead person were kept in the hut, but today the family just leave a few coins. The Lhopus are shifting cultivators (growing maize, millet and sorghum); they raise cattle, but they also hunt, fish and gather forest products. Nowadays, with the introduction to the region of the two important cash crops of cardamom and orange, the Lhopus supplement their income by going to work in the fields or hiring themselves as porters down to Samtse. Their distinctive style of dress is rapidly disappearing. Men and women wore the same kind of wraparound garment called *pakhi* made of nettle fibre, though nowadays they use machine-woven Indian cotton. It is a rectangular cloth knotted behind the neck, folded into two pleats in the back, bloused over a belt and worn short

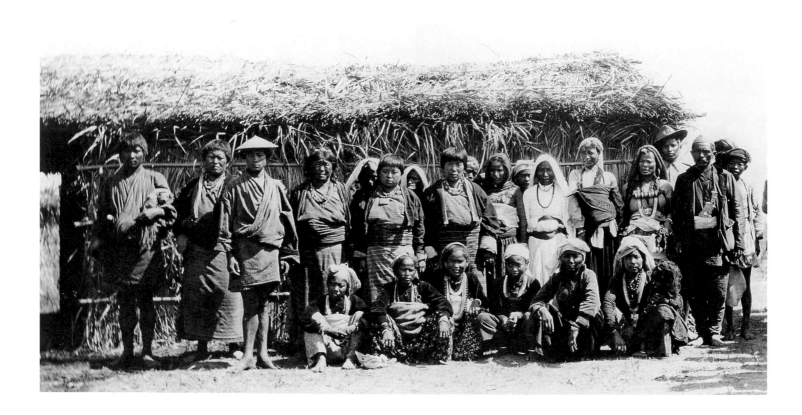

for the men; it is knotted at the shoulder, belted and worn long for the women.

The Lhopus appear to consider themselves different from the Taba Dramtöp – a small group living east of Dorokha across the Amochu river – whom they call Sharmi, 'people of the east'. Very little is known about this group, which was until now more or less assimilated to the Lhopus. According to Jagar Dorji: "... for some unknown reason there is an air of unfriendliness between these two groups of people. Matrimonial and social relationship between them are a rare occasion. Only in certain cases did people dare to face the wrath of the community to seek matrimonial relations."

To the west of the Lhopus, in the region of Denchukha along the northern Amochu river, are the Lepchas, some 1,000 people who speak a Tibeto-Burman language of the Naga group.[13] It is not known when these Lepchas arrived in Bhutan from Sikkim. They do not wear the traditional Lepcha style of dress which is close to that of the Lhopus, but Bhutanese costume.

In the last thirty years, people from the central valleys have settled permanently in the south of Chukha district, and especially in the border town of Phuntsholing. The regions of Gedu and Tala, since long ago sparsely populated mostly

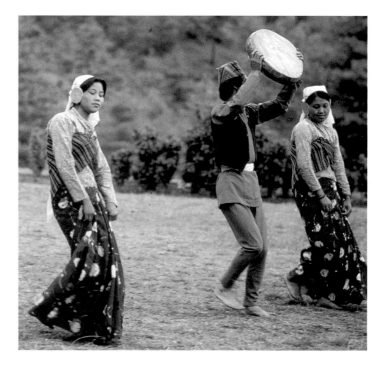

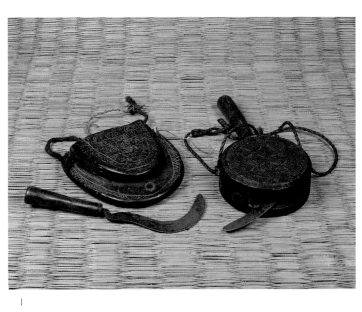

1

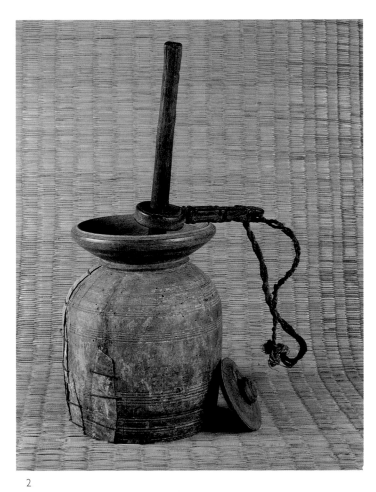

2

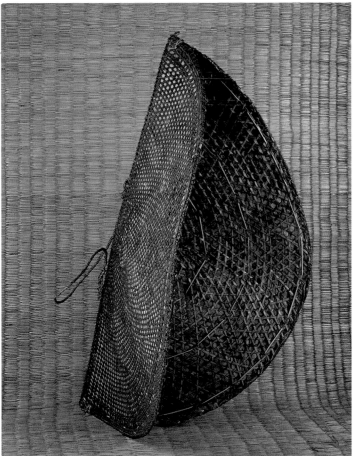

4

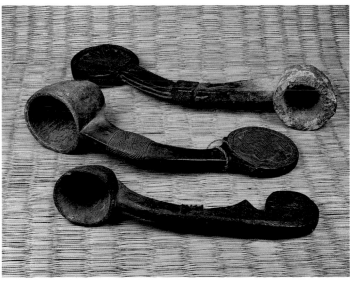

3

*These objects of everyday use are characteristic of the people of Nepali
descent who are mainly farmers in the subtropical southern regions.
1. Sickles; 2. Butter churn; 3. Bamboo raincoat; 4. Ladles.* (E.L.)

by people from Ha and Thimphu, have seen the arrival and settlement of Sharchopas from the east due to the development of a plywood factory and dairy farms. As for Phuntsholing, it is a real melting-pot with people from all over Bhutan, who have settled here for business reasons, as well as temporary migrants from India, especially Marwaris, who came in the '60s to run businesses and shops for Bhutanese from the central regions. However, there is very little social interaction, except for business purposes, between the Bhutanese and the close-knit Marwari community.

Due to the proximity of the Kheng region, people from this region are numerous in Sarpang district and especially in the border town of Gelephu, where even the Indian shopkeepers speak Khengkha.

In the east, the southern district of Samdrupjongkhar has long been populated by Sharchopas, while the border town of Samdrupjongkhar presents a medley of Sharchopas and Indian shopkeepers.

Since the beginning of the twentieth century, the ethnic and linguistic character of the narrow southern belt has changed considerably due to the progressive arrival in this region of people of Nepali descent. All the districts of southern Bhutan – Samtse, the south of Chukha and Dagana, Tsirang, Sarpang, and Samdrupjongkhar (where there has been little settlement) – are home to different groups of people 'of Nepali descent', known in Dzongkha as Lhotshampas, 'people of the southern border'. Their designation as 'Nepali' certainly needs qualification, as it is a blanket term which covers peoples of different ethnic and linguistic backgrounds. The term is used, however, because they all came either directly from Nepal itself, or indirectly from the Nepali-speaking area of Darjeeling in India. These peoples arrived in Bhutan in waves starting at the beginning of this century, when they were called by the Bhutanese to help clear the forested areas of the south. Better adapted to the climate than the Bhutanese from the central valleys, they were always praised, including by the British, for their hard work. They progressively settled all along the southern belt of Bhutan up to altitudes of 1,200 m, and especially in the south of Dagana and Tsirang districts. The people who arrived in Bhutan before 1958 have been given Bhutanese citizenship.

These groups use Nepali as a *lingua franca,* and some no longer know how to speak their original language. Nepali, an Indo-European language, is widely used in Bhutan, especially in business dealings. It is one of the languages of the National Assembly and of the BBS (Bhutan Broadcasting Service). An edition of the weekly *Kuensel,* the national newspaper, is also published in Nepali.

The peoples referred to as Nepali represent an amazing variety. One of the most important groups are the Bahun-Chhetris, known in India as Brahmins and Kshatriyas, the two Hindu upper castes. This group, the only one that speaks Nepali as a mother tongue, follows the Hindu religion and, to maintain caste purity, does not like to marry outside its own caste. Bahun-Chhetris are widespread all over the southern belt, with particular concentration in Tsirang district.

The rest of the 'Nepali' are of Mongoloid stock, and originally spoke languages of the Tibeto-Burman family. The religious background of these groups is diverse: they can be Buddhist or Hindu; a few are Christian. Even if they belong to one of the major religions, shamanistic practices are still prevalent among some of them.

The Sherpas, who speak a language classified as a dialect of Tibetan and are Buddhists, are closest to the western Bhutanese. They are found mainly in the upper ranges of Dagana and Tsirang districts. The Gurungs are an important group and are mainly settled in Samtse district. They are originally speakers of a language of the Bodish section of the Bodic division of the Tibeto-Burman family. They are Buddhists or Hindus, but are ranked low in the caste hierarchy. Like the Sherpas and Gurungs, the Tamangs first migrated from Tibet to Nepal at an unknown date. Ethnically and linguistically they are akin to the Bhutanese of the interior. Like the Sherpas (but unlike the Gurungs), they are Buddhists with strong shamanistic reminiscences. The origin of the Pradhans is the Kathmandu valley, where they constitute an important group of the Newari people. Their language is Tibeto-Burman, but they are Hindus. They are settled all along the southern belt. The Rais and the Limbus are also of Mongoloid stock and are said to have inhabited eastern Nepal since antiquity. In Nepal, they are also known collectively by the name Kiranti. Both speak Tibeto-Burman languages which belong to the same group, the Eastern Himalayan branch of the Bodic division.[14] In Bhutan, they are mostly settled in Samtse district. The majority of Rais and Limbus are Hindus with a low status in the caste hierarchy. They, too, have retained shamanistic practices. Although intermarriage between these different groups now occurs, it is not common, just as it is not common for a southern Bhutanese to marry somebody from the central valleys.

The southern Bhutanese have always engaged in agriculture, increasingly so since the establishment of orange plantations. With the needs arising from development, they turn increasingly to jobs in the civil service and the budding private sector. This applies also to all the other Bhutanese, although a large majority still engages in agriculture. These two sectors contribute to the development of urban centres, which did not exist until the early '70s. In a town like Thimphu, the capital, are concentrated peoples from various ethnic and linguistic backgrounds. This restructuring of the ethnic landscape of Bhutan is further enhanced by the construction of roads which make communications inside Bhutan easier and faster. The challenge now facing Bhutan is how to implement a policy of national integration and nation-building, while also retaining this ethnic diversity which forms an important part of the wealth of the country.

NOTES

1 In Bhutan, the suffix 'pa' added to a name designates someone belonging to a group or the inhabitants of a place. In Dzongkha the 'pa' is shortened to 'p', suffixed to the name of the region. For example, 'Paropa', 'the people of Paro', becomes 'Parop'.
2 However, one can find an introduction to the languages of Bhutan in van Driem (1992: 1–33). See also Imaeda and Pommaret (1990: 115–27) and Michailovsky (1994: 339–40).
3 van Driem (1992: 3).
4 Michailovsky and Mazaudon (1994: 546).
5 van Driem (1992: 8f).
6 I will not deal here with the problem of the term Mön; cf Pommaret (1994).
7 Michailovsky and Mazaudon (1994: 546).
8 van Driem (1992: 7).
9 Ibid., p. 8.
10 Aris (1979: 121f); Michailovsky and Mazaudon (1994: 546). See also Shafer (1966, pt.1).
11 van Driem (1992: 21).
12 Dorji (1996).
13 Shafer (1966, pt.1: 7).
14 Ibid., p. 3; Gaborieau (1978: 107–22). The Bodic division comprises different branches, one of them being the Bodish branch already mentioned earlier. Rai and Limbu languages do not belong to the Bodish section, but to the Eastern Himalayan section.

REFERENCES

Aris, Michael. 1979. *Bhutan: The Early History of a Himalayan Kingdom*. Warminster: Aris and Phillips.
Dorji, Jagar. 1996. *The Lhopus of Western Bhutan*. Unpublished manuscript, Samtse.
—— 1997. 'The Lhopus of Bhutan.' *Tibet Journal*, forthcoming.
Driem, George van. 1992. *The Grammar of Dzongkha*. Thimphu: Dzongkha Development Commission, Royal Government of Bhutan.
Gaborieau, M. 1978. *Le Népal et ses Populations*. Brussels: Editions Complexe.
Imaeda, Yoshiro, and Pommaret, Françoise. 1990. 'Note sur la situation linguistique du Bhutan et étude préliminaire des termes de parenté'. In (ed.) T. Skorupski, *Indo-Tibetan Studies*. Tring: Institute of Buddhist Studies, pp. 115–27.
Michailovsky, Boyd. 1994. 'Bhutan: Language situation', in *The Encyclopedia of Language and Linguistics*. Oxford: Pergamon Press, pp. 339–40.
Michailovsky, Boyd, and Mazaudon, Martine. 1994. 'Preliminary notes on the languages of the Bumthang group'. In (ed.) P. Kværne, *Tibetan Studies: Proceedings of the 6th Seminar of the International Association for Tibetan Studies*. Oslo: Institute in Comparative Research in Human Culture, pp. 545–57.
Pommaret, Françoise. 1994. 'Entrance keepers of a hidden country: Preliminary notes on the Monpa of south-central Bhutan.' *Tibet Journal*, vol. 19, no. 3, pp. 46–62.
—— 'The Mon pa revisited: In search of Mon'. In (ed.) T. Huber, *Spaces and Places in Tibetan Religious Culture*. Dharamsala, forthcoming.
Shafer, Robert. 1966. *Introduction to Sino-Tibetan*. Wiesbaden: Otto Harrassowitz.

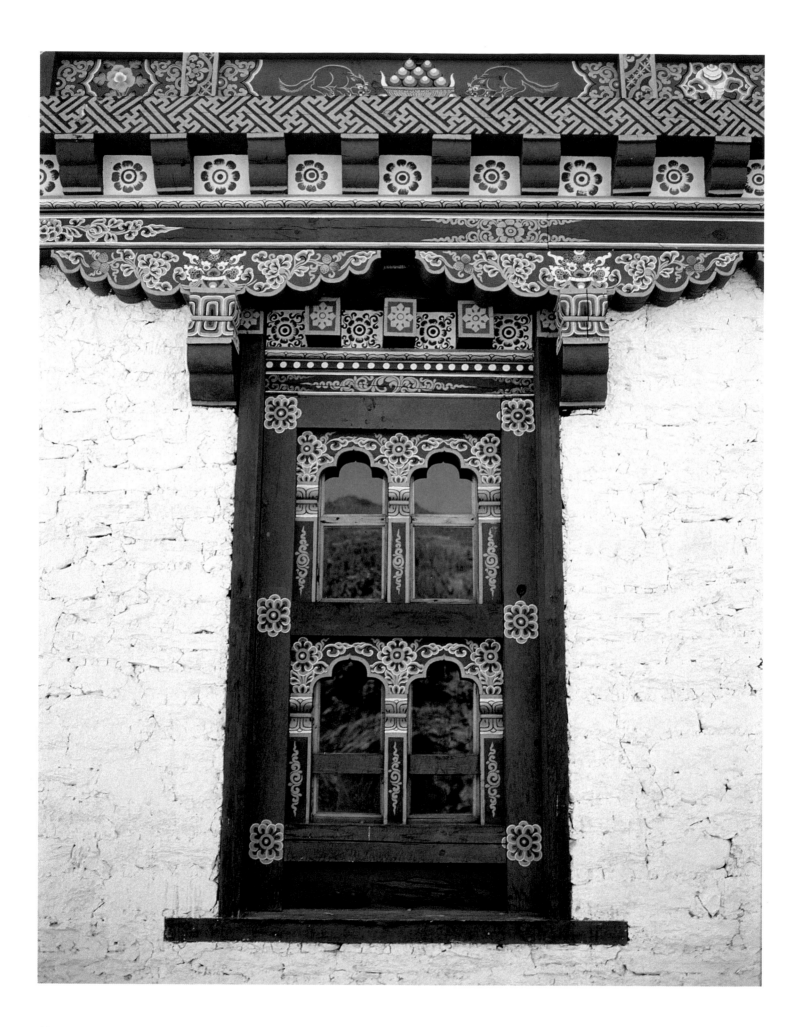

From Fortress to Farmhouse: A Living Architecture

Marc Dujardin

This paper introduces Bhutan's architectural heritage as a 'living architectural tradition', i.e., an architecture that has not yet been deprived of its culture-integrating and culture-generating role. Ever since the country's unification in the seventeenth century, a high degree of architectural coherence has been achieved between Bhutan's state / religious and secular forms of architecture. What may be understood by 'living architectural tradition' is explained and illustrated by way of an architectural reconnaissance of Rukubji, a traditional village settlement in central Bhutan currently undergoing a major process of architectural transformation.

INTRODUCTION

The traditional architecture of the Himalayan kingdom of Bhutan is associated with a number of clear-cut architectural concepts and building types that are deeply rooted in Tibetan Buddhism: majestic and strategically positioned fortress-monasteries (*dzong*), dramatically located temples (*lhakhang*) and monasteries (*gompa*), picturesque clusters of village farmhouses (*gung chim*), and various types of religious and votive structures such as Buddhist stupas (*chörten*), prayer walls (*mani*), different types of spirit houses (*lukhang* and *tsenkhang*) and the technical genius of its cantilever and chain bridges (*zam*).

With elaborate painted woodwork and trefoil arch, this elegant window frame is typical of Bhutanese architecture. (J.W. 1994)

Anyone who has had the opportunity to experience Bhutan's unique built landscape will have marvelled at its strikingly beautiful traditional architecture. Most publications that mention Bhutanese architecture tend to emphasize its monumental character and aesthetic intent. It is possible that such object-oriented descriptions of architecture contribute – albeit unconsciously – to what may be called the 'monumentalization', 'objectification' and 'concretization' of Bhutan's 'living architectural tradition'. In terms of Western values and approaches to issues of cultural preservation and conservation, each and every traditional architectural landscape in Bhutan, each and every building and structure, would seem entitled to conservation.

Yet Bhutan has no tradition of documenting aspects either of its material culture in general or its architecture in particular. From the point of view of its Buddhist religion and its history (a striving, ever since the country's unification in the seventeenth century, for cultural uniqueness), there were no reasons to document the physical or tangible aspects of the material culture. The Buddhist doctrine of the impermanent character and condition of all modes of existence has never associated buildings with eternity.[1] Like other aspects of material culture, architecture does not escape from the wheel of existence (Skt. samsara) – the cycle of life, death and rebirth; architecture, too, is subjected to a continuous process of construction, demolition and re-erection.[2] Like various comparable Buddhist cultures, Bhutanese culture celebrates a continuous process of cultural renewal as its very tradition.

Moreover, an unwritten mode of culture transfer is

intrinsic to Buddhist-inspired societies. Generation after generation and step by step, wisdom, knowledge, art and science are transferred orally and through practical experience. To ensure the transfer of Bhutan's dwelling culture and architectural heritage onto the next generation, written and visual skills and tools – designs and plans – if present at all, are but secondary tools.[3]

However, since the country's emergence in the early 1960s from its state of self-imposed isolation, Bhutan increasingly partakes in a global movement of modern thinking that considers and promotes economic growth, material welfare and individual emancipation as its fundamental goals. Lacking a tradition of conservation comparable to that in the West (where it is the aesthetic aspects of material culture that are venerated, rather than the forces and processes that generate and support them),[4] there are signs that one day the culture-integrating role of Bhutan's material culture in general,[5] and traditional architecture in particular, might dissolve and survive only in fragmented, folklorist and monumental form.[6]

I have chosen to introduce aspects of Bhutanese architecture not in the form of an illustrated catalogue or synopsis of all architectural concepts and types that make up its built landscape. Nor will this paper focus on typological and stylistic reciprocities and differences between Bhutanese and comparable Buddhist-inspired dwelling cultures. A more holistic approach towards Bhutan's 'living culture' will enable us to acquaint ourselves with the fascinating world of this particular culture or consciousness,[7] which does not fit into our current (Western) frames of reference and thinking. By inviting the reader on an architectural journey to Rukubji, a traditional rural settlement in central Bhutan, I hope to introduce traditional Bhutanese concepts of ordered space (farmhouse, *lhakhang* and other votive structures) within their topographical and micro-cultural context. But before embarking on this journey, it might be relevant to sketch out a profile of Bhutan's diverse architectural context. The case of Rukubji is but one fine example of the country's rich and complex dwelling culture.

General context: diversity in a nutshell

Bhutan, enclosed by China (Tibet Autonomous Region) to the north and India (Assam and West Bengal) to the south, possesses one of the most rugged terrains in the world. Within a distance of 100 to 150 km, the landscape bridges altitudes of less than 160 m above sea-level (the plains of Assam and Bengal) to more than 7,000 m (Himalayan Range). Over the same distance ecosystems change from subtropical to temperate monsoon to extreme alpine conditions.

Of a total land area of 46,500 km², only 8% of the land is used for cultivation; this includes orchards and settlements. Approximately 60% is forested, and 20% is perpetual snow / glacier or rocky / barren land.[8] Based on a population figure of 600,000 (1990), the average density is as low as 13 persons per km². If projected over the cultivated land, the density comes to 129 per km².

Until the late 1960s, Bhutan was a rural society without an urban tradition, particularly if compared with the urbanization that has occurred in culturally affiliated regions such as Ladakh (India) and the Tibet Autonomous Region (China). Unlike many developing countries, Bhutan did not undergo a period of colonization, post-industrialization or rapid post-independence urbanization.[9] While there is a limited, though problematic, urbanization process in each of its twenty district centres, 80 to 90% of the population still lives and organizes its habitat as part of a very rich rural tradition.[10]

Terrain and population distribution figures may help us to understand some of the choices man has made to organize his built environment. The inhospitable character of the environment and the hardship associated with such extreme ecosystems partly explain the 'galactic' nature of Bhutan's ethnic sub-cultures, their geographical distribution and distinct dwelling patterns.

Bhutan's traditional dwelling culture: built summary of an intercultural cohabitation[11]

Bhutan's traditional dwelling culture is characterized by an intercultural cohabitation of ethnic groups, each with distinct features and reciprocities, associated with specific ecosystems (alpine, moderate monsoonal and subtropical) and related

dwelling patterns (nomadic, transhumant and sedentary), but above all partaking in one and the same nationhood.

The three major relief zones are associated with distinct habitats and ethnic groups. The inhospitable valleys of the northern zone are thinly populated by yak-herding pastoralists. The numerous fertile valleys of the central zone are well protected by forested mountain ranges. These are the homeland of the Drukpas – that we take here as meaning the people of the inner valleys. The central zone is considered the economic and cultural heartland of the country. The subtropical foothills of southern Bhutan are made up of fertile pockets of land surrounded by dense and often impenetrable tropical jungle. This zone is inhabited mainly by the Lhotshampas, Bhutanese of Indo-Nepalese origin.

The high Himalayan valleys are the domain of yak herders, who live a semi-nomadic and independent life. The best known are the people of Laya in the west and the Dakpas and Brokpas in the east. Most of these pastoralists shelter under black tents, woven from yak hair. The tent is often stretched over an open stone basement. More permanent dry-stone wall structures are built to survive the severe winter months; these are used as storehouses.

The central Himalayan region is subdivided longitudinally into three parts by north–south oriented mountain ranges, each consisting of numerous fertile valleys. The inner valleys are predominantly inhabited by Drukpas. Throughout the valleys of this zone, the traditional settlements clearly reflect the Buddhist background of its occupiers. The main valleys are dominated by strategically-located fortress-monasteries and temples. Traditional settlements, principally dispersed clusters of farmhouses, often developed in the vicinity of such fortresses.

The foothills of southern Bhutan are inhabited mainly by Nepali settlers, who immigrated from the end of the nineteenth century until about 1950 and acquired full Bhutanese citizenship.[12] Here one can therefore observe a settlement pattern that is very different from the Tibetan-inspired architecture of the central region. Besides its ability to withstand the subtropical climate, the southern Bhutanese settlement type primarily articulates the hierarchical living habits of the predominantly Hindu population.

Of all these groups, the Drukpas are the most assertive sub-culture of this unique intercultural symbiosis. They settled originally in the nation's economic and cultural heartland. Associated with the country's national identity and promoted as the unifying factor *par excellence*, it is not surprising that most publications focus essentially on the Drukpas. The documentation of the Brokpas (in the northeast), Layapas (in the northwest) and Lhotshampas ('southerners') has yet to be initiated in a systematic way.[13]

The recent phenomenon of urban development in Bhutan: in search of an urban identity

Urban development was initiated as early as 1964, during the reign of Bhutan's third hereditary king, H.M. Jigme Dorje Wangchuck, with the preparation of the first master-plan for the new capital Thimphu. Before the 1970s, the valley of Thimphu mainly comprised gently sloping terraced fields for agriculture with very little urban development, except for a growing nucleus centred on the newly reconstructed *dzong*.[14] A photo taken in 1967 by Philip Denwood shows the rural character of the valley, whereas one taken in 1989 illustrates a real building boom within a time span of barely two decades.

In the 1970s, major efforts were made to cope with increasing housing shortage and to accommodate all government employees, who were recruited to staff the newly installed government bodies and departments. Complying with Indian (civic and architectural) codes and standards, large tracts of agricultural land were expropriated, serviced and redistributed to the various ministries and departments to house their respective staff. Initially these took the form of 'pool housing' schemes.

At first the local traditional building style and know-how were used, though increasingly Indian standards and typologies were adopted. Large colonies of different types of dwellings (from large bungalows, semi-detached houses and barracks to multi-storey apartment estates) reflecting the social status of their users, gradually made up the urban landscape. Along with the remarkable expansion of government buildings (residential quarters as well as institutional buildings), the commercial centre developed along one of the city's main axes, Norzim Lam, with uniform single-storey shophouses in traditional style.

The 1980s were marked by new policies and strategies to consolidate development areas and streamline the so far relatively unplanned and haphazard urban development. As home ownership was being encouraged, housing colonies which previously had a uniform appearance were dismantled and sold to the private sector, resulting in a more hybrid settlement tissue comprising a mixture of traditional and imported dwelling patterns and styles.

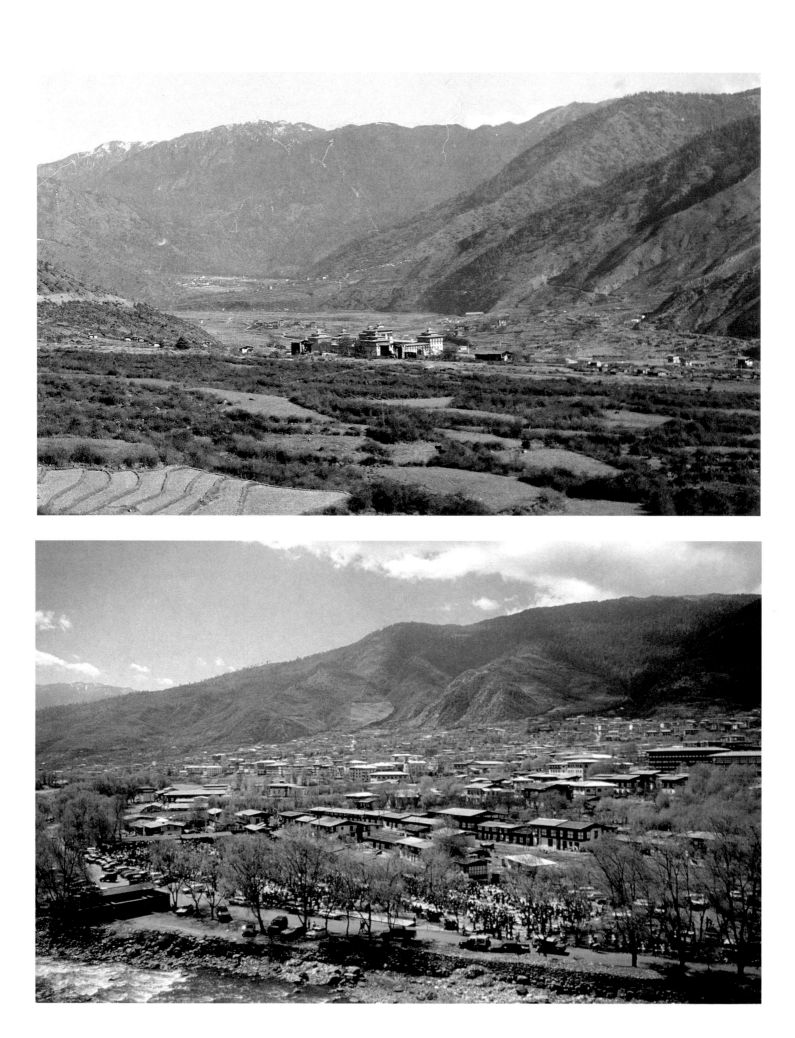

Today, Bhutan is still searching for its own urban tradition and identity. The issues addressed do not exceed the problems of small European towns. To give an impression of the scale and nature of Bhutan's urbanization, in 1986 the population of the capital Thimphu numbered 16,000 of a total population of approximately 600,000.[15] Of the housing stock, 72% was occupied by government officials and/or rented by the Royal Government; Thimphu developed as a colony for bureaucrats recruited from all over the country and from abroad, particularly from India.

Phuntsholing, Bhutan's most important commercial centre and entrepot, with a population of some 16,500 in 1986, is located on the Indo-Bhutanese border, and is of a more hybrid typology and architectural arrangement due to its contiguity with the Indian border town of Jaigaon.

Comparing such architectural developments to traditional dwelling patterns still commonly observed in the rural areas (where 80% of Bhutan's population live), one may feel uneasy about the way urban architecture adopts architectural features from the country's unique traditional architecture. Major efforts have been made to give each (imported) urban building type a traditional appearance. 'Tradition' is seemingly brought down to the level of wallpaper decorations by providing each 'westernized' urban building with a 'Bhutanese' character.

The least one can say is that after barely three decades of urban development, Bhutan is still in its initial phase of urbanization and very much in search of a 'Bhutanese' urban identity, one that reflects the cultural confidence by which the challenges of the modern world are met and balanced with a rich living tradition. Bhutan's constant urge to 'Bhutanize' whatever is imported or adopted from abroad is not only characteristic of urban centres, but applies equally to all major aspects of its material culture. To a large extent, each process of 'Bhutanization' can be considered a process of 'harmonization'.

The following section will briefly illustrate the active role that Bhutan's *dzong* architecture plays in this all-encompassing search for cultural coherence and uniqueness.

Above: Thimphu valley with Tashichödzong amidst terraced fields in the mid 1970s. (P.D.) Below: The modern capital of Thimphu at the end of the 1980s. (M.D.)

STRIVING FOR CULTURAL UNIQUENESS:
THE ROLE OF DZONG ARCHITECTURE

Cultural harmony by way of sacralization: architectural conformity between dzong and farmhouse

It is the coherence and harmony between all aspects of material culture, recognizable in bold forms of artisanate and artistic expression, that demonstrate Bhutan's 'living culture'. The expression of a religious dimension is omnipresent at all levels and in all aspects of Bhutan's material culture, and can be considered the binding factor *par excellence*. Looking at Bhutan's built landscape, the reciprocity between all architectural concepts, and in particular between fortress-monastery (*dzong*) and traditional farmhouse evokes a deep sense of cultural coherence and harmony.

The interrelation between Bhutan's state/religious (*dzong*) and domestic (dispersed clusters of individual farmhouses) architecture best exemplifies the country's striving for harmony (a fundamental cultural theme in Buddhism) and for a distinct identity and cultural uniqueness, a political necessity vis-à-vis its geographical neighbours. Although this architectural coherence, reciprocity and harmony between *dzongs* and traditional village settlements has been a constant throughout Bhutan's history (at least since the Shabdrung Ngawang Namgyel unified the nation), every building structure has also been subject to a cycle of continuous architectural renewal that goes much beyond what we understand by 'restoration' and 'renovation'.

Dzongs could mean to the Bhutanese what medieval fortress-castles may have meant to our forefathers: strongholds of political and religious power. The difference lies in what these forms of majestic architecture mean to us at present: whereas *dzongs* are 'living matter', castles are more or less 'static' or lifeless objects that remind us of a glorious but distant past.

The origin of the concept of *dzongs* predates the period of the Shabdrung Ngawang Namgyel, who is regarded as the architect-builder of *dzongs* in Bhutan. Michael Aris writes:

The idea of enclosing Buddhist communities that combined both sacred and secular functions within massively constructed fortresses (dzong) was not a new one. Several were founded in the region of western Bhutan in earlier centu-

ries by the powerful Lhapa school. For the Shabdrung it proved the ideal solution to the problem of continuous attack from both inside and outside the country.[16]

In one single building complex, the archetypal concept and architectural layout of *dzongs* expresses the cohabitation of administration and state clergy, Bhutan's dual system of government initiated by the Shabdrung. Every *dzong* in Bhutan has retained its original dual concept of administrative and religious centre, and commands an entire region. Focusing on the *dzong's* dual conceptual division, Aris describes:

> *From the beginning it seems the internal layout of every dzong was divided between an ecclesiastical wing occupied by the state monks of the Drukpa school and a civil wing where the business of government was transacted and where the grain tax and other levies raised from the public could be deposited in storerooms. The whole complex was dominated in every case by a tall, usually free-standing structure (utse) containing a set of temples on every floor. Thus the secular triumph of the Drukpa theocracy was actualized in a concrete and unambiguous form that all could see from miles around.*[17]

Visiting *dzongs* today one encounters an architectural and stylistic configuration that differs substantially from what the British experienced as early as 1783, depicted by Samuel Davis' accurate drawings and watercolours. The evolution that took place between the period of the Shabdrung and the present day might as well be described as a process of Bhutanization and sacralization (the first pictorial representations of Bhutanese architecture date from the eighteenth century). In this connection, a Bhutanese scholar, the late Dasho Rigzin Dorji, stated:

> *Ever mindful of the small size of Druk Yul and the hostile and hegemonic attitude of the rulers of Tibet, the Shabdrung found it necessary to promote a distinct cultural identity for Bhutan although she shared with Tibet the common heritage of Mahayana Buddhism. He, therefore, developed distinct Bhutanese characteristics in religious ceremonies and rituals as well as in the dress and costumes of the people.*[18]

In terms of architecture, an all-encompassing striving for cultural uniqueness and identity is manifested by a movement from introvert to extrovert patterns of architectural expression,

reflected by the abundant application and artistic elaboration of wooden oriels (*rapse*),[19] the dominance of 'floating' roof types, and the bold façade treatments of domestic architecture that make every farmhouse look like a small temple.

Punakha Dzong: a living architecture and trend-setter for generations to come

The active role of the *dzong* and / or *lhakhang* as setter of new architectural trends can be illustrated by studying processes of architectural transformation over longer periods. This particular role is well illustrated by the fine examples of the two former capital *dzongs* of Punakha (former winter capital) and Thimphu (former summer capital), especially during and after the 1950s, when the Royal Government decided to make Thimphu its permanent capital. The major reconstruction works of the new capital *dzong* of Thimphu, completed by the end of the 1960s, not only set a trend for new architectural developments in the rural areas, but played a major role in the development of Bhutan's urban, non-traditional architecture.

Like the *dzong* of Thimphu in the '70s and '80s, the new (1990) temple structure at Kuje, situated in the valley of Bumthang, and the major architectural works on the old capital *dzong* of Punakha (1985–96) may well set architectural trends for Bhutan into the next millennium.

The Punthang Dechen Phodrang, commonly known as Punakha Dzong, was built by the Shabdrung Ngawang Namgyel in 1637 at the confluence of the Mochu and Phochu rivers. Its main entrance faces the Dzongchung ('little *dzong*') dated 1328 and ascribed to a saint named Ngagi Rinchen.[20] Not spared from a series of disasters – fires, floods and earthquakes – its morphological history is one of demolition and renovation. The next to last major damage to the *dzong* occurred in 1986, when the southwest side of the complex burnt down, thereby destroying the living quarters of the winter residence of His Holiness the Je Khenpo, the head abbot of Bhutan. The last major damage was caused by the enormous flash flood of October 1994, which almost erased the Dzongchung.

Built in 1637 by the Shabdrung Ngawang Namgyel at the confluence of two rivers, Punakha Dzong, the former capital, is today the winter residence of the Head Abbot of Bhutan. Above: Punakha Dzong in 1994 with the newly reconstructed Machen Lhakhang where the body of the Shabdrung is kept. (M.D.) Below: This view from the southwest was taken by John Claude White in 1906.

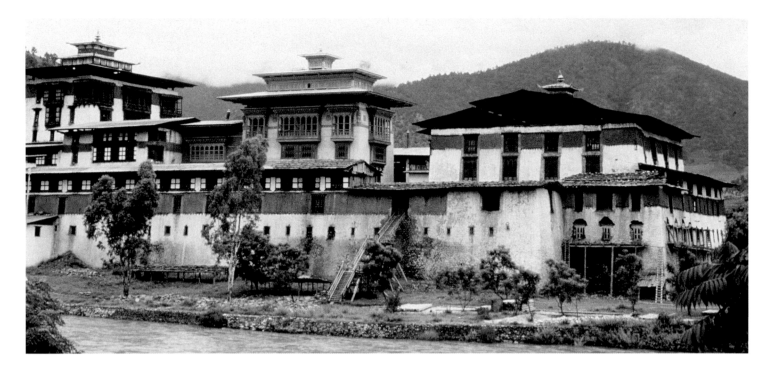

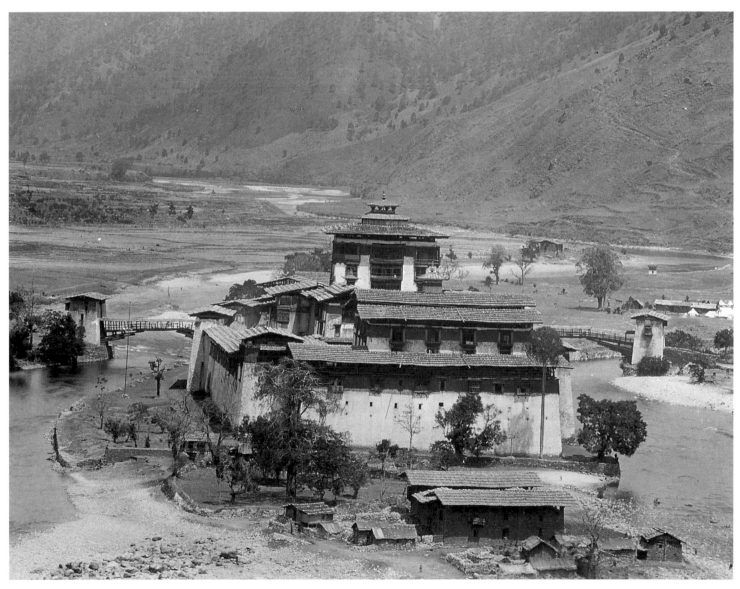

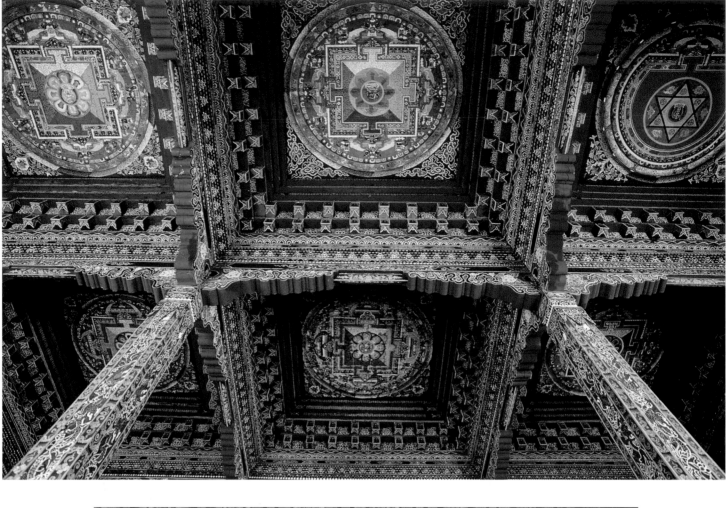

Above: Painters create a riot of colours on a carved ceiling and pillars in Punakha Dzong. Each panel is decorated with a different mandala dedicated to a specific deity. (J.W. 1994) Below: A richly carved capital of the new Machen Lhakhang in Punakha Dzong demonstrates the craftsmanship of contemporary Bhutanese carpenters.(G.N.) Right: The early 1980s saw the prolific use of elaborate painted decorations representing various auspicious symbols on village houses and shops. (J.W. 1994).

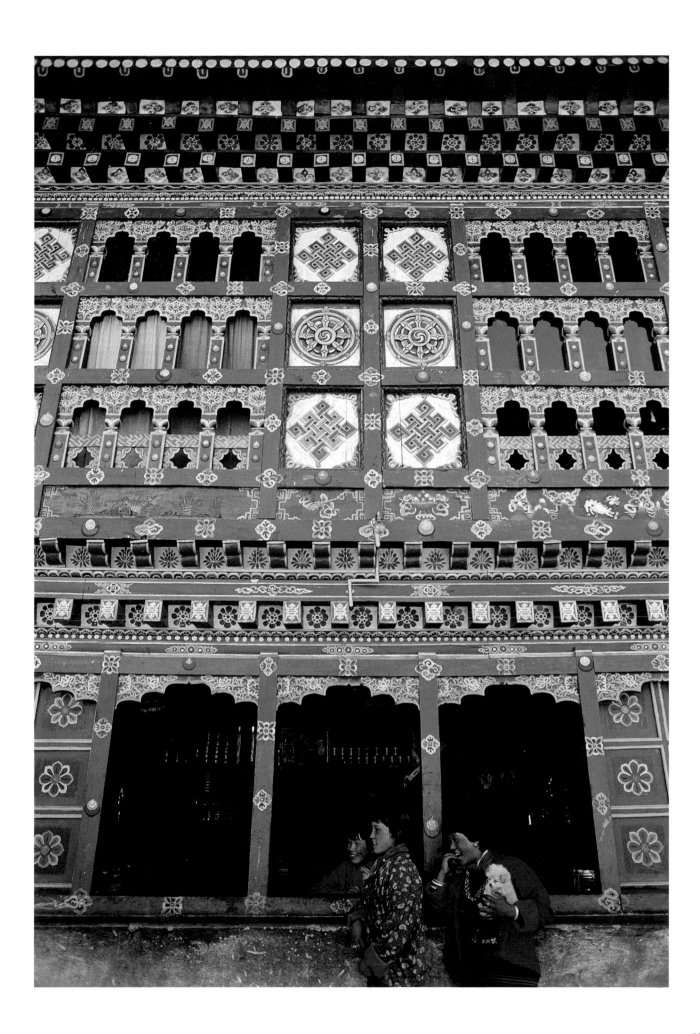

Until the mid '80s, however, the overall architectural configuration of Punakha Dzong differed little from that witnessed by John Claude White, the British Political Officer, in 1906, or even from the configuration depicted in the accurate watercolours of Samuel Davis as far back as 1783. The defensive character of the *dzong's* external walls, and the architectural supremacy of its central tower (*utse*), remind us of conceptual and spatial arrangements also observed in Tibetan architecture.

The reasons for rebuilding a *dzong* (or any other kind of structure) may be various: practical, technical, socio-political, cultural, religious, cosmological. In the case of Punakha Dzong, the recent fire provided the authorities with an opportunity to demonstrate an exemplary attitude and religious devotion through the commissioning of a new temple. H.M. King Jigme Singye Wangchuck ordered the rebuilding of the Machen Lhakhang, one of the most sacred temples within the *dzong*, as well as the monks' assembly hall (*kunre*). The new Machen Lhakhang was built by the best-qualified village artisans recruited from all over the country. They had proved their expertise during the construction of the magnificent new Kuje Lhakhang in Bumthang, commissioned by H.M. The Queen Mother, Ashi Kesang, and inaugurated in 1991. The resemblance between the two temples is striking. The ornamental refinement of the Machen Lhakhang, completed in 1995, is even more impressive. With the recent demolition of the adjacent building, the great assembly hall, *kunre*, a number of valuable art objects such as mural paintings and cosmic mandalas were also lost. Lacking a tradition of documentation and conservation of architectural heritage as discussed earlier in this paper, it is obvious that with the demolition of the old *kunre*, an entire historical architectural concept was lost. However, for Bhutan the re-erection of the new *kunre* is yet another challenge to further the process of architectural refinement and bold formalistic expression of this religious dimension that will undoubtedly find its reflection in stylistic fine-tuning of village settlements, once the participating village artisans and master-carpenters (*zopön*) have returned to their native valleys.

How this culture transfer to the village occurs, and how the whole process of architectural trend-setting and architectural refinement works, is the subject of the final section. To supply the historical background of one such process, I will now introduce the vibrant and integrated dwelling culture of a dense village settlement in central Bhutan.

AN ARCHITECTURAL RECONNAISSANCE: THE TRADITIONAL SETTLEMENT OF RUKUBJI

The geographical situation of Rukubji: the land of the Black Mountain Bjob (Brokpas)

The village of Rukubji is situated in central Bhutan at a height of 3,000 m, 11 km east of the mountain pass of Pelela (3,400 m) and just below the central motor road connecting the district centres of Wangdi Phodrang and Tongsa.

Rukubji belongs to Sephu sub-district (*dungkhag*), falling under the jurisdiction of Wangdi Phodrang district in western Bhutan.[21] Transcending administrative and geographical borders, Rukubji belongs to a region that is commonly known as the land of the 'Black Mountain Bjob', the domain of yak and sheep herders. The area extends to Gangte Gompa in the west and the Nikkarchu river in the east, and includes other areas to the north.[22]

The Black Mountain range splits western and central Bhutan longitudinally into two clear-cut regions with two distinct ecosystems. In contrast to the abundantly forested west side, the far side of the range is predominantly covered with high-altitude dwarf bamboo, which makes the landscape of Rukubji appear harsh and desolate.

Dwelling at the foot of three mountains: the spatial configuration of Rukubji's setting

Traditional settlements in Bhutan are meticulous in their planning and spatial arrangement. The earth is believed to possess divinity, and every settlement foundation is subject to both practical and spiritual considerations. Practical considerations can involve soil structure and topography for cultivation and livestock, accessibility of surface and spring water, and the vicinity of road networks (mule-tracks). Spiritual considerations involve geomancy, a set of divination rituals taking account of geographic features such as the profile and position of mountains, the flow and merging of rivers, etc. Many of these principles go back to Bhutan's pre-Buddhist era and resemble the principles of feng-shui ('wind and water'), the Chinese art of life in harmony with the environment, as well as some of the principles of Indian building codes recorded in the *Vastusastras*.

As regards its *genius loci*, Rukubji is auspiciously located

The large village of Rukubji. Located on the eastern side of the Pelela pass, its houses are grouped at the edge of a wide and fertile plateau. (A.A. 1983) Below: The village is conceived as built over the body of a snake which is a harmful spirit. Thus, the location of the temple on the head of the snake can be understood as the subjugation of the spirit by Buddhism. (M.D.)

at the end of an elongated spur where three mountains meet. In fact, the village itself lies at the foot of a fourth mountain. The spatial layout of the village and its fields is dictated by the confluence of three small rivers. Rising in these mountains, the Zerichu, Palechu and Djebichu rivers embrace the whole of Rukubji's setting, settlement and fields before they merge with numerous streams and, becoming the Manas river, eventually find their way through the plains of Assam in India.[23]

The mountains that define the contours and horizon of Rukubji are familiar elements; they are personified and named (as foot, body, head); they are venerated for their divine power through their association with mountain gods (*yulha*).

Taming the land: historical figures in Rukubji's foundation myths and legends

By directly associating the historical figure of Guru Rinpoche (Padmasambhava) and Bhutan's national hero Drukpa Kunle (1455–1529) with the foundation myths and legends of Rukubji, all who have connections with the village cherish the idea of belonging to an important lineage associated with this very place.

The villagers of Rukubji believe that in his manifestation as an owl and in his capacity as 'tamer of the land', Guru Rinpoche purified the site from evil spirits and demons by subduing a snake demoness. The whole of Rukubji's setting is metaphorically associated with the body of a snake.

It is a popular belief in the village that the temple pins down the eye of the snake. The core of the village cluster, where houses are built and rebuilt, evokes the snake's beating heart. The stretched shape of the plateau, the mosaic of fields and the seasonal variation in colours and texture caused by patterns of shifting cultivation, evoke the body of a snake shedding its skin each year. The fields converging uphill evoke the snake's small tail that remains hidden behind the mountain ridge. The trickle of water seeping down from the plinth of the eastern elevation of the village temple is believed to originate from the lake below the spur where the snake demoness is detained.

Along with its neighbouring villages Chendebji and Tangchebji, Rukubji is known as Bji-Sum ('the three Bjis') after a popular story about Drukpa Kunle.[24] The legend tells of the saint's refusal to cross the Pelela pass to visit the three settlements with names ending in 'bji'. Holding mustard seed in his hand, Drukpa Kunle scattered it over the area where

rice was once cultivated. It is believed that because of this no one ever succeeded in growing rice there. Ever since, the yellow colour of the abundantly blooming mustard plants contrasts with the brownish bamboo vegetation.

Entering the village centre: the daily practice of gradual trespassing

I now take the reader on an architectural hike from the outskirts of the village right to the interior of one of the farmhouses, while also commenting on some of Bhutan's spatial and architectural concepts encountered along the way.

The village centre of Rukubji can be approached from various directions. Driving on the road completed in the mid 1980s, the village suddenly appears in its entirety after a fifteen-minute drive eastwards from the Pelela pass. In earlier times, however, the main mule-track that linked the *dzongs* of Wangdi Phodrang and Tongsa followed the riverbank of the Zerichu, keeping the settlement out of the immediate view of travellers and wanderers. Though numerous tracks lead into Rukubji from all directions, the place where the highway branches off towards an open field below the spur suggests the main entrance to the village settlement. This feeder road runs down until it crosses the small Djebichu river.

Having crossed the Djebichu by a bridge made of six tree trunks, one is confronted by a two-storey *chörten* aligned with the cardinal points on an open piece of land bounded by the merging rivers Djebichu and Zerichu. The *chörten* marks the cremation ground (*duthö*).[25]

Chörtens are Buddhist monuments that exist in a multitude of forms and sizes. Bhutanese *chörtens* can be divided into three major types. The most common type is a square stone structure topped by a gently sloping pyramidal roof of stone slates. The second is of the Tibetan type and is referred to as *khangteg chörten*. It often has a wooden roof similar to those of traditional farmhouses. The third type is the large 'eye-stupa', modelled after the well-known stupas of Bodnath and Swayambunath in Nepal. This type is rarely seen in Bhutan, and the only noteworthy examples are those at Chendebji near Rukubji and Chörten Kora in eastern Bhutan.

Chörtens are erected for various reasons: to ward off evil spirits from places that are identified as thresholds (confluences, bridges, mountain passes, etc.) or to commemorate in stone the visit of a historical figure, lama, or even some beloved relative who passed away.

Today the 'chörten of enlightenment' (changchub chörten), one of the eight Tibetan types, is favoured over the more traditional cubed versions. Each chörten is given 'life' by inserting a 'tree of life' (axis mundi) inscribed with prayers. The erection of a chörten is accompanied by a number of construction rituals and finally consecrated to fulfil its purpose. Chörtens are usually circumambulated clockwise.[26]

The chörten marking Rukubji's cremation ground is of the square type and is characterized by a red belt in the upper third of the cube, displaying a continuous row of slates inscribed with the mantra om mani padme hum.

Heading towards the bridge over the Zerichu, Rukubji's main access to the village, one comes across the micro-hydel power plant that since the mid 1980s provides electricity to each farmhouse (for lighting only). The bridge (zam) has recently been rebuilt in concrete and not as a traditional cantilever bridge. It is here that on the occasion of Rukubji's major festivals such as Bhutanese New Year (losar) and rituals such as harvest ritual (habe), relatives and guests are officially welcomed. For such occasions the bridge is topped by an arch made of green leaves.

Although a small steep track climbs directly to the temple ground, the usual access path leads along a stone wall protecting some of Rukubji's isolated pockets of agricultural land and threshing floors.

When the 'floating' roofs of the first farmhouses appear, the rough track diverts to the right and leads up to one of Rukubji's major entrances, marked by three small chörtens in Tibetan style, grouped under a single wooden superstructure covered with split shingles of softwood. This khangteg chörten south of the village cluster is one of the three chörtens that were specifically erected to ward off evil spirits and mountain deities (yulha) associated with Rukubji's three mountains, namely Bumbiser Pokto in the north, Tanguser Pokto in the west and Barumsarbu Pokto in the south. From here one can proceed in four directions. Turning sharply right, a path leads up to the village temple (lhakhang).

Although unusually located below the dense cluster of houses, the village temple dedicated to Menla, the Medicine Buddha,[27] undoubtedly dominates the village in terms of its position and its ambiguous and dual appearance. The temple is aligned with the cardinal points. Its western side (facing the village cluster) has the appearance of an elaborated farmhouse, while its eastern façade (facing the confluences of the rivers and the cremation grounds) has architectural features usually associated with religious structures.

Chörtens and prayer flags punctuate the Bhutanese landscape. A chörten has many functions; it often commemorates the victory of a lama over a local deity. Prayer flags, erected at powerful places, send prayers on the wind. (J.W. 1994)

To the right, the path leads around the cluster of houses towards the main entrance of the village in the west, from where one path continues along the edge of the elongated cultivated fields and another descends towards the bank of the Zerichu, before climbing up to the village cluster of Bumilo, Rukubji's sister village, located above the highway.

To the left, a track descends to the main threshing floors, some more dispersed farmhouses and the archery field that stretches over a distance of more than 110 metres, where Bhutan's national sport is performed during various festivities and rituals.

The tracks that lead in various directions beyond the chörten are made of small elevated footpaths in the shape of small dikes. These are the only traversable corridors during the rainy season, which completely transforms the entire outdoor space between the houses.

When one continues the approach to the dense village cluster, the farmhouses rise up against the sky like massive inward sloping cubes of compacted earth, crowned by elaborated woodworks (*rapse*)[28] projecting at the first and/or second storey, depending on the number of storeys a building has. Huge multiple-eaved roofs covered with loosely placed shingles held down by wooden stakes and heavy stones, protect the mud walls from being eroded during heavy rainfall in the monsoon period (June–September). Most of the farmhouses are extended at the first level by spacious terraces and secondary timber structures.

Rukubji is a large and densely populated rural settlement in comparison with the average Bhutanese village. And yet there are barely 29 extended families with a population ranging between 300 and 368 persons (1990), depending on whether they actually live in the cluster or are settled at the periphery of the village. The village cluster itself consists of some 24 individual farmhouses of various sizes, each with one, two or three storeys.

Approaching a three-storey farmhouse, one comes across a small *chörten*-like structure built against one of its massive walls of rammed earth. This is a spirit house (*lukhang*), dedicated to the serpent spirit (*lu*) that is identified as the spiritual owner of the land on which the farmhouse was erected.

Lukhangs are of many shapes and forms. Attached or detached are miniature structures with small niches. Sometimes a *lukhang* is no more than a piece of rock in the vicinity of the farmhouse. Only the farmhouses dating from the foundation period of the settlement have spirit houses. Members of the extended families that erect a farmhouse next to the main family house (*gung chim*) venerate the same spirit (*lu*). In Rukubji I have identified 15 *lukhangs* which correspond to the farmhouses of the 15 families (out of 29) that are entitled to participate in some special rituals.

Continuing down the alley one sees that on the projecting and elevated stone plinths of the farmhouse piles of firewood are stored, reducing the outdoor space even more. In this particular house, the sole entrance is via the stable, shared by cattle and sheep. Pigs are never kept inside the buildings and stay at the rear of the compound or in detached pigsties. A steep staircase, with stairs chopped out of three joined tree trunks, leads to the kitchen (*thabsang*), the main living space of a Bhutanese family. This is the room where meals are prepared and consumed, where guests are entertained casually, and where the entire family sleeps in one row on mats and bedding folded up and put aside during daytime.

I observed that very often the dress of the day (*go* and *kira*) is used as blankets.

The traditional Bhutanese interior is characterized by the absence of furniture, except for low tables and perhaps a radio. Compared to Indian and Nepalese villages, places such as Rukubji are realms of silence.

The traditional mud stove is used to prepare meals for the family and fodder for livestock, but above all serves in winter as the main heating source. Traditional stoves are not usually equipped with a chimney, although recent development schemes are gradually introducing improved versions. Nevertheless, three-storey houses are furnished with a shaft of wooden planks that runs from the ceiling of the kitchen right up to the open attic space to partially evacuate the smoke and create a draught for the stove.

The kitchen gives access to storerooms for meat and other goods and, in the case of a two-storey farmhouse, to a *chösham*, a private altar or shrine room. The *chösham* is always located on the top floor. This room is the pearl of the house and is sometimes equipped and decorated like a fully-fledged temple.

A typical Bhutanese ladder, hewn from a single tree, leads to the attic, which is predominantly used to store straw and vegetables. Roofs are accessible by simply pushing away some shingles, and are frequently used for drying meat, chillies and other vegetables. For spiritual protection, each roof is topped by the family prayer flag (*gungdar*), which is replaced each year.

The first floor also gives access to a partly protected outdoor veranda, which is frequently used for cleaning vegetables, for bathing and other sanitation purposes. Very often a single hole in the floorboards serves as the toilet. Nowadays, more hygienic rural sanitation devices are being installed, which makes the outdoor spaces at ground level more hygienic.

Traditional concepts of used space: the household and status of the farmhouse

It is important to remind the reader that Rukubji is not representative of the traditional dwelling culture of the whole of Bhutan. Patterns of social identity, kinship, marriage, land ownership, land inheritance and their spatial implications may differ substantially from valley to valley and from group to group. While in central Bhutan systems of matrilocal kinship prevail, in southern Bhutan patrilocal lineages may be observed.

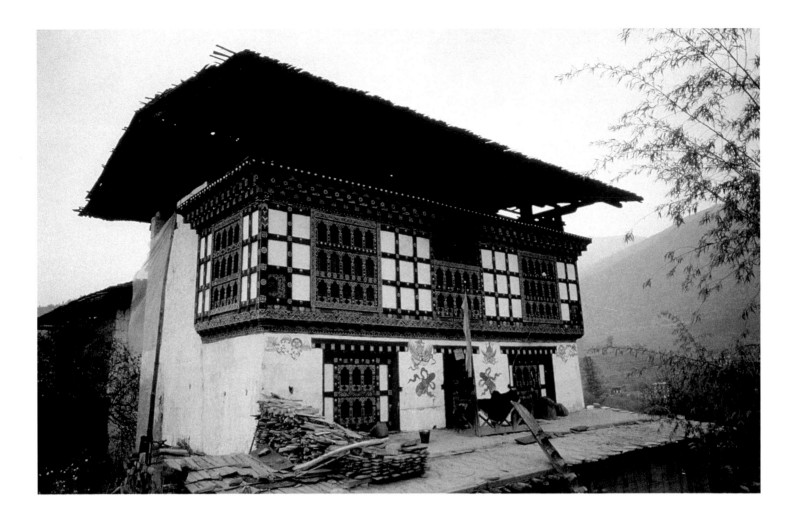

Above: Farmhouse near Bonde village in Paro valley with three-tier windows typical of this region. (M.D.) *Left: The phallic symbols on each side of the door are a common motif of great fantasy, variety and humour. Intended to distract and thereby ward off evil spirits, they are also symbols of fertility.* (J.W. 1994)

The systematic comparison of structural patterns in cross-cultural contexts teaches us that socio-economic and cultural patterns observed in Rukubji show more points of correspondence or even harmony with, for instance, a Zangskari community in Ladakh than with some Bhutanese village settlements across the Pelela pass.[29]

Household and identity

In Rukubji, the household largely determines a person's identity, rights and obligations.[30] Kinship (*rus*, 'bone'), household (*gung*) and the family farmhouse (*chim*) a person belongs to – whether or not he or she actually resides there – constitute linked aspects of identity.[31] It is common practice among the

Drukpas to add to the personal name a name that refers either to the village of origin or to the name of a protective deity identified with the valley in which the village is located.[32]

Household and land

Specific patterns of space use such as housing, land cultivation and land inheritance are defined by the identity and status of the household as a structural part of a larger cultural entity.

In Rukubji, land is passed down within a single household. Land and associated property is passed from mother to daughters. The marriage pattern is matrilocal, with the couple settling in the bride's parental house.[33]

Among the Drukpas, land is usually divided into irrigated and dry land. The irrigated land is divided and rotates among the sisters on a yearly basis. Each sister thereby experiences the (dis)advantages of different pieces of land (in terms of location, soil condition and water). The dry land is divided into equal shares. When a system of shifting cultivation is adopted, the land is called *tseri* land. Until she dies, the mother keeps a share of dry land which is known as *langdo*.[34] The daughter who has taken care of her mother in the best way inherits this *langdo*, which is the object of serious conflicts.

As mentioned above, Rukubji's ecosystem does not permit rice cultivation on irrigated land. Most of the households share 2 to 4 acres of dry land for the shifting cultivation of barley, buckwheat and potatoes. Income is also generated from raising cattle and sheep.

Creating a sense of cyclical change

The social position and changing status of the eldest daughter is one of the most important factors that subjects every family farmhouse to a process of deconstruction and reconstruction. When the eldest daughter (or son, in the absence of a daughter) is married,[35] the parents move out of the 'family house' (*gung chim*) to live in a small single-storey house next door, which is referred to as the 'small house'(*chim chung*). The *chim chung* has a subsidiary and temporary status and can be erected and dismantled without much protocol. Apart from the retired parents, younger married daughters who await the construction of a farmhouse of their own, may spend a couple of years in offshoot structures like the one erected for their retired parents.

When one of the parents dies, the widow(er) progressively renounces material wealth. Some go to live for the rest of their life in a small hut somewhere uphill or at the periphery of the village. Others may move back to the family house and occupy a small room close to the *chösham*, equipped with a one-hole mud stove, where they will lead a secluded life mainly devoted to religious activities. These two dwelling conditions might be regarded as outdoor and indoor hermitages.

After the official retirement of the parents (mother) and the investiture of the new owners (married daughter), plans are made to rebuild the house with the advice of the astrologer and local master-carpenter (*zopön*). With the help of the entire community, the newly-married couple dismantles the old structure (especially the woodwork) and reconstructs a new farmhouse on the same spot where centuries ago the ancestral family was founded.

The farmhouse as social habitat

Households are bound together by their shared use of village resources and practical and ritual obligations.[36] Indeed, the traditional farmhouse, commonly referred to as family farmhouse (*chim*) is not only a private family house. It is identified as the true 'social habitat' of Bhutan. In the rural areas, every village house is the cultural achievement of the entire village community. House construction is essentially an act of cultural belonging in the service of a collective ideological goal, namely the re-enactment of the foundation ritual and the renewal of the allegiance to the house deity. Each house is the materialization of the cultural identity of its users, endorsed by the entire community. The house is the place *par excellence* for social interaction and ritual. At certain ceremonies and rituals, performed for the well-being of all the village inhabitants, a single farmhouse literally accommodates the entire village community, demonstrating a unique and strong sense of cultural belonging.

Above: A house constructed in stone in eastern Bhutan; the bamboo platform is used to dry vegetables, here chillies. (j.w. 1994) Below: Lacking chimneys, Bhutanese kitchens are usually very smoky and the walls are black with soot. The kitchen hearth is the only source of heating for the whole house. (c.s. 1996)

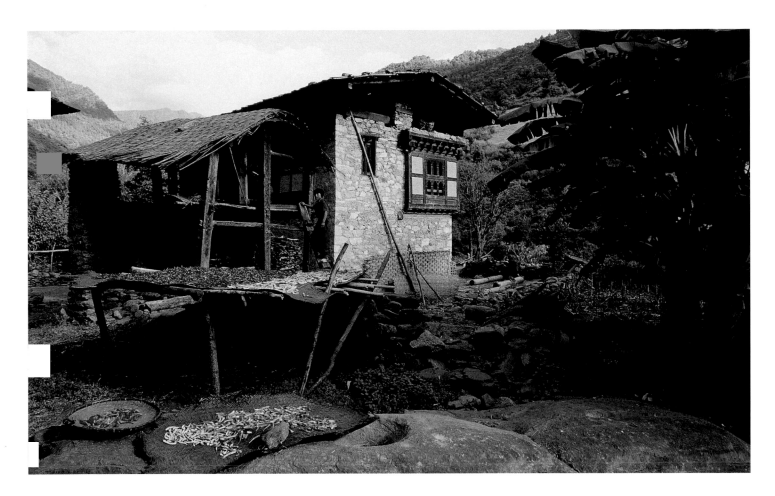

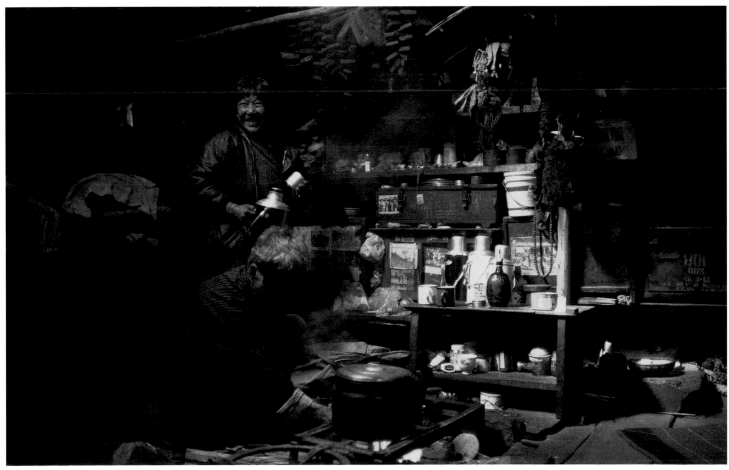

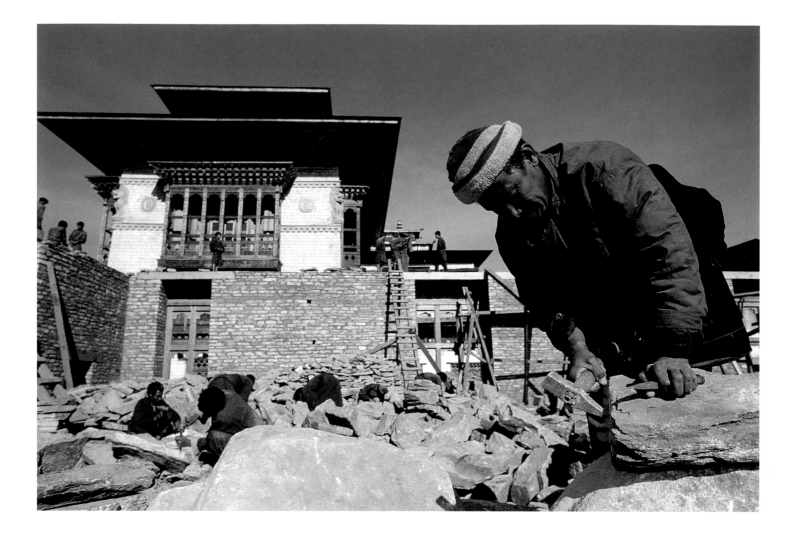

RUKUBJI: AN EXAMPLE OF BHUTAN'S 'LIVING ARCHITECTURE'

The discontent of Rukubji's local deity Dramar Pelzang: spatial mediation of a conflict [37]

It has already been suggested that architecture is the physical embodiment of an ideological concept, and is subjected to a unending cycle of life and death. The spirit house (*tsenkhang*) dedicated to Dramar Pelzang, Rukubji's local deity (*yulha*), and the village temple (*lhakhang*), underwent the same fate.

The relocation and reconstruction of the *tsenkhang* was the last of three transfers initiated in 1980. Notwithstanding the good physical condition of the *lhakhang* and renovation works on its interior in the late 1980s,[38] it was demolished in 1992 and replaced by a structure that leaves no doubt as to its status: an unambiguous religious structure, commanding in scale, form and overall location.

In Rukubji, every family farmhouse is dismantled and reconstructed at regular intervals of roughly 20 to 25 years, which corresponds to the lifespan of untreated timber, but more importantly to certain rites of passage, in particular those associated with the changing social position of the eldest daughter of the household. The demolition and reconstruction of Rukubji's *tsenkhang* and village *lhakhang* cannot be considered a part of this cyclical process. In my opinion, the drastic intervention by the people of Rukubji demonstrates the spatial mediation of a life- and culture-threatening conflict.

Above: A stonemason works on the walls of the new buildings in Punakha Dzong. (J.W. 1994) Opposite, above: Carpenters and masons at work; this scene most probably refers to the construction of Samye Monastery in Tibet in the eighth century as King Trisong Detsen, the Abbot Santaraksita, and Guru Rinpoche look on. Detail from painting p. 167. (E.L.) Below: Detail of a thangka painted in the 1980s showing a Bhutanese house with typically fashionable white-washed walls and large windows of that period. See thangka p. 111. (E.L.)

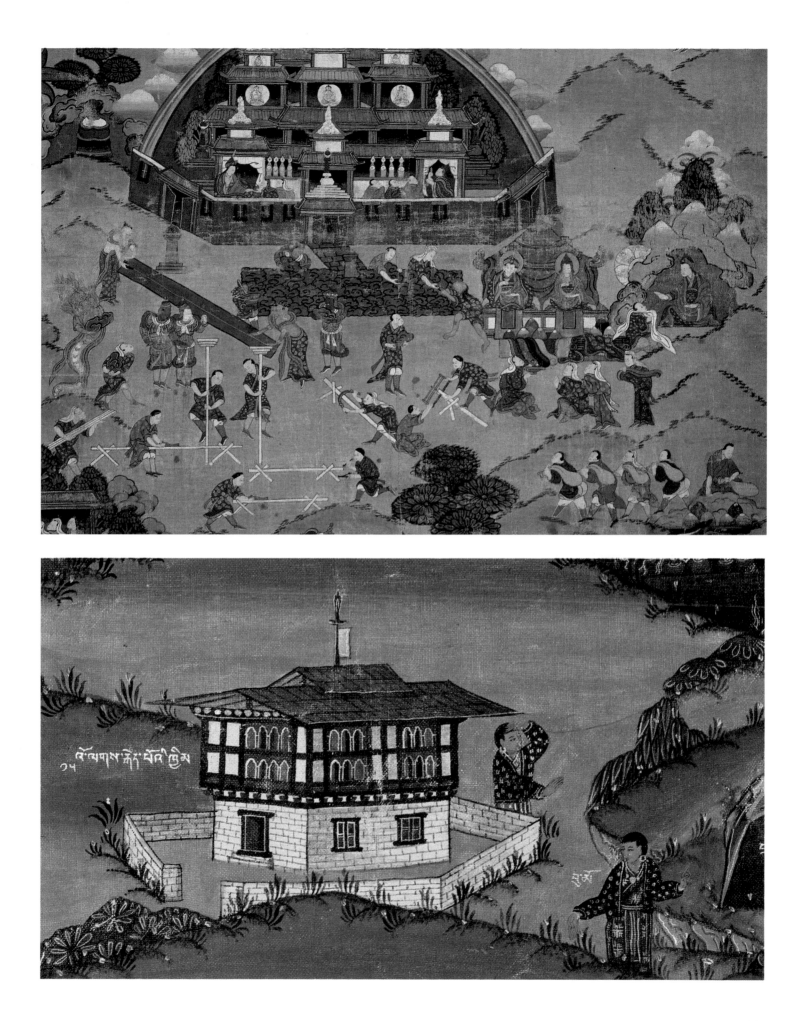

Road versus mountain god:
the aggravation of a dormant problem

Problems began with the construction of the Central Road in the late '70s. Until then the mule-track from Wangdi Phodrang to Tongsa had followed the flow and riverbank of the Zerichu, which placed both the village settlement and the *tsenkhang* of Rukubji's local deity at a higher level.[39] With the completion of the motor road in 1981 just above the site of the *tsenkhang*, it was believed that the dust of the motor vehicles would dirty the building and bring bad luck to the village.

Advised by the local priest (*phajo*), the villagers decided to relocate the *tsenkhang* at a safer spot on the opposite mountain, far above the road. It was relocated to another mountain in 1984, in connection with a general crop failure.

Between March and October 1990, six villagers died of various causes. It was now understood that the local deity had not appreciated the villagers' strategy of frequent relocation.

The Phajo and the Trulku:
in search of the relevant mediator

Since human life was being threatened, the people of Rukubji no longer sought the advice of the local priest in this matter. *Phajos* are usually consulted for "preventing such calamities as famine and drought and insuring the fertility of the land and cattle".[40] In other words, the *phajo* mediates between human beings and natural forces and their associated demons (*dre*).

The advice of a more efficient mediator or harmonizer was therefore sought, one with the authority to deal with "rituals of death and after-life issues".[41] The Gangte Trulku, head abbot of Gangte Gompa, the only Nyingmapa monastery in the neighbouring valley of Phobjika, was consulted during this inauspicious event.

Materializing the conciliated conflict: building as a sign of ritual protection

The *trulku* advised the villagers to move the spirit house of Dramar Pelzang to its original location below the road from where it was removed in 1981 upon completion of the highway to Tongsa. By the end of December 1990, the reconstruction of the *tsenkhang* had been completed. While the earlier *tsenkhang* had consisted simply of a heap of stones

topped by a prayer flag, this time a real building was erected in the form of a little house.

It is not clear to me whether the *trulku* also advised the villagers to demolish the temple in 1990. The least one can say is that the demolition of the village temple in 1992 was preceded by a process of unprecedented architectural transformations challenging the position and state of affairs of the old temple.

Restoring hierarchy and spatial order:
sacralization of domestic architecture

Since the events of 1990, the village of Rukubji has experienced an accelerated process of more profound transformations. In 1991, and prior to the demolition of the old temple, the overall configuration of the settlement was disordered by private initiative. The gabled roof of one of the village farmhouses, made of traditional wooden shingles (*shinglep*), was taken down and replaced by a four-eaved rooftop made of corrugated iron sheets, a type of roof usually associated with royalty and religious structures.

At first glance this initiative seemed no more than another phase in a process of sacralization of domestic architecture, an evolution that can be observed throughout the nation, in rural as well as in urban areas. Architectural features, once restricted to royalty or to religious structures, are now being copied by private parties, especially those belonging to the wealthy class. This same initiative can also be understood as a form of architectural refinement, related to the wave of reconstruction works that various important *dzongs* and *lhakhangs* are currently undergoing.

However, this private initiative disrupted the balanced and harmonious spatial hierarchy of the settlement. The *temple* was 'challenged' and lost its spatial authority. Surveying the spatial configuration, the renovated farmhouse located in the middle of the cluster – with its shiny four-eaved roof, whitewashed walls and bold religious wall-paintings – appears to dominate the village cluster in the same way as the temple whose privileged position it has usurped. Despite its distant and isolated location and its good physical condition, the old temple with is ambiguous architectural concept (half temple, half farmhouse) could no longer compete with the renovated and modernized farmhouse – neither in appearance, nor in size, nor form.

Replicating a higher architectural order: resolving a local conflict and contributing to a global harmony

The construction of a new temple in honour of Guru Rinpoche in the village of Ura in the mid 1980s initiated a process of architectural experiments. By the end of 1990 there followed the construction of a new temple at Kuje in the valley of Bumthang, and recently the completion of the Machen Lhakhang in Punakha Dzong, founded by Bhutan's unifier the Shabdrung Ngawang Namgyel. With these developments, a new trend was set for the concept and construction of present-day and future structures, both reconstructions and new structures.

The participation of Rukubji artisans (master-carpenter and painter) in the reconstruction of some of these important works undoubtedly inspired them to include some of the architectural and stylistic innovations in the design and construction of Rukubji's new temple. This new temple is a fine example of the traditional process of architectural refinement contributing to a process of cultural preservation and identity.

Expanding spatial margins and renewed contract with Dramar Pelzang: spatial and ritual achievements

In essence two things had happened in the village: the flight of Rukubji's local deity following a series of well-intentioned but inauspicious acts of relocation, and the threatening of Rukubji's spatial hierarchy by a private initiative of modernization.

By relocating Dramar Pelzang's *tsenkhang* to its original position, a major step was made towards the normalization and revitalization of the allegiance between the local deity and the founding families. By demolishing and replacing the old temple with a structure that does not leave any space for speculation regarding its status, the spatial hierarchy between temple and cluster was restored.

Also significant is the new spatial margin that has been created. By this single act of rebuilding the temple along the lines of a higher architectural order (Ura, Kuje, Machen), every farmhouse is entitled to continue a process of cyclical elaboration and sacralization without becoming a threat to the overall spatial hierarchy. On the contrary, the first step is made towards a syncretic juxtaposition (coexistence) of traditional (rural) and non-traditional (urban) concepts of ordered space.

CONCLUSION

This paper has focused mainly on the traditional architecture of the Drukpas associated with Bhutan's national cultural identity and exemplified by the traditional village of Rukubji, a dense settlement in central Bhutan

A preliminary profile of Bhutan's complex dwelling culture, characterized by a predominant and varied rural architectural tradition and the first attempts to structure urban space, introduced the reader to the complexity of this Buddhist-inspired dwelling culture. This is a culture in which architecture still plays a culture-integrating and culture-generating role. It was suggested that the fortress-monastery or *dzong* functions as an architectural trend-setter, as well as a catalyst for cultural coherence and harmony, typified by the interdependence and interaction of *dzong* and farmhouse.

We saw how the people of Rukubji make use of a limited repertoire of basic architectural elements to organize and materialize the protection of their spatial and built environment. In the village, one temple (*lhakhang*), four *chörtens*, one dwelling for the local deity (*tsenkhang*) and fifteen spirit houses (*lukhang*) were meticulously positioned to protect the fifteen founding families and their members, a comprehensive spatial hierarchy that regulates daily life in the village.

A seemingly harmonious dwelling situation was suddenly challenged and disordered by two important factors: firstly, the flight of the local deity of the village, which caused death among its inhabitants and threatened the survival of the community; secondly, the disruption of the spatial configuration of the settlement caused by a private initiative, which deprived the village temple of its commanding position. It is interesting to observe how such a situation of conflict can be turned into a positive and culture-generating one.

A traditional society like Bhutan may deal with conflicting conditions inherent in the modern world with such a degree of confidence that it might become one of world's few 'modern' living architectural traditions.

1 See Amundsen (1994: 81).

2 In 1975, Romi Koshla, a renowned architect and researcher of Tibetan architecture, wrote: "Nothing is considered permanent in the unending cycle of life and death and the temples, too, undergo the cyclical change ... Thus, the entire architecture of the temple is wholly subservient to the presence of the deity in the fresco on the wall. The flight of the deity leads to the end of the old architecture and the creation of a totally new architecture ... This process of demolition and re-erection had been going on for decades in Tibet." Koshla (1975: 81–3). See also Dujardin (1994: 2).

3 Compared to the historical cultural codes and guidelines for building found in a Hindu context and recorded in the Vedic writings of the *Vastusastras*, the written and canonical sources in Buddhism are rather scarce. For Tibet this issue is dealt with by Karmay (1987: 92–8) and for Bhutan by Aris (1988: 33–9).

4 See Shils (1981: 68–72).

5 The recent abolition of *dzong ula* and *gungda ula*, two labour services as a form of tax, and the disappearance of the traditional master-carpenter (*zopön*), from the urban construction sites, are but a few examples of how important factors inherent to the country's 'living' tradition are gradually being neglected in the process of modernization.

6 Deeply concerned with this issue, the Royal Government launched a comprehensive programme for cultural preservation (1987), of which the improvement and Bhutanization of existing housing stock was one of the key issues addressed. It is beyond the scope of this paper to discuss this complex issue.

7 See Nitschke (1966: 117).

8 See Standley and Tull (1990: Part A, p.3 and 13).

9 Ibid., p. 1.

10 A policy of decentralization initiated a limited but steady process of urban development in each of the country's twenty district centres. The *dzongs*, which until now serve a dual function as administrative and monastic centres, were historically positioned in locations difficult to approach out of defensive and strategical considerations; these locations are mostly unsuitable for spawning townships. See article by Phuntsho Wangdi in *Kuensel*, 23 March 1996, 'The Tashigang town: where do we grow now'.

11 For a picture of Bhutan's human settlements that focuses on: (1) the interrelation between ecosystem, ethnic topography and dwelling pattern; (2) three distinct housing sectors – rural/urban; formal/informal; traditional/non-traditional; (3) synopsis of characteristic properties of Bhutan's spatial environment, see Dujardin (1994a: 138–44).

12 Pommaret-Imaeda (1984: 11).

13 A systematic documentation of all of Bhutan's sub-cultures as coherent case studies will make possible topical comparison, and might highlight innumerable elements of reciprocity, typifying Bhutan's state of intercultural symbiosis.

14 See picture of the main street in Thimphu in Karan (1967: 18), and NUDC/UNCHS (1986: 1).

15 Population figures for Thimphu and Phuntsholing are borrowed from the UNCHS Urban Planning Project BHU/84/024.

16 Aris (1994c: 28).

17 Ibid., p. 32.

18 Dasho Rigzin Dorji in *Kuensel*, 26 February 1994.

19 *Rapse* (rab gsal) is the Tibetan word for 'light' or 'clarity', and refers to the room with the largest number of windows. In Bhutan, where timber is in abundance, *rapse* have become one the most distinct characteristics of traditional architecture.

20 See Pommaret (1990: 175–78).

21 In earlier times Rukubji fell under the jurisdiction of the Tongsa Pönlop. See Pommaret (1990: 184).

22 For a geographical description of this region, see Pommaret (1990: 182–85).

23 Snaking in an eastern direction, these three small rivers merge with larger streams, such as the Nikkarchu, to form the Longte river until the latter flows into the Mangde river (Tongsa river) that runs north–south across the country. On its way down, the Mangde river and the Bumthang river flow into one another and merge with the Manas river in southern Bhutan before it crosses the border with India.

24 See Dussaussoy (1982: 135).

25 Other cremation grounds are situated: (1) near a *chörten* at the confluence of the Longte and Nikkarchu river, further downstream; (2) at the Pelela Pass; and (3) occasionally in Punakha.

26 For more information on Bhutanese *chörtens*, see Pommaret (1990: 81–3), and a forthcoming publication on stupas, with a section on Bhutan by Niels Gutschow.

27 The main statue in the central niche of the shrine is that of Menla, the Medicine Buddha, flanked by two lamas (without hat); in separate niches to his right a lama of the Kagyupa order with a 'doctor's' hat, and to his left a statue of the eleven-headed Avalokitesvara and of Mahakala.

28 See note 19.

29 Gutschow and Gutschow (1996).

30 Ibid., p. 11.

31 Persons who settled in Thimphu, for instance, spontaneously refer to their family house in their village of origin, and also continue to partake in the various rites of passage and ceremonies associated with the household that actually occupies the family farmhouse.

32 Referring to the place or village of origin, as in Karma URA, Dasho SHINGKHAR Lam; or referring to the protective deity (*yulha*), as in CHENCHO for Paro and Ha, SACHA and DOPHU for Wangdi Phodrang and JAMPE and KUNLE for Punakha. Personal communication with Thuji Nadik, Belgium, 19 June 1996.

33 The information on patterns of land use and land tenure is partly based on a report of the Department of Agriculture, prepared by Elisabeth Tjerkstra (1990).

34 Tjerkstra (1990: 13).

35 The analysis of genealogies in Rukubji revealed the tolerance by which conflicting situations are solved. I came across one family where the eldest daughter was an unmarried mother. The next married daughter in line simply inherited the rights and duties associated with the status of her eldest sister. The younger daughter thus became head of the family.

36 For Rukubji, these obligations relate to practical activities (such as house construction, the maintenance of village footpaths, communal water systems, irrigation channels, the intake channel of the micro-hydel power supply, agricultural activities, etc.), as well as rituals staged for the benefit of the entire community which include housing and construction rituals.

37 According to legend, the mountain god (*tsen*) offered his services to the dying local lama who used to protect the villagers from calamities such as hail and heavy rainfall. The only condition for ensuring his protection was to offer a ram twice a year – one to him in the *habe* or harvest ritual, and one to his consort Raphu Chem, whose shrine is located between the village of Rukubji and Bumilo near the Zerichu.

38 At the time of my investigations, an altar was being constructed in the anteroom of the main altar room, which was beautifully finished with mural paintings. One mural depicts Dramar Pelzang, Rukubji's local deity (*tsen*/*yulha*), on horseback.

39 In John Claude White's account of his first mission to Bhutan in 1905, Rukubji (Rokubi) is referred to as a village located above a traditional camp, used by the Tongsa Pönlop, Ugyen Wangchuck, who became the first hereditary monarch of Bhutan on 17 December 1907. See White (1909: 155 and 171).

40 Chhoki (1994: 112).

41 Ibid., p. 111.

REFERENCES

Amundsen, Ingun B. 1994. 'Bhutan: Living culture and cultural preservation'. In *Rehabilitation, Revitalization and Preservation of Traditional Settlements*. Vol. 67/IASTE 67–94, Berkeley: CEDR, University of California.

Aris, Michael. 1982. *Views of Medieval Bhutan: The Diary and Drawings of Samuel Davis, 1783*. London and Washington D.C.: Serindia and Smithsonian Institution Press.

—— 1994a. 'Conflict and conciliation in traditional Bhutan'. In (ed.) Michael Hutt, *Bhutan: Perspectives on Conflict and Dissent*. Gartmore: Kiscadale Asia Research Series no. 4, pp. 21–42.

—— 1994b. 'Introduction'. In (eds) Michael Aris and Michael Hutt, *Bhutan: Aspects of Culture and Development*. Gartmore: Kiscadale Asia Research Series no. 5, pp. 7–24.

—— 1994c. *The Raven Crown: The Origins of Buddhist Monarchy in Bhutan*. London: Serindia Publications.

Chhoki, Sonam. 1994. 'Religion in Bhutan I: The sacred and the obscene'. In (eds) Michael Aris and Michael Hutt, *Bhutan: Aspects of Culture and Development*. Gartmore: Kiscadale Asia Research Series no. 5, pp. 107–22.

Denwood, Philip. 1994. 'Sacred architecture of Tibetan Buddhism: The indwelling image'. *Orientations*, vol. 25, no. 6, Hong Kong, pp. 42–7.

Dujardin, Marc. 1994a. 'Bhutan's human settlements: The dynamics of tradition and modernity'. In (eds) Michael Aris and Michael Hutt, *Bhutan: Aspects of Culture and Development*. Gartmore: Kiscadale Asia Research Series no. 5, pp. 137–72.

—— 1994b. 'Bhutanese architecture: Dynamics and identification of a regional style', paper presented at the conference 'Towards a Definition of Style: The Arts of Tibet', organized by the School of Oriental and African Studies in association with the Victoria and Albert Museum, London, June 1994.

Dussaussoy, Dominique. 1982. *Le Fou divin; Drukpa Kunley, yogi tantrique tibétain du XVIe siècle*. Paris: Albin Michel.

Gutschow, Niels. 1995. 'Why was it so dark in Kak? From darkness to light – thoughts about a process of change in housebuilding in the Northern Himalaya'. Paper for Islamabad Conference, publication forthcoming.

Gutschow, Niels, and Kim Gutschow. 1996. 'Rinam Dissolved; An Analysis of Land and Water in a Zangskari Village'. Draft report GU 121/7–5 for the German Research Council, p. 33, in (eds) N. Gutschow and C. Ramble, *Space and Territory: The Dynamics of Settlement Processes in the Himalaya*.

Karan, Pradyuma. 1967. *Bhutan, A Physical and Cultural Geography*. Lexington: University of Kentucky Press.

Karmay, Samten G. 1987. 'L'organisation de l'espace selon un texte tibétain du XIIème siècle'. In (eds) Paola Mortari Vergara and Gilles Béguin, *Demeures des hommes, sanctuaires des dieux: Sources, développement et rayonnement de l'architecture tibétaine*. Rome and Paris: Université La Sapienza and Musée Guimet, pp. 92–8.

Koshla, Romi. 1975. 'Architecture and symbolism in Tibetan monasteries'. In (ed.) P. Oliver, *Shelter, Sign and Symbol*. London: Barrie & Jenkins, pp. 71–83.

—— 1979. *Buddhist Monasteries in the Western Himalayas*. Kathmandu: Bibliotheca Himalayica.

Kuensel, 1986–97 (national weekly newspaper). Thimphu: Kuensel Corporation.

Nitschke, Günter. 1966. '"Ma". The Japanese Sense of "Place" in old and new architecture and planning'. In *Architectural Design*, vol. 3, pp. 117–54.

NUDC/UNCHS. 1987. *Thimphu. Urban Development Plan 1986–2000*. Thimphu: RGOB/UNCHS, pp. 129.

Pommaret, Françoise. 1990. *Bhoutan*. Geneva: Olizane.

—— 1996. 'On local and mountain deities in Bhutan'. In (eds) Ernst Steinkellner and Anne-Marie Blondeau, *Reflections of the Mountain*. Vienna: Österreichische Akademie der Wissenschaften.

Pommaret-Imaeda, Françoise and Imaeda, Yoshiro. 1984. *Bhutan: Kingdom of the Eastern Himalayas*. London: Serindia Publications.

Shils, Edward. 1981. *Tradition*. London: Faber & Faber.

Standley and Tull. 1990. *Kingdom of Bhutan Human Settlements Sector Review*. Thimphu: UNCHS/RGOB report, pp. 125.

Tjerkstra, Elizabeth, 1990. *Land Tenure in Bhutan*. Unpublished report of the Farmer Managed Irrigation System Research Project. Thimphu, pp. 27.

White, John Claude. 1909. *Sikhim and Bhutan: Twenty-one Years on the North-East Frontier, 1887–1908*. London: Edward Arnold.

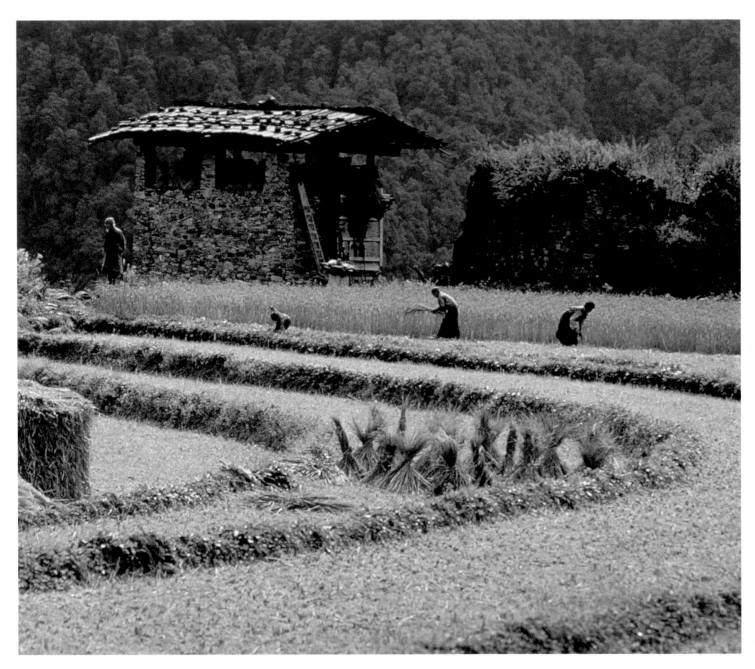

Women harvesting in Wangdi Phodrang. (R.D.)

A Village in Central Bhutan[1]

Martin Brauen

PEASANTS AND PASTORALISTS

The village we visit in the following pages originally consisted of four large households which had to pay their taxes to the monastery or, more precisely, to its owner. Today, descendants of the original owners still live in the village. Their houses are conspicuous by their size and an additional small building for the tutelary deity (*lukhang*).

All the village households produce largely for their own consumption, planting mainly barley, wheat and sweet and bitter buckwheat. Each household also has a vegetable garden. Some families have started to plant potatoes and grow grass and clover for feeding their cattle or to sell.[2] Wheat is grown on different qualities of soil. The villagers distinguish between three types: the first and superior type is land that can be irrigated and planted yearly, and this is found mainly in the region between the bottom of the valley and the steeper slopes; second-quality land can also be planted yearly but is usually quite dry and situated at the valley bottom or on terraces along the flat stretch next to the river; the poorest soil – which tends to be quite a distance away – is found on the steeper slopes and usually has to lie fallow after several years for regeneration.

Crop rotation has been practised since early times. What is new, however, are the potatoes, occasionally grown as an alternative to wheat. Traditional methods of fertilizing include manure (but never human faeces), ashes (used almost exclusively for sweet buckwheat) and burning the fields (for bitter buckwheat); mineral fertilizer is still used rather sparingly and then mainly for potatoes, but recently seems to have become more common.[3]

Ownership of land is recorded in a register (*satham*), of which copies are kept in Thimphu, at the relevant administrative seat (*dzong*) and by the local representative (*gup*). According to the register, the largest household in the village owns about twenty-six acres and the smallest just about one acre. It is noticeable that most fields are small (average 2,780 m²), that a rather small percentage consists of fertile irrigated land, that some households own very little land, and some none at all. If one consults the relevant cadastral plan published by the 'Survey of Bhutan', it becomes evident that in some cases the fields are situated a long way away from the farm (up to a mile). A closer examination of the plan also reveals that much of the land around the village belongs to people who live elsewhere. A not inconsiderable amount of second-grade land belongs to a noble family living in another village. This family also owns the monastery.

Many households keep cattle, horses, sheep, yaks and chickens. Cattle are used mainly for drawing the plough, and milk production is extremely low – at least in this village. For religious reasons, animals are never reared for slaughter, and people very seldom have meat. The main source of proteins are eggs and the local fresh cheese called *datsi*. Sheep are kept for their wool, which is woven at home and then sometimes sold, for instance to tourists.

The village population is sedentary – it migrates neither to the south in winter nor to the north in summer. This makes

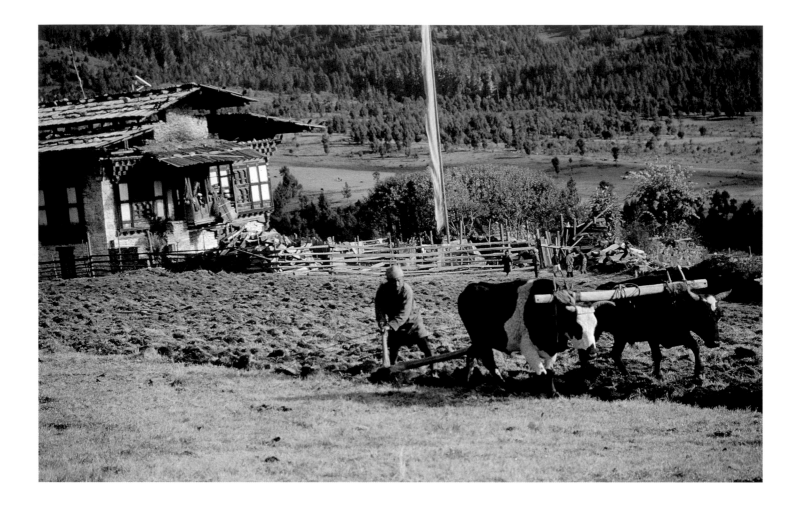

Ploughing, usually by men, takes place in late October in the fields around Shingkhar, Bumthang. (C.S. 1996)

the village and the surrounding area slightly different from other regions in Bumthang, where seasonal migration is still practised, although far less than in former times.

Some tasks are performed exclusively either by women or by men. Women typically shear sheep, weave and spin, while some of the household chores like cooking and looking after the children usually, but not always, also fall upon women. Men plough and harrow the fields, guide the draught animals and do woodwork like constructing ploughs and sawing beams. Wherever modern machines are used, it is usually the men who operate them. Most other jobs are not gender-specific, although harvesting, threshing, winnowing and carrying firewood from the forests to the village tends to be done by women, while men frequently take on work outside the village, a fact that may have something to do with its location, the nearest road being some twenty minutes away.

TAX IN CASH AND IN LABOUR

During recent years the government has raised monetary taxation. This development means that households are becoming increasingly dependent on cash.[4]

The rise in taxation over the last five years has been quite massive, but taxes still form only a relatively small part of a household's cash expenditure. Most of it is spent on groceries – rice, butter, sugar, meat, cooking oil, salt, chillies and vegetable fat – of which the family either produces too little or nothing at all. Of course barter goes on too. But it seems to have declined recently, obviously in response to the introduction of a money economy and a decrease in internal migration.[5]

The last couple of years have also witnessed a change in the nature of the labour tax, which now resembles a form of community work. Every household has to supply labour for the weal of the nation, and this is usually remunerated.

In the past, a group of twelve men would make up a team to supply labour throughout the year, so that on average each would work for the state, for one month. In even earlier times when projects such as road-building or the construction of

fortress-monasteries (*dzong*) were undertaken, teams would consist of only six or nine men which meant that people were even more busy working for the state. This tax (*chunidom*, from bcu gnyis bsdoms, 'twelve together', 'every twelfth') was unpopular, since it often involved work at great distances from one's native village, was unpaid until the early 1980s when a low wage was introduced, and could be evaded by many men of recruiting age (17 to 55), especially by merchants, government officials, etc. This tax was abolished because the government feared that the disgruntled rural population would migrate to larger towns and the capital, and was replaced by a somewhat similar arrangement, the so-called 'household labour tax' (*gungda ula*). Every urban and rural household had to supply fifteen days of work per year for the state, which was remunerated. It was no longer as easy as before to be relieved of this duty, and whoever did not want to work had to pay compensation. This 'community work' applied to men as well as to women who – since a decree of July 1993 – receive equal payment per day.[6]

The state may also require one member of a household to perform *shabtolemi*, i.e. work on projects in the village or the district (building and upkeep of schools, water pipes, cattle-breeding stations, etc.). Work outside the village is remunerated. Should a household be unable or unwilling to supply the required labour, the local representative (*gup*) can demand financial compensation.

The whole family thresh buckwheat, the staple diet of Bumthang valley, at the end of October. (C.S. 1996)

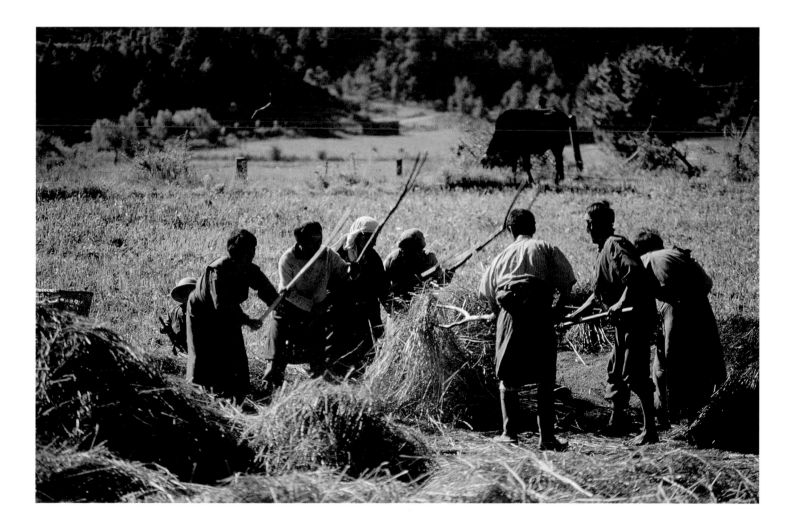

Map of the Village

1 house 'below the monastery'
 1.1 separated house
2 Nyerpön house
 2.1, 2.2, 2.3 separated houses
3 house 'above the monastery'
 3.1, 3.2 separated houses
4 house 'at the gate'
5 house of the blacksmith
6 house of the verger
7 house of Karma and her
 husband

A monastery and *gomchen* school
B Taga temple
C stupa
D water-driven prayer drum
E *mani* walls
■ small building for the place [or site] deity

The land register shows that nearly all households in the village are headed by women who also own the farm and the land belonging to it. The two households where men seem to be in charge and which are non-agricultural, prove the exception to the rule: Ngophel (house 2.3, which separated from house 2, Nyerpön), works outside the village on various construction sites and seems to be doing quite well, while the blacksmith (house 5) earns his living from his craft and has become one of the richest men in the area.

Normally the land and farm are transferred or bequeathed by the mother to her eldest daughter, apparently without much formality, as the land register often still shows the name of an owner who has either died or is no longer solely responsible. In this village the 'normal' procedure is not always a matter of course, but occasionally goes askew because of unexpected developments within the family. In such cases much ingenuity is spent on renegotiating a 'normal' settlement.

An example of a 'normal' household is that of Lemö, who took over from her mother Chönyimo (house 4, known as '[the house of those] next to the gate'). Here the question of which daughter would eventually take over the farm caused headaches for a while. The two elder daughters left the village several years ago, and the youngest daughter Sonam was still unmarried and childless during our first visit in 1988. Meanwhile she married, had a son, separated from her husband, had a second son by another man ... and is still waiting to give birth to a daughter. If she remains without female offspring, the succession will have to be arranged differently, either by adopting a girl or by the return of one of Sonam's sisters to the village; the second alternative seems more likely. The idea that a male member might become head of the household – for instance one of Sonam's brothers – seems not to have crossed anyone's mind.

The history of another household, that of the Nyerpön family (house 2), where several sisters, each with a husband, live together, illustrates the difficulties that arise once the daughters become marriageable. Imagine a household where three married sisters each have two daughters. What would

A woman of Bumthang spins wool in the noonday sun. (J.W. 1994)

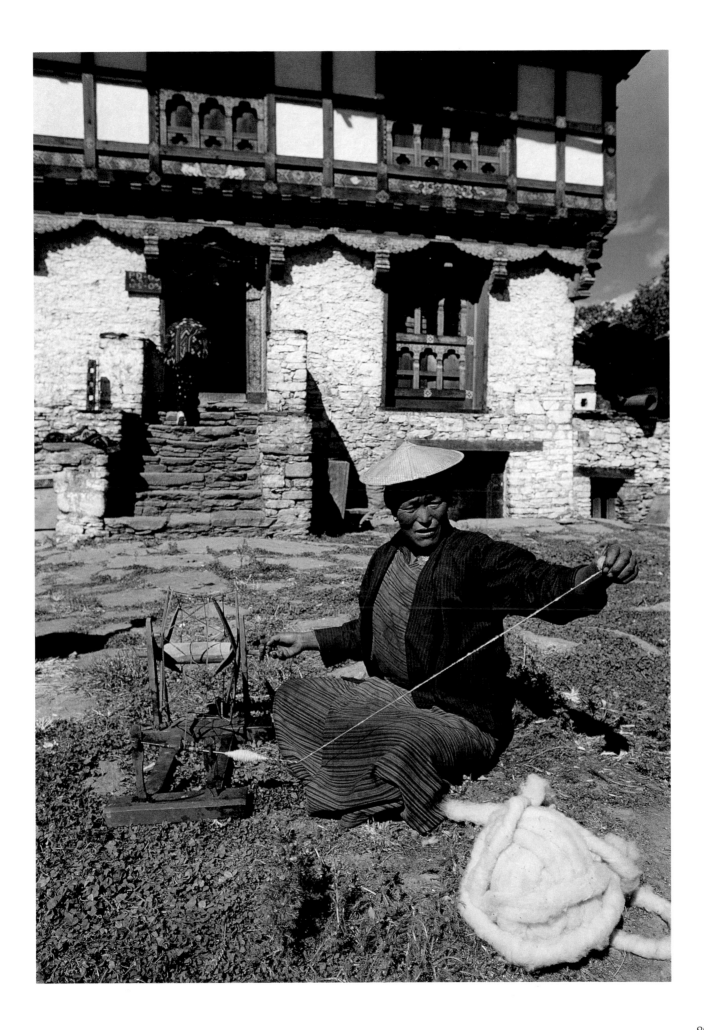

happen if these daughters were to follow tradition and stay at home after marriage? Quite apart from the fact that such a large household could hardly survive economically, living in such close quarters would presumably lead to disintegration on account of frictions and squabbling. The power and independence of the women is primarily based on the ownership of land. A woman without land would inevitably have to play second fiddle to her sisters. But what if several sisters, and even their daughters, are all determined to stay in the house? Bickering, disagreements, quarrels can be expected … and do indeed happen, as the Nyerpön household shows: one of three sisters living at home bore first a daughter and then a son. Tsitsima, the daughter, grew up in the large household. When she became pregnant – the father of the child being allegedly the husband of the head of the household – quarrels erupted until finally Tsitsima and her mother were 'banished' from the house (house 2.2). Her situation is especially hard, because she was given no land, she has no husband to work as a wage-earner, her mother died in the meantime, and by now she has three (illegitimate) children.

The father of one of Tsitsima's children is her married cousin. Children born out of wedlock are not unusual in the village or, for that matter, in other parts of Bhutan. What is unusual for anyone familiar with the Tibetan kinship system, is that it was her cousin who got Tsitsima pregnant. In certain areas of Bhutan, however, intimate relationships and even marriages between cousins are not frowned upon as long as the partners are so-called 'cross-cousins'. This means that a man may marry the daughter of his maternal uncle, but not of his maternal aunt. In Bumthang people say: "The daughter of the maternal uncle belongs to the nephew." In such matrilateral cross-cousin marriages the mother's brother (the maternal uncle) plays a special role. The importance of the mother's side of a family can also be gauged from the fact that after a divorce it is primarily the mother's siblings who look after the children. Intimate relationships between cousins are not regarded as improper, although officially they were made illicit several years ago. In this village Tsitsima's (extramarital) relations with her cousin seem to be an exception, which may suggest that the law will lead to the disappearance of intimate contacts between cousins.

The ingenuity as well as the determination with which the traditional preeminence of women is being upheld, can be illustrated by the changes introduced over the last five years in the house of those 'above the monastery' (house 3),

The 'luck box' (yang gam) is filled with precious objects like beads of coral and turquoise placed there at the time the house was constructed, and is always kept in the house. It is never opened as it contains the 'luck' of the house and the family. (E.L.)

which also had important repercussions on the house of those 'below the monastery' (house 1).

Let us first look at the house 'below the monastery', where some years ago everything indicated a normal process of inheritance. The property was registered in Tshomo's name, but she died, leaving three daughters and two sons. Following tradition, the eldest daughter Tashi Dolma succeeded her as head of the household. She married Karma Tenzin from the house 'above the monastery'.[7] One of Tashi Dolma's sisters, Bale, married a man from another village who, again following tradition, moved in with his wife. When the two brothers married and moved to their spouses' houses – one to the neighbouring village, the other, Karma Söpa, to the house 'above the monastery' – and the third sister found a husband in the capital Thimphu, all these movements followed well-established patterns.

What at first sight appeared a sensible and conventional arrangement was, however, threatened by the fragile situation at 'above the monastery', a household which had

Opposite above: The spinning wheel is found in most houses in central and eastern Bhutan, where weaving is an important economic activity. Below: The noodle machine is typical of the central region of Bumthang where buckwheat noodles are an essential part of the diet. As the dough is quite hard, a family member sits on the lever to press with more force. The noodles are caught with a large bamboo spoon. (E.L.)

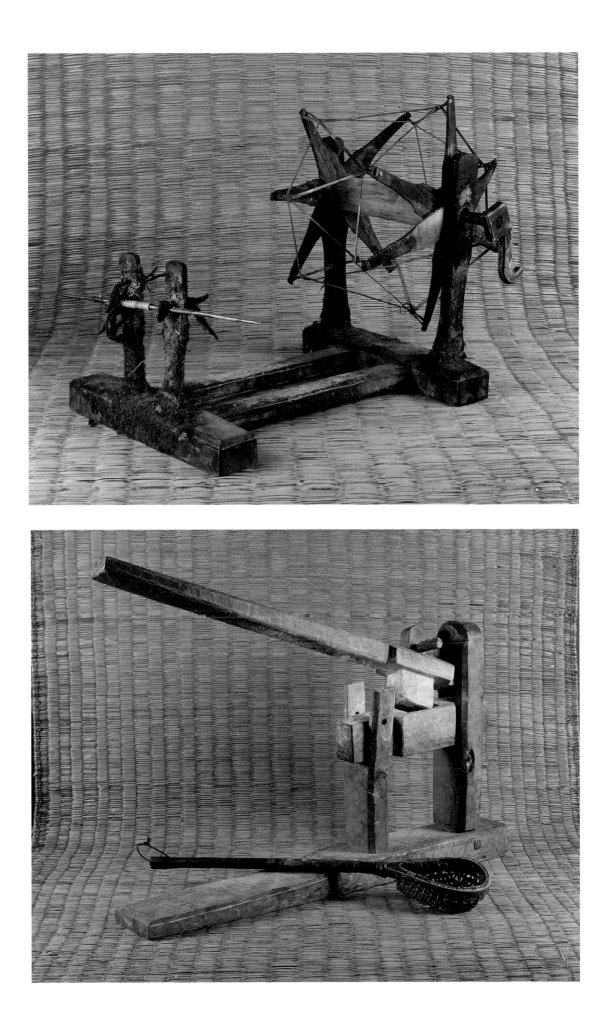

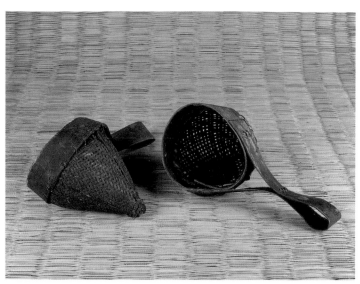

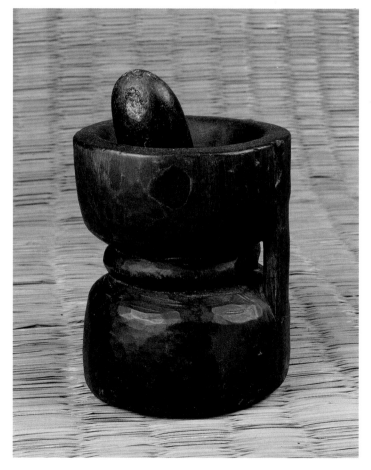

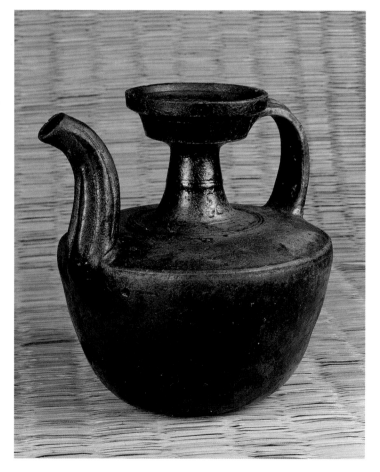

Above: Alcohol ladles are made from a gourd; their curved ends are used to press the fermented grain while the hollow is used to take up and serve the liquid. Below: Mortar and pestle are used to grind spices, especially chillies, an important part of the Bhutanese diet. (E.L.)

Above: Bamboo tea strainers are also found in all households. Below: Clay teapots (jamjee) were very common in ordinary families but today are quite rare, having been replaced by cheap aluminium teapots. (E.L.)

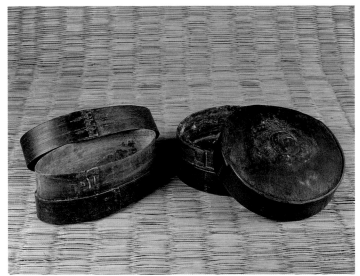

been fractured a generation earlier. Its rightful owner was and, according to the land register, still is, Lhadön, but she had died some time ago. Her sister Tsering Dolma had set up a household of her own (house 3.1), receiving a number of fields at the time – an informal arrangement which went unrecorded in the register. Lhadön's official successor was her daughter Dorje Dolma, whose position as head of the household, however, became increasingly contested over the years. Not only had her marriage to Karma Söpa from 'below the monastery' been dissolved, but also – and much more seriously – she had only produced a son and no daughter. In such a situation it is possible to adopt a 'substitute daughter'. So a girl from the neighbouring village was adopted. By acquiring an official successor to the head of the household, and a wife for the head's son at the same time, this step could have killed two birds with one stone. When the relationship turned sour – there were quarrels with the girl and with her parents – Dorje Dolma considered adopting Yeshe, a niece from 'below the monastery'. Meanwhile, however, Dorje Dolma's stepfather had died, the only able-bodied man in the household. This event together with the failed adoption were the decisive factors that led to the search for a permanent solution, and eventually one was found: a distraught Dorje Dolma asked her sister-in-law Tashi Dolma, the head of 'below the monastery', to take over her household, and this was accepted. She brought her daughter Yeshe with her, who had for a while been considered for adoption and can now expect to become the head of the household in due course.

Left: Stone water container from Bumthang. Today, they are re-placed by cheap aluminium pots. Right: Made mostly in the eastern valley of Sakteng, these wooden and bamboo boxes are still very popular and are found in every kitchen to store cheese, butter, salt or chilli powder. (E.L.)

This transfer again shows very clearly how strictly people adhere to the rule that 'a woman takes over farm and land'. This becomes even more striking if we consider that Karma Tenzin, the husband of the new household head, originally came from 'above the monastery'. So now he was moving back into his mother's house (or more precisely, his sister's), but by no means as its owner or head. This position is tradi-tionally reserved for a woman, who in this specific case was his wife after she transferred from 'below the monastery'.

... AND WOMEN DECIDE

We have seen how successfully women uphold their owner-ship rights to farm and land and thus maintain a powerful position, which naturally enough extends to the manage-ment of the household itself, so that nearly all households are headed by a woman.

What exactly does it mean to be the head of a household? What duties does it involve and what kind of special privi-leges; what constitutes its 'power'? Let us again turn to a specific example, the house 'below the monastery' (house 1). Here Bale has become the head after her elder sister, Tashi Dolma, left to take over 'above the monastery' (house 3).

Left: Butter is still transported and kept in airtight pigskin bags which weigh about ten kilos. Right: Coarse tea leaves are pressed into the shape of a brick or cone and wrapped in bamboo leaves for transport. The coarse leaves are used mostly for butter-tea. (E.L.)

After playing second fiddle, Bale now decides about all the work to be done in the house and fields. She also decides on what to sell and to buy, or calls together the other family members for discussion and deliberation. However, she also bears final responsibility. She has to make sure that there is enough to eat in the house; if there is a shortfall, for instance, she borrows grain and negotiates conditions. Bale also manages the family's finances, partly even for her brother Sonam Thöndup who, having married into a family in the next village, no longer lives in the house. Very often after finishing with his wife's fields he works for his sister. He also eats at 'below the monastery', but receives no part of the harvest, not to mention payment for his labours. If he wants to buy something for himself, for example a new *go*, his sister Bale gives him money or the clothes he needs. If Sonam Thöndup has to do government work, he keeps only part of the wages for himself and delivers the rest to his sister. Should he fall ill, he is primarily looked after by his original family, who order the performance of certain ceremonies, buy medicine, etc.; when he dies, his original family will pay the costs when they exceed the provisions of the state life insurance.

The rights and duties of the female head of household also touch upon religious matters. It is her responsibility to see to it that various rites are performed – for instance for the planting and harvesting festivals; she either takes part herself in the thrice monthly *mani* recitations or entrusts this

duty to somebody else, and for births and deaths she has to decide whether the family is to send a member to the rituals and who it is going to be, and also how much the household should contribute to the costs of the celebrations.

When someone builds a new house – and between 1988 and 1993 three or four large houses were rebuilt – the head has to decide whether the household should participate and if so, with how many hands, a calculation which takes into account how much help that household has given in the past or can be expected to give in the future. She also deals with taxes, especially the labour tax required by the government. She decides who will be 'seconded' to the community labour duty, and for how long.

The women in the village play a rather important part in shaping opinions about local politics. At political events at the district level, sometimes up to 90% of the participants are women, a very high percentage compared with other parts of Bhutan. It is said that a district officer transferred to Bumthang was both astonished and offended when the first meeting he called was attended almost exclusively by women.

One local office often held by women, usually by a household head (sometimes by another member of the household), is that of liaison officer (*leshen*). The post is normally held for the duration of a year. As the name implies, the liaison officer provides a link between the village and higher-level political offices such as the local representative (*gup*) or the district officer (*dzongdag*). Practically speaking, this means that the liaison officer provides accommodation for members of the government, assembles the villagers in the case of important notices and resolutions, concerns herself (or himself) with the implementation of the laws, and

organizes the supply of labour whenever village-wide work needs to be done. As against this emancipation of women on the local level, nearly all political positions tend to be held by men, from the local *gup* to the members of the National Assembly (*chimi*), and from the higher-level employees to the ministers of the central government. Religious affairs are also largely dominated by men, as we shall see later.

RURAL POVERTY

Estimates of the number of landless families in Bumthang vary between 10 and 30%. In this village the poorest households are those that own no land and that are headed by a single woman, i.e., landless households without a male member who could be either a wage-earner or a self-employed craftsman.[8]

Probably Tsitsima is the hardest off, since she has three children to provide for. Although the fathers are known – two men living in the village – they seem indifferent to the plight of Tsitsima and her children. In a social system where women are routinely powerful there is also the danger that – if they are single, young and economically weak, i.e., own no land – they may be taken advantage of. Only a woman who owns property will be able to have a long-term relationship. If she does not own anything, no man is prepared to enter a serious relationship, since he himself is unlikely to have property of his own. But again there are exceptions to the rule: if a man has a well-paid job, he may even marry a landless woman. Thus Ngöphel from the Nyerpön household married a woman from a neighbouring village, but did not move in with her. Instead, they started a family in his village and at first lived in rather poor circumstances in a hut on the edge of the monastic compound. The husband, an experienced carpenter and bricklayer, was never without well-paid work and now earns enough to build a single-

The lady of the house chats with a guest while warming milk on the fire. Her husband repairs a bag. Region of Sö (3,700 m) in Paro district. (C.S. 1996)

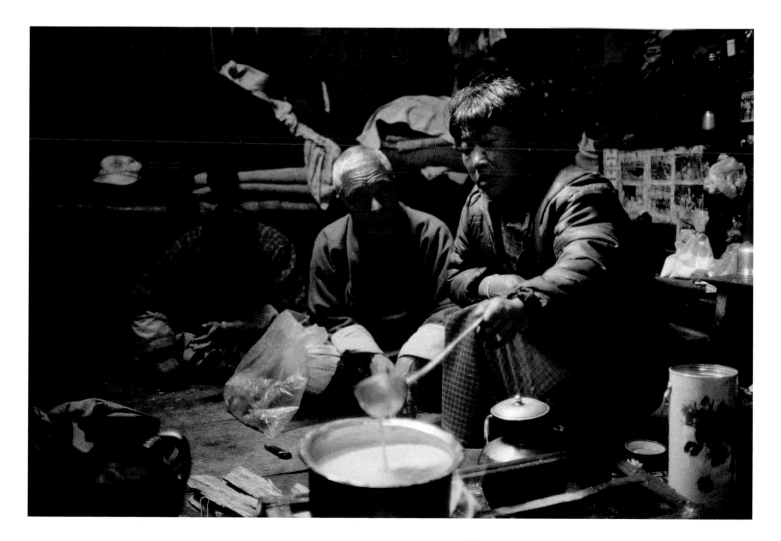

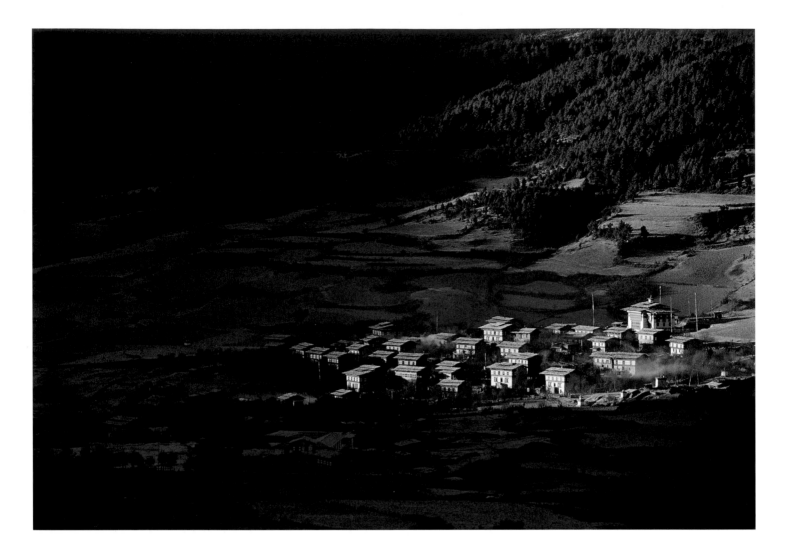

The large village of Ura in the Bumthang region is a rare example of a cluster village and has been enriched during the 1980s by the growing of potatoes as well as by forestry. (J.W. 1994)

storey house for his family and send four of his five children to school.

Landless women risk staying single and, if they are young, also risk having illegitimate children, without the fathers being held to account. For married men such infidelities may be awkward, as they are financially dependent on their wives. If the wife asks for a divorce, her husband would be left destitute since he owns no property himself; he might marry his lover or earn sufficient from occasional labour. On the other hand, the head of the household knows full well that without a man in the house, she will have great problems, because certain types of work – especially ploughing – can only be performed by men. For married women who are also household heads infidelities are easier to accommodate, for they cannot be expelled from the farm they themselves own.

Specific data relating to marital infidelity and illegitimate children are usually difficult to obtain. In this village, however, nobody is shy about it. Everyone seems to know that the astrologer and teacher is the father of his cousin Tsitsima's second child and that he fathered other children in the area as well, and nobody is in the dark about who the father of Tsitsima's other two children is. It is equally well known that Lemö had an affair with a stranger and bore him a child. Her young daughter Sonam is already separated from her first husband after a short marriage and is having an affair with someone else … while her younger cousin from the Nyerpön house already celebrated her second 'scarf ceremony', a kind of marriage festivity; she still lives with her son from her first marriage and her second husband in her mother's house, which she will eventually inherit, while her unpropertied first husband has moved to Thimphu.

THE RELIGIOUS ROLE AND POSITION OF WOMEN

We have become acquainted with a village where the women are self-confident and play an important role, and where they are usually the property owners, while the men have no property and little say. When a girl is born, this is not regarded as something negative as in so many other Asian countries. Quite the opposite. The arrival of a daughter is not only welcomed but fervently desired, because by tradition only she may inherit her mother's property. Girls in general are very positively regarded in Bhutan, because by common consent Bhutanese men and women alike think they are more caring of their parents and grandparents than sons would normally be. And indeed the emotional ties between parents and daughters appear to be stronger than those between parents and sons.[9] The reasons for this state of affairs are at least two-fold: for one, girls and women are seen as more vulnerable and endangered – especially during pregnancy and child-birth – and therefore more in need of support, and secondly they, more than their male counterparts, tend to respect their elders and help them with their chores.

Owning property, making decisions, being highly regarded and respected … one might think that village women had more power and had drawn a better lot than their menfolk, who normally do not own any property, on marrying leave their original family household, have little to say at their new abode and only have hard work to do. So does the paradisial 'Shangri-la' envisioned by James Hilton indeed exist? Not 'somewhere in Tibet', but in Bhutan, and not one where males predominate but females, a very special Shangri-la?

Images of paradise are all too often reality at one remove. The above description of village life was too one-sided, painting too rosy a picture. It is true that the women of this particular village are powerful, that they are usually in charge in everyday matters, that they own land and farm and often know more about agriculture, money and local politics than the men. But one aspect of village life has so far been barely mentioned: the religious and spiritual 'superstructure', the world-view that strongly influences the lives of the people.

Theoretically speaking, in Buddhism everybody can attain salvation from the cycle of suffering. Social differences do not matter, and if one takes Buddhist teachings seriously it is obvious that there are no grounds for differentiating between male and female believers. Thus it says in one text:

"Be it a woman, be it a man who is awaiting the vehicle [of the Buddhist doctrine] – with this vehicle they will attain nirvana."[10] It is very likely that in the time of the Buddha, the status of women was higher than when the Buddhist scriptures were written down and conservative monks were gaining the upper hand; thus gradually women came to be regarded as second-class beings. According to these texts, women are tainted by various negative qualities which pose a danger for pious men. Originally a religious movement embracing women and men, Buddhism developed into a doctrine where the male plays a dominant role and seems to be closer to enlightenment than the female.

One of the later schools of Buddhism, the Mahayana or Greater Vehicle, reflects the ambivalence towards women characteristic of earlier times: some texts claim that women cannot be born in the Paradise of Amitabha or Aksobhya without changing their sex because women are weak-willed and less able to control their sexual urges than men. However, other texts clearly indicate that gender makes no difference in attaining Buddhahood.

In contrast to early Mahayana Buddhism, there are numerous female figures in the teachings of the Vajrayana School, which developed rather late (c. sixth century) and eventually also found its way to Bhutan. The fundamental insight of Tantric Buddhism proclaims that as part of the Absolute the female ought not to be ignored but to the contrary must be carefully nurtured. Because of this revaluation, which presumably is consonant with the early higher status of women during the Buddha's lifetime, Vajrayana Buddhism accords women a more respected place. It is therefore hardly surprising that some Tibetan saints ignored the Buddhist rule of celibacy and had female companions or even wives. One only has to think of the saint and magician Padmasambhava, who contributed greatly to the introduction of Buddhism in Tibet and Bhutan, or of the great teacher Marpa. We also know of several female Tantric figures, who took up relations with men in order to gain enlightenment.

In spite of this later revaluation of the position of women, Buddhism in Tibet and Bhutan never completely lost a certain scepticism vis-à-vis women. The legend of the village monastery (see Brauen 1994: 74), as well as its present functions, show that the religious role and position of women differs markedly from her secular and social standing. The monastery was founded by men, monks occupied it for a long time, and at present it serves as a school for lay religious practitioners (gomchen) where girls are strictly excluded.

Outsiders invited to perform ceremonies are invariably monks, and the religious dances (*cham*) of the annual *tshechu* festival are traditionally never performed by women, but always by men, namely lay religious practitioners and – rather surprisingly – laymen.

The men's religious education (and later teaching) also affords them a closer and more institutionalized grasp of Buddhism itself and its associated practices such as art, medicine and astrology, while women's Buddhism tends to be restricted to private and personal affairs. Monasteries usually have a great number of monks and very few nuns, which means that many more men than women are able to read and write. In this village a school for lay clerics was opened in 1988, basically a sensible idea since it allows a decentralized education, focuses on the training of lay people and imparts mainly traditional knowledge instead of Western concepts. This insistence on traditional customs and values, however, also means that girls lose out. So it is not only conservative Catholicism or Protestantism, Victorian morals or Iberian machismo that proves an obstacle to women's education, but Buddhism also.[11]

Today girls can go to state schools, but since there are so few it usually involves a long journey. It is also rather a drain on the family budget because school uniforms, bedding, board and equipment have to be paid for. Girls' chances of going to a state school seem to be lessened precisely because of their special position in the social hierarchy: they are eventually expected to take over the farm. It is commonly argued that to farm and manage the household does not require a school education, and if a girl does go to school, later she may not want to return to the village. And who would then look after the property? Girls are also regarded as more vulnerable than boys, and many parents worry that daughters may get pregnant if they go to school. It is also widely believed that boys have greater learning abilities, an impression probably derived from the fact that during socialization boys are treated differently from girls, who are encouraged to adopt extremely gentle, modest and shy behaviour; at school this attitude earns them the reproach of lacking motivation and participating too little.

So the educational gulf between girls and boys and between women and men, prefigured in Buddhism, is in danger of becoming even wider under the current school system if the problems are not recognized and effective counter measures put in place. Most importantly this means establishing educational facilities at the local level which also admit girls, perhaps something similar to the school for lay monks in this village.

Bhutanese women are, however, by no means completely excluded from religious life. They fulfil religious functions which are closer to popular Buddhism than to the doctrinal Buddhism practised and taught at the monasteries. For example, women carry the main responsibility for the recitation of as many *mani* as possible on the eighth, fifteenth and twenty-ninth day of each month. On those sacred days women – at least one from every household – sit at the village monastery, turn the great prayer drum, and recite the mantra *om mani padme hum* from morning to afternoon to gain as much merit as possible for themselves and the villagers, and to ward off evil. It is usually the women who, early in the morning, make an incense offering to the local gods, and they represent their household during ceremonies at the monastery performed for the benefit of the village – men only turn up if their wife is absent. But women never act as ritualists as laymen do, with one exception: among oracular healers there are also women, although not in this village, but in the vicinity.

The strong position the men have in the religious field presents a contrast, as we have just seen, to the power the women exercise in secular and social life. Buddhism has long regarded women as human beings at least one evolutionary stage lower than men – broadly and somewhat crudely speaking – and this also applies to the Buddhism found in Bhutan. More than once was I told that women are born as women because they had not accumulated enough merit in their previous life, and in the Himalayan region I often heard pious women admonish others to lead a morally correct life so that they might be reborn as men. This is easier said than done, for a woman has to be reborn as a woman nine times before she can hope to be reborn as a male.

So even if their economic power may be restricted, in Bhutan the men control one important source of power: the religious and spiritual sphere. With this comes the great advantage of having a better chance than the women to improve their rebirth. In a society where the afterlife is a subject of such great concern, such a privilege should not be underestimated.

1 This contribution is based on field study undertaken by the author in 1988 and 1993 in a village in the Chökhor valley of Bumthang (central Bhutan). The research results have been published in more extensive form in Brauen 1994.

2 The average harvest per acre in the whole of Chökhor varies from 390 kg (wheat) to 814 kg (bitter buckwheat). Interviews with the villagers showed noticeable variations in quantity, the highest amounts being harvested in areas with relatively little land suitable for planting. Wheat and barley are used to make local bread and *tsampa* (flour made from parched barley or wheat), while buckwheat is turned into a kind of pancake, bread or noodles. A considerable part of the grain harvest is used for the production of alcohol, and a small part for religious purposes such as offerings to the monastery.

3 Guenat (1991: 147).

4 A statistical survey of households in the Chökhor valley found a relatively high average income of about 5,000 Nü (income derived from the sale of agricultural products, from non-agricultural work and remittances from family members no longer living at home; ibid: 117). This result has to be treated with caution, however. Firstly, because the high average results from the very high income of only a few households, as we can see from the fact that half of all households earn less than 3,500 Nü. Secondly, such an average says nothing about the situation of marginal and poor households.

5 Ibid., pp. 121ff.

6 Other types of labour tax were, or still are, the rdzong bsel 'u lag, the mi rtsis 'u lag and the me phu 'u lag. The rdzong bsel, 'cleaning the *dzong*', calls for every household to perform five days of unpaid labour (like cleaning, painting and repairing the administrative and monastic buildings) in and around the *dzong*. The mi rtsis 'u lag – now abolished in Bumthang – was levied according to the number of family members, as its name 'number-of-people tax' indicates. It consisted of repair work on public facilities such as water-tanks and bridges, and a family of five would give five days of labour per year, a family of seven would work for seven days, and so on. The me phu 'u lag (also abolished) was levied on the number of hearths and meant that one family member would work on public facilities for up to ten days, not more than three times per year, and would be paid.

7 Tashi Dolma married Karma Tenzin, while Karma's sister married Tashi's brother and brought him into her household. Such marriages are common in many parts of Bhutan.

8 The village had three such households, house 2.2 (Tsitsima), house 2.1 (Chöngamo) and house 7 (Karma). Widow Chöngamo, who looks after her two granddaughters, is something of an exception in that she owns a field.

9 Wikan (1990: 5ff).

10 Samyutta-Nikaya: pt. 1, I/5, para. 6.

11 Wichterich (1984: 37).

REFERENCES

Brauen, Martin. 1994. *Irgendwo in Bhutan: Wo die Frauen (fast immer) das Sagen haben*. Frauenfeld: Verlag im Waldgut.

Guenat, Dominique. 1991. *Study of the Transformation of Traditional Farming in Selected Areas of Central Bhutan: The Transition from Subsistence to Semi-subsistence, Market-oriented Farming*. Zurich.

Wichterich, C. 1984. *Frauen in der Dritten Welt: Zum Stand der Diskusion um die 'Integration von Frauen in Entwicklung'*. Bonn.

Wikan, Uni. 1990. *The Situation of the Girl Child in Bhutan*. Oslo: UNICEF.

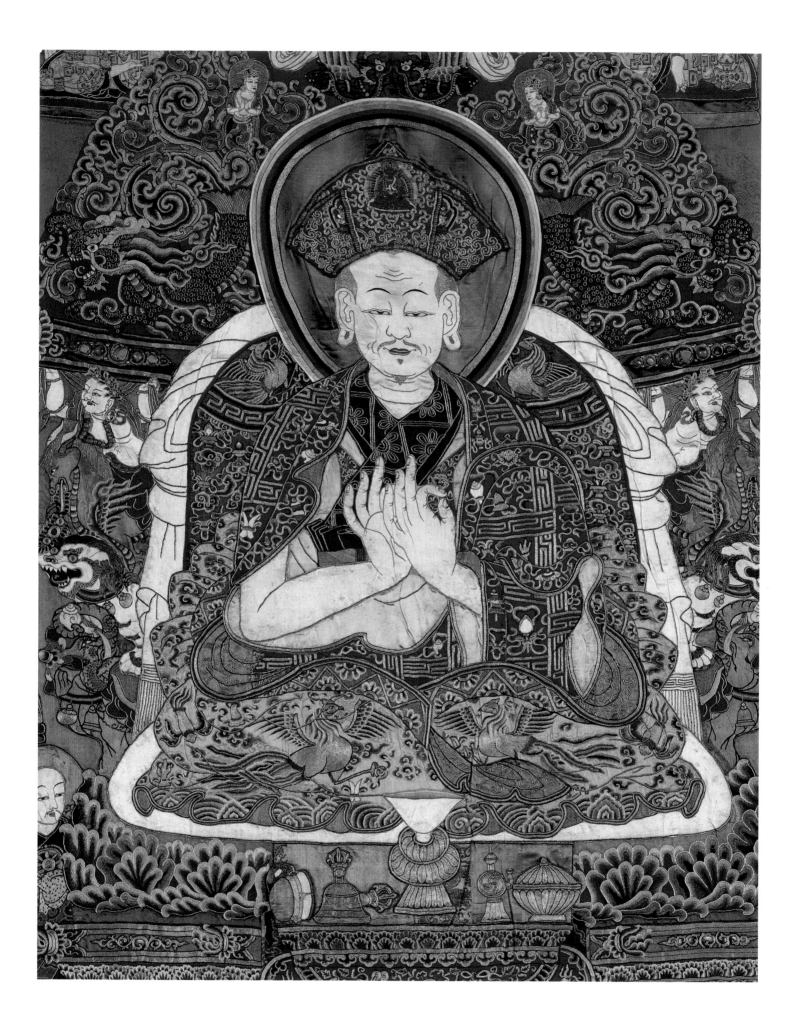

The Thirteen Traditional Crafts

Barry Ison

The Himalayan mountains are a fragile environment where the actions of wind, water, earthquakes and fire have made serious changes in the topography. The intervention of people on this environment has, to date, been without major effect. However, that influence is changing and, unless checked, could be disastrous to the Himalayan states and their neighbours.

The Himalayas possess an unforgettable aura and magnetism, a personality at once diverse and distant but also familiar and friendly; there are high mountain peaks, rushing streams and delicate waterfalls, narrow fertile valleys and mountain slopes carpeted with the rich colours of autumn leaves or spring rhododendrons, of the tall pine forests, green and glistening in the monsoon rains, or ghostly and reflective in winter.

Tucked away in a small section of this vast mountain chain is Bhutan; unique, mysterious, independent, with a rich cultural heritage. Because of its long isolation, Bhutan has been able to preserve its diverse customs and values, its close ties between communities and old families, its way of worship, its traditional skills and, above all, a simple and uncomplicated way of life. To understand Bhutan, one needs also to understand the nature of the Himalayan kingdoms and their historical and cultural relationships; how they viewed their neighbours, and how they were seen in return.

Drukpa hierarch from an appliqué thangka heavily embroidered with silk and gold threads, a speciality of Bhutan. Detail from p. 176. (E.L.)

To adequately describe Bhutan is to first picture the visible; towering snowscapes, high mountain passes, large fortress-monasteries or *dzongs*, rows of fluttering prayer flags, powerful racing rivers, colourful festivals, and attractive national costumes. The intangibles within Bhutanese culture form an equally vital part of the fabric that binds the country together: the immense importance of the royal family; the code of conduct and responsibilities (*driglam namzha*); the physical, mental and verbal guiding principle of 'the science of crafts' (*zorigpa*); the option for an individual or group to withdraw from the world and be apart – or the possibility to be at peace with oneself and one's environment and yet still be part of one's community. A way of life is available for most people where materialism is of minor importance and quality of life is measured by a standard quite foreign to the everyday values that most people in the West live by; solitude instead of crowded places, introspection instead of busyness, serenity instead of anxiety.

Out of this physical and temporal environment and people's response to living in it, has evolved a series of traditional skills, ancient and sophisticated, colourful and complicated, and in many ways special because they are so unique. These traditional skills or crafts came to be known as *zorig chusum* (thirteen traditional crafts) and today represent hundreds of years of knowledge and ability that has been passed down from father to son and mother to daughter.

Prior to the unification of the country under the Shabdrung Ngawang Namgyel in the seventeenth century, Bhutan was a country of isolated valleys and small kingdoms.

Under the rule and guidance of the Shabdrung, elements of secular and religious life were brought together in a system of administration, law and worship that created a unity and harmony out of extreme diversity.

The principles of the Bhutanese way of life have been formalized into ten activities – five major and five minor. Within the five major activities there are three main emphases:

Firstly, the activities that assist, teach or uplift others. In this category there are two sub-groups:

> *zorigpa* (which includes *zorig chusum*), divided into
> > three groups:
> > *lüzo*, the physical: *zorig chusum*
> > *ngagzo*, the verbal: teachings, worship, words
> > *yidzo*, the mental: meditation, clear thought, good
> > > values, prophesying and foretelling the future
> *sowarigpa*, which provides knowledge of health

Secondly, the activities that reflect personal development and self-enlightenment; this emphasis involves Buddhist philosophy (*nangdenrigpa*).

Thirdly, the activities that involve verbal expression and intercourse between people, also divided into two sub-groups:

> *darigpa*, which includes poems, stories and grammatical
> > exercises
> *tshemarigpa*, which involves debating the finer points of
> > religion and, today, law

The term *zorig chusum* (bzo rig bcu gsum, pronounced *zori chusu*) refers to the thirteen traditional crafts of historical Bhutan. *Zo* refers to the ability to make; *rig* is the science or craft; *chusum* means thirteen. Unravelling the origins of the term and how it is relevant today in respect to the crafts carried out all over the kingdom is an extremely complex task. Opinions differ considerably even among those whose families have had a long-standing relationship with *zorig chusum*. It is believed that the *zorig chusum* were formally categorized, named and set down into groups during the rule of Tenzin Rabgye (1680–94), the 4th Desi (secular ruler).

While there are references to *zorig chusum* in religious texts, there is no comprehensive source or literature that can provide a definitive list or trace the historical evolution of each of these crafts. Nor is there an authoritative body or group of people with an overview of the historical development of the crafts, as natural barriers had isolated the many different cultural groups within the country. In order to shed some light on this old but rich and valuable tradition, one has to piece together information derived from the oral tradition, physical evidence and opinion. As well as providing a link with the great master craftspeople of the past, it is hoped that *zorig chusum* can provide a real source of income and employment.

Consensus seems to approve the following groupings as the *zorig chusum* :

> *Shingzo*: woodwork, including the building of *dzongs*, temples, palaces, houses, mandalas, tools and other implements.
> *Dozo*: stone arts. This includes stupas, stone pots, stone tools, and millstones, and has a special section called *tsigzo*, which refers to the building of stone walls.
> *Parzo*: carving. Wood-carving, slate-carving and stone-carving are included.
> *Lhazo*: all types of painting including *thangkas*, mandalas, shrines, wall-painting and house decoration.
> *Jinzo*: clay arts. This includes the making of statues, pottery, and masks; mortar / plastering, rammed-earth construction (*dzamzo*) and moulded offerings (*torma*).
> *Lugzo*: casting, mainly of bronze. Statues, bells, musical instruments, tools and kitchen utensils were produced, as well as slip-casting for both pottery and jewellery.
> *Shagzo*: wood-turning. The craft of turning bowls from the precious knots and special parts of a tree or root. The *dapa* or serving dish, wooden plates, buckets, ladles and the small hand drum beaten during ceremonies were its products.
> *Garzo*: blacksmithy. Craftsmen would produce swords, knives, axes, ploughs, chains and other utensils.
> *Tröko*: includes all ornaments made from gold, silver or copper. These were often cut out, beaten, drawn or engraved.
> *Tshazo*: products of cane and bamboo. There are a very large variety of these with names differing from district to district. There is the *bangchung* to carry food, the *palang* to store beer or other liquor, the *tshesip* or box, the *belo* or hat, the *redi* or floor mat, the *luchu* for storing grain, the *balep* or bamboo thatch and, of course, the bow and arrow.

Mani stones are placed in low walls that are erected to bless a site and bring merit to the one who commissions it. The inscribed and painted six-syllable mantra 'Om Mani Padme Hum' liberates sentient beings from the six realms of existence. (J.W. 1994)

Dezo: paper art. The word *de* refers to the Daphne plant from which traditional paper was, and still is, made. Today paper is also made from raw materials such as bamboo and rice stalks.

Tshemzo: this craft includes items that are stitched together or embroidered, made from cloth or leather, and which have a large variety of uses. There are two special categories:

> *tshemdrup*: sewing and embroidery.
>
> *lhendrup*: appliqué work and patchwork – items made by stitching cloth together. Hat-making and boot-making are also included.

Thagzo: weaving. This also includes the preparation of the yarn, dyeing and the numerous designs. This is probably the largest grouping in terms of variety of products and number of craftspeople involved.

Every year people from throughout and beyond the district gather for a festival (*tshechu*) held within the walls of the *dzong*. Men and women come to the annual festival wearing their finest hand-woven clothes (*go* and *kira*) with the expectation that their attire, often made over many months of intricate weaving, will stand out in the crowd. Wooden and cloth masks, appliqué costumes, long horns and cymbals are all featured on this special occasion. The *dzong* holds and represents all that master craftspeople have been doing within a community over many hundreds of years.

ZORIG CHUSUM IN CONTEMPORARY BHUTAN

The relationship between craftsperson and environment has traditionally been a sensitive and supportive one, in which the environment was harvested according to specific needs. The Daphne plant was cut to be made into paper, but the craftsman was also aware that if he did not cut with the future in mind he would have to forage further and further afield to obtain raw material. The basket-weaver needed to make sure that the cane and bamboo would still be there for the next season after the current season's market demands were met. Similar principles applied to vegetable dyes, clay, slate, sources of stone colours, wood stains and many other locally available materials.

Children were brought up with an intimate knowledge of their parents' activities. Girls were taught spinning, dyeing and weaving by their mothers or aunts. Sons were taught

to carve on slate or wood. Sons or daughters would ply the treadle-lathe for turning bowls, or prepare the Daphne that would become paper. Today much of that has gone. Children go to school. That, in may ways, has been a blessing for Bhutan – to educate its children to read and write and so help build a modern nation. Like so many countries in the region, Bhutan has inherited an education system that has not traditionally paid attention to cultural values and skills. Many young people today therefore have little relationship with, or knowledge of, the skills of their parents or grandparents. Nor do they see the importance or relevance of these skills to themselves in a new Bhutan where videos and computers represent contemporary cultural values. Yet, the traditional skills of Bhutan have the potential for employing more people than any other sector in the country outside agriculture, and would come a very close second to agriculture.

Bhutan cannot compete with the less expensive skilled labour of the south; it cannot produce cheap garments, factory-made golf clubs or fishing tackle, or assemble watches, computers or VCRs. Bhutan's distinct advantage lies in that which is culturally its own, and which the Bhutanese can produce better than anyone else. Bhutan's crafts are being copied elsewhere, mass produced and are finding a market internationally. It is to the credit of the Royal Government of Bhutan that it has initiated a programme under the sponsorship of the Ministry of Trade and Industry called the Cottage Industry Development Programme, the main objective of which is to promote and develop *zorig chusum*. With this age-old tradition of skills, surrounded by an abundant resource of raw materials, the challenge for Bhutan is to access new and appropriate technologies, understand market options and demands, develop new applications through design and product development, and train its young people to appreciate the value and the skills of their ancestors as a cultural heritage as well as a source of employment and income generation. It is hoped that international exhibitions, articles and publicity will make people throughout the world more aware of the rich heritage and uniqueness of the crafts of Bhutan – decorative, practical and religious – and lead them to discover the privilege and pleasures of understanding and owning them.

Above: Intricately carved low tables (chödom) are found in well-to-do houses and are also decorated with auspicious motifs such as the phoenix, the dragon, and other designs often of Chinese origin.
Below: Painted wooden boxes (gam) such as this one made in 1984 are found in most houses and are used for storing clothes. (E.L.)

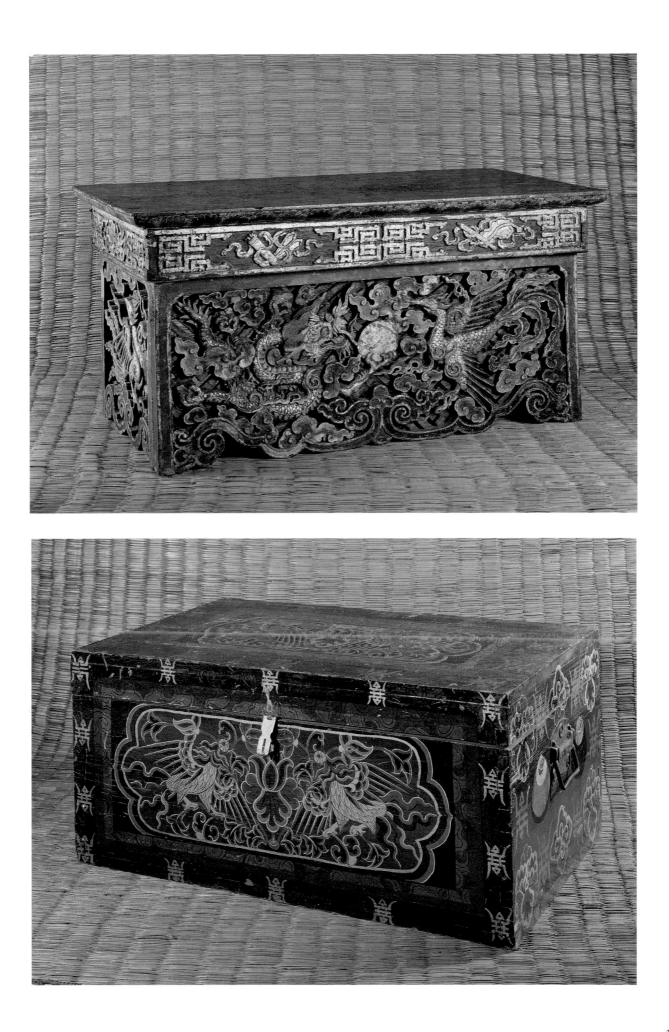

In the following sections, crafts and craftspeople will be introduced in order to present a concise description of a living community of artisans.

SHINGZO: WOODWORK

For centuries timber has been a plentiful resource in Bhutan. Houses, palaces, fortresses (*dzong*), temples, bridges and utilitarian items for the home and the field were made of wood; it is not surprising that the carpenter's craft is the first on the list of *zorig chusum*. The master-carpenter was in great demand, as was his task of planning and measuring. The large constructions of monasteries, palaces and *dzongs* required accurate dimensions to survive the elements – rain, wind and earthquakes. Measurements dictated by the sacred scriptures had to be adhered to; knowing how to build therefore also required an understanding of the texts. *Shingzo*, as all the *zorig chusum*, reflects a devotional act which links the craftsperson to his personal deity.

Sangye Dorje from Ripjaphu village in Wangdi district is a *shingzo lopön*, or master-carpenter, who trains apprentices. Now sixty-nine years of age, he has been working in his craft for more than forty-nine years. When Sangye was twenty years old, he joined Lopön Kunzang Dorje as an apprentice. In those days, the government would select young men to work on official projects, and Sangye was allocated to his new master and another *lopön*, Phub Tenzing. After a short time, it became obvious to the two *lopöns* that Sangye had a gift for construction, so, at an early age, he was appointed as supervisor. Nine years later, he was honoured with the very special title of *zope* (senior master-carpenter) by the late Home Minister, Lyonpo Tamshing Jagar.

Almost fifty years ago, Sangye travelled with his *lopöns* to Tongsa in central Bhutan to work on the king's new palace, Kunga Rabten. In those days he was young and inexperienced and now he speaks proudly of his *lopöns* so willing to teach him the intricacies of joining wood, planning large constructions, and the importance of accurate measurement and scale.

As a master-craftsman, Sangye is most in demand because of his ability to plan and provide accurate measurements, and to give clear instructions regarding measurements. In 1987, Sangye joined many other *lopöns* from around Bhutan to repair the *dzong* at Punakha (winter residence of the head lama of Bhutan's monk body) which had been partly

destroyed by fire. This has been his ultimate achievement and he frequently walks around the massive structure wondering that he has really helped to rebuild such an important edifice. The *dzongs*, palaces and other large buildings have stood for centuries because of the skills of men like Sangye.

DOZO: STONEWORK

Masonry is a very old craft in many areas of Bhutan. The abundance of rock and the high degree of skill possessed by the master-masons have given rise to the very large monasteries and administrative structures called *dzongs* which are found throughout the country. The *dzongs* were built hundreds of years ago. Their massive stone walls and foundations of huge boulders demonstrate the sophistication of the masons so many generations ago, when the country had little contact with its neighbours. Within its stone walls can be found the works of the painter, the carver, the sculptor, the bronze-caster, the jeweller, the wood-lathe master, the paper-maker, the tailor and the potter. The *dzong* most comprehensively represents *zorig chusum* and all the craftsmanship that is involved in the thirteen categories.

The village of Rinchengang faces Wangdi Phodrang Dzong from the opposite mountain slopes just above the main road between Thimphu and Wangdi. Most of its houses are made of rammed-earth construction and yet this is home to many of the master-masons of the country. Sanchu and Chado are both masons of the highest calibre from Rinchengang. When Sanchu was fifteen and Chado thirteen, they entered the service of the Royal Government of Bhutan as apprentices to Lopön Nokri, also from Rinchengang. Their first task was the rebuilding of Thimphu Dzong. Now in their sixties, Sanchu and Chado are both currently working on the rebuilding of the walls of Punakha Dzong.

When an apprentice starts out, his *lopön* will teach him how to prepare a stone block. Many hours are spent fashioning a boulder of rock into a cube of stone that can be fitted alongside and on top of another cube of stone. All the angles of the stone block are important. Using an angle scale, the trainee continues to practise his stone-cutting until he is able to produce a block that is of an acceptable standard to his *lopön*. Once a young man has mastered the skill of preparing a stone block, he becomes a mason and prepares the blocks for building. He will then aspire to be appointed as a senior master-mason (*zope*) highly valued because he can plan

and supervise the angles in building a wall.

Both Sanchu and Chado are *zopes*. Their accuracy in building walls with correct angles earned them their titles and for many years now they have worked together on large constructions throughout the kingdom. Because the task of rebuilding Punakha Dzong was so large and important, they were brought in to complete the renovation together with two other *zopes*, Gachu and Gyeltsen, also from Rinchengang.

The correct preparation of mortar is very important and is closely supervised. The clay for the mortar used in Punakha Dzong is brought from the district of Ha to the west. The clay is ground by hand and needles of blue pine are added as a binding element. The *zopes* maintain that a mortar well made hardens to an even stronger consistency than stone blocks.

Besides the *dzongs*, there are many other buildings and constructions that require the skills of the *dozo lopön* – shrines (*chörten*), temples (*lhakhang*), bridges, houses and, these days, walls that shore up the sides of a road. Many of these structures no longer utilize the time-consuming task of preparing mortar; people prefer to mix cement, which is easily purchased. However, the *zopes* are adamant that their traditional recipe for mortar produces a much stronger binding compound than the cement of today.

PARZO: CARVING WOOD, SLATE AND STONE

As Bhutan possesses an abundance of wood that is easily worked (being predominantly pine), wood-carving is evident in many forms throughout the country. Wooden masks are used in dancing; carved wooden decorations are found on houses, palaces, *dzongs* and temples; wooden symbols adorn shrines and the corners of houses; swords and knives are kept in wooden sheaths or scabbards, and knives mostly have wooden handles. Furniture – tables, beds, thrones and altars – are objects for the carver to beautify.

Lopön Tsagye, from the village of Garselu in Wangdi district, was attached to Lopön Kabo at the age of twenty-five because his uncle felt there was no future for him in his village. Lopön Kabo had established a small school near the temple of Changangkha in Thimphu, and Tsagye and four other young men lived and worked with their *lopön*, learning the names and uses of different tools, the skills of working with wood and the variety of different objects and designs that could be used. Eleven years ago Lopön Kabo was asked to move to Bumthang district, where a new

lhakhang was being built at Kuje. Competition among wood-carvers is considerable. During the building of Kuje Lhakhang there were sixty wood-carvers working on various assignments at any one time. Tsagye moved with his master and, after Lopön Kabo died, stayed on in Bumthang. Now a *lopön* in his own right, Tsagye works on a variety of commissions. They range from larger works in temples to small items like the eight good-luck symbols often seen in Bhutan.

Before he can obtain wood, Lopön Tsagye requires a permit from the local authorities. Having received a permit, he walks through nearby forests until he has identified a suitable tree. The tree, or part of the tree, is cut down and the trunk and branches reduced to manageable size. These are then buried nearby for a period of one to three years to ensure adequate seasoning. When Lopön Tsagye requires wood and feels that one of his stashes could be ready, he recovers the wood and brings it to his workshop in Bumthang.

The wood is first dried over a period of several weeks. To ensure ease of carving, the wood must not be too dry but slightly damp and soft. Lopön Tsagye uses a variety of chisels which he obtains from Thimphu. He keeps them sharp by using a grinding stone from India, and then refining the edges with a stone that comes from Tibet. The sharpening process is completed on a piece of leather. With over forty chisels, maintaining his tools is quite time-consuming. Lopön Tsagye's designs, created from examples he has seen and his own ideas, are traced onto the wood, carved with a variety of chisels and finally finished with sandpaper or *soksom* (a rough-surfaced leaf). His most challenging works are the animal masks used in dancing and made from blue pine (*thongbushing*).

Not as easy as wood, but impressive in its final form, is slate-carving. The material is found in old mines; one of the largest, now becoming commercially developed, is the Shar mine about half an hour's drive from Wangdi. Known as *dona* in Dzongkha, the master slate-carver is the *dona lopön*. In Bhutan, the process of slate-carving is carried out on black slate.

Historically, slate-carving has been an important craft in Bhutan. Examples of this ancient craft can be seen everywhere: on the outskirts of villages, high up on mountain tops, at the junction of rivers. Passing by *chörtens* and shrines in the mountains, one often finds images of deities and holy scriptures carved on slate and embedded into the stone walls of these structures.

Three known *dona lopöns* remain in Bhutan, but apart from Lopön Kunzang none are actively pursuing their craft.

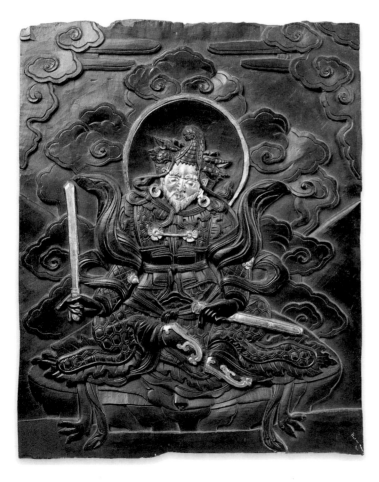

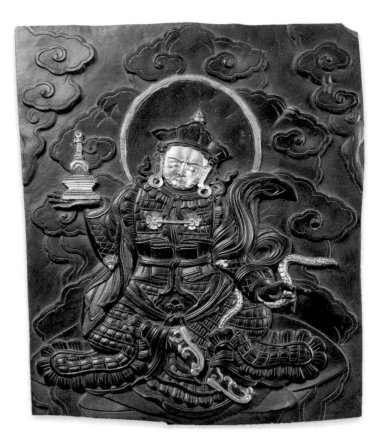

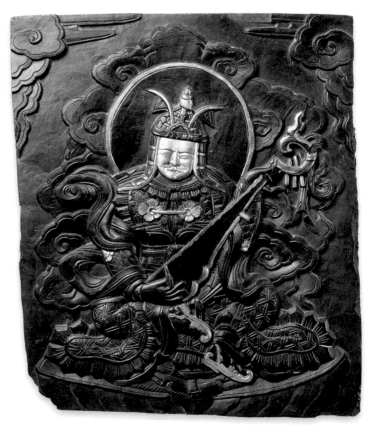

The demand for the large and heavy slate panels has diminished, and there have been no technical or design inputs that have been able to recover a market demand. Lopön Kunzang joined his own *lopön*, a Sherpa by the name of Sangye Tamang, when he was a teenager. He learnt fast and well, and by the time he was twenty he was given a commission by a great lama, Lama Sonam Zangpo. Lopön Kunzang now works as the administrator of the painting school. He no longer teaches, as slate-carving is no longer offered on the syllabus.

The details for the measurements and dimensions of a particular subject are prescribed in the scriptures and must be adhered to rigorously. The main subject – an image of Lord Buddha or of Guru Rinpoche – requires particular attention to the instructions of the sutras. Innovation is only allowed when filling in the background. For Lopön Kunzang, slate-carving, like most of the art in Bhutan, is a religious activity that generates merit. As a master-craftsman and a creator of beautiful works, Lopön Kunzang finds tremendous satisfaction in working images in slate that are accurate depictions of great lamas and deities. He has dreamed about his work and after completing a particularly virtuous carving he has sometimes been granted a special dream. Since his dreams are a special gift, he cannot divulge them or recreate them in his work.

Less in evidence these days is the work of the master stone-carver. Products like grinding stones for milling wheat often seen in a water mill, large hollowed-out stones for husking grain, stone bowls, scripture carved on stone and built into *chörtens* and images of deities carved into the side of large rocks reflect the demand of the stone-carver in earlier times. The stone-carver would normally be a specialist in working both stone and slate. New *chörtens* and shrines no longer include works of stone, and there is little demand for grinding-stones and bowls. Which is a pity, as there is an abundance of raw material, including white marble found in Ha.

Slate carvings of the Guardians of the Four Quarters, also called the Four Great Kings, who usually protect the entrances to dzongs, temples and monasteries. Above left: Guardian of the North, Namtöse, who holds a banner and a mongoose spitting jewels; Above right: Guardian of the West, Chenmisang, who holds a chörten in his right hand; Below left: Guardian of the South, Phakyepo, who holds a sword in his right hand; Below right: Guardian of the East, Yulkhorsung, who plays the lute. (E.L.)

LHAZO: PAINTING

One of the first and most lasting impressions on those who visit and travel through Bhutan is the variety and quantity of designs and colour everywhere – on house walls, inside temples and *dzongs*, on printed prayer flags flapping against the dark forest background, in the beautifully woven clothes, on wooden chests and carved tables, and surrounding the altars in homes or in buildings of worship. Of all the *zorig chusum*, painting seems to represent most comprehensively the colours, feelings, forms, beliefs and hopes of the people of Bhutan.

In earlier times, only natural colours were used. Yellow was obtained from Gasa and Tamshing, red from Wamrong, black from Phuntsholing and Tashigang, and white from Paro. Additional colours were obtained from Tibet to the north. These days chemicals are mixed together with the earth pigments, giving a brighter effect.

The designs of Bhutan have been passed down through many generations of great painters. The dimensions of religious works have been precisely detailed in the scriptures, and before any colour can be added to a work, many hours must first be spent drawing the figure or design exactly as it has been drawn for centuries.

A *lhazo lopön* can decorate a house, an altar, reproduce a *thangka*, paint a deity or place a little colour on an everyday household item. However, to become a master takes many years of disciplined training and constant practice under the supervision and training of an experienced master. Like all the crafts of Bhutan, painting is considered an act of devotion. Thus a painter never signs his completed work. Nevertheless, within the constraints of prescribed detail an experienced craftsman or patron can recognize the signature of an artist by the character and the skill that is intrinsically a part of his work. Perhaps the greatest painter in Bhutan today is Lopön Ugyen Lhendup. All the great institutions in the country have *thangkas* painted by him hanging on their walls.

Lopön Ugyen started his life as a painter at the age of eighteen. Until then he had to help around the house. His father died when he was still very young, so he was required to assist his mother in the fields and at home. One day, at Tsakaling (Mongar), Ugyen saw a painter and "like a thunderbolt" knew he wanted to become a painter too. Ugyen's first teacher was his cousin, only five years his senior.

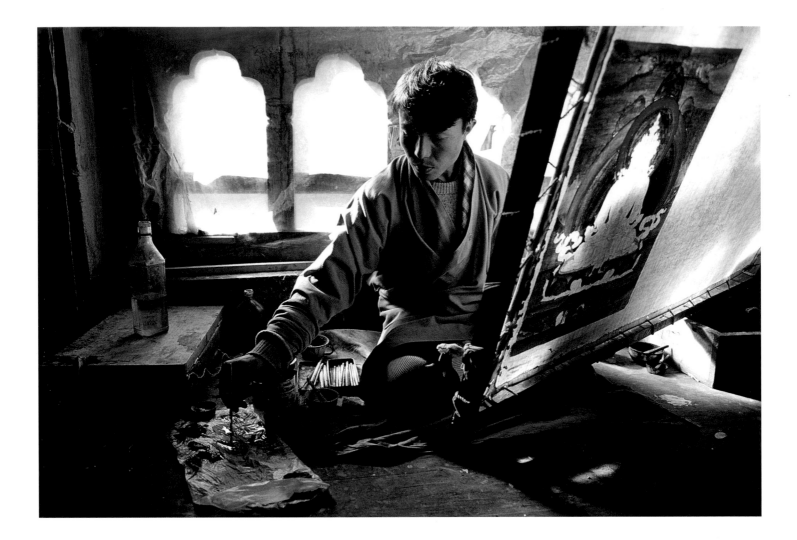

He started at a monastery called Thotho Jhasong Gonpa. His fierce yearning to learn led him to his other teachers – Lopön Chödra from Tibet and Lopön Lhakpa from Khengkhar in Mongar district. Becoming a successful painter, Lopön Ugyen states, requires a passion and dedication with no thought about money. One of the principal reasons for painting is to gain enlightenment, which is the main reason Lopön Ugyen still paints.

The profession of thangka painter is considered both prestigious as well as of benefit to one's karma as the artist works mainly with religious subjects. (J.W. 1994)

Biographical thangka of Drukpa Kunle (nicknamed 'The Divine Madman', 1455–1529). One of the most popular of all the religious figures in Bhutan, he is seen here at the entrance to Chime Lhakang with his dog and bow. Drukpa Kunle wandered throughout Bhutan subduing harmful local deities and preaching religion in an un-orthodox manner with bawdy humour. Painted in the 1980s, this thangka illustrates some wonderful examples of vernacular architecture. See detail p. 79. (E.L.)

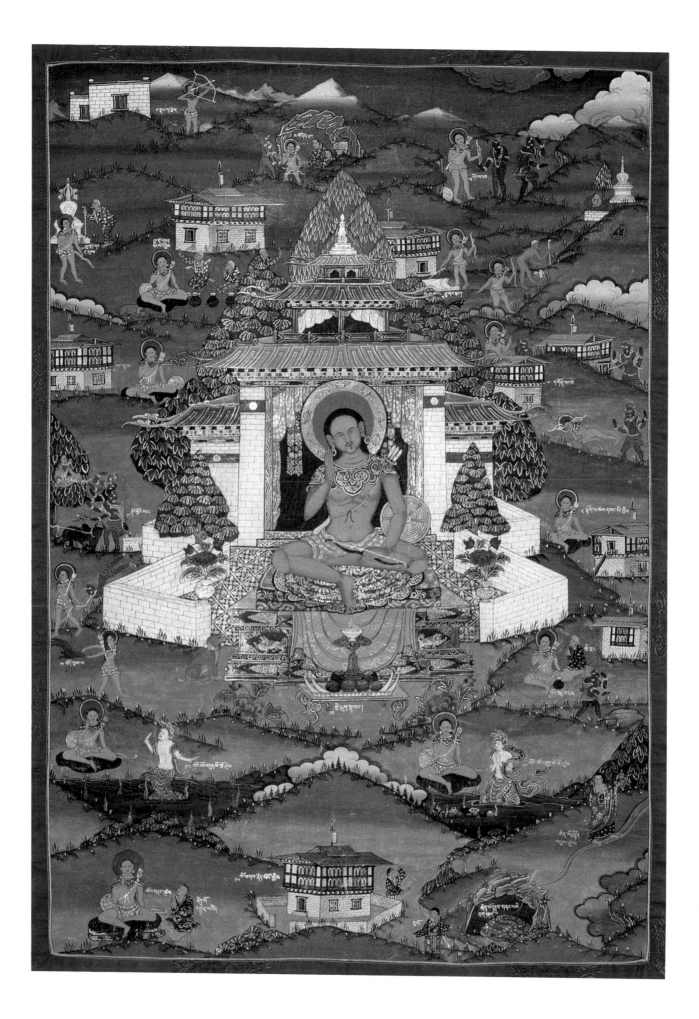

JINZO: CLAY CRAFTS – STATUES, MASKS AND POTTERY

Clay statues are considered by the Bhutanese to have a greater religious significance than those of brass or other metals as the entire production process involves great ceremony, and the elements they contain represent portions of the earth and waters from many parts of Bhutan, together with the blessings of many high lamas, past and present.

Perched on the crest of a ridge overlooking the town of Wamrong in eastern Bhutan, is the *lhakhang* of Tashi Chöding Zangdopelri commenced in 1985 by Lama Daza. Though small, it is particularly appealing because of its location, dramatically situated above a bend in the road.

Craftsmen are renowned for their skill in making large clay statues such as this one representing a manifestation of Guru Rimpoche. (J.W. 1994)

There are panoramic views over the mountains and valleys to the east and down towards the plains of India to the south. Inside, the three statues are Guru Rinpoche, Lord Buddha to his right and the Great Shabdrung to his left. Facing the statues to the far right is Phub (Phurpa), and Guru Dorje Drolö, two aspects Guru Rinpoche is said to have assumed. The master-craftsman who supervised the work was Lopön Om Tong, the foremost statue-maker in Bhutan. Now forty-nine years of age, Lopön Om Tong started in his profession when he was eighteen years old.

During his travels around the country, the late king Jigme Dorje Wangchuck, noted that apart from the master-sculptor Lopön Pelden in Paro Hephu, there was a distinct lack of *jinzo lopön* in Bhutan. Upon his directions, thirty-five young men were selected to train under Lopön Pelden. One of those was Om Tong, a long way from being a *lopön* himself. After three years of training, first in preparing the clay, then in making small clay statues, papier mâché and clay masks and painting them, he was selected to work with his master on

Only very few potters are now found in Bhutan as aluminium pots and plastic containers make their way even to remote villages. (J.W. 1994)

the *tshog shing* ('tree' of small statues representing the different religious lineages) in the Ta Dzong in Paro. This became his first major assignment. Since then he has become a master himself and has worked throughout Bhutan, in Pakistan and in Nepal.

In ancient times the frames of the statues were built from bamboo and large-stemmed grass. Nowadays copper or iron rods are used. The centre of a statue contains a carved column of wood, the *sogshing*, which represents the 'life force' of the statue. It is usually made of juniper wood (*shugpa*). The top of the *sogshing* is carved in the shape of a stupa, and the bottom is carved to resemble a *dorje* ('thunderbolt', Skt. vajra). The *sogshing* is divided into several sections. The first is the head, the second the neck, the third the heart and the fourth the navel. On each section holy scriptures (*zung*) are written in gold paint. At the third section, near the heart, is placed an ancient statue blessed by many great lamas. Once the *sogshing* has been completed, it is blessed by a lama during a special ceremony called the *zungdrup*. The structure is now ready for the first layer of clay, a sticky variety called *kusa* mixed with Daphne bark (*deshing*), which has been boiled, beaten and torn into strips. Volunteers will often come from nearby villages to provide manual labour, beating and mixing the clay with *deshing*, and preparing it into kilo-weight balls.

The *lopön* in charge of construction prepares a special clay, which contains small samples of clay from all over Bhutan blessed by high lamas. Powdered gold, silver, copper and iron are mixed into the clay together with ground *zee* (etched agates highly valued in Tibet and Bhutan), turquoise, pearls and other precious stones. Finally, holy water blessed by high lamas is poured into the clay, both during the preparation as well as after, to keep it moist. As the bodies of the statues are being built, the *lopön* in charge adds small portions of the special clay to various parts of the body according to his

choice at the time. The head is completed last, and that is the task of the *lopön*. Animal glue is applied to the statues and once that has dried they can be painted. This is usually carried out by painting masters and natural colours are used. Once the statues have been completed and the whole of the temple covered with murals, a ceremony called *drupchen* is held, often presided over by a high lama. The ceremony lasts three days, and the *lhakhang* is now considered consecrated and available to the community for worship.

Masks, an important feature in the religious and cultural life of Bhutanese communities, are produced in two media; wood (already discussed in an earlier section) and cloth, classified as *jinzo*, as clay and gum are also used. The first step in the long process of making a cloth mask is to carve the clay mould. Any clay will do. Being a sculptor, the craftsman builds the face, sometimes cutting, sometimes moulding, until he is satisfied with the detail. Then he prepares the squares of cloth and the glue. In earlier times, the skins of animals were used instead of cloth, but this did not permit the kind of detail and finish that has developed with the use of cloth. Nowadays a finer cloth allows for fifteen or so layers; previously the thicker khadi (cotton cloth) from India only permitted five or six layers. The gum is produced by boiling animal skins, which takes many hours, but the finished product is strong and can be stored for years in the form of solid blocks. A piece of the gum is cut off and soaked in water for several hours. The squares of cloth are then soaked in the gum, taken out and placed over the clay mould. This process is repeated until all the details of the mask have been transferred to the cloth covering. After the cloth has dried, the clay mould is broken and the cloth mask removed. Details are then added using a mixture of gum and sawdust. This last process assists in developing prominent features such as cheeks, chin, eyebrows and nose. The final finish is a coating of slip-clay. Once dry, the mask is painted.

Lopön Danba lives in Tamshing, Bumthang district, and is a highly skilled sculptor. He learnt from his father who came from Lhodra in Tibet. Unlike most mask-makers, Lopön Danba can also paint, being a *lhazo lopön* as well as a *jinzo lopön*. He likes to be able to create a mask from the very first process to the last so he can control the quality and personality of each character.

LUGZO: BRONZE-CASTING

Bhutan, Tibet and Nepal have all had a long tradition of bronze-casting. The highest points on temples, stupas and *dzongs* were crowned with bronze crests. Large bells for temples were cast in bell-metal. Smaller hand bells were made for monks to ring during their prayers. Statues of Lord Buddha, Guru Rinpoche and many great lamas were moulded using the lost wax process. *Dorje, phurbu* and other ritual items were made for monks and their places of worship. Ladles and kitchen utensils were fashioned for domestic use. Sword handles were shaped for nobles and warriors. In fact, the craft of bronze-casting covered a wide range of items for use in the house, the religious domain and the battlefield.

The craft is thought to have come to Bhutan many years ago from Tibet, but is now well-entrenched as part of the traditional skills that are considered Bhutanese. During the times when trade flowed freely between Bhutan and its neighbours, there was a constant exchange among the craftspeople of the region.

Lopön Kunle is the most senior master bronze-caster in Bhutan. He comes from Jamdo in Paro. When he was a young boy, Kunle watched a neighbour casting bronze and ever since he has had a keen interest in the craft. Noting his interest, his father took him to Dechenchöling near the Royal Palace in Thimphu where he learnt at the workshop of the silver and gold masters sponsored by the Royal Government. Later, as Kunle developed both his interest and his skills, he was sponsored by the Royal Government to go to Nepal to learn under the great master Sidera Shakya, who had a workshop in Patan in the Kathmandu valley. It was in Nepal that Kunle finally realized the potential of his craft. In 1975 Lopön Kunle returned from Nepal and set up his first bronze production centre in Thimphu near the site of the present painting school. Now it became the turn of the silver and bronze craftsmen to come to him for their casting.

In Bhutan two methods are used for bronze-casting; the first uses wax, and the second uses sand and molasses. Lopön Kunle employs the lost wax process for his casting. Some of the tools used are: a small hammer (*thochung*), an angular file (*setha*), a flat file (*setha bom*) and metal bits which are ham-

This bronze container is used for ceremonial offerings and is associated with good fortune as its name, yangtro, suggests. (E.L.)

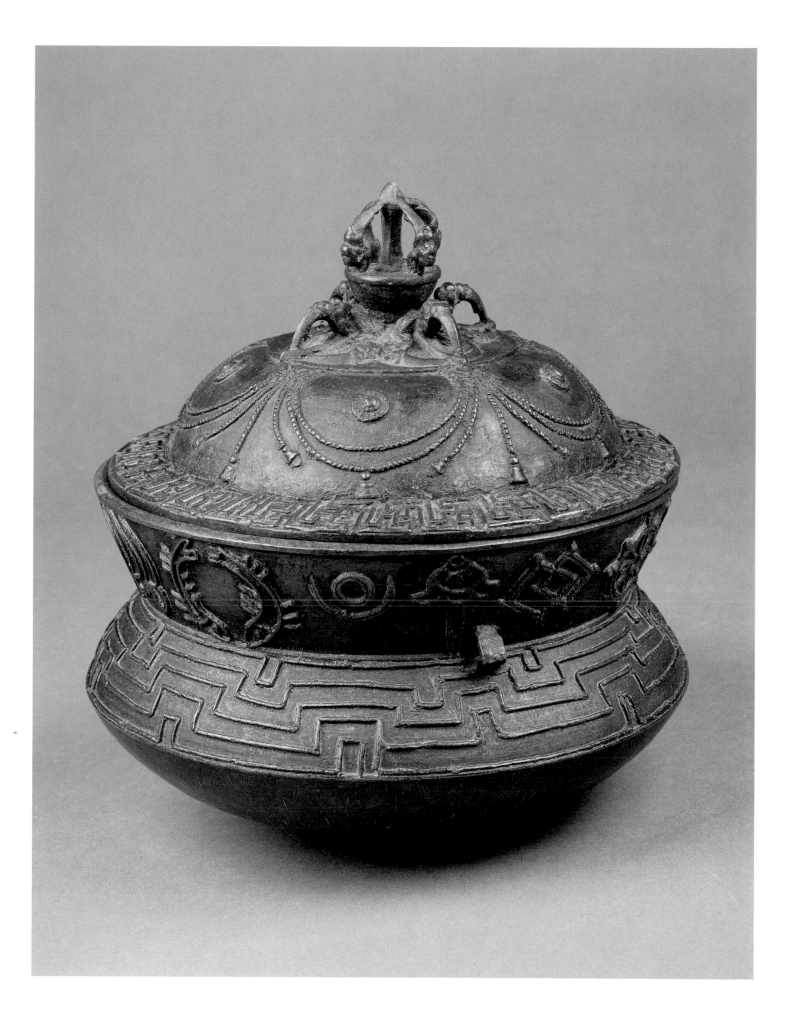

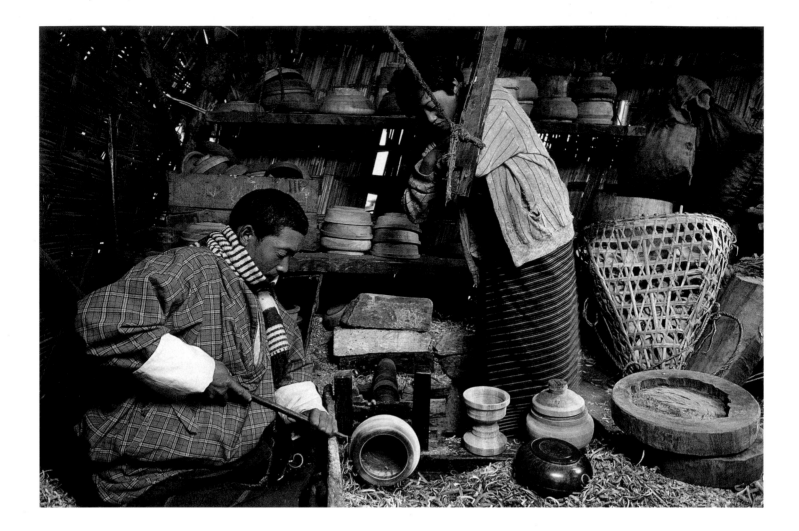

mered for shaping (*zong*). Raw materials are obtained mainly from India.

The craft of *lugzo* flourished under patronage in the past. In the contemporary market place many alternatives are available. Domestic items are now available in plastic, aluminium and steel. Knives can be imported from a number of sources and even religious items are being brought from Nepal and India. With a loss of patronage and increased market competition, the demand for quality craftsmanship has diminished and may eventually disappear.

SHAGZO: WOOD-TURNING

A *shagzopa* is skilled at making a variety of bowls, plates, cups and containers from a large range of woods. In the past his tools were simple and always made by himself, although today factory-made tools from India are also used (metal chisels, knives and the pedal lathe). A small wooden cup,

Wooden bowls and containers are produced on a simple lathe. The main region of production is Tashiyangtse in northeast Bhutan. (J.W. 1994)

made from the burl (*dza*) of a tree, represents the finest tradition of a *shagzopa* or master of the wood-lathe. It is said that the *dzas* of old were greatly valued by nobles and rulers because if poison was poured into a bowl made of *dza*, they would either shatter or absorb the poison so no harm would come to its owner. Although varying considerably in quality, some *dza* bowls can fetch a price of a thousand dollars or more. A *shagzopa* recounts:

If you go out at night when it is dark and only a few stars are shining in the sky, you can look around at the mountains surrounding the valley and, if you are lucky, you may see a small light on the side of a nearby slope. That could be a dza. The next morning you should go out to the place from where the light shone and if you dig, you may find a dza.

There are three areas in Bhutan reputed to produce the finest turned wood products; probably the best known is Tashiyangtse, only a few miles from Bumdeling, home of the famous black-necked crane. While opinions seem to vary, Paro is said to have the older and finer tradition. Khengkhar, the traditional heartland of *zorig chusum*, in Mongar district, has produced renowned craftsmen.

Sonam is a *shagzopa* and one of four wood-turners in Tashiyangtse contracted to the Royal Government to produce wooden bowls and other items. Sonam's grandfather came to Tashiyangtse from Kham in Tibet in the 1920s. He was travelling to Bhutan on pilgrimage to visit holy shrines when he was attacked by robbers in Tibet. Gravely wounded, he arrived in Tashiyangtse with his seven-year-old son and after some time died of his wounds. The son was taken in by friends, grew up and eventually married a local girl, who gave birth to Sonam. Sonam and his father both practise the skills of wood-turning which, Sonam maintains, his grandfather first introduced to the people of Tashiyangtse. Even today, Sonam still uses natural dye stains brought from Tibet.

At the age of fourteen Sonam, who had by then become well-known for his skills at both carving as well as wood-turning, was called to Thimphu by Dasho Ramjan Thinle to work on the renovation of the *dzong*. He eventually returned to his home in Tashiyangtse to promote the craft of *shagzo*, and he produces for the emporium in Thimphu as well as for traders who come from all over Bhutan. Finding the right wood is essential and, depending on the kind of order he may have received, Sonam will spend days in the forest looking for an appropriate tree. He is constantly on the lookout for the knot in a tree which will produce a *dza*.

GARZO: BLACKSMITHY

The origins of working iron and other metals for making tools, knives, swords and farming and kitchen utensils have been lost in ancient history. A country of steep valleys and fast-flowing rivers, Bhutan used to be divided into many small principalities until technology from Tibet produced the chain link bridges hundreds of years ago; perhaps the skills and tools of the blacksmith came from the north.

Sixty-one years ago, Tshering Dorje travelled from Tibet to the valley of Bumthang in central Bhutan. Tshering's mother had died immediately after his birth, and after he was considered strong enough to travel, he was taken by his

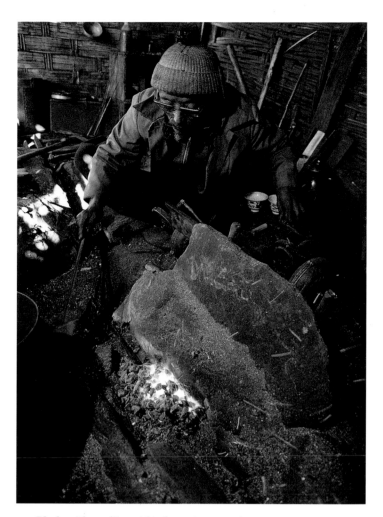

Blacksmith working at his forge. (J.W. 1994)

father Sekho and his uncle, both blacksmiths, to the 'land of the south'. Travelling to Bhutan was not a new adventure for Tibetans from Lhodra (in the south of Tibet). Tshering's people lived in a village called Sekhar Guthok, famous for the nine-storey tower built by the great saint Lama Milarepa in the eleventh century. Every winter, when it became extremely cold, most people in the village would migrate south to Thangbi village (Bumthang district), where they would stay, mixing quite happily with the local people. Many of those travelling south brought items for trade and some of the people were blacksmiths. Thus when Tshering's mother died, his father and uncle, who had no other family in Sekhar, were attracted by the option of moving to a milder climate and a ready market.

Three years after they arrived in Thangbi, Tshering's father died, so he was raised and instructed in the craft of blacksmithy by his uncle. He grew up like all the other boys, helping with chores or playing in the valley around the

village. His uncle never married, so Tshering had to assist in those tasks that his aunt or cousins would normally do. Sometimes he would help his uncle at the forge, but it was not until he was nineteen that he and his uncle decided that he should become a blacksmith like his father.

While he does not recall any particular manner in which his uncle taught him, he does recall that his earliest tasks were to bring in the charcoal and water, and he would often sit and watch his uncle stoke the fire, heat up the metal and beat it into shape. Later he would help in hammering and over a period of time gradually came to learn the finer skills of shaping a cooking pot or refining the blade of a knife. Tshering remembers sometimes going on what he considered a great adventure into the forests with his uncle. The handles of knives needed a very hard wood, and his uncle knew where to find the appropriate trees. Many times they spent nights on the mountain slopes beneath the temporary shelter of branches, watching the fire that kept them warm and safe from wild animals. Tshering would imagine forest creatures creeping around their camp but was never afraid.

Tshering's uncle died many years ago, and now Tshering runs his own workshop. He has a son, but he has not been able to pass on his skills as they have decided that there is a better future in pursuing business than the family tradition. With the many imports from surrounding countries, competition has reduced the demand for his craft.

TRÖKO: MAKING METAL ORNAMENTS

Bhutanese jewellery is of two main types: the first comprises semi-precious stones like turquoise, coral or etched agate (*zee*); the second comprises the finely worked but mostly heavy silver and gold adornments for the *kira* (*koma*), bangles, necklaces and rings.

The master-craftsmen, *tröko lopön*, have the skills to work in gold, silver or copper. Most have grown up as apprentices, working for masters who passed on their skills. Each has chosen to specialize in a particular aspect of the craft. Lopön Kencho Tshering of Paro Chudzom is renowned throughout Bhutan for his work in silver and gold jewellery. Lopön Kencho Dorje of Paro Shaba has become famous for his skill at producing horns. Both *lopöns* learnt their skills as apprentices of the great craftsman Lopön Pema Dorje of Paro.

From the age of five, Kencho Tshering learnt to make silver and gold jewellery from his father who was a *tröko lopön*.

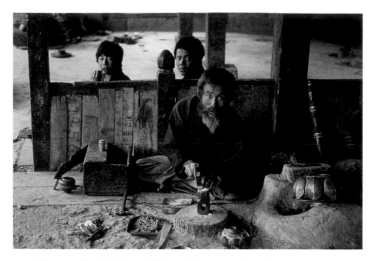

Silversmith at Dechenchöling, Thimphu valley. (G.V.S.)

Kencho worked at his father's side until the age of twelve, learning to mould, beat and fashion simple items of jewellery. For the next three years, Kencho worked with his father to produce jewellery that was sold in the local markets. His father realized that Kencho had abilities that could be developed beyond his teaching capabilities, and when he was fifteen, he took Kencho to the great Lopön Pema Dorje at Dechenchöling in Thimphu. Kencho remained with Lopön Pema Dorje for twenty-seven years. From fifteen to nineteen years of age, Kencho was taught the intricacies of quality jewellery. He learnt to work beautiful silver boxes (*chaka*), silver and gold brooches (*koma*), bangles (*dobchu*) and a variety of rings (*zuki*). At the age of twenty, Kencho studied to draw animals and the methods of making friezes. Considering Kencho an expert, his master Lopön Pema decided to take Kencho with him as he visited many places around Bhutan. Together they travelled to Paro, Bumthang, Tongsa, Gasa, Ha and Punakha. Despite a crippled left hand, Lopön Pema Dorje was the foremost *tröko lopön* in Bhutan working under the sponsorship of Her Majesty the Queen Mother. When he died at the age of fifty-eight, Lopön Pema Dorje's apprentice Kencho became Lopön to Her Majesty and took charge of the workshop at Dechenchöling.

The two essential skills required of a *tröko lopön* are firstly to beat and then to draw. Around the age of ten or eleven an apprentice would be given a series of tasks to develop his ability in beating. His *lopön* would draw a design on a piece of metal (often brass) and have his apprentice beat out the

This intricate silver box is a superb example of a personal amulet box (gau), containing prayers, small statues or relics. It is worn at the neck when travelling. (E.L.)

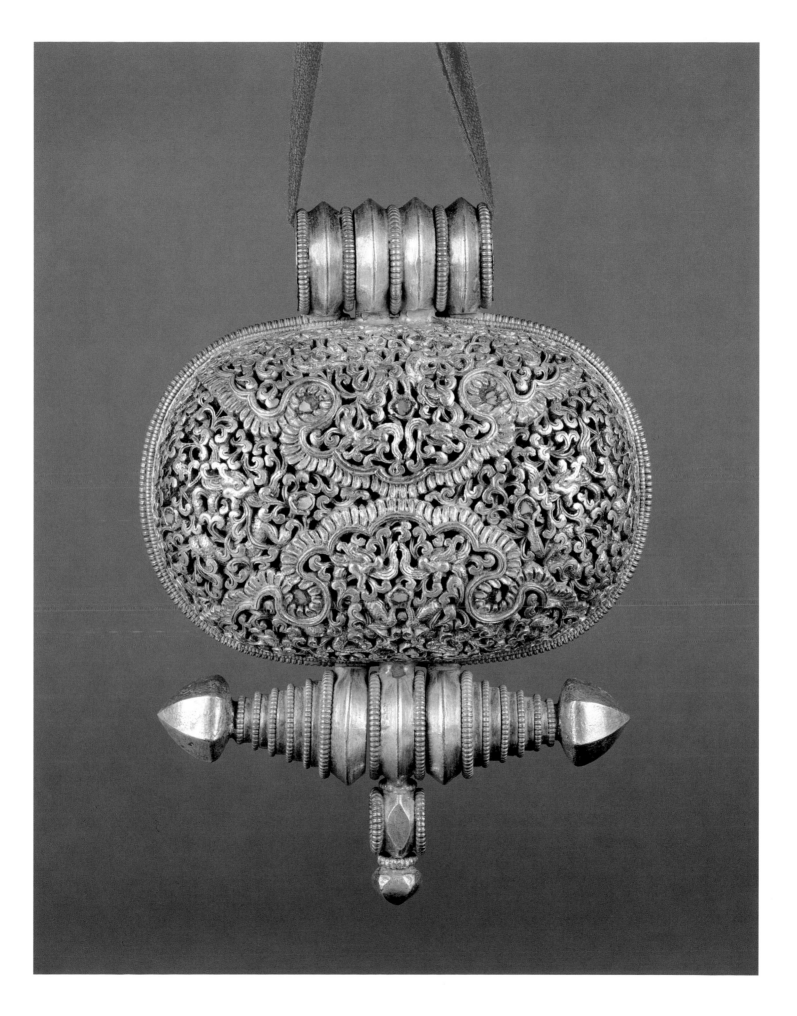

design. It was only through constant practice that an apprentice could gain the proficiency and the skills required of a craftsman. As he learnt to fashion a quality piece of jewellery, he was also taught the art of design. Being able to create new and attractive items was an essential element for a successful *tröko lopön*.

TSHAZO: CANE AND BAMBOO CRAFTS

Throughout Bhutan, cane and bamboo products have always complemented wood as the most commonly used domestic items. Among the large range of practical applications, cane and bamboo were made into storage containers, baskets for carrying, food utensils, musical instruments, bows and arrows, walls for houses, fences, rope and floor mats. Not only is bamboo one of the most commonly used raw materials, but it probably also represents the most widespread skill and largest traditional cottage industry.

The versatility of bamboo in different climates meant that at most altitudes where people lived, one species or another could be found. Some of the weaving communities are sedentary and have been able to produce and sell their craft from their traditional villages. Other communities needed to travel both because of the source of raw material and because of their traditional marketing outlet.

The major areas of production in terms of a quality and unique product are the following:

The region adjoining Kangpara village in Tashigang district (including communities up and down the valley from Kangpara) where possibly the best quality cane and bamboo weaving can be found. Items woven are small round covered baskets for storing dry foods (*bangchung*), quivers, large storage baskets (*chezem*) and a range of round, square and flat baskets (*baykhun, lagchung*) for the kitchen, storeroom and to tuck away in the folds of a *go, kira* or saddle blanket.

The Shemgang district has an abundance of raw materials and produces possibly the largest quantity of woven baskets, including *bangchung*.

Lying within Mongar district, the area around Khengkhar has a tradition of making quality cane and bamboo baskets. Some craftsmen believe that the Kangpara craftsmen originally came from Khengkhar.

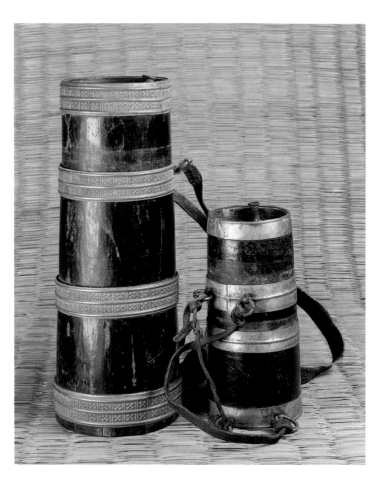

Alcohol or water containers can be made out of different materials such as bamboo, horn or wood and ornamented with brass rings. Liquid is poured into a cup or sipped with a bamboo straw. (E.L.)

Every year around mid to late October, a group of young men and women come to Punakha and camp by the river near the *dzong*, where they make large baskets for storing rice, and floor mats. For one or two months this group of people make and sell their products to the villagers in the region. They have chosen to set up their camp near the river where people cross the bridge, an appropriate site from which to advertise and sell their products. These people come from Sephu on the other side of Pelela pass. They collect their bamboo as they travel west down into Punakha valley.

Above: Bamboo and rattan weavers are mostly from the region of Kheng in south-central Bhutan and produce, among other items, the famous double basket called bangchung. (J.W. 1994) *Below: One of the best known artifacts of Bhutan, the bangchung is used as a container to carry cooked food in the fields or when travelling. It also serves as a plate.* (E.L.)

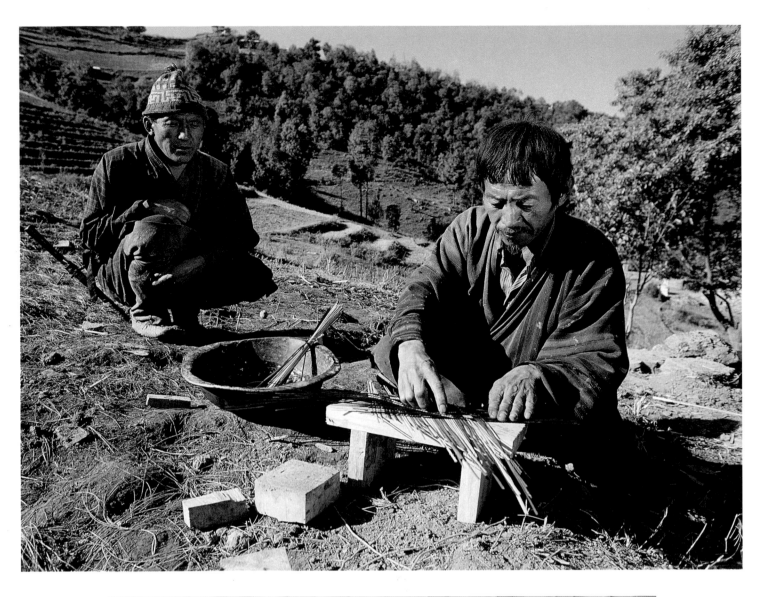

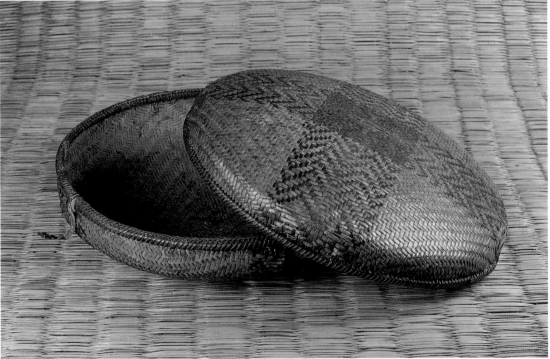

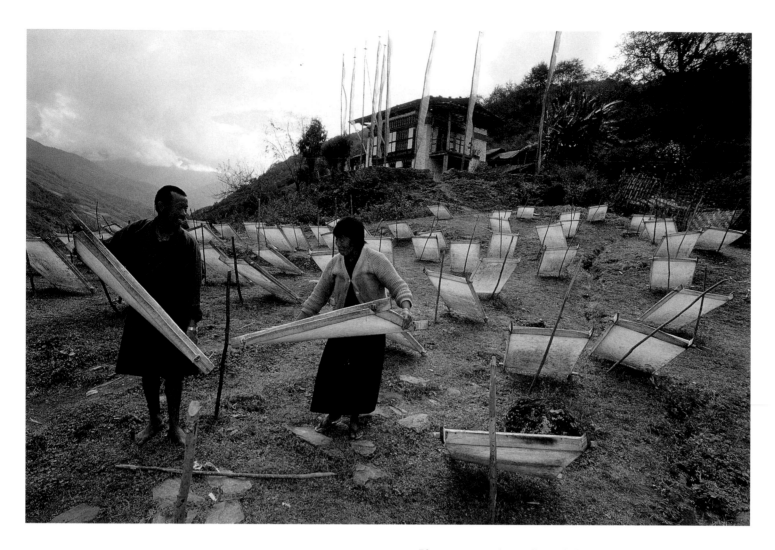

Bhutanese paper is usually made from the bark of the Daphne bush and is left to dry in the open air on bamboo frames, as here at Bumdeling. (J.W. 1994)

DEZO: PAPERMAKING

Handmade paper has been a traditional craft in Bhutan going back into the distant past. However, it is likely that the production of handmade paper was introduced from Tibet several centuries ago. Whether it was originally made by monks to record holy scriptures, or whether it was also made by lay craftspeople is uncertain; today, however, it is made by both.

In Bhutan paper is made mainly from the Daphne plant (*deshing*). The other major ingredient is called *aipin*, which is a gum obtained from the root of a creeper.

At the age of nine, young Dorje joined a monastery called Riksum Gonpa near the Bumdeling lake in Tashiyangtse. During the first few years, Dorje learnt to write and memorized holy scriptures. As he grew older, he was taught some of the crafts carried out at the monastery – painting, preparing moulded offerings and carving. As an apprentice, he started by carrying out the simpler tasks such as cleaning

brushes, preparing painting surfaces and learning and practising the accurate dimensions and shapes of deities. Later, as he improved his skills, he was permitted to draw and paint complete designs and images himself. His development in carving and other activities followed a similar pattern.

At the age of twenty Dorje learnt how to make paper, and six years later he married and left the monastery to live as a *gomchen* and keeper of Phanteng Lhakhang a few hundred metres above the Bumdeling road. Aside from his religious duties, Dorje also continued to make paper. Just three years ago, Dezo Lopön Dorje taught his wife how to make paper and now that she has become expert in the process, he is free to wander into the forests looking for raw materials. The demand for his paper has enabled him to take on four apprentices, who learn the craft and assist him in his production.

Having located suitable plants, Dorje cuts down the bush, strips the bark and ties it into bundles. The bundles are then

carried home and soaked in water to wash off the outer layer of residue and dirt. It is then left in the sun to dry. Using a knife, the outer layer of bark is peeled off, leaving bare the inner softer portion, which is again soaked in water and washed by treading on the wet fibres. This process gets rid of the remaining vegetable matter. The fibre is then placed in a pot and ash water poured over the top through a sieve. The mixture is then boiled for many hours. Finally the softened fibres are beaten and then churned into a pulp. The mixture is now ready to be poured over a screen and placed on the mountain slopes in the sun. Once dry, the fibre becomes a thin sheet of translucent paper, which is peeled off and stacked in piles ready to be taken to Tashiyangtse. Lopön Dorje and his wife can produce 8,000 sheets of paper a year, earning him more than most of his neighbours.

TSHEMZO: TAILORING

The three main crafts in *tshemzo* are: stitching clothes such as the *go* worn by men and the *tögo* and *nornang töthung* (jackets); embroidery and appliqué, seen mostly during festivals and in the temples; and the production of traditional Bhutanese boots.

The tailoring of garments has never been a very refined craft in Bhutan. The garments sewn usually included joining together lengths of hand-woven fabric to make blankets, rain capes, floor coverings, the men's *go* and women's dress length, *kira*. In Bumthang, simple jackets (*tögo*) were handstitched, and in the east, among the Brokpa people living in Merak and Sakteng, a lighter jacket called the *nornang töthung* was made and worn. More recently men and women have learnt to operate sewing machines, and have become adept at producing other garments such as blouses and jackets.

A needle is perhaps the simplest and most versatile of all craft implements. It can be used to sew rice sacks as well as to produce the finest stitches. Embroidery and appliqué has always been mainly carried out by monks, as they were required to prepare special temple and ceremonial hangings. Traditional dance costumes, which varied considerably from character to character, also required both stitching and appliqué. Fabrics were often imported from China and, more recently, synthetics from both China and India have been used.

The most laborious and refined items are probably the *thangkas*, artistic depictions of deities and religious teachings which are mostly painted but sometimes embroidered,

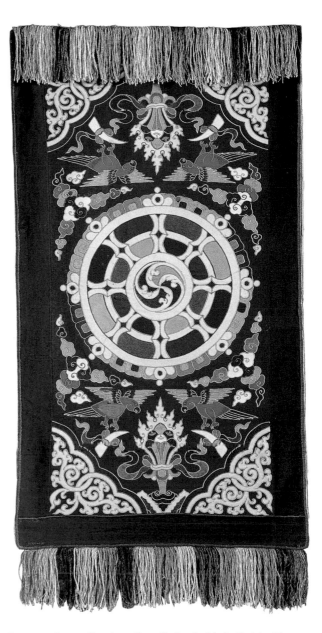

Rectangular appliqué textile, called a thrikheb, that is, 'throne cover'. The presence of the Wheel of Law symbolizing Buddhism indicates that textiles such as these are for the court or for high lamas. (E.L.)

a task that is very exacting and takes many months. The small stitches are demanding enough, but added to this are the requirements for precise measurements laid down in the scriptures. Embroidered *thangkas* were all hand-sewn, often in poor light, as a monk sat patiently at a small *dzong* window in the late afternoon after his daily round of monastic duties, trying to catch the last of the sun's rays and finish another small area. The most significant items produced are the large silk *thangkas* portraying Guru Rinpoche or the Shabdrung, that are hung against the wall of the *dzong* once a year during the *tshechu* festival.

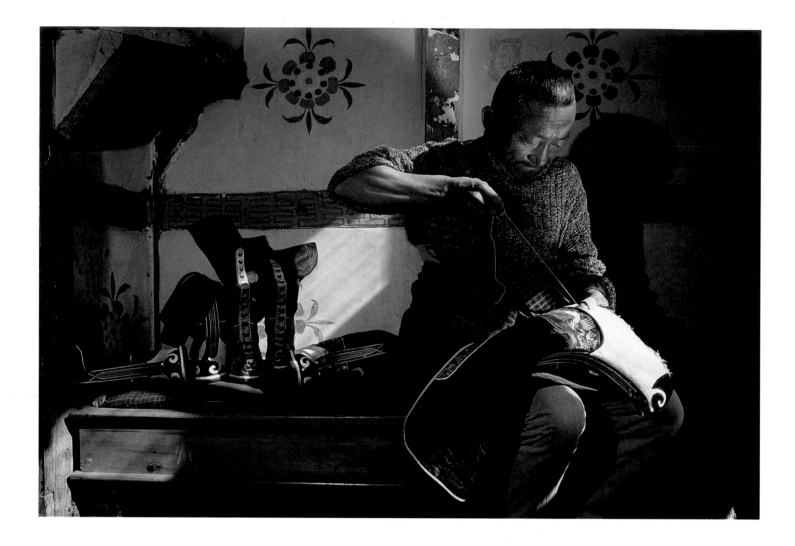

One of the last bootmakers of Bhutan. This elaborate craft combines leatherwork, stitching and embroidery. (J.W. 1994)

Appliqué and embroidery are also found on the *kushung* and the *shingkha*, both poncho-like garments worn mainly by women during festive occasions in eastern Bhutan.

The craft of stitching boots (*tshoglam*), though linked with tailoring and embroidery because of the needlework, is really a separate activity in itself. Boots worn on both ceremonial occasions as well as everyday life are made.

Chief among boot-makers is Shabgye Tshoglam Wangdi, the Royal Bootmaker, who lives in Paro and is the only one in the kingdom still holding this title. At the age of fifteen, Wangdi became apprenticed to master Yeshe who had gone to Tibet many years before and had learnt the craft and become a master boot-maker over a period of fifteen years. On his return to Bhutan he started making the special ceremonial boots and it was at this stage that Wangdi joined him.

When a customer comes to Shabgye Tshoglam Wangdi to order a pair of boots, first the outline of his foot is drawn.

This is compared to existing patterns to determine the size of the boot. First the sole (*thi*) is made by cutting out a thin card according to the size of the foot. The card is covered with light cotton cloth and stitched on. Leather is then cut to the same size and glued to the cloth-covered card. Holes are made in the leather and later on this is attached to the bottom of the three sections of the cloth appliqué that makes up the main part of the boot. The leather is tough and hard to work with, and making the *thi* is time-consuming and difficult. The main boot is made of three sections, each one of cloth appliqué (mostly brocade imported from China), sewn separately and then finally joined to complete the main part of the boot, apart from the sole described earlier. The lowest section is called the *kachu* which, like the *thi*, is cut out based on the size of the foot. The middle portion is called the *pö*, which distinguishes the rank of the wearer; yellow for His Majesty or the head abbot (*je khenpo*), orange for a minister (*lyonpo*), red for a senior official (*dasho*) and green for anyone else. The long upper section of the boot is called *yupa* and is based on a square of brocade which is decorated with

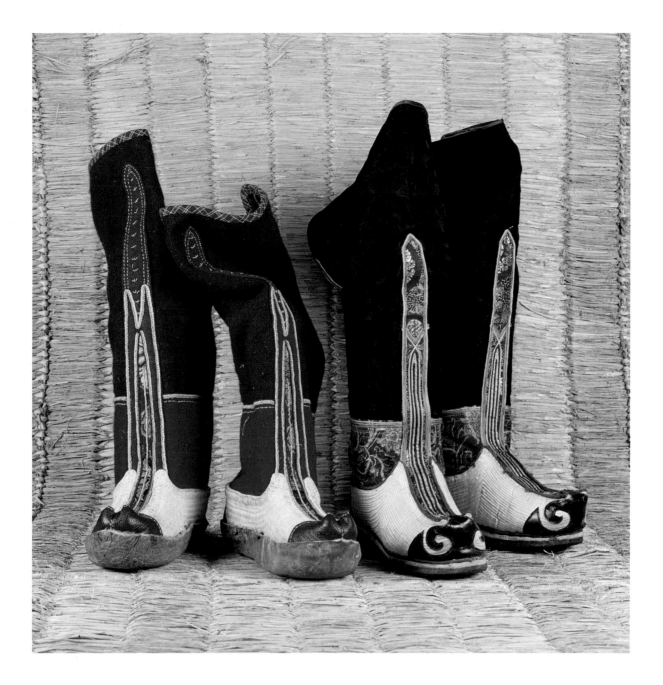

appliqué, using various other fabrics and colours depending on the choice of the customer.

The boots are identical and can be worn on either foot. This apparently allows the wearer to alternate and prevent excess wearing out on any particular boot. Several designs are used on boots; either traditional ones or one a customer has created. The most common designs include 'monster face' (*tsipata*), 'precious stone' (*norbu*), 'small mountain' (*dari*), and 'bird' (*tshere*). Only royalty can use the dragon on a boot.

The craft of *tshoglam* is an old one, its origins unclear as boots are also made in several countries in the region. The craft of making simple boots from uncured leather is still practised in villages of rural Bhutan. However, today the

Traditional boots are made of leather and cloth; each one in a pair is the same shape when new and adjusts to the individual's feet. Woven garters hold them in place. The pair on the left with red cloth denotes that they belong to a religious person, while the pair on the right is for a person of high government rank. The colours indicate the status and only the king may wear boots ornamented in yellow. (E.L.)

craft is slowly dying out. Shoes are much more practical and comfortable, and Shabgye Tshoglam Wangdi cannot find and keep apprentices who want to learn this ancient and beautiful craft.

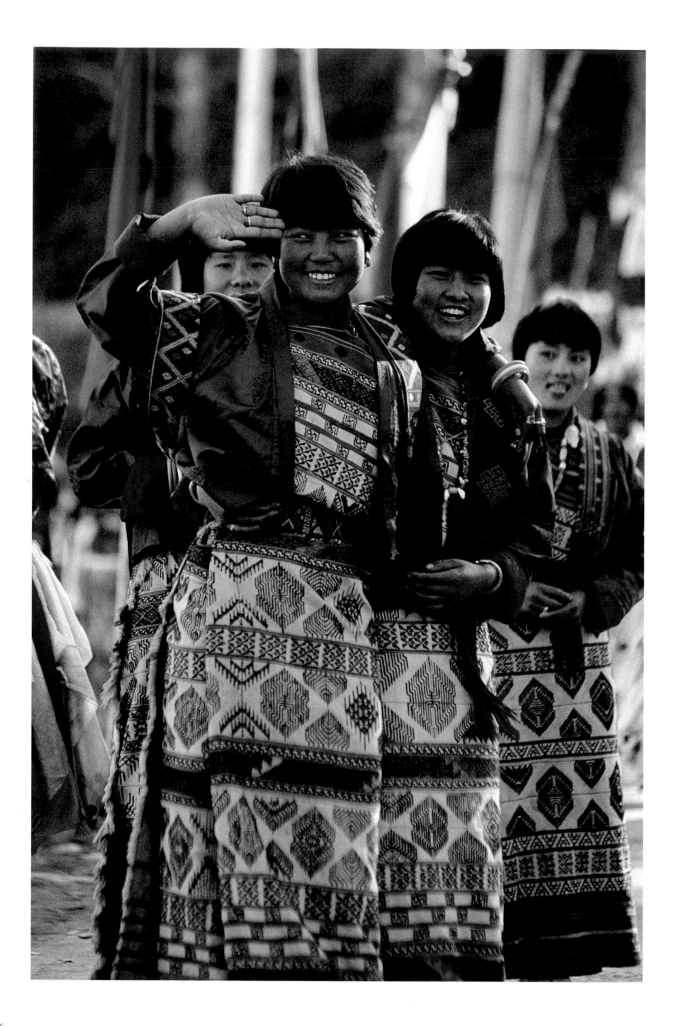

THAGZO: WEAVING

As a craft, the textiles of Bhutan, probably more than any other *zorig chusum*, have attained a level of sophistication equal to most other weaving traditions within the region and even further afield. A recent book *From the Land of the Thunder Dragon: Textile Arts of Bhutan* (edited by Diana K. Myers and Susan S. Bean) deals in detail with the different weaving traditions of Bhutan (see Select Bibliography).

Perhaps the finest weavers in Bhutan are to be found in Lhuntshi in eastern Bhutan, or at least originate from that area, for many weavers are recruited by wealthy patrons and taken to larger urban areas like Thimphu, where they weave fabric to the design and colour preference of their patron.

Khoma, the best-known village, is an hour's brisk walk from the Khoma bridge on the main Mongar–Lhuntshi road. Gonpakap, on the crest of a ridge high above Khoma, reputedly offers the finest fabrics because of the presence of a sacred temple around which the village is clustered. The weavers of Gonpakap feel that their weaving is superior because of the special gift and blessing from the deities of that sacred site.

Lhuntshi weavers have traditionally used both silk and cotton yarns. The designs used by the Lhuntshi weavers are numerous and continually added to as experienced weavers are able to build on old patterns or to create new ones. Perhaps the most intricate and time-consuming design is called *thrima*; it looks like chainstitch embroidered onto the fabric; in fact warp elements and supplementary weft threads are interworked. The two best-known fabrics are the *kushüthara* and the *ngosham*. Both refer to the background (white for *kushüthara*, blue for *ngosham*), on which are woven intricate designs of various colours. Other *kiras* of the same type are referred to as *jangsham* (green background) and *naksham* (black background).

In addition to the various types of *kira* cloth, the region offers an older tradition which produced the *kushung* and the *lhago*, both poncho-type garments which were worn as smocks without a belt. Like the *kushüthara*, the *kushung* had

Dancers wearing the dress (kira) with white ground called kushü-thara originating from the Lhuntshi region. One of the most highly valued of textiles in Bhutan, it is woven in either silk or cotton, and is patterned with silk supplementary weft. (J.W. 1994)

detailed patterns on a white background, while the *lhago* was predominantly red. The *kera* or belt is a twelve-inch wide, five-foot long piece of fabric, sometimes with a white, sometimes a yellow background. It is the traditional means of tying the *kira* into place around a woman's waist and, although usually not very visible, is also beautifully woven.

Each of these fabrics is a speciality of certain villages; even those items of clothing that are no longer worn every day are brought out during festivals. The *lhago*, a plain red felted fabric, for instance, is woven in Taya and Shawa in Khoma Gewog. The *kushung* is woven only in Taya. During 'Lha', the annual three-day festival in December, the *lhago* is worn on the first two days and the *kushung* on the third and last day.

As they are considered the highest form of weaving skill and are preferred among customers, many of the styles of Lhuntshi are imitated throughout the country. As in many communities in the region, women who can afford to do so vie among themselves to design and wear the finest samples of *kira* fabric, especially on ceremonial occasions when people are expected to wear their best.

The weaving of Lhuntshi has developed, with new designs and colours added to existing combinations, but the craft still produces the same items that it did centuries ago. For the communities of Lhuntshi, weaving represents a traditional skill that provides cloth and clothing. It is a skill enjoyed for its artistic value that also provides merit. Weaving enables a woman to gain a reputation within and beyond the community as a great craftsperson. Probably most important is the value of a finished piece, which is bartered or sold and used to obtain commodities not locally available (including yarn).

One project recently started in Khoma had little if any sustainable developmental impact. Young women were given a book of photographed designs produced by expatriates and told to copy the patterns. Older women would come to watch with some bewilderment. New applications were produced such as table linen, but eventually the project came to a close.

Bhutan remains an example of a large weaving sector still operating with the same technologies, applications and markets as the weavers of earlier centuries, in a sense still subsistence-based, yet having the degree of sophistication to match any weaving tradition and the potential patronage of local and international markets.

The weaving sector in Lhuntshi district and in Bhutan as a whole deserves some attention in terms of the large number

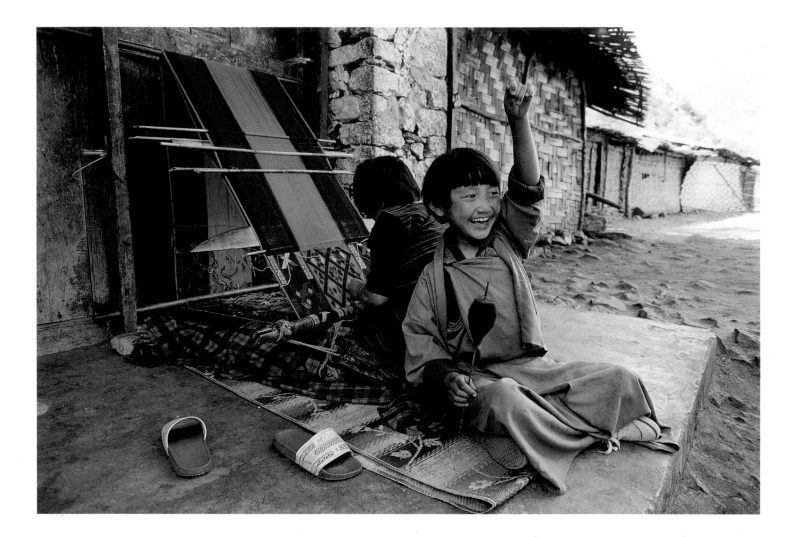

of products that could be developed, and hence the increased demand both locally and for international markets. A project commenced in Bumthang using woollen yarns and expanded under the Ministry of Trade and Industry to potentially include all the traditional skills of *zorig chusum*, has demonstrated through the use of product development and design the large number of new items such as clothing, bags, table and bed linen and decorations, the potential both within Bhutan and in international markets.

Besides silk, cotton and wool, traditional weaving yarns include nettle fibre. The two main areas for nettle-weaving are Jara Gewog (block) in Lhuntshi district and Khaling Gewog in Tashigang district, both in eastern Bhutan. In Jara, the most famous village, Yumche, is nestled between large rocks above and below, and because of the limited arable land, the inhabitants rely heavily on an income from cloth woven from nettle fibre.

The nettle plant can be harvested and processed all year round. Since many villages in the area practise mixed agriculture, growing grains, vegetables and fruit, they begin

Above: The most elaborate textiles are woven on a backstrap loom that may be placed on a platform or balcony outside the house. Daughters learn the craft from their mothers. (J.W. 1994). Below: An expert weaver demonstrates the technique of supplementary-weft patterning by inserting the threads with a bamboo stick. (J.W. 1994) Right: Detail of a kira showing the remarkable craftsmanship of Bhutanese weavers, especially in the supplementary-weft patterns. It takes between nine and twelve months to weave a dress of 1.5 m by 2.5 m to this standard. (F.P. 1992)

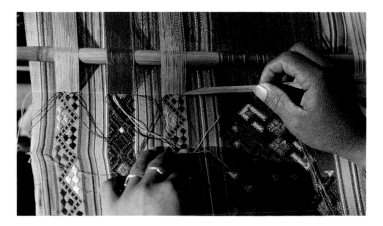

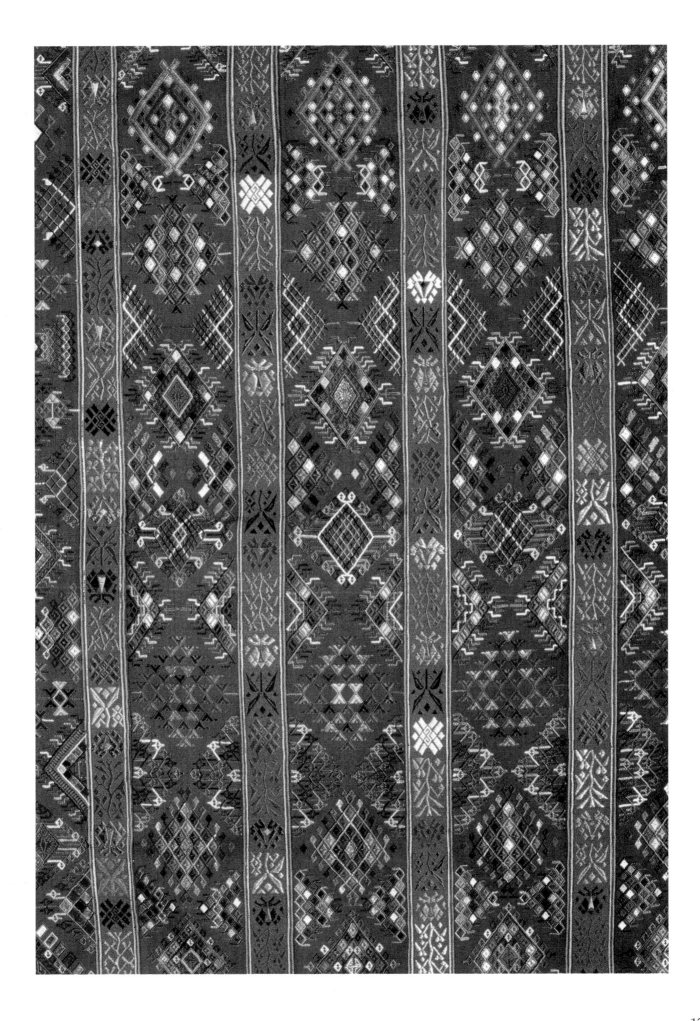

producing nettle yarn during the ninth and tenth months of the Bhutanese calendar – November and December. Although Yumche weavers are active all year round, most other villages in Jara Gewog weave predominantly during the eleventh and twelfth months in the Bhutanese calendar, that is in January and February, the depths of winter, when little grows and it is cold outside.

Yangchen Lhamo is a young woman of thirty who now lives in Autsho with her husband and two young children. Although Yangchen was born and brought up in the village of Karchung Pam, only half an hour from Yumche, she moved with her husband who has set up a shop in Autsho. At the age of fifteen or sixteen, Yangchen started weaving nettle cloth. When asked who taught her how to weave she says, "no one, it was easy, so I didn't have to learn". She learnt observing her mother and aunts, all of whom are weavers.

The nettle fibre is produced as follows. The bark is peeled off by hand and soaked in water (sometimes with ash mostly from the *nakshing* or *nak* tree) for a period of at least fifteen days. The time required for this process depends on the climate and temperature. The bark is then taken out and beaten to remove residue matter, and the fibres are separated from the residue. They are twisted by tying to a toe and rolling between the hands, and then washed to obtain a clean light colour. After drying, the yarn is ready for weaving. The same nettle yarn is used for both warp and weft threads. The nettle cloth is woven on a backstrap loom (*pangthag*).

The finished cloth resembles an evenly woven, strong burlap or hessian and is called *kyethag*, which means 'fabric for carrying things', as it is mostly used to make strong bags. The natural colour is a pleasant, soft, medium beige. In earlier times, when people had little choice of yarn, *kyethag* was used as cloth for wearing apparel. Sometimes *kyethag* was dyed, mainly red, and a simple pattern woven into the fabric. While the width is usually determined by the size of the bag most commonly used (*phechung*), it can be woven into any width up to 27", the maximum size of the usual backstrap loom.

Nettle-weaving in Khaling Gewog is carried out in Lemi village, about five or six hours' walk from Khaling. This type of weaving is carried out in conjunction with the need for a heavy duty cloth for bags and sacks. Most women can weave with the nettle fibre. Women can also weave the more complex patterns of the *kushüthara* using cotton and silk thread. In Lemi nowadays designs are added, using imported yarn from India.

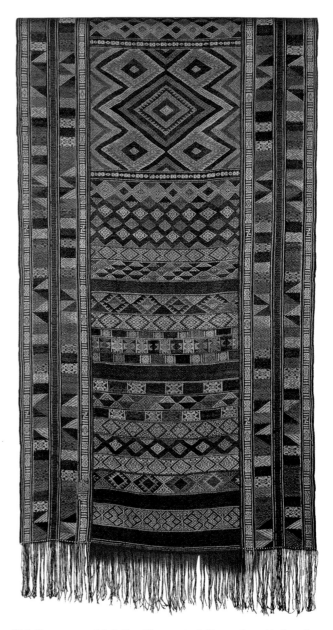

This fine ceremonial cloth with a central diamond motif, chagsi pangkheb, demonstrates the intricate weaving of supplementary-warp and weft patterns in subtle colours. See also p. 26. (E.L.)

Weaving of short staple cotton fibre is carried out in the Mongar and Pemagatshel area as the climate of that area is favourable to the plant. The cotton is harvested, and following the removal of the black seeds, spun on a simple wheel. The natural-coloured fabric is woven on a backstrap loom and then mostly used for domestic applications. The cloth is without any pattern and resembles a heavy handloom cotton.

The weavers around Pemagatshel have developed this craft into woven products with considerable potential for development into designs and colours that could be applied to a far larger market. While the present range of products

(shirts and ponchos, table linen and wall hangings) are quite appealing, with a background of off-white and a pattern in 'Indian red', the options for applying a larger number of designs, natural colours and applications are quite considerable.

TRADITIONAL CRAFTS AND MODERN MARKETS

There are some who say that traditions should not be tampered with. Others might say that when a weaver, for example, has the creativity to pick up any colour she feels suitable, she should be free as an artist to do so, and the finished item is a personal statement of her ability and choice. In some very precise arts and crafts, mainly for religious reasons, rules are laid down as in *thangka* paintings and embroidery or the retelling of the story of Lord Buddha in a mural.

For the most part, however, the crafts of Bhutan have been constantly influenced by the market. Even before the arrival of foreigners and officials, craftspeople were being influenced by the availability of raw materials such as dyes, yarns and metals. Designs, colours, sizes and finished products were also influenced by market demand from its various neighbours. Not only have raw materials and market demand influenced craftspeople, but so has the availability of new technologies. The *thrithag* or pedal loom, for example, came into Bhutan from Tibet to supplement the *pangthag* or backstrap loom. In a similar way the Indian spinning-wheel was faster than the drop spindle. Nowadays these technologies exist side by side, each having its particular advantage over the other.

The craftspeople and producers of Bhutan have an age-old tradition with skills that they have grown up with. The challenge is for them to utilize these for the markets that have been tested successfully by its neighbours, which are already proving receptive to items which have been test marketed on a small scale. This will first require a thorough understanding of locally available raw materials and how they are processed, of the various crafts traditions and how they have evolved, of designs and how they are passed on and developed and of the traditional technology and training.

A vital part of the training, as mentioned earlier, should occur through the formal education system. It is important that when young men and women leave school they take with them an understanding of their craft traditions, a respect for those involved in these activities and a willingness to consider this as a future vocation or profession.

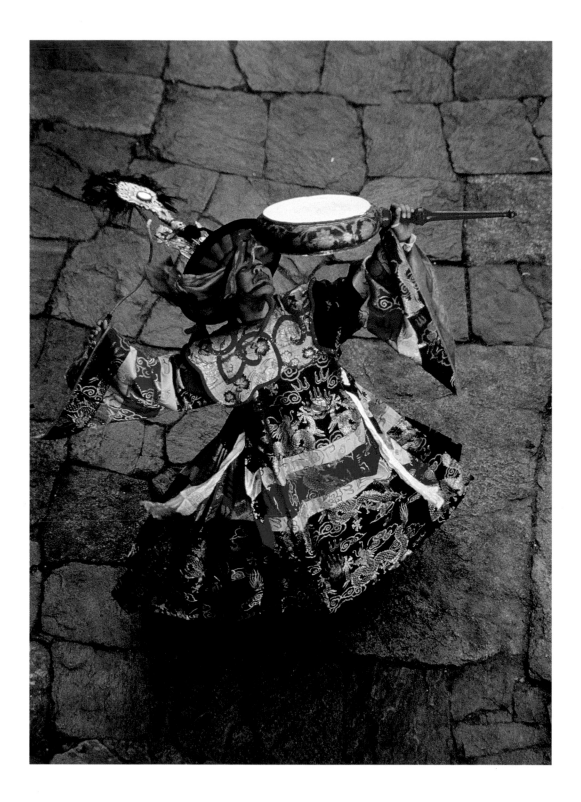

The Shanag (Black Hat) dancers are tantric priests who purify the earth from malevolent forces. (J.W. 1994)

Bhutanese Buddhism

Woodblock for the printing of prayer flags. (E.L.)

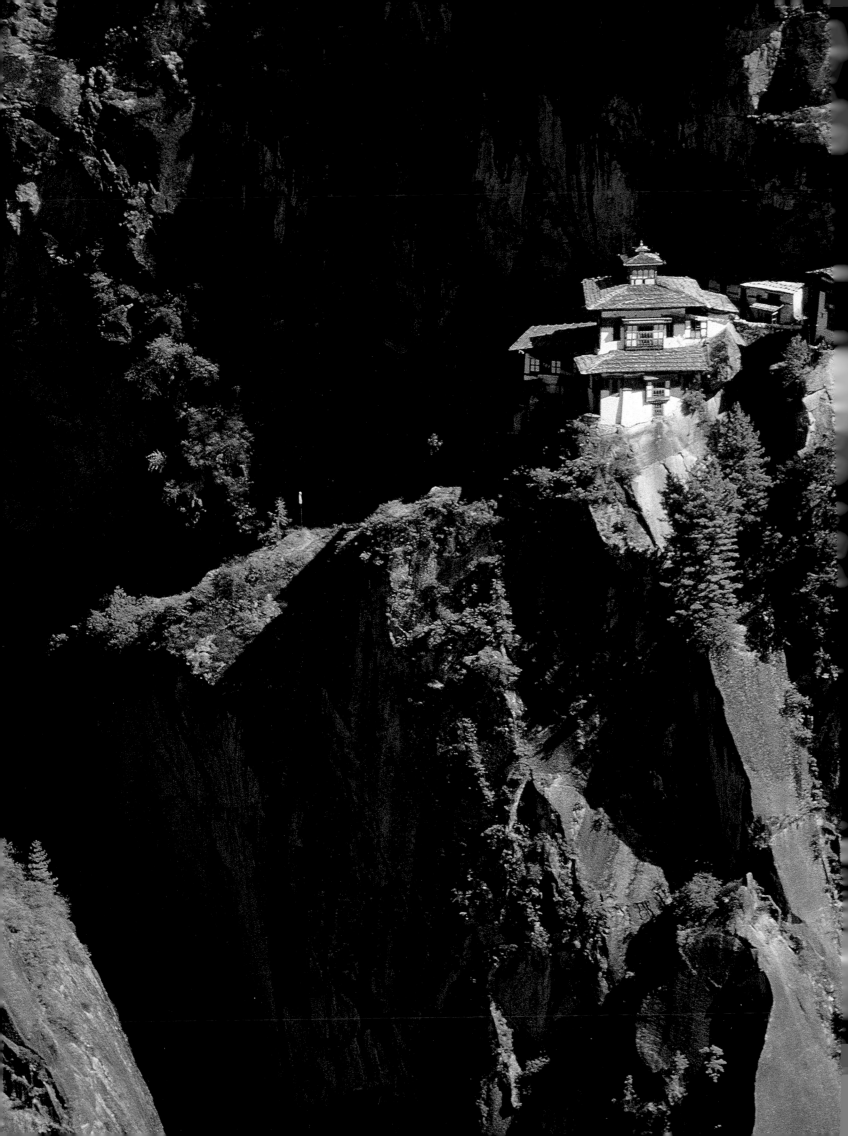

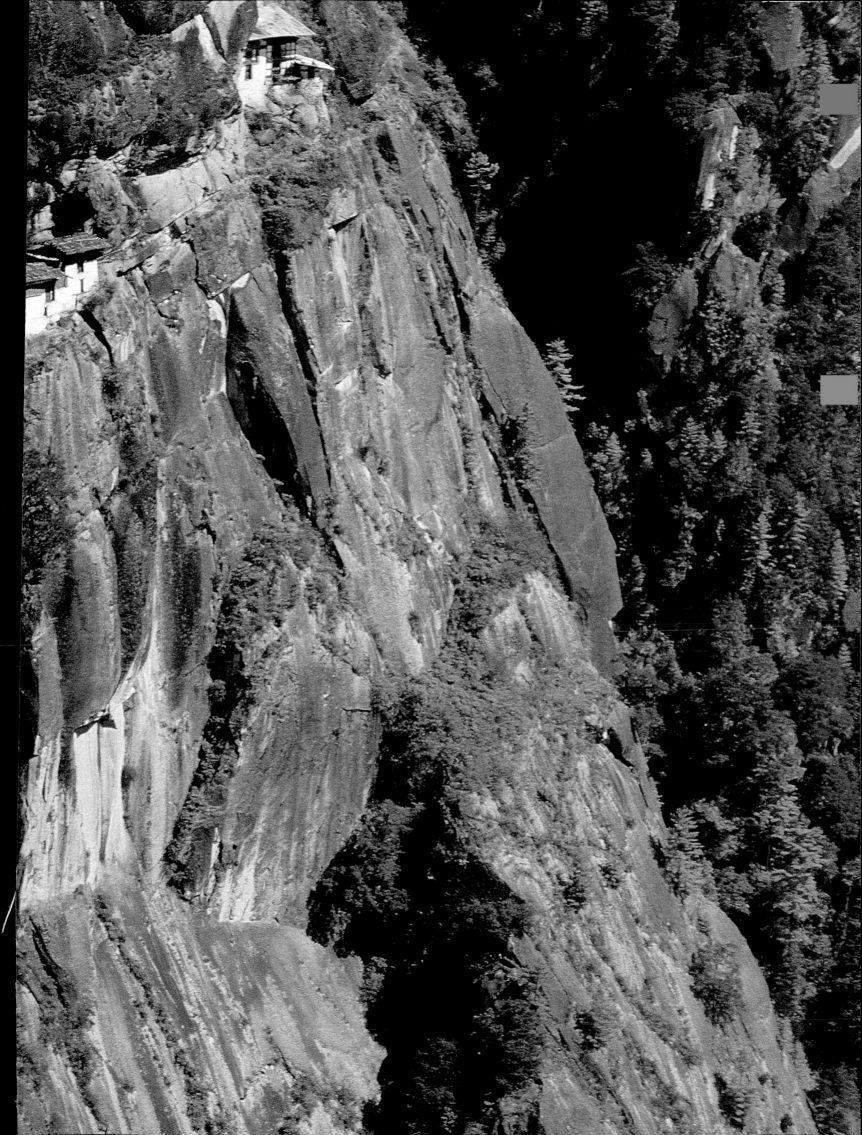

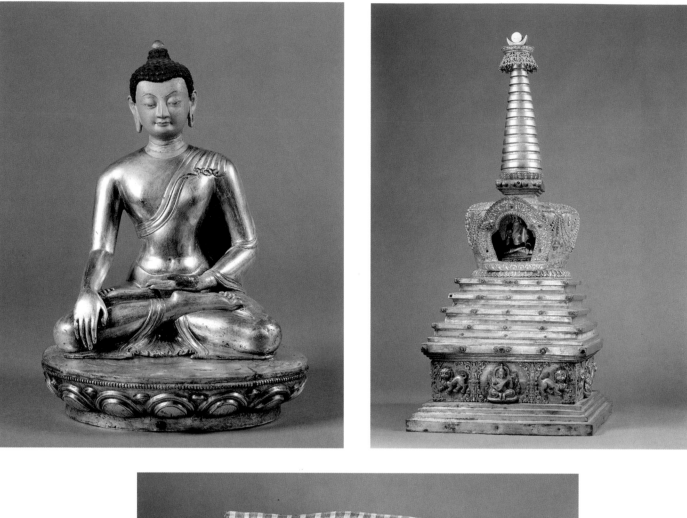

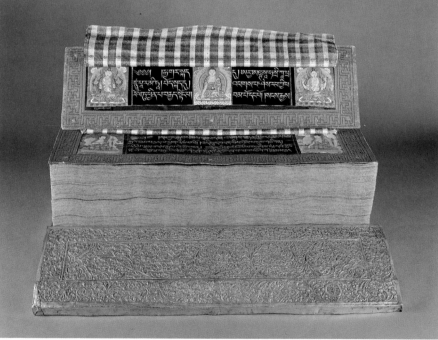

Sacred images of the Buddha, the religious book and the chörten are found in all temples and symbolize the body of the Buddha, his speech and his mind. Here, the Buddha is the historical Buddha Sakyamuni, the book is the Prajnaparamita, a well-known philosophical text, and the 'victory' (rnam rgyal) chörten commemorates the Buddha's voluntary prolongation of his life to help all sentient beings. (E.L.)

Religion and Rituals

Mynak Tulku

It is said that the religious philosophy of Buddhism is as vast and as deep as the ocean, and even in a country the size of Bhutan the different rituals performed by Mahayana Buddhists are so varied that any attempt at a comprehensive summary can do no more than hint at the variety of beliefs and rituals in the religious domain. Buddhist discourse also pervades art and ritual performance.

Lord Buddha is said to have taught no less than 84,000 dharma teachings to combat the 84,000 delusions. He 'turned' (that is, taught) the wheel of Hinayana, the wheel of Mahayana and the wheel of Tantrayana. Almost all these teachings were translated into Tibetan and compiled in the Kanjur (bKa' 'gyur) which runs to 108 volumes, while a collection of 225 volumes known as Tenjur (bsTan 'gyur) contains early Indian commentaries on the Buddha's teachings. The number of volumes of different editions vary slightly.

The different schools of Buddhism define Buddhist philosophical subjects by dividing the corpus of teachings into a more limited number of topics. For example, the Nyingmapa (rNying ma pa) and the Kagyupa (bKa' brgyud pa) traditions divide Buddhist studies into Thirteen Great Texts;[1] the Sakyapa (Sa skya pa) tradition into Eighteen Great Texts;[2] the Gelugpa (dGe lugs pa) into Five Great Texts;[3] and the Kadampa (bKa' gdams pa) into the Six Texts of Kadampa.[4] The Eighteen Great Texts of the Sakyapa tradition include

Previous pages: Taktsang, Paro Valley. The temples of the Tiger's Lair date from the end of the 17th century and were commissioned by the 4th Desi (Regent) Tenzin Rabgye. See also p. 29. (G.N./T.W.B.)

two books written by the school's own master, Sakya Pandita Kunga Gyeltshen (Kun dga' rgyal mtshan; 1182–1251). All the texts studied by the other schools are translated into Tibetan from the original Sanskrit.

All schools have also to study other philosophical books written by Indian scholars as well as their own scholars, and also books on rituals. In all the traditions the curriculum requires monks to study for many years under great masters. On completion, they are awarded degrees by their respective schools: *kashi* (bka' bshi); *kachu* (bka' bcu); *kachen* (bka' chen); *geshe* (dge bshes); *rabjam* (rab 'byams). Degrees are awarded by different schools for successful completion of 5, 13 or 18 Great Texts. The Sakyapas are said to have been the first to introduce degrees at the conclusion of the course of studies on the basis of proficiency in dialectical debate.

Bhutanese Buddhism belongs to the Mahayana tradition; it is therefore important to describe briefly the different branches of Buddhism as reflected in the texts of the Mahayana scholars. Buddhism is generally divided into two great schools: the Mahayana or 'Greater Vehicle', and the Hinayana or 'Lesser Vehicle', nowadays more commonly known as Theravada. The Sanskrit word yana, meaning 've-hicle', suggests a path, a means of leading sentient beings to higher states dependent on their capabilities. These yanas are the 84,000 branches that the Buddha taught for the benefit of all sentient beings.

In actual fact the situation is more complex. In the early days of Buddhism, three vehicles known as the Triyana, developed. These were: Nyentho Thegpa (nyan thos theg pa,

Skt. Sravaka Yana) or 'Hearer Vehicle'; Rangyel Thegpa (rang rgyal theg pa, Skt. Pratyeka Buddha Yana) or 'Solitary Realizer Vehicle'; and Thegchen Thegpa (theg chen theg pa, Skt. Mahayana) or 'Greater Vehicle'. The first two belong to the Hinayana. The Mahayana is, in turn, divided into two vehicles: Pharchin Thegpa (phar phyin theg pa, Skt. Prajna-paramita Yana) or 'Perfection Vehicle'; and Ngagi Thegpa (sngags kyi theg pa, Skt. Mantrayana) or 'Mantra Vehicle'. The latter is sometimes referred to as Vajrayana, a transla-tion of the Tibetan term Sang nga Dorje Thegpa (gsang sngags rdo rje theg pa).

In India, the birthplace of Buddhism, four major Bud-dhist philosophical schools developed and some, in turn, developed sub-schools.[5] Vaibhasika, for example, has no fewer than eighteen sub-schools. The Vaibhasika and Sautrantika schools are considered to belong to the Hinayana tradition, and the Yogacara and Madhyamika philosophical schools are considered to be Mahayana. The theories and histories of these schools are discussed in many sources and lie outside the scope of this introduction.

Buddhism came to Tibet and Bhutan in the seventh century AD and, in due course, it developed into different schools. Four great schools predominate in the region.[6] There are also sub-schools,[7] and minor schools.[8] Another tradition divides the schools into Eight Great Traditions or Teachings (sgrub brgyud shing rta chen po brgyad),[9] excluding the Gelugpa school, which was the last to appear in Tibet.

Unlike the schools of Indian Buddhism, which are named after their theories, the schools of Tibetan and Bhutanese Buddhism are named after the period during which they were established, the instructions on which they were based, or the places where they originated. Buddhist doctrine in general is divided into two groups: Do (mdo, Skt. sutra) or discourse, the Buddha's teachings other than his tantric teachings; and Nga (sngags, Skt. mantra), secret teachings, consisting of tantric doctrine. In the sutra teachings there are no divisions into 'new' or 'old'. However, all the Bud-dhist tantras or secret teachings that were translated into Tibetan before the time of Pandit Jina Mitra, who was invited to Tibet by King Tri Relpachen (Khri Ral pa can; 866–901), are called Nyingma, or 'old'. Translations by Rinchen Zangpo (Rin chen bzang po; 958–1051) and others after the assassination of the Tibetan king Langdarma (863–906) are called Sarma, or 'new'; these terms refer to historical periods. Other schools such as Kadampa, Kagyupa, Dzogchenpa (rDzogs chen pa) and Chagchenpa (Phyag chen pa) are

The 67th Je Khenpo Ngawang Trinle Lhundrup (1971–87), also known as Nyizergang Trulku, at Tashichödzong in Thimphu. (F.P. 1982)

named with reference to the practices and instructions on which they are based, while the Sakyapa, one of the four main schools, and Drigungpa ('Bri gung pa) and Talungpa (rTa lung pa), which are sub-schools of the Kagyupa, are named according to the area where their first monasteries were built by their founders.

Sectarianism is only one aspect of contemporary Himal-ayan Buddhism. There is also a non-sectarian movement, one of whose greatest teachers in this century was Jamyang Chökyi Lodrö ('Jam dbyangs chos kyi blo gros) who passed away in Sikkim in 1959. He discussed the various schools of Buddhism in a small book, *A Brief Discourse on the Essence of All the Ways: The Opening of the Door to the Dharma*, which he composed just before his death at the request of the Political Officer of India in Sikkim. The first, and still the best, expression of the thought of the Rime (ris med) or 'non-sectarian (or non-partiality) movement', of which he was a great scholar and which developed in Tibet in the middle of the nineteenth century, is a monumental treatise entitled *Sheja Kunchab*

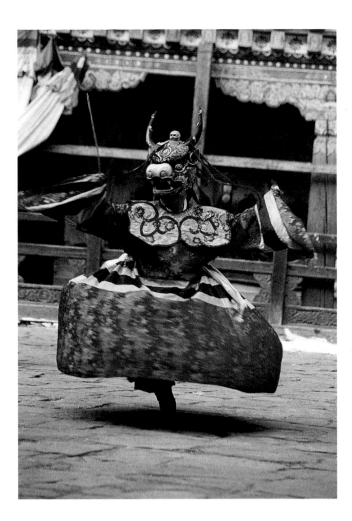

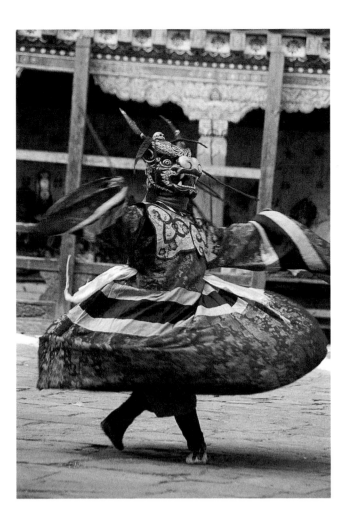

The Shinje Yab Yum dance is performed at the beginning of religious dance festivals and represents the bodhisattva Manjusri as the Lord of Death. (J.W. 1994)

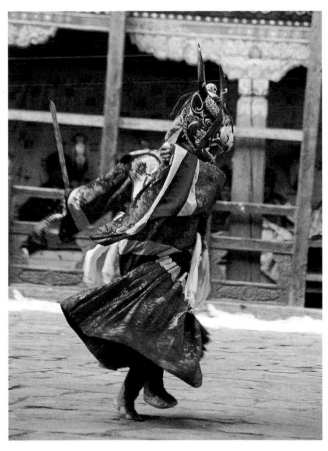

(Shes bya kun khyab), *Encompassment of All Knowledge*, written in three volumes by Kongtrul Lodrö Thaye (Kong sprul blo gros mtha' yas; 1813–99).

Buddhism as practised and studied by the four major schools of Tibetan Buddhism is taught in different ways. The Kagyupa, for example, have special meditation teachings known as the 'Six Yogas of Naropa'.[10] The Nyingmapa have nine methods called 'Nine Vehicles' (or paths),[11] and the Sakya-pa have teachings called 'Views of Paths and Fruits'.[12] The curriculum of textual study also differs from school to school.

Generally speaking, however, all the schools use two kinds of texts. First, there are Tibetan translations of original Sanskrit works (now often lost in the original language), accompanied either by commentaries written in Sanskrit and translated into Tibetan, or written directly in Tibetan. Second, there are philosophical treatises written by the masters of each school, also often accompanied by commentaries.

Commentaries, frequently written by local scholars, are particularly important for novice scholars as they begin to study the texts. The easiest commentaries are called *chendrel* (mchan 'grel), and consist of notes written in small letters on the root text itself in order to make the text accessible to the beginner. The more advanced commentaries on each text, written by scholars from different schools of Buddhism, are books in themselves, which fall into different categories such as *kadrel* (dka' 'grel), commentaries on difficult points, *gyachar drelpa* (rgya char 'grel pa) extended commentaries, and *namshe* (rnam bshad), detailed commentaries. Besides these commentaries, it is important to memorize the text and its synopsis called *sache* (sa bcad).

The existence of different schools, each with its primary texts and commentaries, and with different ritual performances and protective and mountain deities, should not lead to the assumption that the various Buddhist schools are radically different one from the other. Quite the contrary. All schools accept the main core of Buddhist philosophical teaching, all take refuge in the Three Jewels (the Buddha, his teachings and his followers), all accept the 'Four Truths' at the core of Buddhist theory.[13] All the above may be summarized as Buddhist practice, as stated in the sutras:

> *To refrain from all evils,*
> *To accumulate good*
> *And to purify one's own mind*
> *Is the teaching of the Buddha.*

RELIGION IN BHUTAN

Bhutan is the only independent Mahayana Buddhist country in the world today. It is generally thought that Buddhist teachings arrived in Bhutan in the seventh century AD, when the first two temples were built in the country. Kyichu Lhakhang in Paro, western Bhutan, and Jampe Lhakhang in Bumthang, central Bhutan, were built in the first half of the seventh century by the Tibetan king Songtsen Gampo (Srong btsan sgam po; 629–710), who is credited with the construction of 108 temples in one day.[14] Lhakhang Karpo and Lhakhang Nagpo, both in Bhutan's Ha valley, also come from this same period.

The major growth of Buddhism in Bhutan started in the eighth century AD with the visit of Padmasambhava, also known as Guru Rinpoche. His teachings laid the foundation for one of the most important and unifying forces in the development of Bhutan's unique cultural and religious tradition. There are countless stories about the ways in which Padmasambhava subdued the local deities of the Bön religion, which was practised in Bhutan and other parts of Central Asia before the introduction of Buddhism and its acceptance by the people. Many of the mountains and local deities which the people worship today were originally Bön gods who, as a result of Padmasambhava's work, were taken into Buddhism as protector deities. Taktsang Temple in Paro and Kuje Temple in Bumthang are some of the well known sacred sites in Bhutan associated with Guru Rinpoche.

The dates of Guru Rinpoche's visit to Bhutan raise important questions concerning the first appearance of Buddhism in the country. Gedun Rinchen (dGe 'dun rin chen), the 69th Je Khenpo (head of the monastic institution in Bhutan), determined that Padmasambhava visited Tibet in 749.[15] Based on this date, and on the biography of King Sendarkha of Bumthang, Guru Rinpoche would have visited Bumthang in 737. According to the story, when the king asked Guru Rinpoche to remain in Bumthang, the latter said that he had no time as he had to go to Bodhgaya for twelve years and would also spend one month in Nepal before visiting Tibet.[16] He said he would return to Bhutan later. It is generally believed that Guru Rinpoche visited Bhutan several times, and that the first visit took place in 737, i.e., twelve years before he went to Tibet.

However, old sites and documents suggest that Bhutan's associations with Buddhism date back to several hundred years BC. There are sites in Punakha and Tongsa that are connected with the story of King Drime Kunden, which concerns previous lives of the Buddha, and goes back to between 2000 and 1000 BC.[17] In Mangde near Tongsa, old people claim that the name of the Mangde valley derives from Mende Zangmo (Men sde bsang mo), Drime Kunden's queen, who spent twelve years in exile with her husband; the valley, they say, was originally called Mendelung, the valley of Mende Zangmo. King Drime Kunden and his queen were condemned to spend twelve years in that remote area as punishment for giving away the Royal Gem to an old Brahmin, who had been sent by an enemy king to capture it.

Another important site associated with the story of Buddhism in Bhutan is the stupa at Sharadzahog (Shar ra dza 'og), where tooth relics of Buddha Kasyapa (Sangs rgyas 'Od srung), regarded as the third Buddha (Gautama Buddha, Sakyamuni, the historical Buddha, is considered to be the

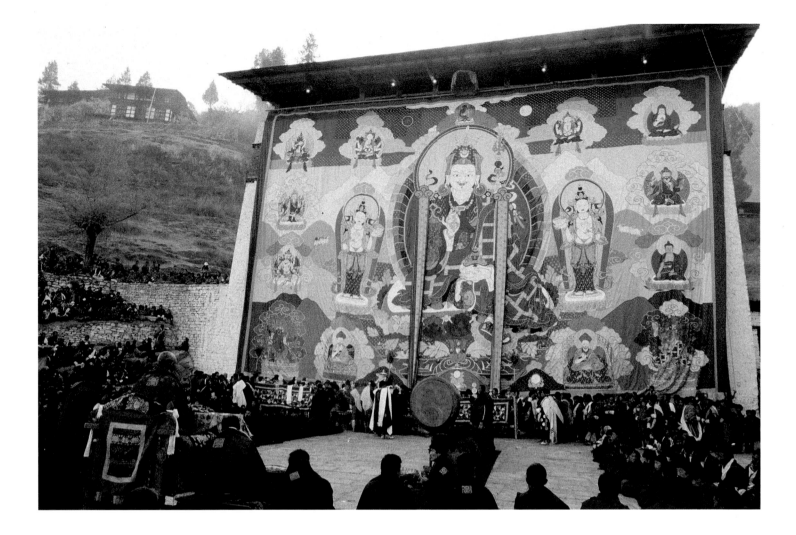

A large banner is unfurled at dawn on the last day of the Paro festival. It depicts Guru Rinpoche together with his two consorts and eight manifestations. It is believed that by the simple act of viewing this banner, one is delivered from all future reincarnations, whence its name 'thongdröl', 'the thangka which liberates by sight'. (F.P. 1982)

fourth among the one thousand Buddhas to be born in this eon), together with writings were discovered at the beginning of this century. The 69th Je Khenpo, Gendun Rinchen, believed that Arjuna of the Pandavas (of the Indian epic *Mahabharata*) brought the tooth relics to Bhutan and built a shrine for them;[18] the historian Lopön Nado (slob dpon gNag mdog) states that the relics were brought by an Indian king named Ugten (dBugs bstan).[19] There are records suggesting that Ugten was a contemporary of King Tri Relpachen (866–901) of Tibet. A textbook on the history of Bhutan for classes 9 and 10, recently published by the Department of Education, states that the stupa was built by a prince Arjuna, a disciple of the Indian Buddhist philosopher Nagarjuna, who lived at the end of the first and the beginning of the second centuries AD.[20] Archaeological excavations will be necessary to clarify the history of the stupa.

The name Sharadzahog, the location of the above mentioned stupa, means 'east (place) under the king'. It occurs in a work by the 10th Je Khenpo, Tenzin Chögyel (bsTan 'dzin chos rgyal; 1755–62), where it is spelled 'Sharatshohog' (Shar ra mtsho 'og).[21] He claimed that originally the name must have been 'Radzahog' ('under the Raja'), and that it was a place where an Indian prince came and built a palace, a belief that was confirmed by a relic found by Bhutan's first king when he was renovating the stupa. It was said that this relic was found in an earthen casket inside a stone box on which were writings in an Indian language that stated that the box contained relics of Buddha Kasyapa, the third Buddha. The relics are now looked after by the Thimphu/Punakha Monastic Body. Every year the public can receive the blessing of the relics on the fourth day of the sixth month of the Bhutanese calendar, which is the day on which the Buddha gave his first sermon in the Deer Park at Sarnath. This is a national holiday in Bhutan.

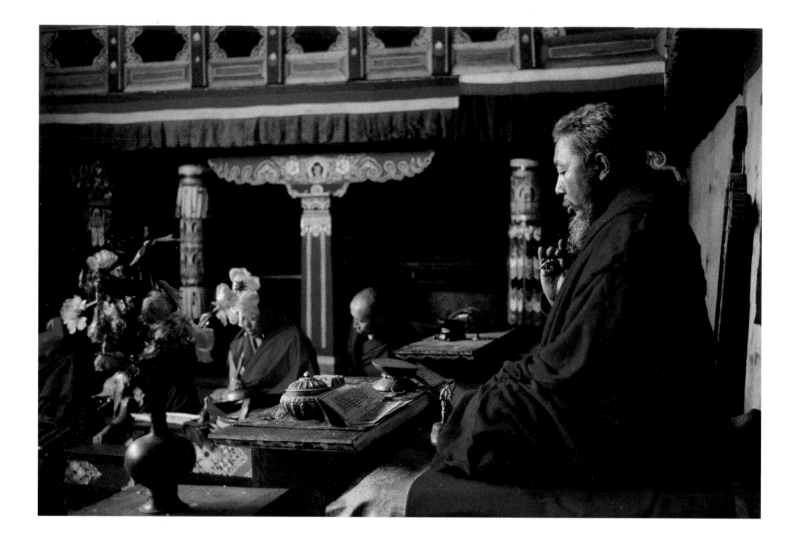

*Presided over by a reincarnate lama (trulku), a ritual for long life takes place in Tamshing monastery in Bumthang. (*c.s. 1996)

According to Tenzin Chögyel, after the eleventh century many schools, such as the Sakyapa (Sa skya pa), Nenyingpa (gNas rnying pa), Lhapa (Lha pa), Drigungpa ('Bri gung pa), Shingtawa (Shing rta ba), Nyingma Katerpa (rNying ma bka' gter pa), Chagzampa (lCags zam pa), Gandenpa (dGa' ldan pa) and Kardrugpa (Kar 'brug pa), propagated their teachings.[22] From the thirteenth century on, many Tibetan masters came to Bhutan to propagate the teachings of their schools. Many of these schools were able to establish only small temples, and in the course of time they merged with other schools. Today, the Drukpa sub-school of Kagyupa is the state religion of Bhutan, but the Nyingmapa school also has wide currency.

The Shabdrung Ngawang Namgyel, who unified Bhutan into a single state and built many fortress-monasteries (*dzong*), codified the teachings and traditions of Buddhism now followed in Bhutan. To uphold these traditions, he appointed eight great disciples in the fields of transmission of the lineage, oral tradition, religious law and ritual, which are carried on today as the living tradition of the country.[23]

RITUALS

Mahayana Buddhist rituals are one of the most important parts of everyday Bhutanese life; they are indispensable in the day-to-day life of the people. Before discussing some of the more important rituals, a short survey of the basic requirements of a Buddhist ritual performance is necessary.

Mandala (*kyilkhor*)

In Buddhism different mandalas are used for different rituals; each deity has its particular mandala. A mandala or *kyilkhor* (dkyil 'khor) is a kind of blueprint suggesting the palace of the deity, its doors, its gates and the locations of the main deity and its retinue. Mandalas are used for visualization, for self-generation and for initiating a disciple into the various mandala deities. Mandalas are required for rituals such as

initiation, fire-offerings, consecration, prayers for departed persons, and even for cremations. They are made in various ways; some are three-dimensional, intended for permanent use, others are flat and constructed out of coloured sand, carved onto metal or stone, painted on cloth or printed on paper. In addition, there are mandalas which, like *thangkas* (Buddhist scroll paintings), are hung or painted on temple walls. Mandalas may also be painted on the ceilings of temples or on gates, where they are intended to bless those who pass beneath.

There are various rules for the construction of a mandala on a new site, which also requires the permission of both the human and the non-human owner, such as the goddess of earth. The lamas make offerings of ritual cakes and other substances to gain permission to use the site.

Ritual dough offerings (*torma*)

Many Mahayana Buddhist rituals require ritual objects such as several kinds of *torma* (gtor ma; Skt. bali) and musical instruments. *Torma* are normally made of parched barley flour and decorated with designs in butter. There are different designs and different-coloured *torma* for each deity and each purpose. Each Buddhist school has its own ancient traditions of *torma*-making. The traditions of *torma* design are so well established that a Buddhist priest knows simply by looking at a *torma* what ritual prayers are being performed by which Buddhist school. Above is a drawing of some of the *torma* made in the Pema Lingpa tradition.[24]

Each *torma* has a symbolic purpose: it may represent a deity, serve as an offering to a particular deity or be used to expel evil spirits after a ritual. There are many kinds of *torma*. One may represent the main deity in a prayer, during which the deity or deities are invoked. Another kind of *torma*, the *wangtor* (dbang gtor) or 'torma of initiation', becomes the actual deity being invoked and imparts initiation when the master places it on the head of a disciple. There are *torma* used as food offered to the deities. Melted butter is used as a binder.

The origins of *torma* can be traced back to the Buddha's own time, and several of the rituals performed then are still carried out today in Mahayana Buddhism. One such ritual, *gyashi* (brgya bzhi), meaning 'four hundred', involves the use of 100 butter lamps, 100 *tsatsa* (miniature stupas), 100 ransom *torma* – which represent the life of the person for whom the ritual is enacted and function as a type of ransom, and 100 morsels of food for the gods; the ritual is performed in the four directions. It is said that this particular ritual was performed by the Buddha at the request of the god Indra, who had fallen ill due to the influence of four evil forces.[25] Several stories from the Buddha's own time relate how he was requested to give *torma* for the hungry ghosts and other beings.

The shape, materials and ways of making *torma* have changed according to what is available in each region. In India, for example, a *torma* may consist of offerings of fruit, grain, milk, butter, sweets; in Bhutan, *torma* are made with barley flour or cooked rice, and some require mixing of substances such as the Five Precious Objects,[26] Five Grains,[27] and Six Aromatics.[28] Three white substances (such as butter, curds, and milk) and three sweets (such as sugar, honey, and molasses) may be mixed to gain certain powers. The use of the five grains is believed to overcome poverty and famine, while the six medicinal aromatics are thought to overcome illness and epidemics.

Each deity has its own particular design, combining colour and shape. For example, white-coloured cone-shaped *torma* are used for peaceful deities; red triangular *torma* are for wrathful deities. Three-sided *torma*, usually coloured red, are used as weapons to expel evil spirits and are normally thrown out at crossroads on the ninth, nineteenth or twenty-ninth day of a month at a time and in a direction fixed by the astrologers. A cross of coloured threads, known as *dö* (mdos)

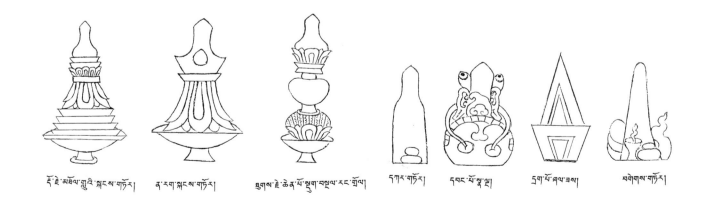

རྡོ་རྗེ་མཁའ་འགྲོ་མའི་སྐོང་གཏོར། ན་རག་སྐོང་གཏོར། བྲུལ་རྗེ་ཆེན་པོ་སྤྱག་བསྩལ་རང་གྲོལ། དགར་གཏོར། དབང་པོ་སྒྲུ་ལྔ། དུག་པོ་ཞལ་ཟས། བགེགས་གཏོར།

and believed to have been introduced by Guru Rinpoche, is used with the *torma*. The pre-Buddhist Bön religion also uses these kinds of *torma,* as well as the coloured thread-cross designs, in its rituals. Two wooden sticks are bound together in the shape of a cross on which coloured threads are woven to create a cobweb-like structure. These can be very simple or very large and complicated, measuring up to a few metres in size. They represent a particular deity's palace and its surroundings. There are representations of weapons, animals and objects belonging to the deity. After days of prayer, these are destroyed and cast away along with ransom offerings, normally represented by an effigy of a person. These are used as devices to which all the evil and sickness of an individual or a community are transferred and thereby eliminated. Such offerings take many forms and differ according to tradition and deity. Every year in many of the temples, monasteries and *dzongs* the ritual of casting away *torma* is performed on the twenty-ninth day of the last month of the year, in some places accompanied by dances. These *torma* embody all the evil and misfortunes of the community and end the negativities of the previous year.

Mention must also be made of the *tshog* (tshogs) or 'feast offering' (representing food). The *tshog* is usually made of barley mixed with butter, local wine and brown sugar. Red-coloured *tshog* shapes are usually decorated with coloured butter on the top. The top is pointed and represents wisdom; the base is round, symbolizing peace. The *tshog* can also be any edible substance like cakes or fruit. Normally it is accompanied with different fruits and sweets; together they are offered with prayers to the 'field of merit', the assembly of all Buddhas, bodhisattvas, meditational deities, etc. This ceremony forms part of most rituals, and the offerings are distributed to the participants and others at the end as a blessed food.

Ritual practitioners (*lama, ngagpa* and *gomchen*)
Important rituals are presided over by monks, tantric masters or married lay religious practitioners (*gomchen*). They must have received initiation (dbang), authorization (lung) and explanation (khrid) from their particular teachers, and completed the full mantra recitation retreat of the particular deity being invoked before they are qualified to preside. Other lamas (bla ma), *ngagpas* (sngags pa), and *gomchens* (sgom chen) who participate in the rituals must have received appropriate initiation or at least the authorization of the text of the ritual. Knowing how to carry out a particular ritual is not sufficient.

For each higher meditational deity there is a particular initiation, followed by authorization; this must be given by a teacher who has received it through an unbroken lineage of a particular school. An initiation can take from a few hours to many days, and it empowers the disciple to practise the tantras in order to attain Buddhahood.

Each initiation involves many rituals at different stages: the vase initiation, crown initiation, vajra and bell initiation and name initiation – when each disciple receives a secret name from his master. Normally initiation is followed by authorization, which involves reading the entire text by the master without much ritual. This gives the disciple permission to study the book. The third stage is explanation of the text. When one cannot attend an initiation ceremony, one may go to a high lama to receive authorization to read or practise a particular text. Each major school has collected initiations which can last months when performed together. In addition to these initiations, authorizations and explanations, monks undergo training to perform particular rituals. For example:

Choga (cho ga) rituals and *chaglen* (phyag len) traditions of ritual practice require training in the particular tradition of a specific school, monastery or master passed down the generations.

Nga (sngags, Skt. mantra) and *chagya* (phyag rgya, Skt. mudra) involve learning the correct reading of mantras, which are words of power in Sanskrit, and performing mudras, the hand gestures that accompany the reading of mantras or other prayers, since the movements of the hands represent implements and other ritual elements.

Dang (gdangs) and *yang* (dbyangs) are the rhythms, intonations and elaborations of a particular line in a ritual text. *Yang* is more elaborate than *dang*. Each school has its own written notation system. Below are some notations according to the tradition of Pema Lingpa.

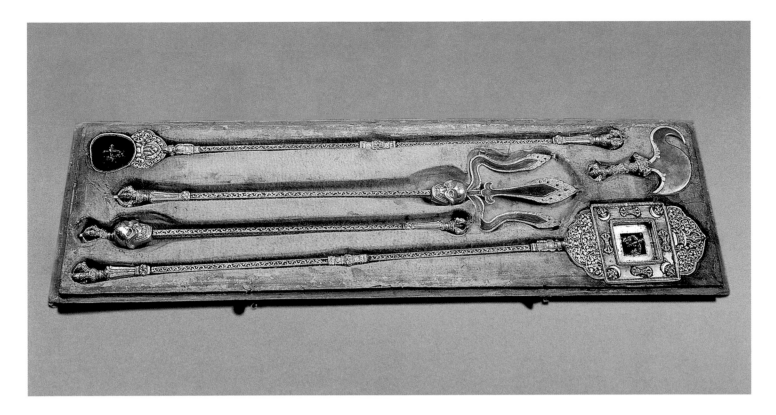

Set of five implements for the fire-offering ceremony; these are the gangzar (dgang gzar) and ganglu (dgang blugs), which are the two ladles the tsesum (rtse gsum) which is the trident, the drigu (gri gugs), the cutting knife, and the yutho (dbyug tho), the stick.

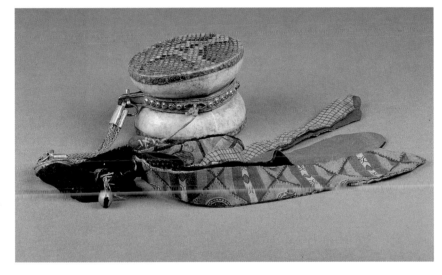

Small double-sided drum (damaru).

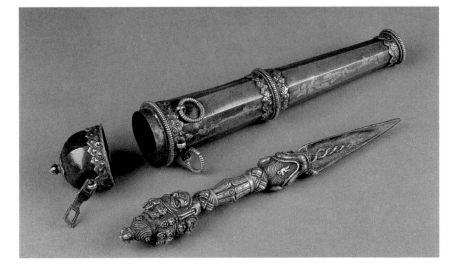

The magical dagger (phur bu) is employed to ward off or pin down malevolent forces but is also used to symbolically kill them, thereby liberating their mind into higher realms. (E.L.)

Thig (thig) lines or drawings, and *dultson* (rdul tshon) coloured sand, refer to the drawing of lines for the preparation of mandalas according to specified sizes and ratios and the construction of the mandala with coloured stone powder and sand according to the traditions of the particular school.

Gar (gar) and *cham* ('cham) are two kinds of religious dance, which many monks have to learn. The first reference to religious dances performed in Bhutan concerns the *cham* performed by Guru Rinpoche at Kuje Temple where he subdued the demon Shelging Karpo (Shel ging dkar po) and made him one of the protective deities of that temple, before his visit to Tibet. Bön religion practised *cham* dancing, but it is usually assumed that the first Buddhist *cham* was performed by Guru Rinpoche at Samye, the first monastery built in Tibet in the eighth century AD. *Gar* refers to dances performed by monks around mandalas indoors as well as outdoors, without masks, in a calm, peaceful manner, with slow movements of the hands holding bell and vajra or hand drums. *Cham* are dances with masks or black hats, performed in a forceful or wrathful fashion, executed with an emphasis on vigorous foot and hand movements. *Gar* and *cham* both have dual purposes for believers. Those watching the sacred dances receive blessings through their enjoyment of the performances, while those dancing are making offerings to the Buddhas, bodhisattvas and others who are invoked by the dances.

No outline of Bhutanese religious practice would be complete without mention of the specific rituals of consecration, fire-offering ceremony, purification rite of incense-burning in honour of mountain deities and ritual offerings to the protective or local deities.

Consecration (rabne)

Upon completion of a temple, an image or a house, people invite lamas to perform a consecration ceremony known as *rabne* (rab gnas) on an auspicious day fixed by an astrologer. The consecration ritual is long, with recitations on self-generation, vase-generation, purification, the opening of the eyes, and so on. It is important to hold a consecration ceremony, particularly for images, because according to texts on consecration, misfortune ensues if a completed image remains without being blessed for a long time; as long as it has not been consecrated, it is unfit for worship. The books also speak of the advantages that derive from consecrating images.

The main purpose of the consecration ritual is to invite the wisdom beings from their pure Buddha-fields through the power of the practitioner's meditation, the potency of the ritual and the devotion of the hosts. The wisdom beings are invited, merge into the object being consecrated, and their presence is sealed by the procedures of the ritual until the object is damaged by any of the four elements.[29] Thus the object is blessed and becomes sacred.

A similar ritual called *argha pöcho* (ar gha spos cho), a de-consecration or transformation ritual, is performed when a consecrated image has to be repaired or renovated. In this case the wisdom beings are transferred into a mirror, which is then covered with a red cloth and ritually sealed. Once the image is restored, the mirror is ritually uncovered and the wisdom beings return to the repaired image.

However, Sakya Pandita said that the need for consecration was not specified in the sutras, and in his book, *The Right Practice of Different Views* (*Domsum Rabgye*), he wrote:

> Consecration of images is not taught in the Sutras.
> However, if blessing ceremonies and offering rituals
> on auspicious occasions,
> Such as those performed for a king at his enthronment
> are consecration rituals,
> Then one may say that consecration rituals are taught
> therein.[30]

Fire ceremony (jinsek)

The Sanskrit term 'homa' is rendered as *jinsek* (sbyin sreg, 'give/present' and 'burning') in Tibetan. Generally fire-offering rites are conducted after completion of a long retreat, during ritual ceremonies and on the construction site of temples or stupas. As already mentioned, many monks undergo required meditation retreats after receiving initiations. The performance of fire-offering rituals please the deities who help the disciple to gain accomplishments on the path. They also serve to remove obstacles and the faults of incorrectly or incompletely recited mantras.

There are four types of fire-offering rituals: peaceful (shi wa), increasing (rgyas pa), subduing (dbang) and forceful (drag po); there are also fire-offering ceremonies based on many meditational deities. The basic rituals and ceremonies are the same. They require preparation of sites, drawing of mandalas on which the fire-offering rites are set, as well the preparation of the required substances. These substances are placed on tables, which are covered with the appropriate colour, and the same colour characterizes the clothing which the master or the ritual practitioner is required to wear for the ceremony.

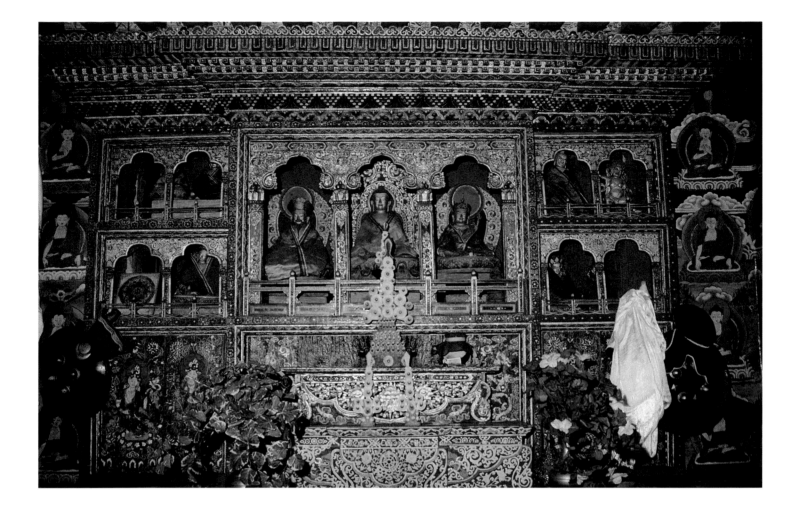

Generally a peaceful fire-offering ceremony is performed to overcome the results of unwholesome actions or obstacles and defilements, while the purpose of performing an increasing fire-offering ceremony is to expand wealth, wisdom and merit and to gain longevity. A subduing fire-offering ceremony is performed to subdue forces harming sentient beings; the forceful fire-offering ceremony is conducted to banish negative forces. Each of these ceremonies requires differently shaped mandalas, which are placed under the fire and may differ from tradition to tradition. When these four ceremonies are performed together, each master of the ritual has a different coloured cloth and direction: peaceful, white and east; increasing, yellow and south; subduing, red and west; and forceful, black or dark blue and north. Each substance offered in the fire, including the wood used for each category, is dictated by the texts, such as kusa grass for protection from impurities, butter to increase the life span, sesame seeds to remove sins, mustard seeds to clear obstacles, barley to gain rapid accomplishments, wheat to overcome illness, and so forth. The various sites on which these fire-offerings are performed, the dates and times, the source of the fire to light the offering ceremonies and even the way to put out the fire with water or with water mixed with milk, are all specified.

Rites of cremation also belong to the category of fire-offering rituals, and each school generates a particular deity for the purpose. The body, consisting of flesh, blood and bone, is transformed by meditation into nectar and offered to the fire deity, while each substance is offered to banish the sins and defilements of the departed person.

Deity invocation and incense-burning rituals (*lhasang*)

Invocation of local and protective deities and incense-burning rituals for the mountain deities are everyday rituals in Bhutan. Every locality, mountain, temple, lake or small spring has its deities, which are worshipped by the local population. Every morning the head of the household burns leaves or aromatic or perfumed herbs in front of a stupa-shaped burner as *sang* (bsangs), purification, in honour of the mountain deities. In this landlocked country, in olden days travellers had to cross mountains on foot; on reaching each summit, an incense-burning ceremony would be performed and the deity invoked by placing a prayer flag on the pass or at least putting a few stones on a *lhatse* (lha rtse), a pile of stones decorated with prayer flags. On special days a single flag is also raised on every house, and particular deities are invoked. The origin of invocation and purification rites of incense-burning goes back to eighth century Tibet. It is said that to celebrate the successful completion of Samye monastery, Guru Rinpoche and King Trisong Detsen (Khri srong lde btsan; 790–844) performed this ritual on Hepo Hill near Samye on the tenth day of the fifth month. As the whole valley was filled with the fragrance of incense smoke, the day was named *zamling chisang* ('dzam gling spyi bsangs), 'world purification day'. The day is still marked with the burning of incense and is dedicated to the mountain deities.

As mentioned earlier, many of the local deities were originally Bön deities, converted to Buddhism by Guru Rinpoche. They were bound by oath and incorporated into the Buddhist pantheon. Each one has its own prayers, composed by the saint who subdued and introduced the deity into Buddhism. One such deity is Chundu (Khyung bdud), worshipped in the Ha valley of western Bhutan and by people in other parts of Bhutan and in Tibet. He is mentioned in several of the mountain deity invocation prayers in Tibet. According to the invocation prayer, he has special relations with Vajrapani and Guru Rinpoche, who subdued him and made him a protector of the dharma; he is praised in the prayer as the warrior god of Bhutan, Tibet, China and Sikkim. Bön traditions and rituals are still practised in some parts of Bhutan during the celebration of local festivals. Every year, on the fifteenth day of the tenth month, a man from a particular family of the Bön tradition of Ha valley performs a morning ritual on the roof of Paro Dzong. At the same time this family invites Buddhist lamas to perform annual prayers in the house, an excellent example of coexistence and tolerance between religions.

There are rites performed for birth, marriage, promotion, sickness and death and many other life crises and events. All include the basic rituals of initiation, purification, consecration and the offering of *torma*. Water or incense purification ceremonies are performed for birth, while sometimes simple initiation for long life is performed. Incense and water purification ceremonies and consecrations with the presentation of the eight lucky signs, initiation for long life, etc., are performed for promotions and marriages. Offerings of *torma*, fire-offering ceremonies and the long life initiation are performed against sickness, while fire-offering ceremonies and initiation for a departed person are performed to overcome misfortune in the intermediate state (bar do) and to help rebirth in a better state of existence. Astrology is used to fix dates, times, directions and to predict the future. It plays a very important role in overcoming misfortunes and facilitating ceremonies to avert misfortunes. There are many varieties of divination using dice, rosaries, bootstraps, mirrors, etc., which are performed by lamas and other religious practitioners. *Pawo* and *pamo* (dpa' bo, dpa' mo), male and female oracles, are also consulted for divinations as well as to find missing objects and the like. High lamas and oracles also foretell the future.

All the rituals include a basic set of offerings, whether on the altar in front of images, *thangkas*, books, miniature stupas or even photos of saints and teachers, or around a mandala. Normally the arrangement consists of seven bowls which are placed in a row on an altar or around a mandala. The first two are filled with water for drinking and washing. The third is filled with grains and flowers as crowns for the female deities or with garlands for the male deities; the fourth is filled with grains and a few incense sticks, which represent offerings pleasing to the sense of smell. The fifth is a butter lamp, which is like a sun and moon to illuminate darkness; it represents the dispelling of the darkness of ignorance. The sixth bowl is filled with scented water, intended to soothe the mind. The seventh bowl normally contains a ritual cake as a food offering. In some rituals one may find an eighth bowl filled with grains, which represents music.

Ceremonial butter lamps made of solid gold are rare. Butter lamps are usually made of copper alloy or silver. Today they are lit with vegetable oil rather than butter. The lighting of butter lamps – as an offering of light to deities – is one of the most common means of increasing one's merit. (E.L.)

Opposite: Amitayus (Tshe dpag med) is the deity of Long Life and is represented seated cross-legged and holding the vase containing the elixir of longevity. He is one of the most popular deities in Bhutan. (E.L.)

Left: Green Tara (sGrol ma), the deity of Compassion born from the tears of Avalokitesvara who cried over the sins of mankind. (E.L.)

Below: The Sixteen Arhats were the first of the Buddha's disciples to attain Buddhahood and the Mahayana tradition added two later. Hashang, depicted here on the left, is surrounded by children, and often wrongly identified as the 'laughing Buddha'. On the right is Gopaka. (E.L.)

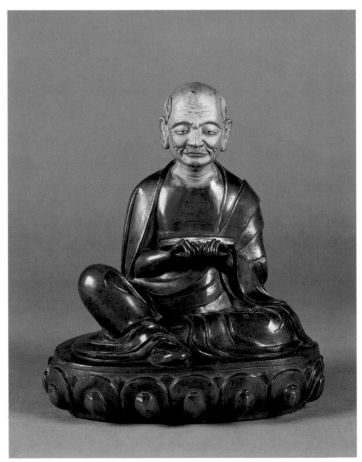

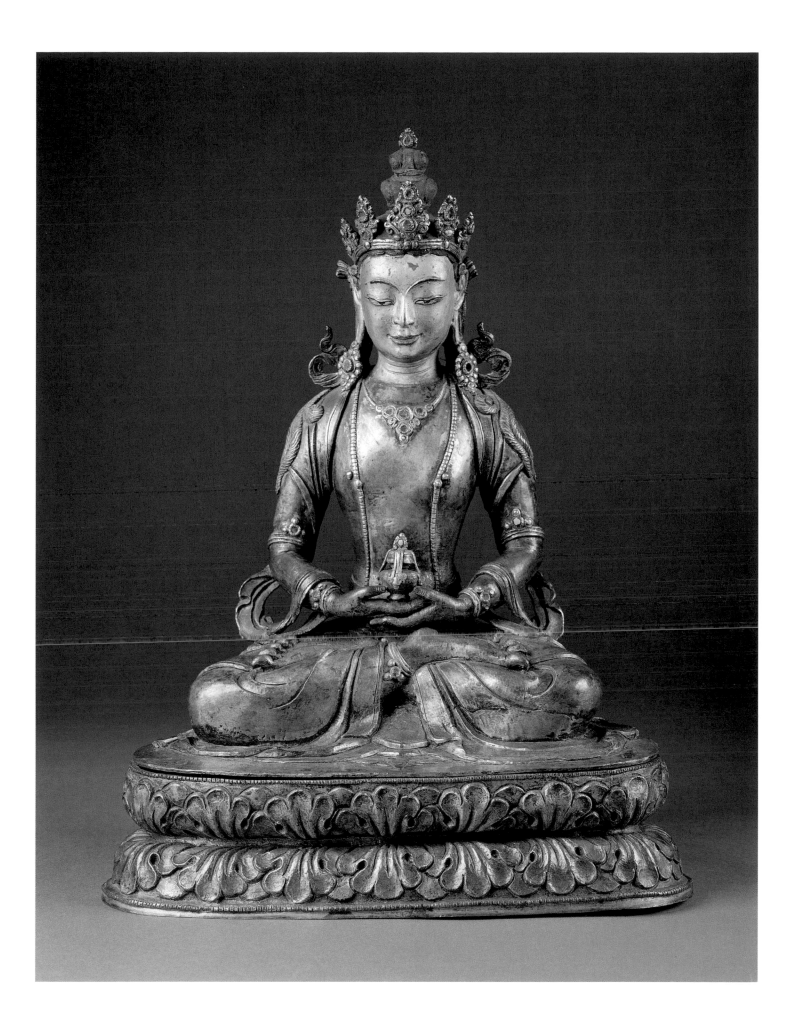

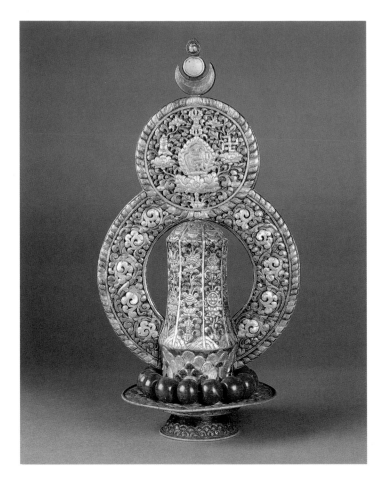

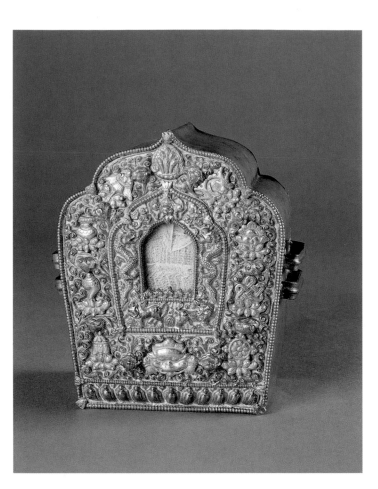

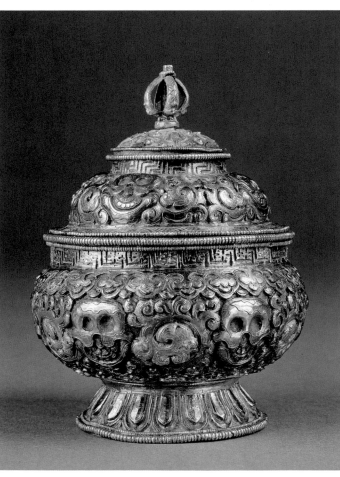

Objects used in religious contexts. Above left: The tshetor (tshe gtor) is a ritual offering used to perform longevity empowerment. Above right: The reliquary is often ornamented as here with the eight ausipicious symbols, and is used as a portable altar or as a shrine on an altar for a specially precious relic. Left: The silver vessel drubphor (sgrub phor) is used for ceremonial offerings. (E.L.)

Opposite: A bumpa is a ritual vase filled with scented holy water. The aspergillum terminates with a gold medallion from which the faithful are given water into the palm of the right hand which they drink as well as apply to the top of their head. The peacock feathers serve to sprinkle water in temple offerings. (E.L.).

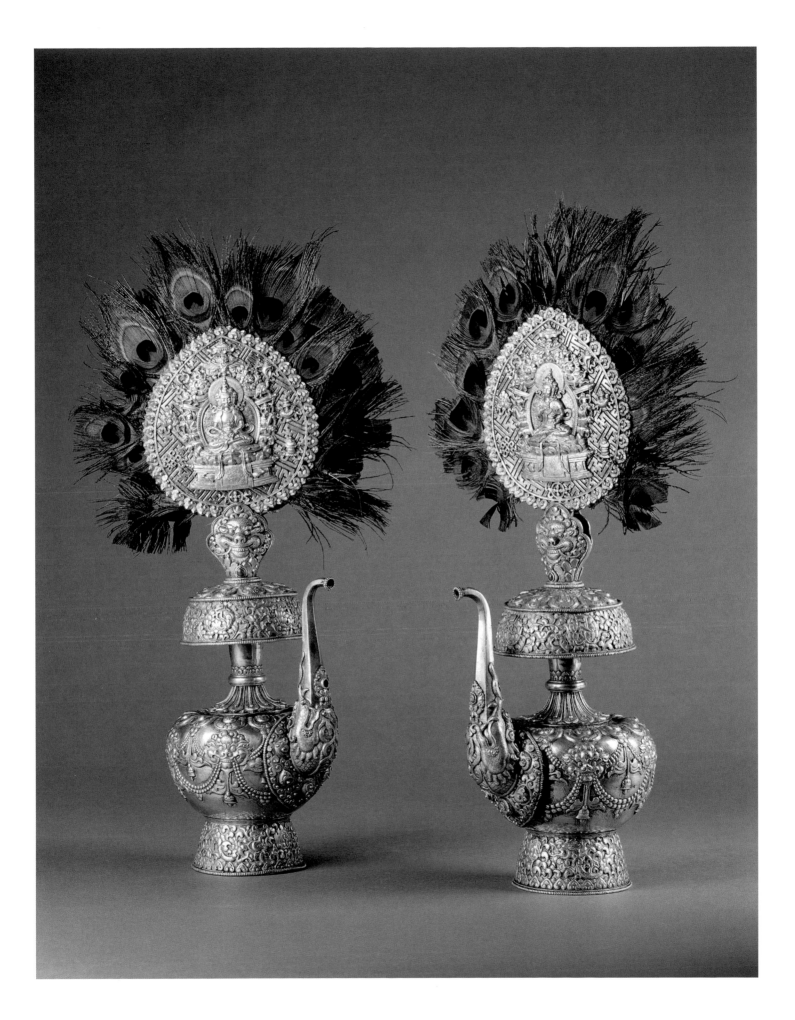

The clergy use different hats according to the religious school and for different occasions. Top left: A hat from the Nyingmapa school and, right, from the Drukpa Kagyupa. Left: The blue cloth hat is worn by a Drukpa head lama on certain auspicious occasions such as processions. (E.L.)

In the case of offerings to the protective deities, the number of bowls is reduced to five. First, water representing blood; second, a heart-shaped *torma* made with tsampa representing the five senses – eyes, ears, nose, tongue and heart; third, incense sticks representing the smell of burning fat; fourth, scented water representing bile; and fifth, a ritual cake coloured red and triangular in shape representing the food offering of flesh and bones. All these are symbolic offerings, and it is believed that through the powers of meditation, the chanting of mantras and the performance of mudras (ritual hand gestures) these offerings of normal substances are turned into the ritually required substances.

Finally, it is important to mention that each ritual, regardless of its nature, includes prayers for the lineage gurus (teachers) and the Buddhas, taking of refuge in the Triple Gem (Buddha, dharma and sangha), generation of bodhicitta (compassion for all sentient beings), invitation to the deity, offering of *torma*, hymns of praise, meditation on the deity with the chanting of mantras, prayers for present and future benefit, offering of farewell food with hymns of praise, apology for any shortcomings in the ritual or incomplete or over-reading of words or prayers and a benediction prayer. In initiations and other rituals, there are prayers for self-generation, the giving of initiation to disciples or requesting the deities' help in overcoming misfortunes.

According to the Tantrayana Buddhist tradition practised in Bhutan, there are 424 kinds of diseases, 360 different *dön* (gdon), spirits or demons causing diseases, and 80,000 *gegs* (bgegs), spirits or evils causing obstacles or hindrances. There are rituals to overcome all these negative forces and many others as well, which one has to face in this world.

This is no more than a suggestion of the vital spiritual richness and complexity of Bhutanese religion and ritual. Limitations of space prevent the elaboration of further detail.

1 The Thirteen Great Texts studied by the Nyingmapa and
Kagyupa are:

1 *Pratimoksasutra*
2 *Vinayasutra*
3 Asanga's *Abhidharmasamuccaya*
4 Vasubandhu's *Abhidharmakosa*
5 Nargarjuna's *Mulamadhyamakakarika*
6 Candrakirti's *Madhyamakavatara*
7 Aryadeva's *Catuhsatakasastra*
8 Santideva's *Bodhisattvacaryavatara*
9 Asanga's *Abhisamayalamkara*
10 Asanga's *Mahayanasutralamkara*
11 Asanga's *Madhyantavibhaga*
12 Asanga's *Dharmadharmatavibhaga*
13 Asanga's *Mahayanottaratantra*

2 The Eighteen Great Texts of the Sakyapa are divided into six
categories as follows:

I **Teachings belonging to the Mahayana Perfection
Doctrine including the five teachings of Maitreya**
1 *Abhisamayalamkara*
2 *Mahayanasutralamkara*
3 *Madhyantavibhaga*
4 *Dharmatavibhaga*
5 *Anuttaratantrasastra*
6 *Boddhisattvacaryavatara*
II **Monastic Discipline**
7 *Pratimoksasutra*
8 *Vinayasutra*
III **Madhyamika/Middle Way (View)**
9 Nagarjuna's *Mulamadhyamakakarika*
10 Candrakirti's *Madhyamakavatara*
11 Aryadeva's *Catuhsataka*
IV **Abhidharma: Phenomenology**
12 Vasubandhu's *Abhidharmakosa*
13 Asanga's *Abhidharmasamuccaya*
V **Logic and Epistemology**
14 Dignaga's *Pramanasamuccaya*
15 Dharmakirti's *Pramanavartika*
16 Dharmakirti's *Pramanaviniscaya*
17 Sakya Pandita's *Tshadma rigter*
VI **Right Practice of the Different Vows**
18 Sakya Pandita's *Domsum Rabgye*

3 The Five Great Texts/Five Subjects studied in the Geshe degree
curriculum in Gelugpa monastic universities:
1 *Prajnaparamita* – Perfection of Wisdom
2 *Madhyamika* – Middle Way (View)
3 *Pramana* – Valid Cognition
4 *Abhidharma* – Phenomenology
5 *Vinaya* – Monastic Discipline

4 The Six Great Texts of the Kadampa (bKa' gdams pa) tradition:
1 *Bodhisattvabhumi* – Bodhisattva Ground
2 *Sutralamkara* – Ornament of Discourses
3 *Siksasamuccaya* – Compendium of Precepts
4 *Bodhisattvacaryavatara* – Engaging in the Bodhisattva's Way
of Life

5 *Jatakamala* – Life Stories of Buddha
6 *Udana* – Specific Teachings

5 The Four Classical Schools of Buddhist Philosophy
developed in India:
1 Vaibhasika (bye brag smra ba)
2 Sautrantika (mdo sde pa)
3 Cittamatra (sems tsam pa)
4 Madhyamika (dbu ma pa)

6 The Four Major Schools of Mahayana Buddhism:
1 Nyingma (rNying ma)
2 Sakya (Sa skya)
3 Kagyu (bKa' brgyud)
4 Gelug (dGe lugs)

7 The Sub-schools of the Four Major schools of
Tibetan Buddhism:

I **Sakya developed into three sub-schools:**
1 Sakya founded by Kunga Nyingpo (1092–1158)
2 Ngorpa founded by Ngorchen Kunga Zangpo
(1382–1444)
3 Tsharpa founded by Tsharchen Losel Gyatsho
(1502–67)

II **Kagyupa School developed into four major and eight
minor sub-schools.**
Four Main Schools:
1 Karma or Kamtshang Kagyu founded by
1st Karmapa Dusum Khenpa (1110–93)
2 Tshalpa Kagyu founded by Zhang Yudakpa
Tsondu Dakap (1123–93)
3 Barom Kagyu founded by Dharma Wangchuck
4 Phagtru Kagyu founded by Phagmo Drukpa Dorje
Gyelpo (1110–70)
Eight Sub-schools:
1 Drigung Kagyu founded by Kyopa Jigten Gonpo
(1143–1217)
2 Taglung Kagyu founded by Taglung Thangpa Tashi Pel
(1142–1210)
3 Throphu Kagyu founded by Jampe Pel (1173–1225)
4 Drukpa Kagyu founded by Lingchen Repa (1128–89)
5 Martsang Kagyu founded by Marpa Chökyi Lodrö
6 Yerpa Kagyu founded by Sangye Yerpa
7 Yazang Kagyu founded by Yazang Chöje
8 Shungseb Kagyu founded by Tashi Repa

8 Minor schools of Tibetan Buddhism:
1 Bodlug founded by Buton Rinchen Drup (1289–1364)
2 Bodong founded by Bodong Panchen Chogle Namgyal
(1375–1451)
3 Jonang founded by Jonang Kunga Nyingpo (1575–)
(According to Jamyang Chökyi Lodrö there are more
Sakya sub-schools)
4 Shije founded by Pha Dampa Sangye of India
5 Chöd founded by Machig Labdrön (1031–1129)
(The above division of major schools, sub-schools and
minor schools is based on Jamyang Chökyi Lodrö.)

9 The Eight Great Systems or Teachings:
 1 Nyingma introduced by Padmasambhava
 2 Kadam founded by Atisa (982–1054)
 3 Sakya founded by Sachen Kunga Nyingpo
 4 Kagyu founded by Marpa (1012–96)
 5 Shangpa Kagyu founded by Khyungpo Neljor (978–1097)
 6 Shichöd (Shije and Chöd introduced and founded by Pha Dampa Sangye and Machig Labdrön)
 7 Jodong (Jonangpa and Bodongpa) founded by Kunpang Thuje Tsondru (1234–) and Bodong Panchen Chogle Namgyel (1375–1451)
 8 Nyendrup tradition founded by Thangtong Gyelpo (1385–1509)

10 The Six Doctrines / Yogas of Naropa:
 1 Candaliyoga (gtum mo'i gdams pa) – Yoga of physical heat
 2 Mayakayayoga (sgyu lus kyi gdams pa) – Yoga of illusory body
 3 Prabhasvarayoga ('od gsal gyi gdams pa) – Yoga of clear light
 4 Samkrantiyoga ('pho ba'i gdams pa) – Yoga of consciousness transference
 5 Svapnayoga (rmi lam gyi gdams pa) – Yoga of dreams
 6 Antarabhavayoga (bar do'i gdams pa) – Yoga of intermediate rebirth

11 The Nyingmapa have divided the various yanas or teachings of the Buddha into nine categories:
 The three external teachings:
 1 Sravakayana – Hearer Vehicle
 2 Pratyekabuddhayana – Solitary Realizer Vehicle
 3 Mahayana or Bodhisattvayana – Greater Vehicle
 The three outer tantras:
 4 Kriyatantra – Action Tantra
 5 Caryatantra – Performance Tantra
 6 Yogatantra – Yoga Tantra
 The three perfect inner tantras:
 7 Mahayoga
 8 Anuyoga
 9 Atiyoga

12 Lamdre – View of Paths and Fruits: the philosophy and practice of the complete range of the paths and fruits as taught and transmitted by Sakya tradition. This tradition of transmission of entire teachings and initiations is divided into two systems: The Ngorpa sub-school explained it in the assemblies and called it Tshogshed (assembly explanation), while the Tsharpa sub-school explained it for selected disciples and called it Lhobshed (private explanation).

13 The Four Great Seals signifying a Buddhist theory are:
 1 All things are impermanent.
 2 All contaminated things are miserable.
 3 All phenomena are empty and selfless.
 4 Nirvana is peace.

14 Gyabö Yigtshang (rGya bod yig tshangs) by Taktshang Lotsawa.
15 Gedun Rinchen, folio 64.
16 rGyal po sin dhu ra dza'i rnam thar, p. 14, in Olschak (1979: 186). The book states that this is hidden by Denma Tsemang (lDan ma

rtse mangs) a chief disciple of Guru Rinpoche. The Dzongkha script is said to have been introduced by him.
17 Gedun Rinchen, folio 60, and Lopön Nado (1986: 4).
18 Gedun Rinchen, folio 19 .
19 Lopön Nado (1986: 4).
20 Department of Education History Text of Class 9 and 10, p.10.
21 Tenzin Chögyel, folio 6.
22 Ibid., folio 7.
23 In order to keep the Drukpa Kagyu traditions of Buddhism intact for posterity, the Shabdrung Ngawang Namgyel had the following disciples:
 Four chief upholders of the lineage:
 1 Neten Chenpo (Great Arhat) Pekar Jungne
 2 Gelong Chenpo (Great Bhiksu) Dechen Lhundrub
 3 Drubthob Chenpo (Great Siddha) Jampel Gyeltshen
 4 Jatang Chenpo (Great Renouncer) Pekar Tashi
 Four great sons of upholders of oral traditions:
 5 Kasöl Dzinpa (Upholder of Oral Tradition) Damchö Gyeltshen
 6 Dongyu Dzinpa (Upholder of Tantric Meanings) Sonam Özer
 7 Domgyu Dzinpa (Upholder of Vinaya Tradition) Sakya Özer
 8 Chagsöl Dzinpa (Upholder of Tradition Laws) Thinle Drukgyel

24 Pema Lingpa (1450–1521), Bhutan's revered 'treasure revealer' (tertön), is recognized as one of the Five Sovereign Tertöns. See Padma Tshewang et al. (1995).

25 The four devils / four evil forces or hindrances are:
 1 Skandramara (phung po'i bdud)
 The evil of aggregates.
 2 Klesamara (nyon mongs pa'i bdud)
 The evil of afflictions / delusions.
 3 Mrtyupatimara ('chi bdag gi bdud) The evil of death.
 4 Devaputramara (lha'i bu'i bdud)
 The evil of the son of the god (lust).
26 The Five Precious Objects are classified in a number of ways:

1 gold	2 silver	3 pearls	4 coral	5 turquoise
1 gold	2 silver	3 copper	4 iron	5 tin
1 gold	2 silver	3 coral	4 pearls	5 sapphire

27 The Five Grains are classified in at least two ways:

1 barley	2 rice	3 wheat	4 white peas	5 sesame
1 barley	2 wheat	3 white peas	4 buckwheat	5 unhusked rice or thick-shelled barley

28 The Six Aromatics are:
 1 *Chugang* – bamboo pith
 2 *Gurgum* – saffron
 3 *Kakola* – cubeb (greater cardamom)
 4 *Lishi* – clove
 5 *Dzati* – nutmeg
 6 *Sugrmel* – cardamom
29 The four elements are earth (sa), water (chu), fire (me), wind (rlung).
30 Sakya Pandita Kunga Gyeltshen, vol. NA p. 29 (reproduced in *The Complete Works of the Great Masters of the Sa skya School of Tibetan Buddhism*, 1968 p. 311).

Gedun Rinchen (dGe 'dun rin chen, 69th Je Khenpo). *Pal ldan 'brug pa'i gdul shing lho phyogs nags mo'i ljongs kyi chos 'byung blo gsal rna ba'i rgyan*. Woodblocks, Tango monastery.

Lopön Nado. 1986. *'Brug rgyal khab kyi chos srid gnas stangs 'brug dkar po*. [White Dragon]. Tharpaling monastery, Bumthang.

Olschack, Blanche C. 1979. *Ancient Bhutan: A Study on Early Buddhism in the Himalayas*. Zurich: Schweizerische Stiftung für Alpine Forschung.

Padma Tshewang, Khenpo Phuntshok Tashi, Butters, Chris and Saetreng, Sigmund K. 1995. *The Treasure Revealer of Bhutan: Pemalingpa, the Terma Tradition and Its Critics*. Kathmandu: Bibliotheca Himalayica.

Sakya Pandita Kunga Gyeltshen. *Sgom pa gsum gyi rab tu dbye ba shes bya ba'i bstan bcos*. Reproduced in *The Complete Works of the Great Masters of the Sa skya School of Tibetan Buddhism*. Vol. 5, Tokyo: The Toyo Bunko, 1968.

Tenzin Chögyel (10th Je Khenpo). *Lho'i chos byung bstan pa rin po che'i 'phro mthud 'jam mgon smon mtha'i 'phreng ba bya ba gtso bor skyabs mgon rin po che rgyal sras ngag dbang rnam rgyal gyi rnam pa thar pa kun gyi go bde bar bkod pa*. Woodblocks.

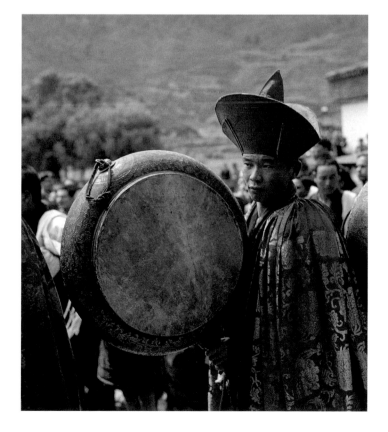

Drukpa monk in full ceremonial attire at the Punakha festival. (A.A. 1970)

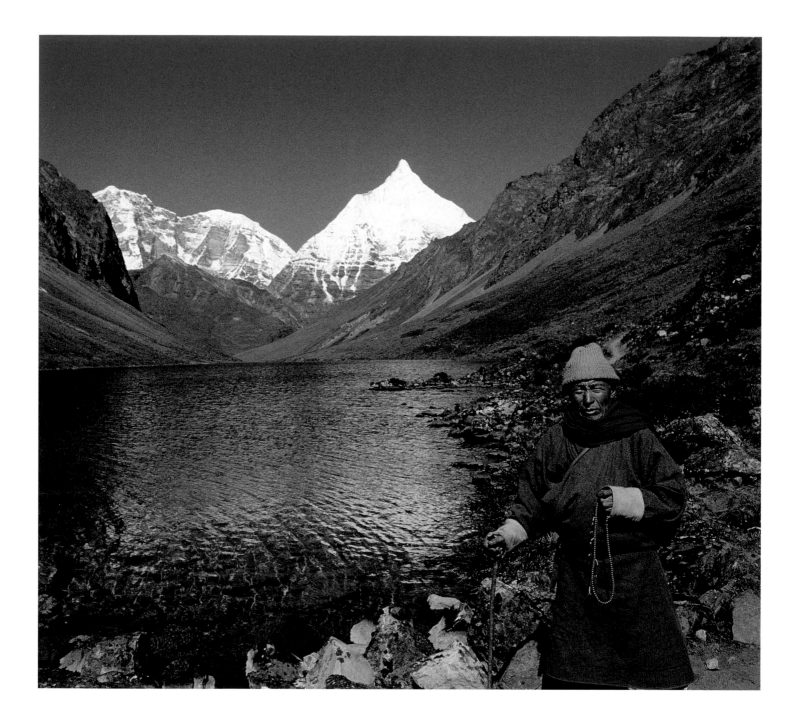

The local priest of Shana in Paro in a sacred landscape; the lake hosts a water-deity while Jichu Drakye mountain incarnates a mountain deity. (C.S. 1996)

Gods and Sacred Mountains

Christian Schicklgruber

Since olden times each year on an exactly specified day, the inhabitants of all the villages in the Paro valley gather together in a huge cave high up in the mountains. This is the god Ödöpa's ('Od 'dod pa) 'dwelling place' (gnas khang); here he demands his offerings and worship from the villagers. Whoever does not attend to these demands has to be prepared to lose his soul to him or to find his fields dry up and his cattle die. This gathering has taken place for many generations, ever since people settled in the valley. Since then the villagers have learned to live with their divine neighbour.

One day – so it is said – the Tibetan saint Drukpa Kunle (1455–1529) came to the cave to stay for the night. He was destined to use his magical powers to subdue unruly powers, and was well known for his religious abilities but also as an opponent of all conventions and norms.[1] All the women and men in the cave praised Ödöpa's name and prayed for his benevolence. Drukpa Kunle, however, worshipped only himself and went to sleep. At the stroke of midnight Ödöpa returned from his wanderings with claws extended, long hair sweeping the ground and eyes flashing. He woke Drukpa Kunle and barked at him: "You have failed to pay obeisance to me!" Drukpa Kunle responded that he worshipped only himself and no one else. Before Ödöpa could land his deadly blow, Drukpa Kunle got hold of him, took the skin off his penis and stuffed him into it like in a sack. This was a terrible torture. When it rained, the sack would expand and get heavy, but when the sun shone, it would contract and nearly suffocate the prisoner. Drukpa Kunle left the god whimpering for mercy and went on his way. Only many years later did he return to this part of the country and free Ödöpa on condition that he took a solemn oath (dam can) to protect the lama's religion, Buddhism. The god had no choice but to comply. But he asked Drukpa Kunle to give him a region where he could demand offerings. The lama replied that someone would soon come to grant him his wish. This happened to be the Shabdrung Ngawang Namgyel (1594–1651), the first ruler of Bhutan. The Shabdrung presented Ödöpa with a large territory where he could demand offerings from the villagers. In return he had to protect the inhabitants of the valleys against all the supernatural powers living in rocks and forests, and to make their fields fertile and their cattle healthy and fecund.[2]

SACRED LANDSCAPE

Even today, people present offerings to Ödöpa and in return he protects them against all sorts of calamities and enemies. And the villagers watch over the purity of the rocky mountain which they regard as Ödöpa himself.

Is the mountain identical with Ödöpa, or is it simply his throne? From the Bhutanese perspective the question itself is meaningless. A lama, when asked during a ritual for such an 'autochthonous deity' (yul lha gsol) why he does not make the usual dough figures, torma (gtor ma), representing the gods, answered that "there is no need to, because the god is present" – pointing at the mountain. The same god is depicted on scrolls and wall paintings as a mythological

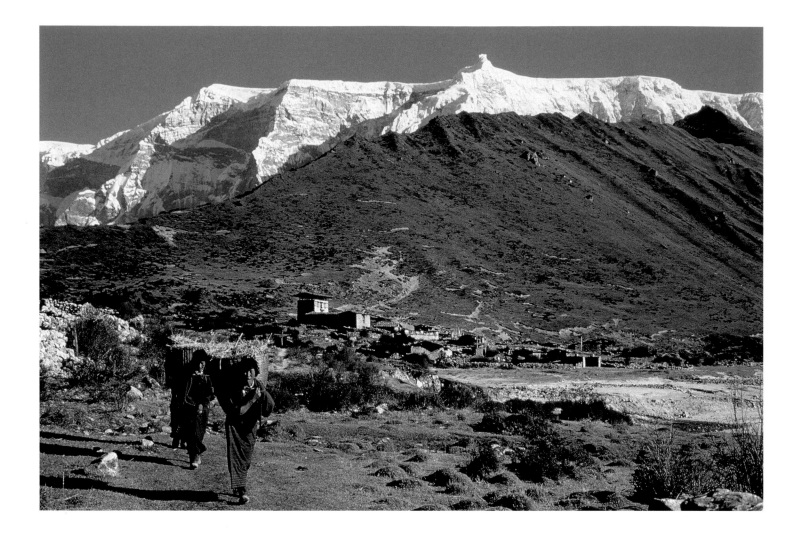

Hay is carried home in large baskets amidst the spectacular landscape of Lunana at 4,000 m. (R.D.)

warrior on a horse; thus does he fight enemies and cover great distances. When one stands facing the mountain, no one says, "That is the throne of the tutelary god" but, "That is the tutelary god".

It may be that the Western perception of the landscape is too secular to see more than a mass of rock and ice. In the West nature and the whole cosmos has come to be regarded as the creation of a single god, as something he gave us to exploit. While our traditional dichotomy of heaven and earth, above and below, divine and human, was already laid down in the Old Testament, in the East this did not happen even after religious concepts began to be recorded in writing – quite the opposite: nature was included into the highest cosmo-logical truth and accorded transcendental significance.[3]

The origins of a religious interpretation of landscape are much older than the arrival of Buddhism. Although the written sources tell us little about this time and its religious

temper, it seems highly likely that the pre-Buddhist religion was a mixture of animistic conceptions and shamanistic practices. Every feature of the landscape – be it rocks, forests, mountains, rivers or lakes – acquired a supernatural exis-tence, which may best be understood as a kind of spirituality. Often people keep certain stones at home to have these powers close to them and to be sure of their protection and benevolence. And stones are not thoughtlessly removed from the fields, because they may constitute the essence and blessings of a particular spot.

Certain chosen persons are able, in trance, to communi-cate with these powers. During specific rituals it is also possible for gods and demons to enter these shamans' bodies and use them as intermediaries to inform the people about their wishes and demands. This type of religion fits in well with the needs and desires of a peasant population living in close contact with a natural environment from which they draw their sustenance, and such concepts and religious prac-tices have in part survived to the present day. The difference between this religion and Buddhism was succinctly put by a

Bhutanese who said: "I would never dare to ask the Buddha to keep my cows healthy or to protect me in war."

According to the pre-Buddhist traditional understanding, every rock and piece of earth belongs to a *shidag* (gzhi bdag), a non-human 'owner of the earth'. In this context, 'earth' stands for the foundation of human existence in its entirety. Whenever one disturbs the non-human owners, for instance by ploughing or house-building, one has to apologize to them. Man does not live alone.

But not all *shidag* are powerful. In the Himalayas and their northern high plateau, height is an abstract entity constituting purity, power and authority. A three-tiered model (lha btsan klu rigs gsum) explains the universe: heaven above (gnam), the human sphere in the middle (bar) and the underworld below ('og). Each has its own category of non-human beings: above are the heavenly gods (gnam ki lha), in the middle the owners of the land and the tutelary deities of men and Buddhism (btsan, yul lha, dgra lha, chos skyong),[4] and below serpent-like beings (klu).[5]

Men share their habitat with the divine beings of the middle level. Among them the *yulha* (gods of the region) are most directly involved with the life of the human community. They will be the main subject of our discussion.

Serpent-deities (lu) also have their abode (lukhang) within the dzongs, as here in Punakha. (c.s. 1996)

SACRED MOUNTAINS

Most often the *yulha* are mountains. These mountain gods are much closer to men than the heavenly gods. They concern themselves with human affairs. We shall show that they play a major part in the creation of a social and political space and set the rules for all social and religious conduct.

Who are these gods of the landscape?[6] A simple answer to this question is impossible due to the multi-layered interpretations of the world in Buddhist thought. Geoffrey Samuel has defined the situation succinctly: "For the Tibetans, the universe in which they live is seen as capable of multiple interpretations, which are not necessarily exclusive. Rationality is not, as it tends to be in contemporary Western society, the single dominant mode of legitimate discourse."[7] The blurred semantic fields of the local languages further emphasize the difficulty of any characterization. To put it rather crudely one could say that the Bhutanese do not fulfil Western demands for precise systems of classification.[8] Neither do Buddhist texts give precise descriptions of the mountain gods, because they deal mainly with the philosophical problems of monastic Buddhism and in their historical parts concentrate on the life and activities of great rulers and not of the common people. Mountain gods and similar subjects are scarcely mentioned, even in passing. Nevertheless we shall attempt to get closer to the picture.

As a first step, the terms for the local gods provide some help. *Kyelha* (skyes lha) literally translates as 'birth god'. This god is the protector of one's birth and he accompanies one through life. The *yulha* (yul lha) is the god of the locality, that is the area in which one lives and makes one's living. As long as one does not move to a different locality, no problems are posed in one's relation with the *yulha*. If one leaves one's birthplace, one comes under the influence of a new *yulha*, who has to be propitiated.[9] *Pholha* is the god of the male lineage. Like the *yulha*, he belongs to the group of the 'five head-gods' ('go ba'i lha lnga) that rest on the body throughout a person's life.[10] According to this classification system, the *pholha* usually sits on the right shoulder and the *yulha* on top of the head. Another member of this group is the *dralha* (dgra lha), the god of war, who assists people during violent encounters. All these gods are directly linked to people or to places. In everyday usage any of these terms may be applied to one and the same god. How a term is used often depends on the context. Somebody might call a

god the 'birth-god', because he was born under the god's protection. The same god might be called *yulha* by a new-comer, while in a ritual with military implications everyone would call him *dralha*.[11]

All these gods are regarded as *jigtenpe sungma* ('jig rten pa'i srung ma), gods who have not left the world of earthly entanglements. They are not in a position to gain enlighten-ment, the supreme goal of Buddhism.

In the villages, people know many stories about the lives of these gods. Chundu (Khyung bdud) is the tutelary deity of Ha province in western Bhutan. He was a favoured soldier under the Shabdrung Ngawang Nyamgyel, who was the first to unify the various valleys making up Bhutan. One day the Shabdrung ordered his servants Chundu and Ap Genyen (Ap dge bsnyen), the deity of Thimphu, to go to the land of the demons to fetch fire. The wily Chundu managed to steal the fire. On the return journey they met people offer-ing them food and alcoholic beverages. When, after a substantial meal, Chundu fell asleep, Ap Genyen took his fire away and presented it to the lama. When Ngawang Nyamgel heard of Chundu's negligence, he beat him and banished him to Ha. After he had heard what had really hap-pened, the Shabdrung helped Chundu to receive worship-ful prayers from the people of Ha.

There is another story about Chundu, which explains why no irrigated rice cultivation is possible in Ha. It happened that the tutelary god of Paro, Jichu Drakye (Ji chu brag skyes), once redirected the spring waters which irrigated the Ha valley, and thus Chundu's territory, towards Paro. As soon as Chundu realized what had happened, he stopped the flow of water. Before the quarrel between the gods escalated, they negoti-ated a compromise. The water would continue to flow as long as Chundu received the first offerings of Paro's rice harvest.

Then there was an even more dramatic quarrel between two gods from Bumthang province in central Bhutan. Ralla Pholha and Chasa sent such violent magical storms against each other that one lost his right arm and the other his pal-ace, which was swept away. In so far as the gods can be seen as representatives of certain regions, these stories would in-dicate that relationships between the various areas were not always harmonious. The gods also use their military aspects to come to the help of their devotees. Thus Chundu is said in the seventeenth century to have wiped out a Tibetan army with his magic powers. The anniversary of this victory is celebrated to the present day.[12]

Tsen, deities of place, are often kept in a special chapel with weapons such as swords. (E.L.)

These legends, or perhaps events, encapsulated in anec-dotes about the lives of the sacred mountains allow us a tentative summary of the basic characteristics of the 'deified landscape': the sacred mountain is the spiritual centre of a territory, it serves to protect the inhabitants under certain conditions, its worship (re-)establishes its relationship to the people, its character is more similar to that of men than to that of the gods-on-high, its space has to be kept pure, and the mountain god's position is subordinate to Buddhism.

However, there are also pre-Buddhist gods in Bhutan who never made their peace with the new religion. In the Kurtö region the *pcha* (phyva) gods lead an independent existence. Their rituals show no trace of Buddhism. When they are worshipped, the villagers remove the Buddhist statues from the altar. During the ritual they are represented by *lhami* (lha mi; literally 'god–men') drawn from the most important fami-lies in the village.[13] But these are the last vestiges of archaic traditions without any influence on religious life in general, and we shall now focus on the Buddhicized gods.

Opposite: These objects are all associated with tsen, local deities who may be benevolent or malevolent towards a community. With a warrior-like appearance, red is often their symbolic colour. Above left: Ritual cakes (torma) called magtor, ritual cake of the warrior, are offered to tsen and play an important role in annual ceremonies performed for the well-being of the household. Above right: Tsen are sometimes depicted as masks. Below: The medium is possessed by the deity when he places the tsen hat on his head. (E.L.)

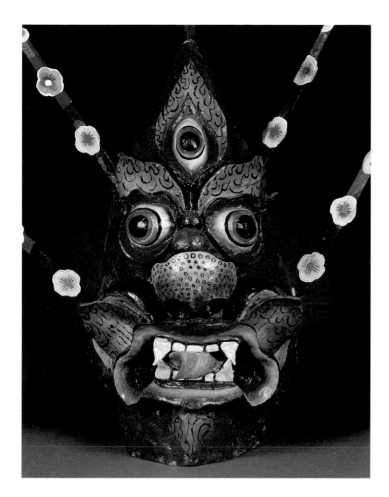

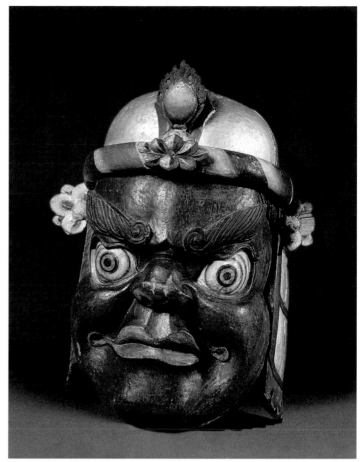

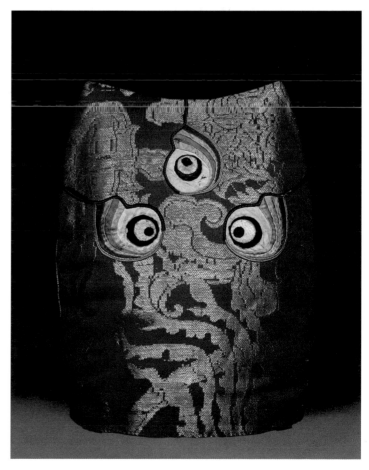

MOUNTAINS AND MEN

To retain the benevolence of the gods people not only have to perform regular offerings but also to observe ethical and social norms. This concerns the individual as well as relationships between people.

A young man from the village of Jakar had stolen a religious text from a monastery and sold it out of greed. The police tracked him down and arrested him. While the young man was still in custody and thus not able to ask the god for forgiveness, the spirit punished the father for the son's crime. By making a noise he tricked the father to climb onto the roof and then made him fall to his death.

A harmonious relationship between mountains and men requires a harmonious relationship between men. The ultimate aim of all the rules overseen by the mountain is social harmony. If a rule is disregarded, the mountain withdraws its protection. Then all the malicious *numina* hiding behind every corner will be set loose. The lapse of a single person may have disastrous consequences for the whole region –

the cattle fall ill, the soil suffers drought, or hail destroys the crops. Thus society pressures the individual to act according to the social norms.

There may also be serious repercussions if the god's abode is disturbed. An expedition in 1983 to the summit of Mt Jichu Drakye so incensed the god that hail struck the region. A delegation from the affected villages went to the king to ask him to stop such expeditions in future. The king acceded to the request and prohibited further expeditions. Such disturbances irritate not only the mountain gods but also the *tsen* gods in the rocks and the *lu* of the waters.

It is obvious that such a situation calls for delicate handling in the case of development projects like the building of roads or dams, which interfere with the landscape. We already mentioned that even after ploughing the gods of the locality have to be propitiated. The reactions of the gods dwelling in the landscape to such extreme 'breaches of the peace' from development projects are differently perceived in the affected villages. Some believe that the gods may be satisfied with simple ceremonies, while others ascribe any calamity such as sickness or poor harvests to the wrath of the annoyed gods. These differences in interpretation may even cause the splitting-up of village communities. This illustrates the reverse side of the principle we mentioned earlier: if the harmony between gods and men breaks down, so will the harmony among men.

MOUNTAINS, BUDDHISM AND HISTORY

Before we turn to the history of Bhutan, some general remarks about the changing place of sacred mountains in the region's religious history may be called for. The religious interpretation of the landscape and its gods was such a basic experience that it survived under Buddhism and continues to play an important role in the daily life of the people.

Within a multi-level system of meanings, the mountain was able to retain its position as the most important spiritual reference of everyday social and economic life for those living beyond the bounds of monasteries. For the monks inside the monastery the mountain is a protector of the Buddhist doctrine and is included in the entourage of the great gods.

With the arrival of a centralized power and of Buddhism, the 'Land of the Sacred Mountains' also received a script. The incorporation of sacred mountains into written texts brought about two developments which at first glance seem contra-

dictory: on the one hand, popular cosmologies were subordinated to those defined by the new religious centres and the mountains gods took their place in the hierarchy as followers of the new and greater gods. On the other hand, they profited from the effects of the written word per se, in that their role was now securely recorded and thus claimed veracity.

Textual rituals concerning the mountain gods usually follow a basic pattern. The *yulha* and his entourage (wife, servants, relatives, etc.) are invoked with an iconographic description. Once the group is thus installed, the most varied offerings are presented. Then it can be asked for protection and fulfilment of every kind of wish, ranging from protecting Buddhism to safeguarding the basics of physical existence.

Once the worship of the *yulha* was incorporated in ritual texts, the mountain became embedded in a generally applicable and practicable religious context. Previously, worship of the mountain had been the exclusive territory of the local religious specialist; the necessary knowledge had been transmitted orally. Now everybody with the right to study the holy scriptures and perform the relevant rituals was able to communicate with the mountain. The local religious dignitaries were joined by lamas from the monasteries – relations with the holy guardians became delocalized. The localized relation to the god could now be manipulated by a centre of power far away from the locality.

To gauge the consequences of this situation for political history we have to look beyond the borders of Bhutan, where no relevant source material exists, and propose a structural model based on the methods of comparative ethnology.

The creation myths of the pre-Buddhist kingdom have been identified by Ariane Macdonald, and Samten Karmay has carried the subject further until after the foundation of the first Tibetan kingdom in the seventh century.[14] In the sources they discuss, the mountain is regarded as the seat of the paternal ancestors. Before the establishment of a central power, a large part of what is now Tibet was divided into nine political entities. Each had a mountain as its spiritual centre, and all nine mountains were regarded as brothers (lha dgu, the 'nine gods'). Each ruler was seen as a collateral

A rare rhino horn carving represents a sacred mountain landscape, a subject appealing to the nobility and high clergy. Among rocks and waterfalls, Milarepa (1040–1123), the great ascetic famed for mystic songs and one of the founders of the Kagyupa school, is depicted singing in a cave. The strange squat figure at the base of the carving may well be a yeti. (E.L.)

cousin of one of the mountains. So mountain and ruler shared the same divine ancestors. One of the local lords managed to conquer the other territories one by one. In order to secure his annexations the new ruler paid homage to each sacred mountain in the conquered territories. He asked it to be witness to his edict which proclaimed his rule over all the once-independent regions. This process engendered a pragmatic 'restructuring', and the constellation of the 'nine gods' was adapted to the changed circumstances.

The spread of Buddhism in Tibet during the eighth and ninth century helped to consolidate the central power. Those members of the old nobility who opposed the central ruler, were all adherents of the old pre-Buddhist beliefs. During the often violent conflicts between the nobility and the king, the 'nine brothers' reappeared as the ruler's witnesses to the power of Buddhism. These pre-Buddhist mountain gods endorsed Buddhism, a religion increasingly embraced by those siding with the king.[15]

This short historical excursion has shown the mountain to be at the intersection of territorial, genealogical and political interests. Political power can be claimed by those who hold the key to the interpretation of the sacred mountains along with the prescribed rituals.

THE ROLE OF THE MOUNTAIN IN
THE EVOLUTION OF BHUTAN

We shall now try to throw some light on the role of the local gods during the evolution of Bhutan from a country composed of a number of sovereign local principalities until the monarchical period.[16] As Françoise Pommaret mentions in her contributions to the present book, the early history of Bhutan is barely documented. She has succeeded, however, in documenting the mythical descent of the first chief of Bumthang to the head of the local deities. Although we are aware of the danger of hasty generalizations, it seems not unreasonable to suggest that in Bhutan generally local rule legitimized itself by claiming divine descent.

In the eighth century, the king of Bumthang Sendarkha (later known as Sindhu Raja), invited the great Buddhist saint, magician and missionary Guru Rinpoche to his country. Guru Rinpoche is regarded as the founder of the Nyingmapa school of Tibetan Buddhism and succeeded in firmly establishing Buddhism in Tibet during the eighth century. The king had neglected to worship the tutelary deity of his paternal lineage,

Shelging Karpo. When his son died soon afterwards, this was explained as the god taking his soul in revenge. The king himself fell seriously ill. At this juncture, hope centered on Guru Rinpoche. And indeed he overpowered the god in a magic battle and tamed him. The king recovered, he converted to Buddhism, and his country again began to prosper. Then Guru Rinpoche went on a journey through the country, and by the time he left Bhutan, numerous pre-Buddhist gods had sworn an oath of adherence to the new religion.

Today Guru Rinpoche is celebrated as a second Buddha. Thus on the tenth day of each month great dance festivals are performed in his honour at a succession of fortress-monasteries (dzong). The choreography of these dances goes back to the saint himself. They repeat the dance steps he originally performed when Samye, the first Buddhist monastery on Tibetan ground, was established. In Bhutan the dances were first performed after the victory over Shelging Karpo. Visitors at this spectacle repeatedly witness a dramatic and vivid re-enactment of Guru Rinpoche's victory over his devious opponents.[17]

With his deeds Guru Rinpoche opened the way for many generations of saints who would subdue the local gods. In these battles, magic often played an important part. It is said that once the learned priest Terkhungpa meditated for seven days and nights on the shores of a lake. During the last night the waters suddenly began to boil and Godü Chenpo (sGo bdud chen po) appeared in the shape of a black giant. His eyes blazed, and fat dribbled from his mouth. In his right hand he held bow and arrow, and with his left he brandished a snake. The priest showed no sign of fear. After facing each other for a considerable time the demon proposed a competition to find out who was the more powerful. Whoever was able to become the tallest and the smallest would swallow the loser. The demon won the first round, and the priest the second. To settle the question they agreed to swallow each other. First the priest swallowed the demon. Having arrived at the intestines, the demon began pulling them so as to kill his opponent. But the priest raised his body temperature to such an extent that the demon, fearful of burning and in great pain, begged to be spewed out. Once released, he insisted on swallowing his opponent. Again the priest raised his body temperature so much that the demon rolled on the ground with excruciating pain. The tormentor inside the stomach only stopped his torture when the demon promised to become a follower of the lama.[18]

A different method of subduing malicious local demons

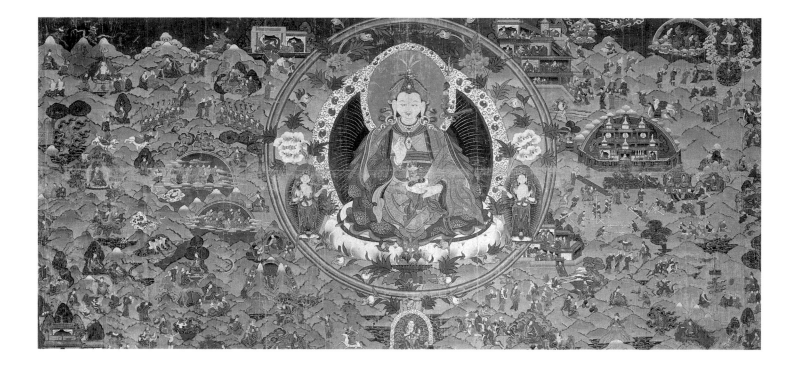

involves the construction of Buddhist buildings. During the second half of the eighteenth century Lama Shida built the Chendebji Chörten in order to literally nail down a demon which had threatened the inhabitants of two valleys.[19] This *chörten* was designed in the Nepalese style, and in 1982 Ashi Kesang, the mother of the present king, had a second one built next to it in the Bhutanese style.

One of the greatest religious masters of Bhutan is Pema Lingpa (1450–1521). Pema Lingpa derived his authority from Guru Rinpoche, the only teacher he accepted, from whom he learnt in dreams.[20] Guru Rinpoche had hidden many sacred texts and ritual objects throughout the Himalayas, because in his time mankind was not mature enough to understand these religious items and to handle them in the proper way. Among many other texts, Pema Lingpa discovered one which gave a list of local gods. Many of them he was able to subdue by magic. Pema Lingpa's descendants based their claim to rule partly on their ability to perform the correct rites for the local deities.[21]

The configuration of political power, Buddhism and local tutelary deities found one of its most dramatic expressions during the seventeenth century. The lama Ngagi Wangchuk (Ngag gi dbang phyug; 1517–54), great-grandfather of the founding father, the Shabdrung Ngawang Namgyel, had a dream-vision of the Buddha Aksobya, who guided him from Tibet to the region of modern Bhutan. Taking the form of a suspended flame, he showed him the spot where the saintly

Above: Pictorial biography of Guru Rinpoche (wall painting on cloth with pastiglia details) illustrating the life of the Indian mystic considered to be the Second Buddha. His life story, like that of the Buddha, is composed of Twelve Deeds. Guru Rimpoche is seated with his two consorts on either side: Mandarava, the daughter of the King of Zahor in India, and Yeshe Tshogyel, his Tibetan wife. Below: On the lower right of the painting a water-deity offers a jewel to Guru Rinpoche as a token of allegiance. See also detail p. 79. (E.L.)

man built a temple. Over time this temple evolved into the largest monastic fortress of Bhutan and the family seat of the royal family, the Tongsa Dzong.

Many years later Mahakala, the personal guardian deity of the Shabdrung, guided him across the main chain of the Himalayas to Bhutan. Mahakala offered the country to the lama as a 'heavenly region', where he was destined to end the rivalries of the local lords and establish an empire where Buddhism could flourish in peace and harmony.[22] With the assistance of Mahakala, the Shabdrung was able to vanquish one local ruler after another and to finally create a unified country. His military prowess was due to the fact that Mahakala's fierce aspect was stronger than that of the local gods. Mahakala is the overlord of all *yulha*, the guardian of the Drukpa religion and of the rulers of Bhutan. As mentioned above, the Shabdrung had succeeded in turning many of these local *numina* into protectors of the new religion and of the inhabitants of the region. Among the sixteen qualities he ascribes to himself in a poem of his own composition is that of subduer of demons' armies (see p. 196, *The Sixteen "I's"*).

In this context Mahakala appears in the shape of Legön Jaro Dongchen (Las mgon bya rog gdong can), the 'raven-headed Mahakala of action'. As such at the end of the last century he assisted the father of the first king of Bhutan, Jigme Namgyel, to reconquer the local principalities which had sprung up after the death of the first Shabdrung and produced a lengthy period of civil-war-like violence. During these campaigns and those against the British along the southern borders of the country, Jigme Namgyel worshipped the gods of all the local temples his army passed. His main protector, however, was the raven-headed Mahakala in the form of a headgear shaped like a raven's head. Jigme Namgyel wore this 'raven crown' on all his military campaigns. Today the raven crown symbolizes royalty. Michael Aris regards the raven crown as a derivation of the battle helmet of a *tsen* deity.[23] If one accepts this interpretation, it is one more example of the process whereby a central power appropriates local traditions and refashions them into state-supporting symbols.

The relationship between pre-Buddhist localized religious conceptions and the supra-regional approach inherent in Buddhism is reflected in Bhutan in many ways, for instance in the multi-level perceptions of a mountain or the acceptance of localized gods into Buddhist temples. We already mentioned Mt Chundu with its three pinnacles, which is regarded as the seat of the Buddhist trinity (rigs gsum mgon

Mahakala (mGon po), here with six arms, is one of the protective deities of Bhutan and of the Drukpa Kagyupa school. In his form as Legön Jaro Dongchen, that is with a raven head, he is the protective deity of the Wangchuck dynasty. See p. 209. (E.L.)

po) – the bodhisattvas Avalokitesvara, Manjusri and Vajrapani. Bodhisattva Avalokitesvara is an emanation of the Buddha Amitabha and is regarded as the bodhisattva of the present age. Manjusri is the bodhisattva of Wisdom and the bodhisattva Vajrapani an emanation of the Buddha Aksobhya.

To illustrate the acceptance of local gods into Buddhist temples we give an example which goes back to 1652. In commemoration of the victory of Guru Rinpoche over the tutelary deity of the king of Bumthang, the lord of Tongsa Dzong, Minjur Tenpa (Mi 'gyur brtan pa), built the Kuje temple with an altar dedicated to the *pholha* Shelging Karpo. The second Kuje temple was built by the first king of Bhutan, while the third was erected by Ashi Kesang, the mother of the present king. The most recent temple preserves the largest statue of Guru Rinpoche in Bhutan. In accordance with Buddhist tradition, such statues are filled with precious and

sacred objects, and among them are statues of the tutelary gods of the neighbouring villages. These deities could leave their original altars because Guru Rinpoche is their master and they cannot refuse to serve him.

MOUNTAINS AND TIME

So far we have mainly discussed the spatial aspects of the sacred mountains. They are the guardians of a specified territory or protect Buddhism in regions far away from the religious centres. Now we turn to the temporal aspects in the sense of stability (of the social order), the seasons (and the various breaks in the agricultural calendar) and cyclical processes (of the soul relative to the cycle of rebirths).

Since they are the ancestors of pre-Buddhist rulers and the guardians of social norms, the mountains represent a continuous social and political order stretching from the distant past to the present. Being divine representatives of the social order, they legitimize it in a way which far surpasses all human understanding of change and changeability.

The mountains also define the rhythm of the seasons, setting the spatial and temporal coordinates for working and exploiting the soil. The agricultural calendar orients itself not only on written astrological calculations, but also on certain rituals performed for the tutelary deities. Some inhabitants of the small village of Dur in central Bhutan accompany their herds throughout the year. In late spring, they take their herds from the pastures around the village high up to alpine grazing lands and return in autumn. In this way they follow their *yulha*, who also changes his abode according to the seasons. Each move has to be preceded by a *sang* ritual (lha bsangs) – a cleansing incense-offering – performed by the whole village community.[24] From this day there is a division between the place of ritual and the abode of the *yulha* and therefore also between the semi-nomadic and the sedentary villagers. To cross this demarcation would anger the *yulha* and cause sickness among the cattle. The barrier remains closed and nobody ventures to the alpine pastures before the pastures can support the herds after the snow-break, and likewise the herds will not return prematurely to ruin the unharvested fields. Quarrels are thus avoided and social harmony is preserved, while nature is carefully used to supply a livelihood. The outsider notices the effect and may draw the superficial conclusion that this is also the cause of the migrations of the *yulha* and, in his wake, of the cattle herders.

A gomchen, religious practitioner who has not taken monastic vows, chanting prayers. (C.S. 1996)

The cycle of the human soul within the cycle of rebirths is more complicated. In pre-Buddhist times, at procreation the soul would come from the mountain to enter the new being; it would return after its death. In Buddhism, after it leaves the body, the soul is believed to remain within the cycle of rebirths – except when the deceased enters nirvana.[25] In the Paro valley in western Bhutan people fear that the *yulha* may kidnap their soul. This may happen after death, or even before, for any number of misdeeds. Thus the mountain god Ödöpa once stole the soul of an Indian soldier who had made derisory remarks about the local population's worship of the *yulha*. Shortly afterwards a black dog sidled round him several times. The following day he fell sick and died. The black dog had been the servant of the mountain god sent out to fetch the scoffer's soul. The mountain god can in principle take anyone's soul and keep it, taking it with him on his wanderings across his territory until he himself

escapes an existence entangled in earthly affairs. Therefore the funeral rites have to be performed by a highly experienced lama. Only he can prise the soul from the *yulha*, and direct it to a place beyond the reach of the gods of the soil, either to the 'Pure Buddha Land of the East' or the 'Pure Land of the Great Spirituality of the Buddha Amitabha'.

It is not clear whether these beliefs are based on a pre-Buddhist conception rivalling the Buddhist doctrine of the soul, which is tied to the cycle of rebirths, or whether they can be ascribed to the human character of the *yulha* as a robber of souls.

In any case, people tend to put the fate of the human soul after it has left its mortal shell into the hands of a member of monastic Buddhism. The locally-based religious specialist takes this world as his demesne. It is he who in rituals dramatically condenses the relationship and mutual expectations of men and gods.

Below: Sacrificial cakes, each dedicated to a local deity, are placed on the altar of the house before a ritual, thus ensuring the deities' presence during the ceremony. (C.S. 1996)

THE MOUNTAIN APPEARS

The master of rituals in Gunitsawa village, Phub Tshering, knows all the hymns to Ödöpa; he communicates directly with the god. He does this twice a year for the benefit of the whole village population at a shrine erected for the god in the village – the god's abode in the midst of men. Every household must be represented by at least one member. The god must see the villagers gathered together in harmony while they pay homage. Every household may ask Phub Tshering to perform a ceremony at its own house altar for special problems, be it a sick member of the family or some particular undertaking that needs divine support.

For the ritual a suitable body must be present within which the god can settle and receive the offerings. Like other masters of rituals throughout the Himalayas, Phub Tshering creates a *torma* (gtor ma), a ritual cake made of dough. He creates not only the god to whom the ritual is mainly

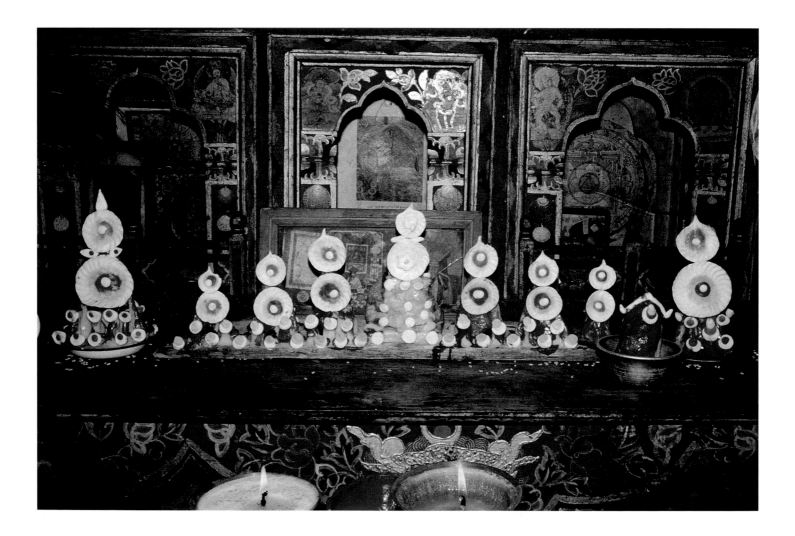

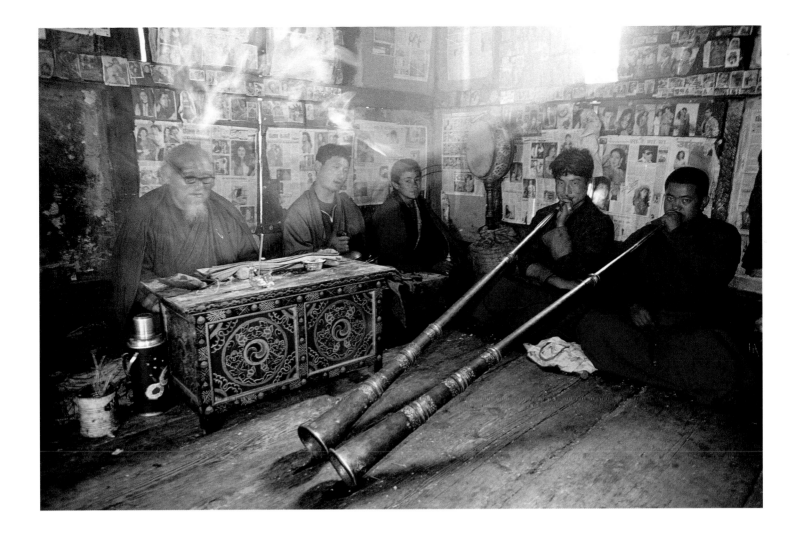

addressed, but the complete relevant religious environment. This includes figures from Tibetan Buddhism, which transcend the local boundaries and by their presence provide the event with supra-regional significance.

On the tenth day of the eighth month of the Fire Ox Year the left edge of the altar at Phub Tshering's house is occupied by a special *torma* (g.yang zas gtor ma) spreading good fortune to everyone. Next to it, a second *torma* represents good fortune from all directions (g.yang chang), and right beside it stands a bowl with flour and butter (phyed mar). A *torma* of Ödöpa completes this outer group. The central part of the altar is taken up by a reconstruction of the whole personified sacred area from the village up to the heights of the Tibetan border. These local dignitaries are joined by one of the supreme protectors of the teachings of all traditions of Tibetan Buddhism, namely King Pehar (rgyal po Pe har).[26] But let us read the representations again from left to right. The first *torma* represents Ödöpa himself, the chief object of the ritual. Next to him stands Drakye, an ice-covered mountain at the entrance of the Paro valley and the guardian of

Almost all houses have an altar room where ceremonies take place regularly so that the household and village deities remain happy. (J.W. 1994)

the town of Paro and its environs. Then comes King Pehar, who is venerated wherever Vajrayana Buddhism is practised. The central figure is coterminous with the ritual itself and is called *lhasang*. Applied pieces of dough represent the three levels of the cosmos – heaven, earth and underworld. These three spheres are to be cleansed from all conscious and unconscious impurities (grib).[27] Then comes Genyen Jagpa Melen (dGe bsnyen Jag pa Melen), Bhutan's god of war (*dralha*), protector of the state religion and *yulha* of the capital Thimphu. He is flanked by Chari Tsen, the *yulha* of the neighbouring village. So as not to neglect, or indeed forget any other 'owners of the soil', the last *torma* of this group represents *shidag* in general. The group on the right is made up of a *torma* representing the goddess Tsheringma (bkra shis Tshe ring ma), who has her abode on the snow-capped Jomolhari. She is also worshipped far beyond the Bhutanese border

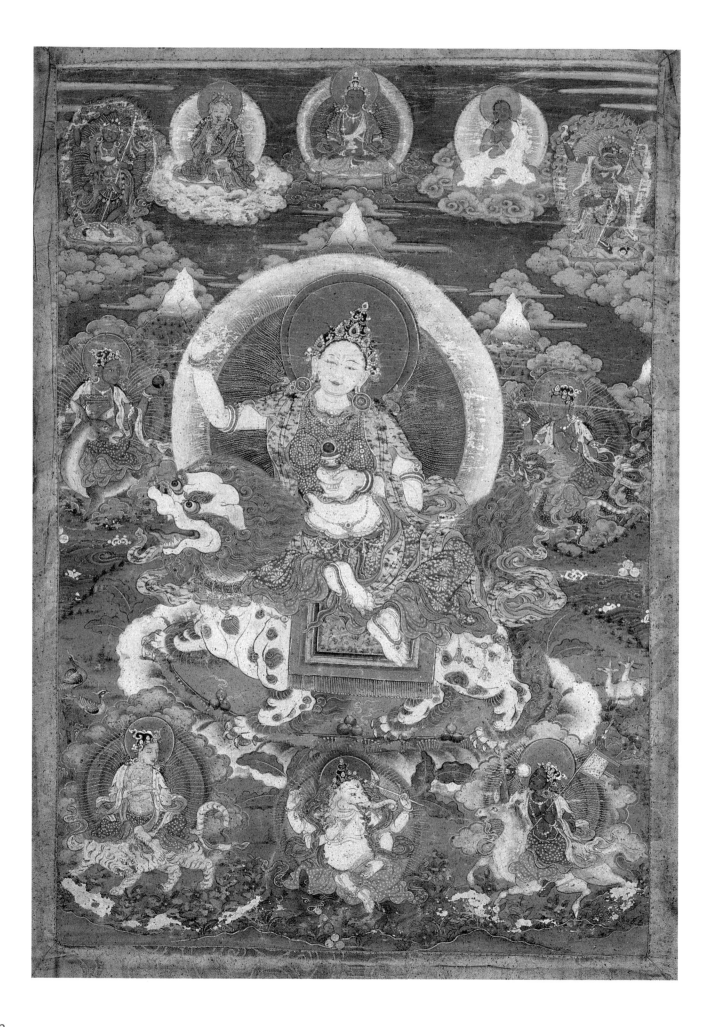

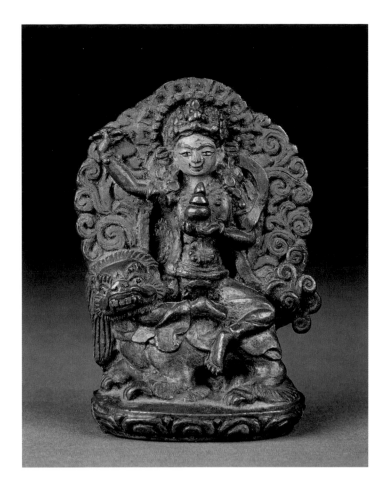

master (bla ma'i zhabs rten). This preparation causes all bad influences and demons to flee the place of worship (bgegs skrod). Now they can invoke all the gods and goddesses represented on the altar and ask them to participate in the ritual (spyan 'dren). Once they are present, all the offerings at the altar (mchod pa) are sacrificed. At the same time they praise the kindness and benevolence of the gods (bstod pa). The next event is a meal offering (tshogs). Should any mistakes have been made until now, the lama presents his apologies (bkang gsol/mdzod gsol). Now the gods have been coerced to listen to requests in return: they are asked to protect the Buddhist doctrine and all the inhabitants of the region and all sentient beings, to repulse all enemies, to grant fertility and safeguard peace within the community (dge ba bsngo ba). The final prayer again asks for the gods' blessings and protection for the future (bkra shis). At the end of the ritual the lama bids farewell to the gods, who return to the rocks or to the hills and stone cairns or again to the high mountains. From their abode they watch over the order of the world.

The deity Tsheringma (above as a carving and left in a thangka), seated on a white lion and holding the vase of longevity, is the senior of a group of five sisters who were mountain and local deities converted into protectors of Buddhism. Very popular in Bhutan, they are associated with wealth and cattle, with a dance dedicated to them. The Five Sisters are all depicted on the thangka. On the bottom row is found Tshodag, an elephant-headed deity also associated with wealth. On the top row sits Tshepame, deity of Long Life, with Guru Rinpoche and Milarepa, two saints associated with the subjugation and conversion of Tsheringma. (E.L.)

throughout the Buddhist Himalayas and Tibet. The second and final figure of this group is another '*torma* of good fortune' (g.yang 'gugs).

In front of these deities are placed various offerings such as milk, butter, water, incense, flowers, wine in a skull bowl and several butter lamps. Phub Tshering and his assistants take their seats opposite the altar. For the next hours they read sacred texts, say prayers and play musical instruments – in the presence of the gods of the landscape.

They begin with an invocation of the Three Jewels of Buddhism (dkon mchog gsum) – the Buddha, his teachings and his followers. Then they pray to their initiation

1 On the life of this so-called 'divine madman', see Dowman and Paljor (1980).

2 This story is based on a tape-recorded interview with Phub Tshering from Gunitsawa, 10 November 1996.

3 On the cognitive anthropology of non-European conceptions of nature, see Gingrich (1996) and Gingrich and Mader (1995).

4 This list of gods of the middle level is far from exhaustive and only meant to give an idea of the multiplicity of names.

5 See Tucci (1949: 717–25); Stein (1972: 203f).

6 There exists an extensive scholarly literature about this class of gods, e.g., Tucci (1949); Nebesky-Wojkowitz (1956); Blondeau in Blondeau and Steinkellner (1996).

7 Samuel (1993: 23).

8 For an attempt to classify the gods and the associated terminology, see Pommaret (1996).

9 This protection of a new member of the family plays an important part in the wedding ceremony; see Schicklgruber (1991).

10 Nebesky-Wojkowitz (1956: 327f) calls these gods "a group of five ancient Tibetan deities". Its composition varies with the sources, cf. Stein (1972: 222). Information acquired during field research shows differences between regions, and even individual informants.

11 For examples of the same god being given different names according to specific circumstances, see Schicklgruber (1996).

12 Pommaret (1996: 46ff).

13 Pommaret (1994: 660–69).

14 Macdonald (1971: 190–391); Karmay (1996).

15 In other parts of the Buddhist Himalayas a link between mountains and political power still survives. In Dolpo (western Nepal) the mayor's office (gras po) is claimed by those who are direct descendants of the *yulha*; see Schicklgruber (1996).

16 See Pommaret in this volume ('The Birth of a Nation'), where she presents the history of Bhutan from the viewpoint of a historiography based on written sources concentrating on the spread of Buddhism and the lives of great lamas.

17 Anyone familiar with the religious background will notice how these dances illustrate the path to enlightenment. The same is true for other types of Buddhist art, where the level of understanding depends on the background knowledge of the observer.

18 Nebesky-Wojkowitz (1956: 241ff).

19 This topos is often found in the Tibetan culture area. King Songsten Gampo 'nailed down' a demoness, who was active throughout the Himalayas, by building nine monasteries, after which she was unable to harm the country any further. Two of the monasteries are situated in present-day Bhutan.

20 Aris (1979: 24).

21 Ibid., p. 22.

22 Pommaret, this volume ('The Birth of a Nation') describes how the lama had to flee Tibet to save his life.

23 Aris (1994: 56).

24 Karmay (1995: 161–207).

25 It is not possible here to enlarge upon the specific connotations of the 'soul' in Buddhist thought. It may be mentioned that it is more akin to something like 'state of consciousness' (rnam shes) than to the pre-Buddhist conception of the soul (bla).

26 Nebesky-Wojkowitz (1956: 94ff).

27 On the meaning of grib, see Schicklgruber (1992: 723–34).

REFERENCES

Aris, Michael. 1979. *Bhutan: The Early History of a Himalayan Kingdom.* Warminster: Aris and Phillips; New Delhi: Vikas.

—— 1994. *The Raven Crown: The Origins of Buddhist Monarchy in Bhutan.* London: Serindia Publications.

Blondeau, Anne-Marie, and Ernst Steinkellner. 1996. *Reflections of the Mountain: Essays on the History and Social Meaning of the Mountain Cult in Tibet and the Himalaya.* Vienna: Verlag der Österreichischen Akademie der Wissenschaften.

Dowman, Keith, and Sonam Paljor. 1980. *The Divine Madman: The Sublime Life and Songs of Drukpa Kunley.* London: Rider.

Gingrich, André. 1996. 'Hierarchical merging and horizontal distinction: a comparative perspective on Tibetan mountain cults.' In (eds) Anne-Marie Blondeau and Ernst Steinkellner, *Reflections of the Mountain.* Vienna: Verlag der Österreichischen Akademie der Wissenschaften, pp. 233–62.

Gingrich, André, and Elke Mader. 1995. *Metamorphosen der Natur: Ethnologische Beiträge zum Verhältnis von Weltbild und natürlicher Umwelt.* Frankfurt/Main: Suhrkamp.

Karmay, Samten. 1995. 'Les dieux des terroirs et les genévriers: Un rituel tibétain de purification.' *Journal Asiatique*, 283, no. 1, pp. 161–207.

—— 1996. 'The Tibetan cult of mountain deities and its political significance.' In (eds) Anne-Marie Blondeau and Ernst Steinkellner, *Reflections of the Mountain.* Vienna: Verlag der Österreichischen Akademie der Wissenschaften, pp. 59–76.

Macdonald, Ariane. 1971. 'Une lecture des Pelliot Tibétain 1286, 1287, 1038, 1047, et 1290: Essai sur la formation et l'emploi des mythes politiques dans la religion royale de Srong bcan sgam po.' In *Etudes tibétaines dediées à la mémoire de Marcelle Lalou.* Paris: Maisonneuve, pp. 190–391.

Nebesky-Wojkowitz, R. de. 1956. *Oracles and Demons of Tibet.* Graz: Akademische Druck- und Verlagsanstalt.

Pommaret, Françoise. 1994. 'Les fêtes aux divinités-montagnes Pcha (Phyva) au Bhoutan de l'est.' In (ed.) P. Kværne, *Tibetan Studies: Proceedings of the 6th Seminar of the Internation Association for Tibetan Studies*, 1992, Fagernes. Oslo: Institute for Comparative Research in Human Culture, pp. 660–69.

—— 1996. 'On local and mountain deities in Bhutan.' In (eds) Anne-Marie Blondeau and Ernst Steinkellner, *Reflections of the Mountain.* Vienna: Verlag der Österreichischen Akademie der Wissenschaften, pp. 39–58.

Samuel, Geoffrey. 1993. *Civilized Shamans: Buddhism in Tibetan Societies.* Washington, D.C. and London: Smithsonian Institution Press.

Schicklgruber, Christian. 1991. 'Der patrilineare Klan und die Ordnung der Welt: Weltbild und Lebenswelt reflektiert an der Institution Ehe bei den Khumbo in Ostnepal.' Ph.D. diss. (unpublished), Vienna University.

—— 1992. 'Grib: on the significance of the term in a socio-religious context.' In (eds) Shoren Ihara and Zuiho Yamaguchi, *Tibetan Studies: Proceedings of the 5th Seminar of the International Association for Tibetan Studies.* Narita: Naritasan Shinshoji, pp. 723–34 .

—— 1996. 'Mountain high, valley deep: the yul lha of Dolpo.' In (eds) Anne-Marie Blondeau and Ernst Steinkellner, *Reflections of the Mountain.* Vienna: Verlag der Österreichischen Akademie der Wissenschaften, pp. 115–32.

Stein, Rolf. 1972. *Tibetan Civilisation.* London: Faber & Faber.

Tucci, Giuseppe. 1949. *Tibetan Painted Scrolls.* Rome: Libreria dello Stato.

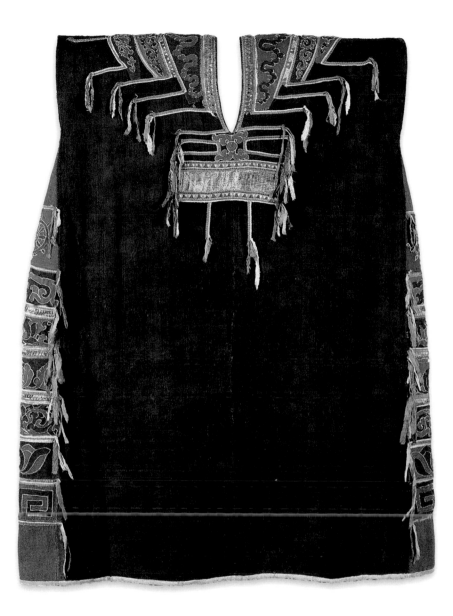

The shingkha is a sleeveless poncho-type tunic made of wool with silk and wool appliqué patterning. It is seldom worn today except at some religious ceremonies which take place in the region of Kurtö, or by clowns at festivals. (E.L.)

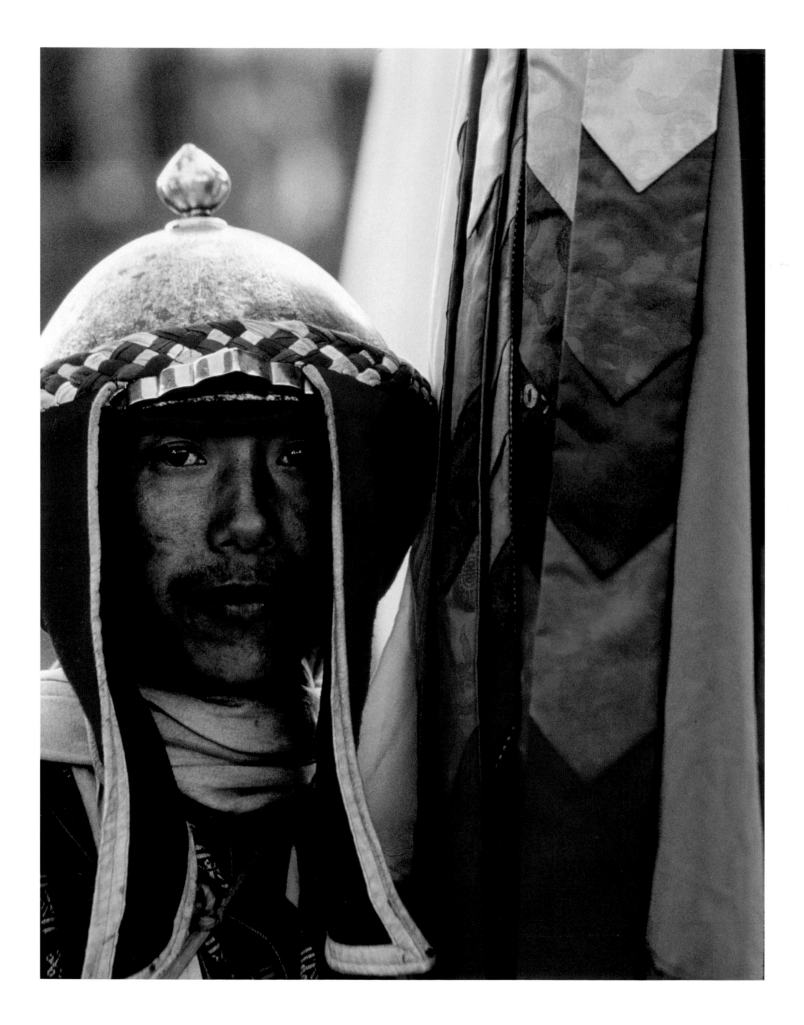

History and Nationhood

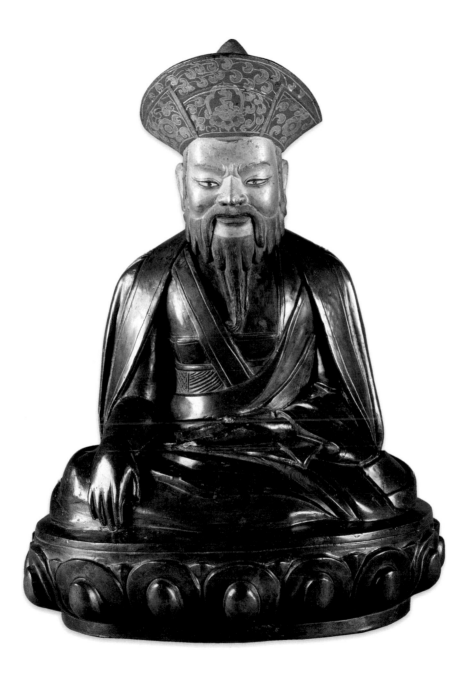

Above: The Shabdrung Ngawang Namgyel (1594–1651), religious hierarch of the Drukpa Kagyupa school of Buddhism, unified Bhutan in the 17th century. (E.L.) Opposite: A helmeted soldier from the ceremonial royal guard, dressed in historical costume. (J.W. 1994)

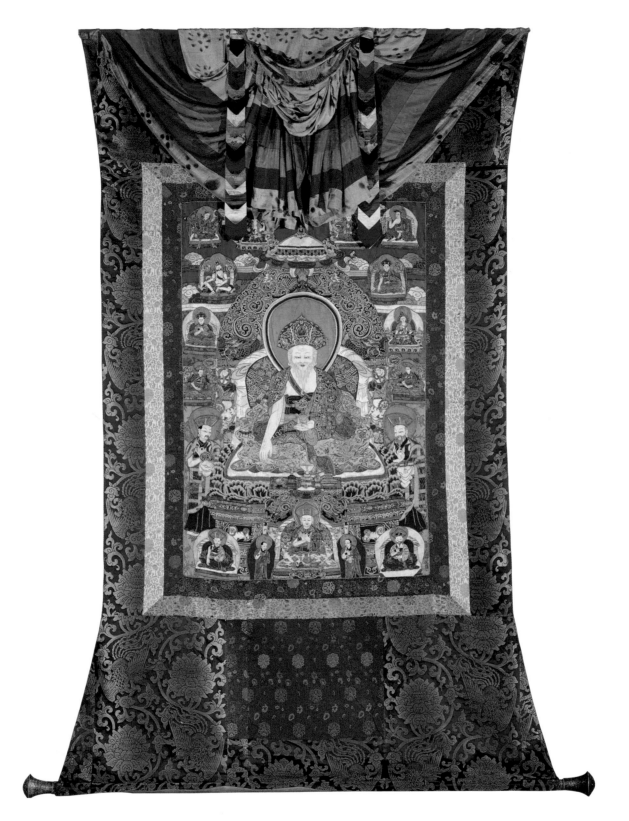

Above: The Shabdrung Ngawang Namgyel's lineage and previous incarnations are depicted on this large appliqué and embroidered thangka (Shabdrung Pünsumtshogpa). The Shabdrung is seated at the centre and on the left stands the first Je Khenpo Pekar Jungne (1604–72); on the right, the first regent, Desi Tenzin Drugye (1591–1656). On the second row from the top, to the left is Naropa, the 10th century Indian master, and on the right, Tsangpa Gyare, founder of the Drukpa Kagyupa school in the 12th century. Seated beneath the Shabdrung and flanked by a Desi and a Je Khenpo, is an unidentified Drukpa hierarch who may be the Shabdrung incarnation who commissioned this thangka at the beginning of this century. The Shabdrung's father, Tenpe Nyima, is found on the bottom row to the right. (E.L.)

The Birth of a Nation

Françoise Pommaret

THE NAMES OF BHUTAN

The history of Bhutan presented here is written following the view that Bhutanese have of their own history (largely derived from the references cited below). It thus starts with the names of Bhutan. The modern term Bhutan is thought to derive from the Indian term 'Bhotanta' which means 'the end of Tibet', i.e. the end of the area culturally related to Tibet. This is the term that has been adopted in modified form by Westerners, and today Bhutan is used as the official name of the country for the outside world. In Dzongkha, Bhutanese call their country Druk Yul, 'Land of the Dragon.' The anecdote explaining the etymology of this name and involving the lama Tsangpa Gyare has already been given in the chapter 'Ethnic Mosaic'.

In pre-seventeenth century texts, however, Bhutan was known by various other names which are still used today, along with Druk Yul, in Dzongkha. All these names begin with *'lho'*, which means 'south', and was used to refer to regions south of the Tibetan plateau. The names were: *Lho Yul*, 'southern country'; *Lho Jong*, 'southern valleys'; *Lho Mön*, 'southern country of Mön' (Tibetans used the term 'Mön' for the forested areas south of the Himalayas populated by people of Mongoloid stock who were neither Tibetan nor Buddhist); *Lho Mön Tsenden Jong*, 'southern Mön country of sandalwood', referring to the precious wood which grows in Bhutan; *Lho Jong Men Jong*, 'southern valleys of medicinal herbs', referring to the abundance of healing herbs found there; and *Lho Mön Kha Shi*, 'southern Mön country of four approaches'. The 'approaches', or more exactly 'mouths,' were situated at the four extremities of present-day Bhutan. They were: Dungsamkha (Deothang / Pemagatshel) in the east, Pagsamkha (Buxa in Cooch Bihar) in the south, Dalingkha (near Kalimpong) in the west, and Tagtsekha in the north.

PREHISTORY

In the absence of any archaeological research, it is extremely difficult to assess the importance of prehistoric culture in Bhutan. However some clues may be gleaned from stone tools chanced upon by peasants while ploughing their fields, and from megaliths or standing stones. The tools are believed to be weapons of the gods and demi-gods which fell to earth during their battles. People keep them in their houses because they are thought to bring good luck. Megaliths can be found especially in central and eastern Bhutan. Their exact purpose is not known; some may have been used for border demarcations and some for religious cults. In eastern Bhutan it is said that the stone is connected with the life of a person; if the stone falls, then the person may fall sick or die.

Bhutan is surrounded by regions that had prehistoric cultures, though at the moment it is impossible to establish a connection between Bhutan and any of these regions for lack of proper research. It is well known, for example, that Tibet

has a considerable number of megaliths, and stone implements have also been discovered there.[1] Burma, northeast India and southeast Asia abound in similar prehistoric artifacts. To this day only one stone axe found in Bhutan has been inspected by an expert, who suggested a date of 2000–1500 BC.[2]

This circumstantial evidence suggests that Bhutan has been populated at least since the second millenium BC by people who practised agriculture, though without archaeological evidence it is impossible to say any more about what kind of people they were.

THE DAWN OF BHUTANESE HISTORY: ARRIVAL OF BUDDHISM AND FIRST MIGRATIONS FROM TIBET (SEVENTH–TENTH CENTURY)

Very little is known about this period. There are no contemporary historical sources and the only information is given by later and/or religious documents. Therefore, from a modern historical point of view, it is almost impossible to accurately reconstruct this early age.

There is, however, a strong Bhutanese tradition concerning this period, based partly on the religious belief in *terma*, texts which are said to have been hidden at this time to await rediscovery much later by a chosen person, a *tertön*, or 'religious treasure discoverer'. Although it consists of facts which may have been embellished, this tradition is nevertheless the only one which can help the modern historian dissipate the mist of this period.

The first inhabitants

According to Bhutanese tradition, Bhutan was originally inhabited by people called Mönpas (who should not be confused with the people nowadays called Mönpas in Arunachal Pradesh). As already mentioned, the term 'Mön-pa' was applied to people of Mongoloid stock who lived in the densely forested areas south of the Himalayas. Did these people originate there, or had they migrated from another area? There is no way of knowing, and Bhutanese tradition is also silent on this subject.

The religion of the Mönpas was not Buddhism; it was probably a blend of animism (belief that objects like stones, mountains, trees, sky, etc. have a soul), and shamanistic practices (priests journeying in the netherworld and propitiat-

ing spirits that could harm human beings). This religion is known as Bön in the Bhutanese tradition.

Nowadays, residual groups of Mönpas still survive in some jungle areas of Tongsa, Wangdi Phodrang, Shemgang and Dagana districts.

The first Buddhist temples

A decisive event in Bhutanese history seems to have occurred in the seventh century: the building of the first Buddhist temples by a Tibetan king. This most probably took place in a region populated by the Mönpas. It did not mean, however, that Tibet had suzerainty over the 'southern valleys', which is not suggested anywhere in the sources. These temples were considered to be on the border of Tibet and beyond the border. It is possible that during this period the valleys had no political unity and the local people did not greatly object to the building of these temples, which were part of a grand scheme of propagating Buddhism, a civilized religion, unlike Bön which was regarded as a barbarian faith. It is also possible that some Mön people had become interested in Buddhism. It is doubtful whether the facts will ever be known and only suppositions can be made.

Bhutanese tradition records a long story about the construction of these two temples, Kyichu Lhakhang in Paro and Jampe Lhakhang in Bumthang:

The temples were part of a scheme designed by the Tibetan king Songtsen Gampo to tame a huge demoness believed to extend over the whole of Tibet. She created many obstacles, particularly to the spread of Buddhism. The king decided to build a temple on each of her joints so as to pin her down and immobilize her. He is said to have multiplied himself magically and sent his emanations all over Tibet building 108 temples in one day. Of these 108 temples, 13 were the most important. The first one, the famous Lhasa Jokhang in Tibet, was built on the heart of the demoness. Four temples were also built in the central region of Tibet; these were called 'the four great horn suppressors'. Farther away from Lhasa, four more temples were known as 'the temples to tame the border'. One of these was Jampe Lhakhang in Bumthang which was constructed on the left knee of the demoness. Finally came four temples known as 'the temples to tame the area beyond the border'. Kyichu Lhakhang in Paro, built on the left sole of the demoness, was one of these.

Another Bhutanese tradition relates that there are four more small temples supposedly built at the same period as

'supplementary temples': Zunge in Bumthang Chume, Kyinyel in Kurtö, and Lhakhang Karpo and Lhakhang Nagpo in Ha. It is also believed that a few years later, two other temples were built in Bumthang: Anu Lhakhang in the Tang valley and Konchogsum in the Chökhor valley.

Guru Rinpoche (Padmasambhava)

The real introduction of Buddhism in Bhutan is said to have coincided with the arrival of Guru Rinpoche also known as Padmasambhava, sometime in the eighth century. He is depicted as coming to a land of demons and powerful local gods, which suggests that since the time of the construction of the two earlier temples, Buddhism had made little progress in Bhutan.

Guru Rinpoche, the 'precious master', is an extraordinary historical figure whose life story has taken on the dimensions of an epic. Born in the eighth century in the Swat province of what is now Pakistan, he became a Buddhist tantric master and brought numerous teachings to Tibet and other Himalayan countries, including Bhutan. His followers were later known as Nyingmapas, 'the ancients', and they constituted the first Buddhist school in Tibet. He became, for them, the second Buddha, and such was his personality that he is credited with a series of extraordinary achievements which the Bhutanese tradition faithfully records:

Guru Rinpoche travelled extensively in Tibet and Nepal. While he was meditating in the cave of Maratika in Nepal, he was called to Bhutan to recover the 'life-force' of a king in Bumthang. When the Guru restored his health, the king converted to Buddhism.

Guru Rinpoche also went to Paro Taktsang in his form of Dorje Drolö and meditated there for three months. He visited many other places in Bhutan as well: in Bumthang, Thowadra, Rimochen, Kunzangdra, Kuje, Shabjethang, Chöjedra and Mebartsho; in the Gasa region, Belangdra, Göntshephu, Tshalungdra; in the Paro valley, Drakarpo, Namthong Karpo, Chumophu; in Kurtö, Sengye Dzong; and the valleys of Khenpajong and Agyane, which he turned into 'hidden countries' (beyul).

Guru Rinpoche is believed to have left this world from a high pass in Tibet and to have gone to a realm southwest of our own. There he subdued all the flesh-eating demons (raksa), and turned the land into a paradise, Zangdopelri.

Two figures of ancient Bhutan associated with the activities of Padmasambhava and the central region of Bumthang, are Sendarkha and Chikharathö. According to Bhutanese tradition, Guru Rinpoche saved the life of the king of Bumthang Sendarkha (later known as 'Sindhu raja'), who converted to Buddhism as a result. Chikharathö ('dog mouth goat skull'), was a monstrous being born to an unfaithful queen of Tibet. Padmasambhava tricked him into exile from Tibet and into a valley of Bumthang.

In eastern Bhutan, we find the enigmatic figure of Prince Tsangma.

Prince Tsangma

According to Bhutanese historiography, Tsangma was the ancestor of the six ruling clans of eastern Bhutan which disappeared after the Drukpa unification of the seventeenth century.[3]

Prince (lhase) Tsangma was the son of the Tibetan king Tride Songtsen. His two other brothers were Relpachen, who became king after his father's death, and the heretic Langdarma, who assassinated his older brother, Relpachen, in the first half of the ninth century.

Prince Tsangma was banished from Tibet by a plot of his brother Langdarma and some 'evil' Bönpo ministers. He first arrived in the Paro valley where he is said to have had a son by a girl at Namthong Karpo, and to have started two lineages: the Gyeldung in Paro and the Dungdrok in Thimphu. However, he did not settle there and proceeded to eastern Bhutan. He travelled throughout eastern Bhutan going as far as what is now Tawang in Arunachal Pradesh. Finally Prince Tsangma settled and built a castle at a place called Mizimpa at Tsenkharla (probably above Kangthang Woong where, not far from present-day Tashigang, stand the ruins of a castle). He married a lady whose father had come from southern Tibet and was from a good lineage, and they had two sons.

Because the local people knew Prince Tsangma's sons were of royal blood (chögyel gi dung), they asked the brothers to become their chiefs (je pön). The elder son went to the region of Laog Yulsum (Tawang) where he settled and founded the Jowo clan. The younger son stayed in eastern Bhutan. His descendants became the chiefs of all the valleys in eastern Bhutan, and founded the five other ruling clans: Je, Bjar, Yede, Tungde, and Wangma.

Bhutanese sources also explain the origins of the nobility of the regions of central and eastern Bhutan.

The origin of the noble 'Dung' families of Bumthang, Kheng and Zhongar (Mongar)

Dung is a general term meaning 'bone' (i.e. clan), and can refer to any important family in central and eastern Bhutan. The term, however, also functions as a title. As an honorific, Dung tends to be applied specifically to the noble families of Bumthang and Kheng.

The history of these noble families is complicated because there are two different accounts of their origins. These accounts are based on different sources, which reflect the conflicting ambitions of the two main families: the Ura Dung family and the Zhongar Dung family, each claiming the honour of being the first Dung.

The Ura tradition

Following the death of king Chikharathö, his subjects in Bumthang had no chief. As they were quarrelling, they decided to search for one. They prayed to their god, the God of Heaven, and he sent them his son who entered a village woman's womb. When he was born, he was called Lhagon Pelchen and after a few years he became their chief, followed by his son and grandson. The latter, however, had no heir. He told the people that after his death they should go to central Tibet, and when they saw a large crowd of children they should drop some fruit from the region of Mön among them. The child that seized most of the fruit would be his reincarnation. They should take that child and bring him back to Ura.

The local people followed these instructions and brought the child back to Ura, hidden in a yak hair bag. Under the name of Lhawang Dragpa, he became their chief. One day he decided to find out the background of his family, so he sent some people to central Tibet to make inquiries. They learnt that the child who had been kidnapped in a raid some years earlier was a descendant of king Langdarma's son, Ösung. Pleased, as they had proof that their lord was of royal blood, the villagers returned to Bumthang. Lhawang Dragpa then married a lady from Chökhor. The Dung families of Bumthang, Kheng and Zhongar are descended from their offspring.

The Zhongar tradition

A young girl was on her way to marry the king of Dungsamkha. One night she slept on the shore of a lake called Mukulung Tsho. During her sleep, the chief of the local gods, who was the son of the God of Heaven, crawled on her in the form of a white snake. When she arrived at Dungsamkha, she gave birth to a son. When he grew older, the boy found out the identity of his father but was killed by his father's enemy, a water-snake (lu). As his brain was eaten by a

fish, the boy then became a fish. He was caught in the net of a man who, discovering that the fish could speak the language of humans, decided to keep him alive. When the man went out to work, the fish would change into a child and do the housechores for him as he had no wife. One day the man found out and threw the empty fish skin into the fire, where it was burnt. Because the child was the son of a god, he was stronger than other men. He was therefore made chief of the region, and he won control over Ura and Zhongar.

One day he made his subjects cut down the summit of a mountain so that he could see further. This they did, but they were unhappy and managed to kill him. Before he died, he predicted that he would be reborn in central Tibet. He told his people that they should go with cowries and seek him there. They would recognize him because he would be the child who seized most of the shells. Everything happened as he had said, and the child who was taken back was called Lhawang Dragpa.

From this point, this version and the previous one are similar. Lhawang Dragpa became the ancestor of the Dung families, among whom the Zhongar Dung is ranked first.

In fact, these two stories tell us almost the same thing. The first 'chief' of Bumthang was half god, half human. After his grandson – or he himself – died without heir, a young boy of royal blood had to be brought from Tibet. This boy, and later chief, was the ancestor of the Dung families of Bumthang, Kheng and Zhongar.

The origin of the 'Shelngo' noble families of Bumthang, Kurtö and Zhongar (Mongar)

It appears that the Dung were not the only ruling families of these areas. Other noble families who became chiefs of some parts of Bumthang, Kurtö and Zhongar, were known by the general term 'Shelngo'.

The following events are said to have happened after the assassination of the Tibetan king Langdarma in the middle of the ninth century.

After Lhalung Pelkyi Dorje had killed King Langdarma who was opposed to the Buddhist doctrine, he fled to Kham in the east. The rest of his family, his six brothers, had also to leave Tibet: three arrived in Bumthang by way of Phari and Paro, and three arrived in Kurtö by way of Lhodra.

Of the three brothers who arrived in Bumthang via Paro, one settled in Tang and one settled in Chökhor, where his descendants became the famous 'Chökhor Pönpos'. The third brother went north

of Bumthang and settled at Tshampa, a region lying between the border and Chökhor.

Of the three brothers who arrived in Kurtö via Lhodra, one decided to stay there and his descendants were known as the Kurilung 'Pönchen Shelngo'. Another brother went east, and it seems that after a battle with the chief of the Tashigang area, he won control over the region. The last brother went to Zhongar and took over that area. As he was clever (khyengpo), his descendants were called the 'Khyengpo Shelngo'.

With this story, the series of events concerning the early age of Bhutan's history (seventh–tenth century), and related in the Bhutanese documents presently available, come to an end. Seventh-century Bhutan was populated by Mönpa people of Mongoloid stock who were not Buddhist; it was not a unified country, but a series of 'southern valleys' beyond the border of Tibet.

The first trace of Buddhism appeared when the Tibetan king Songtsen Gampo built two temples: one in Paro and one in Bumthang. However it was after the arrival of Guru Rinpoche in the eighth century on the invitation of a king of Bumthang, that some parts of the country (Bumthang, Paro) became Buddhist, while other areas retained the animist faith.

It seems that some migrations from Tibet began in this period. They probably continued into the ninth century, especially after the troubled end of the royal dynasty in Tibet which plunged the country into chaos. As we have seen, Bhutanese tradition has preserved the memory of the arrival of persons of royal descent, such as Chikharathö, Prince Tsangma and Lhawang Dragpa, and of prestigious men like the brothers of Lhalung Pelkyi Dorje, but large numbers of ordinary people must also have sought refuge in the southern valleys.

According to all the stories, due to the prestige of their lineage, these persons of high rank married local ladies, and were able to become chiefs of various regions and start ruling lineages. While nothing is known about the political state of western Bhutan in the tenth century, Bumthang, Zhongar and Kheng seem to have been ruled by the families of the Dung whose common ancestor was Lhawang Dragpa, and by the descendants of three of the brothers of Lhalung Pelkyi Dorje. Kurtö was ruled by one of the brothers of Lhalung Pelkyi Dorje, while eastern Bhutan was divided between the descendants of another of his brothers and those of Prince Tsangma. However, none of these ruling families became powerful enough to bring the whole country together, and

Bhutan appears at that period to have been divided into a large number of small independent fiefdoms each headed by a chief.

After the assassination of the anti-Buddhist king Langdarma in Tibet in AD 842, Tibet underwent a period of political turmoil and Buddhism almost disappeared except in the remote areas of Ngari in western Tibet, and Kham in eastern Tibet. No contemporary source has survived to tell what happened at the end of the ninth, and in the tenth century. Later sources are also generally silent about this period, except to say that Tibet had lost its unity and that Buddhism was almost extinct.

THE HISTORY OF WESTERN BHUTAN FROM THE ELEVENTH TO THE EARLY SEVENTEENTH CENTURY

From the eleventh century onward the history of Bhutan is closely linked with the different religious schools that appeared in Tibet during what is called 'the period of the second diffusion of Buddhism'. It appears the Tibetan lamas realized that the 'southern valleys' were a good 'field of conversion'. Once the position of their school was secure in Tibet they looked forward to making converts; Bhutan was an entirely new area for missionary activities.

For these centuries there are more sources concerning western Bhutan, and the history of this region is quite well-known. Information concerning central and especially eastern Bhutan during this time, however, is relatively sparse. Western Bhutanese history is predominantly religious and provides little insight into socio-economic aspects. Little is known about the political organization of western Bhutan at the outset of this period. Local chieftains must have ruled the valleys since they are sometimes mentioned as patrons of the various lamas, but it is impossible to draw a realistic picture of the political situation at that time.

From the end of the twelfth century to the beginning of the seventeenth century, the history of western Bhutan is in fact the history of the different religious schools which, while spreading their doctrine, managed to assume temporal powers as well. More particularly, these centuries witnessed the steady rise of the Drukpa Kagyupa school in this area.

The Lhapa Kagyupa School

The founder of this school in Tibet was Gyelwa Lhanangpa (1164–1224), a member of the powerful clan of Nyö and a disciple of the Drigungpa Jigten Gonpo. It seems that early on, Gyelwa Lhanangpa decided to propagate his school in western Bhutan, perhaps because he had inherited estates in the area. His great great grandfather (who became known as the 'Translator of Nyö' after his travels to India with Marpa, the great translator) had, for some unknown reason, received lands and other properties in western Bhutan and passed these on in his family. Gyelwa Lhanangpa must have thought that with such a foothold he had great chances to firmly establish his school in Bhutan. He therefore moved to Bhutan with his disciples at the end of the twelfth century or the very beginning of the thirteenth century. He meditated at Taktsang and Kyichu Lhakhang, but the main seat of the school became the *dzong* of Chelkha in the upper Paro valley. The temples and *dzongs* he built, are now mostly in ruins: Jathel Dzong in the upper Thimphu valley, Beme-thokha Dzong (now Bjimina) in the Gidakom valley, and Dongön Dzong in Thimphu valley at the place where the temple of Dechenphodrang now stands.

Gradually, the local chieftains surrendered their power to Gyelwa Lhanangpa. The Lhapa school gained influence and eventually controlled a large part of western Bhutan. It is certain that this religious school unified the area for the first time under a joint religious and political rule (*chösi*), though this hegemony was only to last a short while.

The rule of the Lhapas in western Bhutan was soon threatened by a new development: the arrival of Phajo Drukgom Shigpo of the Drukpa Kagyupa school in the first half of the thirteenth century.

The arrival of the Drukpa Kagyupa school: The role of Phajo Drukgom Shigpo – his fight with the Lhapas

Phajo (1184–1251) is one of the most important figures in the history of Bhutan, where he introduced the Drukpa Kagyupa school. It is useful to review the details of his life as given in his biography.

In 1211 in Tibet, the founder of the Drukpa school, Tsangpa Gyare, was about to die. He called his nephew Sangye Önre Dharma Sengye, and told him that after his death a man would arrive from eastern Tibet. Sangye Önre was instructed to give him all the teach-

ings and initiations because that man was destined to go and spread the Drukpa school in Bhutan. (Sangye Önre Dharma Sengye later became the founder of the Bardruk branch, 'the middle Drukpa', of the Drukpa Kagyupa school.)

Sometime after this prophecy and the death of Tsangpa Gyare, a young man named Phajo arrived in Ralung. Born in Kham in eastern Tibet, he had been interested in religion since the age of twelve. On hearing of Tsangpa Gyare, Phajo decided to go and meet him in Ralung, but Tsangpa Gyare had died before his arrival. Instead, Sangye Önre took Phajo as his disciple and gave him all the initiations, especially the teachings related to Tamdrin (Skt. Hayagriva). When he thought the time was right, Sangye Önre told him about Tsangpa Gyare's prophecy. Phajo was extremely happy and he left for the southern valleys in 1224.

He arrived first in Lingshi where he was welcomed by the nomads, and then proceeded to Taktsang where he stayed in meditation for a month. During this time Phajo had a vision of Guru Rinpoche, who prophesied that he would have to meditate in twelve places: four dzongs, four rocks and four caves. Later Phajo had another vision revealing that he would find his consort in Wang and that she would be a reincarnation of the famous yogini Machig Labdrön (1055–1145).

Phajo left for Wang and meditated in a cave called Sengye Gyeltshenphu, where a number of girls from the village of Wang Chudor came to see him. One of them, Acho, stayed with him and bore him a son, Dampa. She told him that she had a younger sister in Wang Sinmo village. Since the age of three, this sister had said that her lama was coming; now grown-up, the girl refused to marry.

Phajo understood that she must be the girl of the prophecy and left for Wang Sinmo. There, across the river, he saw a group of girls weaving. He started singing:

Girls on the opposite side of the river,
Stop chatting and listen attentively to my song.
I, a beggar from Kham,
Have arrived at the place prophesied by my lama.
Do you know where she lives,
The girl with whom I am linked by prayers?
The time has come to realize the consequence of
* former acts.*

The girl in the centre, who was Acho's younger sister Sonam Peldön, stood up and replied:

You, an ascetic beggar who is passing by,
Listen to the song of the girl.
Are you the one prophesied by the lama?
Or are you a demon playing tricks?
You look like an emanation of the lama
Prophesied by the Buddha of the past,
I beg you to take me with you.

As there was no bridge there, Phajo followed the right bank of the Wang river, and Sonam Peldön the left bank, until they reached the only bridge in the Wang region. There they met. The bridge is still known as Lungtenzampa, 'the bridge of the prophecy' (nowadays at the entrance of Thimphu town).

Continuing their journey, they reached Dodena in the upper Thimphu valley and from there proceeded to the place where Tango monastery now stands. One day Phajo heard a horse neighing and he had a vision of Tamdrin, the god with a horse-head in his hair; this place therefore became known as Tango, or 'horse-head'. Tamdrin instructed Phajo to perpetuate his lineage and spread the Drukpa school through his children. Nine months later a daughter was born to Sonam Peldön.

Meanwhile the Lhapas had grown concerned about this lama from Ralung. Gyelwa Lhanangpa even sent Phajo a threatening letter, saying that he must either submit to the Lhapas or risk losing his life. When Phajo's daughter was born, two Lhapa lamas came to verify the rumour of her birth and discovering its truth became very concerned. Phajo meanwhile went to meditate in the Punakha region. One day his string of prayer beads broke, and the beads scattered in all directions. A voice resounded in the sky telling him that this was an omen that his teachings would spread all over the country.

After he came back from Punakha, Sonam Peldön gave birth to seven sons at Dodena. Knowing that three of them were demons, Phajo threw all of them into the river from the bridge. Three drowned, while the other four were carried away, unharmed, in different directions. Phajo understood this to mean they would spread the Drukpa teachings in four different directions. Sonam Peldön went to look for them, and brought them back to Dodena.

After the birth of his sons, Phajo became a threat to the Lhapas, who knew the Drukpa teachings would be carried on by his lineage and thus challenge the Lhapa supremacy. Therefore, they sent Phajo a letter from Chelkha Dzong in Paro cautioning him to abide by their rule or leave as they were the lords of this area. Phajo replied that he had a mission from his master to spread the Drukpa teachings, and that the Lhapas were making the people suffer. Angered by this reply, the Lhapas decided to kill Phajo by secret means.

They did not succeed. In fact, Phajo turned their own magical devices against them: the Lhapa magicians vomited blood, a thunderbolt fell on Jathel Dzong, the walls of the Dongön Dzong collapsed, and the Chelkha Dzong was destroyed by fire.

Following these events, people lost faith in the Lhapas and the local rulers of western Bhutan started to patronize Phajo, whose demands were apparently less heavy than those of the Lhapas. The Lhapas then left Paro and went to settle at Bemethokha Dzong, in Gidakom valley. From then on, the Lhapas had little influence in western Bhutan. Their antagonism toward the Drukpas, however, lasted till the time of the Shabdrung in the seventeenth century, when they were defeated after leading a coalition of the Shabdrung's opponents known as the 'five groups of lamas' (lama khag nga).

Phajo built a temple in Dodena and a monastery at Tango. Then he called his eldest son, Dampa, born to his first wife and then fifteen years old, and gave him all the teachings. When Phajo's sons were grown up, he sent them all to preach the Drukpa doctrine in different regions (except for his youngest son, Lama, who received the Dodena temple and stayed there). His son Gartön went to Shar where he established the temple of Shar Khothang and Wachen (Wache) Dzong, and his descendants became the nobility (Shelngo) of Wachen; his son Nyima settled in the Thimphu valley where his descendants became the Changangkha Shelngo; his son Wangchuk went to Punakha and Gön (upper Mochu valley) regions; his son Dampa inherited Tango Monastery and built a small temple at Dechenphu. He later went to Paro and established Namkhe Lhakhang. The Drukpa nobility of Paro was descended from Dampa. Notable among them was the famous Drungdrung who built the Humrel Dzong, later Paro Rinpung Dzong.

Thus at the death of Phajo in 1251, the dominant religious school in western Bhutan was the Drukpa (specifically, the Bardruk, or 'middle Drukpa', branch). Its political influence increased as Phajo's descendants gave rise to a religious nobility (called Shelngo or Chöje). Since these families carried out temporal as well as spiritual duties, they became the most important and powerful entities in western Bhutan.

The other religious schools in western Bhutan

The Lhapas and the Drukpas were not the only religious schools in western Bhutan. Adherents of the major Tibetan schools eventually appeared on the scene, founding monasteries and gathering followers. However, they arrived only in the fourteenth and fifteenth centuries, and never managed to achieve significant temporal power (probably because of the strength and number of Drukpa families).

There were the Nenyingpas who arrived in Bhutan in the fourteenth century; the Nyingmapas with two offshoots: the Dzogchenpas whose influence was spread by the great Tibetan scholar Longchen Rabjampa Drime Özer (1308–63), and the Kathogpas; the Barawas who followed the 'upper Drukpa teachings'; the Chagzampas named after the founder Thangtong Gyelpo (1385–1464) who became famous in Tibet and Bhutan for his iron bridges (hence his nickname 'Chagzampa', 'iron-bridge builder'); and finally the Sakyapas.

Tibetan missionaries regarded western Bhutan as a suitable field for their religious activities. Because of the lack of political unity and centralized power in Bhutan, it was easy for them to settle and gather influence, provided of course that they courted support from the local population. Depending on various circumstances, such as the importance of his patrons and his desire to involve himself in mundane activities, a lama could acquire not just religious authority but also a fair amount of local temporal power, thus contributing to the political importance of his particular religious school. It appears from the historical sources that some religious schools slowly took precedence over laymen in secular matters. This was made easier by the fact that some lamas were allowed to marry, and were therefore able to create hereditary lineages which could combine and retain religious and temporal power.

Such a case was the Drukpa school which, through the descendants of Phajo Drukgom Shigpo, managed to establish a real network throughout western Bhutan, backed by the Drukpa ruling family of Ralung. It would lead to the irresistible rise of the Drukpa school in western Bhutan.

The rise of Drukpa power
(thirteenth to early seventeenth century)

In the thirteenth century, the four sons of Phajo Drukgom Shigpo settled in the four valleys of western Bhutan to propagate the Drukpa teachings. They married ladies of good extraction and founded local lineages of nobility (Chöje or Shelngo). Among them, the most important for the history of Bhutan are the descendants of Nyima who became the Changangkha Chöje in Thimphu, and the descendants of Dampa who were known as the Humrel Shelngo in Paro.

These lineages were very important locally and contributed to the strengthening of the Drukpa school. They maintained good relations with the Gya clan, the ruling family of the Drukpa in Ralung. During the fourteenth, fifteenth and

sixteenth centuries, they invited several prince-abbots of the Drukpa school as well as other prestigious members of the family to come to Bhutan to preach the doctrine and build monasteries. The activity of the Drukpa ruling family of Ralung increased considerably in Bhutan from the late fifteenth century until the beginning of the seventeenth century.

Ngawang Chögyel (1465–1540), nephew and successor of Gyelwangje on the Ralung throne, made many visits to Bhutan. He was sometimes accompanied by his two sons Ngawang Tenpe Gyeltshen (1506–38) and Ngagi Wangchuk (1517–54), the great grandfather of the future Shabdrung. The founding of more than twenty monasteries is attributed to them, not only in western Bhutan but also in central and eastern Bhutan.

One cannot but be impressed by the zeal and dynamism of the Drukpas who, besides those members of the ruling family of Ralung who visited at the request of Phajo's descendants, were also represented at that time by four other families in western Bhutan: the lineages of the Kyura, of the Obtsho Chöje, of the Zarchen Chöje and of Drukpa Kunle.

Drukpa Kunle (1455–1529) is well-known in Bhutan as the 'divine madman' and stories about him abound. He had an unorthodox, and somewhat crude, way of teaching religion and did not care for conventional social behaviour. Refusing the monastic establishment, he wandered freely through Tibet and Bhutan as a yogi (*neljorpa*), explaining religion through outrageous behaviour and ribald humour. He was, in fact, reacting against the dogmatism of the clergy and against social conventions which, in his view, were screens preventing people from grasping the real meaning of the religion.

It is little known, however, that besides being a cultural hero in Bhutan and the subject of anecdotes in which sex plays a great part, Drukpa Kunle was from the Gya clan of Ralung and that his lineage was to play an important role in the history of Bhutan.

After spending the first part of his life in Tibet and making a short trip to Bumthang, Drukpa Kunle had a vision of the goddess Palden Lhamo, who instructed him to go and teach the Drukpa doctrine in Bhutan where his lineage would flourish. From Lake Yamdrok in Tibet, he shot an arrow towards the south and then went to look for it. He arrived in Bhutan via the Tremola pass and Paro, and finally discovered his arrow in the house of a wealthy and religious villager in Töpa Silung, not far from Punakha. He stayed there, and had a son by the lady of the house. This son, Ngawang Tenzin,

was the reincarnation of one of Phajo's sons, Gartön. Drukpa Kunle is also said to have subdued a large number of demons in western Bhutan. He passed away shortly after his return to Tibet.

His son Ngawang Tenzin (1520/29–90) went to Ralung to study with Ngawang Chögyel, and at the age of fifty restored Tango monastery which had fallen into decay. He had a son by a lady from Bjimina and this son, Tshewang Tenzin (1574–1643), was considered the reincarnation of Phajo himself. Tshewang Tenzin therefore took over Tango monastery and later welcomed his distant cousin, the Shabdrung when he arrived in Bhutan. The Shabdrung gave Tshewang Tenzin his first wife, and from this union Tenzin Rabgye was born. Later the great 4th Desi of Bhutan, Tenzin Rabgye (1638–96), was the last in the lineage of Drukpa Kunle.

Judging by the large following of the Drukpa school, and the importance of their activities, it is clear that during the four centuries between the death of Phajo Drukgom Shigpo and the arrival of the Shabdrung in Bhutan, this school grew to be the most powerful and well-established in western Bhutan. Maintaining religious and matrimonial links with the Drukpas of Ralung, they were never cut off from the main centre of the Drukpa school, which was a source of vitality and inspiration.

The rise of the Drukpa school was not meteoric. Although it was the most important in western Bhutan after the Lhapas' defeat, it had to contend with the numerous other religious schools that appeared during these centuries. However, because of their political alliances and the dynamism of the Drukpa teachings, five Drukpa families were firmly established in western Bhutan at the end of the sixteenth century: Phajo's descendants in Paro, Thimphu, Punakha, Upper Mochu valley and Wangdi Phodrang; the Kyura in Tshamdra; the Obtsho in Gasa and Laya; the Zarchen in Paro; and Drukpa Kunle's lineage in Thimphu.

In spite of their importance and strength which undoubtedly gave them socio-political weight, Drukpa families did not achieve any real political unity in Bhutan. This was to be the task of a man with an extraordinary personality and the qualities of a statesman, the Shabdrung Ngawang Namgyel.

CENTRAL AND EASTERN BHUTAN

In comparison with the relatively abundant sources for the history of western Bhutan, sources concerning central and especially eastern Bhutan during the same period are scanty. Some documents may have been destroyed by natural disasters or by negligence, while other texts may remain to be found. Whatever the reason, available information provides only a sketchy understanding of the history of these regions. Moreover, as usual, the sources are written from a religious perspective and do not shed light on political aspects.

Central Bhutan (Tongsa, Bumthang, Kurtö, Kheng)

Central Bhutan had been converted to Buddhism early on by Guru Rinpoche and at the end of the ninth century the area was ruled by descendants of religious and aristocratic families (Dung and Shelngo). Because of the lack of information, it has to be supposed that the political situation was still more or less the same in the eleventh century, and that the Dung and Shelngo remained very much in power.

The following centuries were to witness important changes in the socio-political order. New families of famous religious descent appeared (they were known by the general term 'Chöje'), and imposed themselves on the old order. In Bumthang, a powerful official, the Chökhor Pönpo, emerged as chief.

Central Bhutan did not experience the same influx of religious schools as western Bhutan. Only the Drukpas and the Nyingmapas played a historical role. While in the western region the Drukpa school rapidly took the lead, in central Bhutan it could not achieve pre-eminence; that role was left to the Nyingmapas.

The Drukpa Kagyupas

Ngogtön Chöku Dorje (1036–1102), a direct disciple of Marpa, came to Bumthang in the late eleventh century and founded a temple at Langmoling (Langmolung) in the Tang valley. This occurred before the various religious schools had branched off from the main Kagyupa stem.

The first Drukpa Kagyupa monk to arrive was Lorepa (1187–1250) in the thirteenth century. The founder of the 'Lower Drukpa', he came from Tibet to Bumthang via western Bhutan and founded the monastery of Chödra.

Later the 'Lower Drukpa' were to be incorporated into the main Drukpa stream of Ralung.

Early in the sixteenth century, the Drukpas of Ralung started to take interest in central Bhutan. Firstly, Drukpa Kunle paid a brief visit to this area, followed soon after by his relative Ngagi Wangchuk (1517–54), the son of the 14th prince-abbot of the Drukpas, Ngawang Chögyel. Ngagi Wangchuk, the great grandfather of the future Shabdrung, constructed the first sections of the *dzongs* at Tongsa and Jakar and travelled to Kurtö where he built the Timula and Lhuntshi Dzongs.

Tenpe Nyima (1567–1619), grandson of Ngagi Wangchuk and father of the future Shabdrung, also passed through Bumthang on his way to eastern Bhutan where he was to expand Drukpa activities. He fathered a son, Tenzin Drugdra (1602–78), who was to become the 2nd Desi of Bhutan.

The Drukpas of Ralung developed an interest in central Bhutan only relatively late, which allowed the Nyingmapa school time to consolidate its position in the area. Its prestige was also enhanced by the remarkable Nyingmapa religious figures who lived there.

The Nyingmapas
During the dark period following the assassination of Langdarma which saw the destruction of Buddhism in Tibet, Bumthang was a haven for Tibetans, many of whom took refuge there. It seems very likely that Buddhism could therefore have survived in central Bhutan but the sources are silent.

One of the most significant figures of that period is Longchen Rabjampa Drime Özer (1308–63). He belonged to the important Nyingmapa tradition of Dzogchen, the 'School of Great Perfection', and was one of the greatest Tibetan scholars of all times. He was obliged to seek refuge in Bhutan for ten years following a quarrel with the strongman of Tibet at this time, Tai Situ Changchub Gyeltshen (1302–64). Because of his intellectual and spiritual achievements, Longchen Rabjampa's contribution to the vitality of the Nyingmapa school in central Bhutan was extremely significant. He also founded several temples.

As in western Bhutan, in central Bhutan the descendants of great religious figures came to constitute a religious nobility known as the Chöjes. Among these figures, one of the most pre-eminent was Dorje Lingpa (1346–1405), one of the "five great *tertöns*" or 'treasure revealers'. Bumthang was his main field of activity and, much later, his lineage played

a considerable role in central Bhutan. Dorje Lingpa seems to have settled in Chakhar, the ancient site which had belonged to King Sendarkha (Sindhu raja), and today the so-called Chakhar Lama family claims descent from him. With his son Chöying Gyatsho, Dorje Lingpa established a number of temples: Jakar Lhakhang and Buli in Bumthang, Samtenchöling in Dranla, Wangdu Gonpa in Sephu, Khothang in Shar. His main residence, however, was in the Tang valley of Bumthang at Ugyenchöling which had been founded by Longchen Rabjampa. The most prestigious family of Dorje Lingpa's descendants come from here. The Ugyenchöling Chöjes were to play an increasing political role in Bhutan, and reached the height of their power in the nineteenth century, when one of them, Tshokye Dorje, became Tongsa Pönlop.

Through their religious prestige, these families were able to assume a certain amount of temporal power at the local level, and very often controlled several villages. As in western Bhutan, these families of religious descent became the local nobility, very often marrying into the old Dung families, and thus increasing their prestige. This process is exemplified by the extraordinary development of Pema Lingpa's lineage.

Pema Lingpa (1450–1521) was the first Bhutanese-born religious figure to achieve real fame in the entire Tibetan Buddhist world, and the role played by his descendants was crucial in the socio-political context of Bhutan. Pema Lingpa came from a prestigious lineage, the Nyö, whose history is worth recalling. It begins with a legend:

It is said that a long time ago a queen in eastern Tibet had three sons, but they drowned in a river and she became mad with sorrow. This is the origin of the clan name 'Nyö' which means 'mad.' By way of comfort, a divine son was sent to her and he was the first of the Nyö. The family spread in different directions but the province of Tsang in Tibet was their stronghold.

The first Nyö who came to Bhutan was Yonten Dragpa, the 'Translator of Nyö', who travelled to India with Marpa in the eleventh century. He had some estates in western Bhutan, where his great great grandson, Gyelwa Lhanangpa, settled in the late twelfth or early thirteenth century and introduced the Lhapa Kagyupa school. This was the real beginning of the association of the Nyö clan with Bhutan. From this date, the Nyö of Bhutan developed into a branch distinct from the Tibetan clan.

Gyelwa Lhanangpa's son Demcho (1179–1241) went to central Bhutan, where he founded the temple of Sombrang.

The story has it that he threw his small ritual drum in the air and built the temple where it fell. Settling there, Demcho started the lineage of the Sombrang Chöje. Through marriages and collateral lineages the Nyös of Sombrang came to control a good part of central Bhutan. The importance of the lineage was to be further increased by the proliferation of Pema Lingpa's descendants not only in central but also in eastern Bhutan. It is interesting to note that after settling in central Bhutan, the Nyös followed the Nyingmapa school.

Pema Lingpa's father, Dondrub Zangpo, was a sixth generation descendant of Demcho by a collateral branch of the Sombrang Chöje. Besides Pema Lingpa, Dondrub Zangpo had two other sons. One was Ugyen Zangpo, who migrated to Tawang in what is now the Indian state of Arunachal Pradesh, and whose most famous descendant was the 6th Dalai Lama, Tshangyang Gyatsho (1683–1706).

Pema Lingpa was born at Chel in the Tang valley of Bumthang. He was considered the reincarnation of King Trisong Detsen's daughter, Pemasel, and of Longchen Rabjampa. Because his mother could not feed him, he was given to a wet nurse from a blacksmith's family and learned ironwork from them as a child. He became an accomplished craftsman, being also a gifted wood-carver.

Interested in religion, Pema Lingpa studied with his paternal aunt Drubthob Zangmo who had been the consort of 'Chagzampa' (iron-bridge builder) Thangtong Gyelpo. One day he had a vision of Guru Rinpoche who gave him a scroll of prophecies for discovering hidden treasures. Following the directions in the text, he went to Mebartsho with some friends. Just before reaching the gorge, he is said to have looked strange, and then jumped into the lake fully dressed. Pema Lingpa emerged from the water with a box containing religious treasures. Everybody was surprised and some people started spreading malicious rumours. Therefore, on another auspicious day when Pema Lingpa was ready to enter the lake, a crowd assembled on the rocks to watch him. Holding a butter-lamp, he said: "If I am a demon, I will die. If I am the spiritual heir of Guru Rinpoche, I will fetch the treasures and come back with the lamp still lit." After a few moments he reappeared, holding a ritual skull, a statue of Buddha and the lamp which was still burning. All the people were filled with faith in him and his fame as a tertön started spreading.

In a vision, Pema Lingpa saw himself going to Guru Rinpoche's paradise and receiving teachings and instructions to compose the religious dances now known as Peling Tercham. Invited by the most respected religious and secular figures of the time, Pema Lingpa travelled often to Tibet.

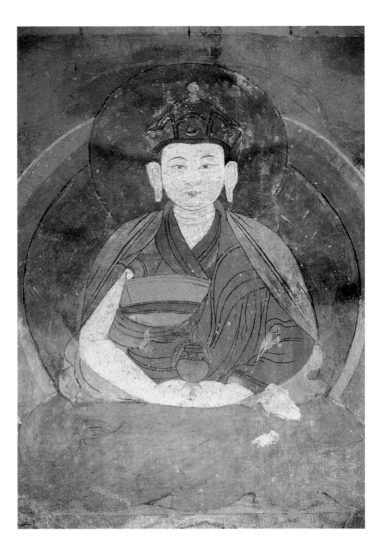

Pema Lingpa, the great Nyingmapa 'treasure revealer' (1450–1521) is found here in a wall painting at Tamshing, the monastery he built in Bumthang. He wears the hat traditionally associated with Guru Rinpoche. (F.P. 1983)

He discovered hidden treasures there as well. He had a residence at Lhalung monastery in Lhodra in Tibet, and built Kunzangdra and Tamshing monasteries in Bumthang.

The proliferation and importance of Pema Lingpa's descendants is quite remarkable. Moreover, three spiritual lineages of reincarnation must be added to the blood descendants; together they wove an intricate network of influence over central and eastern Bhutan.[4]

After his death, Pema Lingpa was reincarnated in the 'Peling Sungtrul' whose residence was at Lhalung in Lhodra and is now at Tamshing Monastery in Bumthang. Pema Lingpa had six sons and one daughter. One of the most important of his sons, Dawa Gyeltshen (b. 1499), married the Chökhor Depa's daughter and settled in Chume Prakhar, where his body is still kept. One of Dawa Gyeltshen's sons,

Tenpe Nyima, married the Chume Dung's daughter. His descendants were known as the 'Prakhar Shelngo', a title indicating their religious heritage, but as Tenpe Nyima had married into the old family of the Chume Dung they were also called the 'Chume Dung'. Dawa Gyeltshen's other son, Pema Trinle, crossed the Pelela pass and founded the monastery of Gangte in western Bhutan. His reincarnation lineage was known as the 'Gangte Trulku' and still exists today. After the Shabdrung's arrival in the seventeenth century, Gangte was the only Nyingmapa monastery remaining in western Bhutan. Dawa Gyeltshen also created a lineage of reincarnations known as 'Peling Thugse' who had their residence at Lhalung and who are still to be found in Bumthang today.

Another of Pema Lingpa's famous sons was Kunga Wangpo (b. 1505), who migrated to Kurtö and started the family of the Khochung Chöje. Kunga Wangpo's great-grandsons Drekha and Langkha (b. 1578) founded the Dungkar temple in Kurtö. The royal family of Bhutan descends from the Dungkar Chöje. Later in life, Kunga Wangpo also went to the Tashigang region where he became the progenitor of the Bidung Chöje. Some years later, one of his grandsons Phola (also called Sangnga), moved to southeastern Bhutan and there started the lineage of the Kheri Chöje.

Pema Lingpa's youngest son was Sangdag (b. 1509). Sangdag's first wife bore him three children, one son and two daughters. The son, Tenzin Chökyi Gyelpo, became the Tamshing Chöje in Bumthang. Tenzin Chökyi Gyelpo's daughter, Chödön Zangmo, married her first cousin and went east to found the monastery of Dramitse. There she and her husband started the lineage of the Dramitse Chöje. One of Tenzin Chökyi Gyelpo's other descendants founded the lineage of the Tsakaling Chöje in Mongar.

It should now be evident that the importance of Dorje Lingpa and Pema Lingpa extends far beyond their religious activities. Through their descendants they were responsible for the establishment of a new Nyingmapa nobility, the Chöjes, not only in central but also in eastern Bhutan. At the end of the sixteenth century, they had achieved religious prominence. They carried on the tradition of their founders' teachings, but also had a certain number of properties in their respective areas. Partly because of the hereditary line of succession and partly through intermarriages among themselves as well as with the old Dung families, this religious nobility was able to acquire a certain amount of temporal power in the regions where they settled. By the time the Drukpas from western Bhutan started to move into central and eastern Bhutan, they were a force to be reckoned with.

The situation in Kurtö was far from simple. As already mentioned, a brother of Pelkyi Dorje settled there in the ninth century and became chief of this region. His descendants were known as 'Pönchen Shelngo', and in the sixteenth century Pema Lingpa's son Kunga Wangpo started the lineage of the Khochung Chöje from whom the Dungkar Chöje later descended. In the middle of the seventeenth century, the names of three rulers of Kurtö appear. Two of them, King Lhabudar of Ragsa and the Pönchen ('great chief') Darma of Kyiling seem to have belonged to the old lineage descended from Pelkyi Dorje's brother, the Pönchen Shelngo. The origin of the last one, King Gawa of Phakidung, is not known. Therefore, although the religious nobility gained importance and must have enjoyed a certain degree of local temporal power, political power in Kurtö at the beginning of the seventeenth century remained in the hands of the old family of the Pönchen Shelngo. Each of its representatives had carved out a small part of Kurtö as his kingdom and this situation was very similar to that prevailing in Kheng and Ura where, until the Drukpa political unification of the seventeenth century, power seems to have remained in the hands of the old Dung families of Tibetan royal origin.

The political and religious situation which prevailed in central Bhutan at the beginning of the seventeenth century was therefore somehow different from that in western Bhutan where a Drukpa religious nobility was a strong political power while coexisting with many other religious schools. Although the Drukpas were present in central Bhutan at an early stage, they did not achieve any political power, and their religious influence was always restricted. The Nyingmapa school retained its influence and a religious Nyingmapa nobility was created through the families of important religious saints. While in Kurtö, Kheng and Ura, the Shelngo and Dung families seem to have retained their ancestral power, in the rest of the central region, the other Dung families lost their local power to the Nyingmapa religious nobility who also often absorbed them through marital alliances. Moreover, at least from Pema Lingpa's time and possibly earlier, the official called the Chökhor Pönpo or Depa, whose precise origins are still disputed, appears to have been a hereditary administrator uniting more or less under his control parts of central Bhutan.

Eastern Bhutan

The history of eastern Bhutan from the eleventh to the beginning of the seventeenth century presents two difficulties which are related to the nature of the sources: the documents are few and much later than the period we are discussing. From the sources only a sketchy picture of eastern Bhutan emerges.

There are probably various reasons for this lack of contemporary texts: a Nyingmapa clergy less inclined than the Drukpas to record their achievements; the splitting up of the region between many petty kingdoms whose histories were transmitted orally for generations in the rulers' families; texts may also have been destroyed by fire, or disappeared because of negligence; some unknown texts may still exist in private hands.

It should be recalled that in the ninth century, Prince Tsangma of the Tibetan royal family is said to have come to eastern Bhutan. He is thought to be the common ancestor of the five main clans of eastern Bhutan: the Je, the Bjar, the Yede, the Tungde and the Wangma. The list of rulers belonging to these clans and given in the eighteenth century chronicle, the *Gyelrig* (rGyal rig), reflects the incredible division of eastern Bhutan into a great number of small independent units, ruled only by these five clans, all of which claimed Prince Tsangma as their common ancestor. This list also shows that some of the clans had settled as far as present-day Arunachal Pradesh. The genealogy of the five clans of eastern Bhutan spans many generations between the ninth and the seventeenth century, for some of the last names cited in the *Gyelrig* also appear in the *Logyu* (Lo rgyus), the history of the Drukpa unification in the seventeenth century.[5] Most of these petty kings seem to have been fierce opponents of the Drukpas, knowing very well that the Drukpa hegemony would bring their power to an end. Some of them, however, helped the Drukpa armies because they hoped to crush their old rivals.

The picture of eastern Bhutan given by the *Gyelrig* and the *Logyu* is that for centuries the descendants of Prince Tsangma spread all over eastern Bhutan and even beyond, and carved out fiefdoms for themselves. Although they were known by the honorific term *gyelpo*, 'king', they ruled very small areas. It seems likely that they married according to clan rules, that is outside their own clan. Hardly anything is known of the people who lived in these 'kingdoms'.

Was Drukpa hegemony the cause of the collapse of the clan structure, or had it already disappeared at an earlier date? The list of kingdoms given in the chronicle, the *Logyu*, suggests that in the seventeenth century, some of the fiefdoms which had appeared earlier had either lost so much of their importance that they were not worth mentioning, or had been taken over by more powerful kings.

Outside the clan society of eastern Bhutan, and at a late stage, a new class emerged, the religious nobility of the Chöjes, families of prestigious religious descent. Up until the turn of the seventeenth century, these Chöjes belonged exclusively to the Nyingmapa school and most of the other Chöje families in eastern Bhutan came from Pema Lingpa's descendants which means that they did not exist prior to the end of the sixteenth century. At the beginning of the seventeenth century, three Drukpa Chöjes appeared. They were the descendants of the Shabdrung's father, Tenpe Nyima (1567–1619), who travelled extensively through eastern Bhutan.

In the early seventeenth century, before the Drukpa conquest, eastern Bhutan presented an interesting socio-political structure. A score of small kingdoms were ruled by representatives of clans of royal descent. Below the rulers in the hierarchy and patronized by some of them, were a number of prestigious religious families who appeared late, not before the middle of the sixteenth century, and who do not seem to have played any political role. At the bottom of society were the ordinary people originally also divided into clans. Unfortunately the written documents do not give any further information about them.

In 1616 the Shabdrung Ngawang Namgyel arrived from Ralung and this event was to change the entire course of Bhutan's history. By the middle of the seventeenth century, Bhutan was unified under the Drukpa theocracy and emerged as a nation.

THE SHABDRUNG NGAWANG NAMGYEL (1594–1651)

His youth in Tibet and flight to Bhutan

Ngawang Namgyel, who was to assume the title of *shabdrung* ('at whose feet one submits'), was born in Tibet in 1594 into the princely family of Gya which was head of the Drukpa Kagyupa school.[6] His father was Tenpe Nyima (1567–1619), who also travelled to Bhutan, and his mother was Sonam Pelkyi Butri, the daughter of the Kyishöpa Prefect of Ü province in central Tibet. His birthplace was the monastery of Gardrong near the oldest Drukpa establishment, Druk Changchubling in Ü province. Ngawang Namgyel's grandfather, Mipham Chögyel (1543–1606), was then reigning as the 17th prince-abbot at Ralung monastery, the Drukpas' main monastery not far from the Bhutanese border. From an early age, Ngawang Namgyel was groomed to succeed his grandfather to the Drukpa throne.

One event, however, was to change the course of his life: Ngawang Namgyel was recognized as the incarnation of the great Drukpa scholar Pema Karpo (1527–92), himself the reincarnation of the founder of the Drukpa Kagyupa school, Tsangpa Gyare Yeshe Dorje (1161–1211). He was not the only contender however: Pagsam Wangpo, a son of the hereditary prince of Chongye, a powerful principality in the Yarlung valley of Tibet, was also recognized as Pema Karpo's reincarnation, and his claim was supported by the ruler of Tsang province, the Tsang Desi. The question of the reincarnation of Pema Karpo was never settled satisfactorily, both claimants acting as if they were the true reincarnation. Pagsam Wangpo was even installed in Pema Karpo's monastery.

In 1606, Ngawang Namgyel was brought from Druk to Ralung where he succeeded his late grandfather as the 18th prince-abbot of the Drukpas. Representatives of all the religious schools of Tibet (except the Gelugpas), and of all the major princes, were present at the enthronement, as were various missions from Bhutan. One of them was headed by the grandson of Drukpa Kunle, Tshewang Tenzin (1574–1643), who later became one of the chief allies of the Shabdrung.

Until the age of nineteen, the Shabdrung devoted himself chiefly to religious studies. His main teacher was Lhawang Lodrö who was to follow him to Bhutan, but he also received teachings from Sonam Wangpo of the Sakyapa school which later always kept good relations with the Shabdrung. The

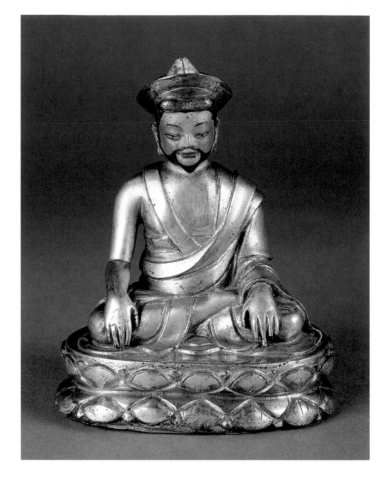

Above: Tenpe Nyima (1567–1619), father of the Shabdrung Ngawang Namgyel, was from the family of Gya in Tibet, and his father was the 17th Prince-abbot of the Drukpa Kagyupa school in Ralung. Tenpe Nyima visited Bhutan many times and after his death his ashes were brought to the monastery of Cheri at the northern end of the Thimphu valley. Right: This unusually large bronze of the Shabdrung shows him taking the earth as witness to his enlightenment and holding the vase of long life. (E.L.)

Shabdrung was also gifted in painting and sculpting.

At that time, relations between the Shabdrung and Phuntsho Namgyel, who had succeeded his father as the Tsang Desi, deteriorated. First a letter was sent by the Shabdrung requesting the Tsang Desi to judge fairly the question of his recognition as Pema Karpo's reincarnation. No reply was given. Then a meeting between the two was arranged at Shigatse Dzong but no solution was found. On their way back to Ralung, the Shabdrung and his men became entangled in a dispute with the retinue of a Karmapa lama at the ferry crossing of the Tsangpo river. Some of the Karmapa lama's men drowned when their yak skin boat capsized during the ensuing fight. The Karmapa lama was a supporter of the Tsang Desi, and a court case was brought against the Shabdrung. The judgement was that he should pay a fine for

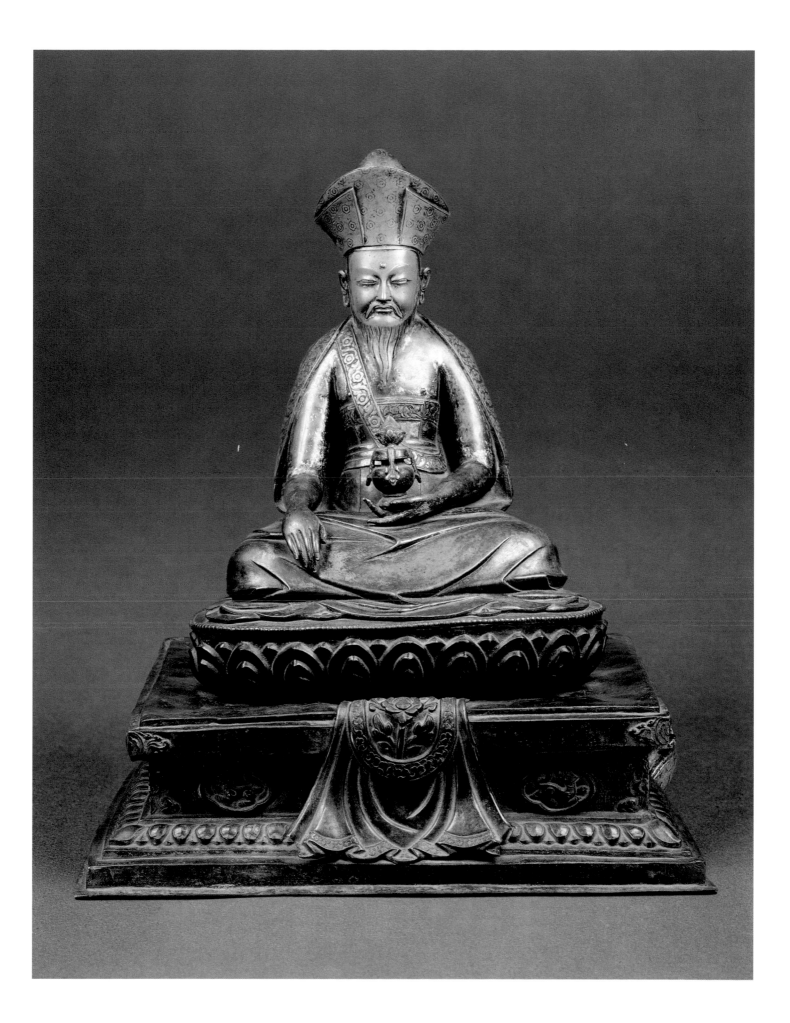

the dead and hand over the relics of the Drukpa school preserved at Ralung monastery and known as Rang-jung Karsapani. This meant that the Tsang Desi openly supported Pagsam Wangpo's claim to the reincarnation of Pema Karpo. The Shabdrung refused to comply, and not long afterwards heard that the Tsang Desi was preparing to attack Ralung and kill him. At that point he started to think about fleeing to Bhutan; his intention was supported by prophecies. One morning, he found a bundle of paddy at his side, although no one from the south had visited him. The parched flour he ate also tasted like rice. One night he had a vision of his protective deities Yeshe Gonpo (Mahakala) and Palden Lhamo offering him the land of Bhutan. He also dreamt of a black raven, a form of Yeshe Gonpo, flying in the direction of the south. All these omens had only one meaning: that the Shabdrung had to go to Bhutan where his ancestors had built so many monasteries and had many followers.

One of these followers was the Obtsho Lama of Gasa whose family had maintained close matrimonial and religious ties with the Gya family of Ralung since the thirteenth century, and whose monastery was one of the oldest Drukpa foundations in Bhutan. At this time, a member of the Obtsho family, Tenzin Drugye (1591–1656), was performing both the functions of 'chief of the choir' (umdze) and of 'treasurer' (chagzö) at Ralung, a proof of the great trust the Shabdrung had placed in him and his family. It is highly possible that Tenzin Drugye influenced the Shabdrung in his decision to take refuge in Bhutan, where he knew the Shabdrung would be welcomed by his family. The Obtsho Lama of Gasa sent the Shabdrung the following message: "Rinpoche, if you are not on good terms with the Tsang Desi, please come to our Southern Country since there is neither a lama, nor a lord [who has authority in the region]. Here you will obtain religious estates."

The Shabdrung started to pack various religious items, among them the most sacred Rangjung Karsapani, a self-created image of Avalokitesvara which had appeared in one of Tsangpa Gyare's vertebra after his cremation.

In 1616, at the age of twenty-three, the Shabdrung left Ralung for Bhutan with his entourage, thus retracing the steps of his ancestors across the Himalayas. It has to be understood that the Shabdrung's flight to Bhutan was not mere coincidence, but a considered decision taken under the pressure of circumstances. He knew that his forefathers had gained numerous supporters for the Drukpa school and that they would welcome him.

When the Shabdrung arrived in Laya, he was welcomed by the Obtsho Lama, who had come with a small troop of men to ensure his protection. He stayed in Laya and then Gasa where he received allegiance from a number of families. Then he left for the upper Thimphu valley via Kabe and arrived at Pangri Zampa which had been built by his great great grandfather Ngawang Chögyel. He also went to nearby Dechenphu which had been the temple of the guardian deities of the Drukpas since Kunga Sengye in the fourteenth century. There the Shabdrung gave a prayer of thanksgiving for his journey and the main deity, the Genyen Jagpa Melen, made obeisance to him. He went to Paro via the Drela (Jela) pass and settled at Druk Chöding, another monastery built by Ngawang Chögyel.

The Shabdrung knew he could count on the support of important families: in the north, the Obtsho; in Paro, Thimphu, Punakha and Wangdi Phodrang, the descendants of Phajo and Drukpa Kunle; and in the south, the Kyura. He unified all these families under his authority as hierarch of the Drukpas, a status they recognized. He travelled extensively in the west to give teachings and initiations, slowly increasing his political influence.

But who was the Shabdrung, the man behind the official figure who appears in the texts? It is difficult to make out from the Bhutanese sources, which are more concerned with relating his religious actions than sketching a portrait of flesh and blood. A document of immense value in this respect, is the *Relaçâo*, written in Portuguese by Father Cacella a Jesuit who, with his companion Father Cabral, appears to have been the first Westerner in Bhutan.[7] They entered Bhutan in April 1627 and stayed with the Shabdrung at Cheri monastery. They were even given a room there to decorate as a chapel, though after a few months they finally managed to leave for Tibet. In his letter Father Cacella paints a portrait of the Shabdrung that gives some idea of the man he was:

He received us with a demonstration of great benevolence, signifying this in the joy which he showed on seeing us and on knowing where we were coming from, where we were from, i.e. from what country and nation, and he asked the other questions normal at a first meeting ...[8] The king [i.e. the Shabdrung] (is) at the same time the chief lama ...
He is proud of his gentleness for which he is highly reputed, but less feared ... The king is also very celebrated for his abstinence in never eating rice or meat or fish, maintaining himself only with fruit and milk ... He occupied himself, as he told us, in praying and in his spare time he made

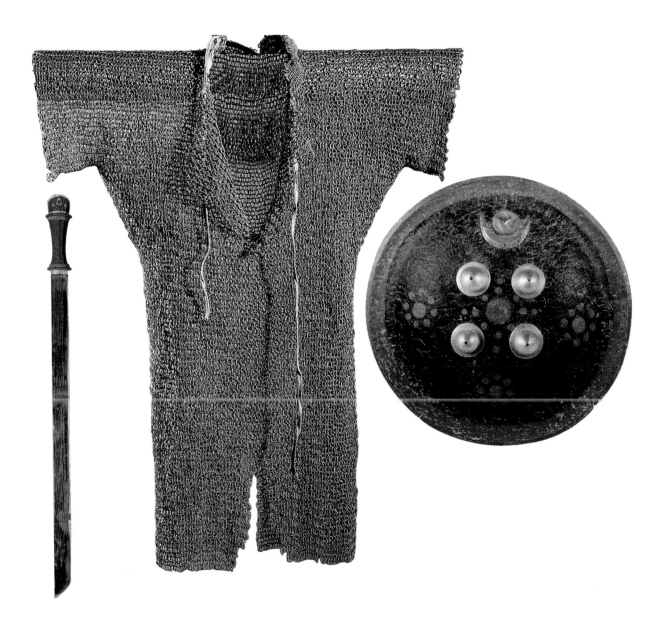

Armoury of a high-ranking officer. The coat of chain mail reflects Moghul metalwork as does the shield of tough rhino hide, embellished in brass with sun and moon. (E.L.)

various objects which he had and he showed us one of them which was the best, being an image of the face of God in white sandalwood, small but very well made and this is an art of which he is very proud, as also that of painter at which he is good ... [9] The king has also a great reputation as a man of letters ...[9] The king has a long beard and some of its hairs reach his waist ...[10]

Still, little is known about the man who played such an important role in the history of Bhutan.

The unification of western Bhutan and the struggle against enemies

The political unification of western Bhutan was a long and complex process. Father Cacella notes that the Shabdrung had fought with the Tsang Desi in the past and that in 1620, in order to defend himself, he built Cheri monastery as his residence on a steep slope. This mention suggests that the Shabdrung's life after his arrival in Bhutan was not peaceful and that the unification of the country was not an easy task. The Shabdrung had to fight simultaneously against the Tibetan armies of the Tsang Desi, and against internal foes: the group of lamas of other religious schools opposed to the Drukpa hegemony.

The first Tibetan invasion organized by the Tsang Desi appears to have taken place a very short time after the Shabdrung's arrival in Bhutan. No date is given but at that time he was staying at Druk Chöding in the Paro valley. Immediately after the Shabdrung's flight to Bhutan, the Tsang Desi took over the Drukpa establishments of Druk Changchubling and Gardrong, but not Ralung. It is evident that the Tsang Desi could not let his mortal enemy settle in a region which was just south of his border and be a permanent threat. Not satisfied with the Shabdrung's flight from Tibet, the Tsang Desi wanted to destroy him. It seems, however, that the Tibetan general leading the invading army was killed and the fame of the Bhutanese and of the Shabdrung spread.

The Tsang Desi ultimately died, but sources do not agree on the date, the Bhutanese placing the date of his death in early 1619, and the Tibetans in 1631. It was at this time that the Shabdrung wrote the *Nga Chudrugma*, 'The Sixteen "I"'s', which were included in his seal:[11]

I am he who turns the wheel of the dual system
 [of spiritual and secular law].
I am everyone's good refuge.
I am he who upholds the teachings of the Glorious Drukpas.
I am the subduer of all who disguise themselves as Drukpas.
I achieve the realization of the Sarasvati of Composition.
I am the pure source of moral aphorisms.
I am the possessor of an unlimited view.
I am he who refutes those with false views.
I am the possessor of great power in debate.
Who is the rival that does not tremble before me?
I am the hero who destroys the host of demons.
Who is the strong man that can repulse my power?
I am mighty in speech that expounds religion.
I am wise in all the sciences.
I am the incarnation prophesied by the patriarchs.
I am the executioner of false incarnations.

His prestige was no doubt increased by the fact that he survived an earthquake which destroyed a part of his meditation cave in Tango in the upper Thimphu valley. He had been welcomed here by Tshewang Tenzin, the grandson of Drukpa Kunle (and therefore a distant relative), who had been in Ralung for the Shabdrung's enthronement. Tshewang Tenzin had offered him the monastery of Tango with all its properties and became his strongest supporter.

In 1619, the Shabdrung was invited to Chapcha by a rich patron named Darchuk Gyeltshen who was also on good terms with the Raja of Cooch Bihar, Prem Narayan. The people of Chapcha who were followers of the Drukpa school, propagated in this region by the Kyura family of Tshamdra, offered the Shabdrung gifts of silver, butter and clothes, and paid allegiance to him. As for the Cooch Bihar Raja, he sent gold, silver items, clothes and an elephant as tokens of friendship.

On his return to Tango in 1619, the Shabdrung heard that his father, Tenpe Nyima, had died in Ralung. He had the body brought secretly to Bhutan, and in 1620 he started to build Cheri to house the ashes of his father, and as his first permanent residence. There he organized the first monk-body with just thirty monks and invited his master Lhawang Lodrö to come and teach in Bhutan.

In 1623 the Shabdrung entered a three-year retreat in a cave above Cheri and during this period he seems to have realized that for the moment he was to take up secular affairs. As soon as his retreat was completed, he went on an extensive tour of Shar (Wangdi Phodrang) district where the

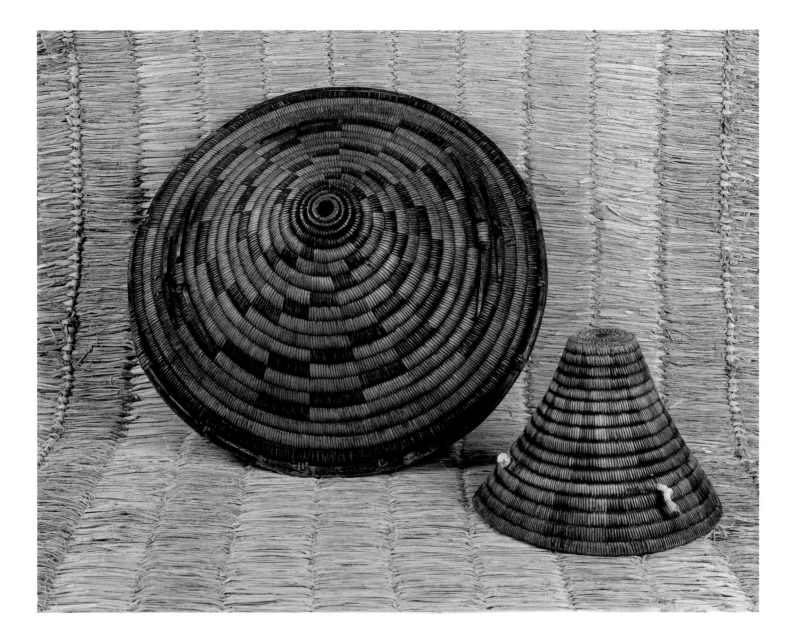

chiefs were the descendants of Phajo's sons, and where the Shabdrung's own ancestors had built temples. Having received allegiances from the Shar people, he returned to Thimphu in 1627, where he met Fathers Cacella and Cabral who were on their way to Tibet.

Although the Shabdrung was welcomed in all the Drukpa areas, it should not be forgotten that other religious schools existed in western Bhutan and that the activities of the Shabdrung were far from pleasing to them. They came to form what the sources call 'the internal opposition', as opposed to the 'external opposition', the Tibetans. The other religious schools understood perfectly well that the Shabdrung's desire to establish a Drukpa hegemony was a direct threat to them. Apart from the Sakyapas, who always kept good relations with the Drukpas, all the other religious

Coiled-cane helmets and shields (dgra li) were the usual equipment for ordinary footsoldiers, together with a bamboo bow and a quiver filled with poison-tipped arrows. Few have survived today. It is with such simple arms that the Bhutanese managed to keep the British at bay during the 19th century. (E.L.).

schools formed a coalition which came to be called the 'five groups of lamas' (*lama khag nga*). The Bhutanese texts are not very explicit about them but they must have included at least the Lhapas and the Nenyingpas.

Their first military attack took place in 1629 when the Shabdrung was building Simtokha Dzong. Their chief was Lama Palden, a Nenyingpa from Langmalung in Wang. He was killed and the attack on Simtokha repelled. However the opposition was not totally vanquished. In 1634 the 'five

groups of lamas' took advantage of the deadly feud between the Tsang Desi and the Shabdrung to call on the former for help. The Tsang Desi at that time was Tenkyong Wangpo, son of the late Phuntsho Namgyel. The Tibetan invasion which followed seems to have occurred at six different places, with the support of the 'five groups of lamas'. Another attack was launched on Simtokha Dzong which this time suffered greatly. In the end, the invasion was repelled.

Three years later the Shabdrung embarked on a campaign of *dzong*-building and would certainly not have done so if he had not been sure of his control over the region. One incident related in the *Lho'i Chöjung* reveals how the Shabdrung was attacked by one of his enemies, a Barawa lama at Göntshephu in the Gasa region: the lama ran away from his monastery and magically dispatched a lightning bolt to frighten or kill the Shabdrung. The latter just ignored it and took over the monastery.

The Shabdrung started to build Punakha Dzong in 1637 and Wangdi Phodrang the following year, but in 1639 the third Tibetan invasion occurred, again at the invitation of the 'five groups of lamas'. A settlement seems to have been made with the Tsang Desi and the 'five groups of lamas' must have been definitively defeated because the Bhutanese sources make no further mention of them. In 1641, the Shabdrung seized the old Lhapa Dzong of Thimphu where Dechenphodrang now stands. He enlarged it and it became the summer residence of the monk-body. Temples and monasteries of the other religious schools (except those of the Sakyapas), were also taken over by the Drukpas. In 1645, the old Drukpa family of Humrel in Paro presented their *dzong* to the Shabdrung and the Kathog Nyingmapas offered him the monastery of Taktsang. Later the Drukgyel Dzong was built to guard the Paro valley against invaders.

The process by which the Shabdrung obtained control of the Paro valley was probably repeated many times during the unification of western Bhutan. The text known as the *Humrel Dungrab* explains that in compensation for the *dzong* the Shabdrung exempted the Humrel family from taxes and *ula* (compulsory labour) in whichever district they wished to settle. Another document of extreme importance has been acquired in the late 1980s by the National Library of Bhutan; to this day it is the only known existing example signed by the Shabdrung Ngawang Namgyel. It is a chart which concerns the Drukpa Zarchen family of Paro and it details the privileges obtained by this family when they recognized the Shabdrung's power in 1646. First the Shabdrung recalls the ties of blood and marriage between the Zarchens and the Drukpas of Ralung; then he comes to the privileges the family would receive: everywhere they went, they would have free lodging, free drinks, free riding horses and free carriage of goods, in addition to which they would be exempted from taxes and *ula*.

While the Shabdrung was completing his takeover of western Bhutan, the Tibetans launched two more attacks on the country. In 1642, the power of the Tsang Desi collapsed and Tibet was now governed by the Gelugpa school headed by the 5th Dalai Lama and supported by the Mongols. Like the Tsang Desi, the Gelugpas thought they could not afford a powerful state on their southern border. In 1644, Tibetan and Mongol armies attacked Bhutan but the campaign was not successful. In 1648/49 several Tibetan and Mongol columns again attacked Bhutan at many points. They advanced as far as Thimphu, Punakha and Paro, but were ultimately defeated. A Tibetan invasion took place in 1657, after the Shabdrung's death, but failed to achieve anything.

Thirty years after his arrival from Tibet, the Shabdrung had unified the Drukpa families under his power, vanquished the other religious schools, repelled three Tibetan invasions, and built a fortress in each valley of western Bhutan, thus establishing a firm political control over this region. Other *dzongs* like Dagana, Lingshi and Tashigang were built after his death.

The monastery-fortresses or *dzongs* are a unique feature of Bhutan. Although *dzongs* existed in Tibet, they were only the seat of administrative power and never had the very particular combined function they came to have in Bhutan. In Bhutan, the *dzongs* housed a monk-body and an administrative organization in the same building; for a long time the monks were also the administrators. They would become the symbol of the Drukpa theocracy which gave its name to the country: Druk Yul, 'country of the Drukpas.'

The Code of Laws (*Katrim*) [12]
One of the Shabdrung's great achievements was the promulgation of a code of laws for Bhutan. It was written down only much later, in 1729, by Tenzin Chögyel, long after the Shabdrung's death. Tenzin Chögyel recorded the laws on the order of the 9th Desi Mipham Wangpo (1709–38), who explained to him: "You must absolutely write down the code which has been transmitted from the royal lineage and from the Chögyels until the Shabdrung Rinpoche, as well as the

customs which have been maintained intact by the first Desi and others." There is a famous sentence in the *Lho'i Chöjung* (folio 56a) which defines the situation before the Shabdrung, as well as his achievement:

> By introducing laws where there had been no Southern laws and by fixing handles on pots where there had been no handles, he committed many actions which established beings on the good path to beneficial happiness.

The code is written in such a way as to organize along Buddhist lines the relationship between the Drukpa monastic community, representing the state, and lay patrons (*jinda*) and subjects in the judicial and economic fields.

Whereas the monk-body gave teachings and initiations and performed rituals for the benefit of the lay community and the country, the subjects in exchange had to provide material and financial support. Thus, when a family received an initiation for the first time and became followers of the Drukpas, the names of its members as well as their lands and places of residence were recorded in a register (*satham*), which was kept in each *dzong*. Each year they had to pay the 'initiation fee' (*wangyön*) in the form of taxes, *ula*, and free transport. In turn, to thank the lay community, the monk-body performed a *tshechu* every year which was also the occasion of a general initiation called *tromwang*. The code explains:

> The welfare and the prosperity of the people greatly depend on the fair judgement of cases and also on the taxes, ula and government loads transport.

Among other taxes, there were contributions of meat, butter, salt, wood and cereals as well as of paper and clothes. The *ula* consisted of compulsory labour for the government such as the building and maintenance of the *dzongs*, monasteries, roads and bridges. The transport of loads for the government was a very heavy tax for the people. Moreover they had to feed, lodge and provide horses for any government official on tour. This tax was so unpopular that the Code addresses the issue:

> Steel helmets were padded inside and decorated with a braid in five colours for lucky protection. The plain steel helmet, above, was probably for a bodyguard while the brocade-ornamented helmet, below, for a general. (E.L.)

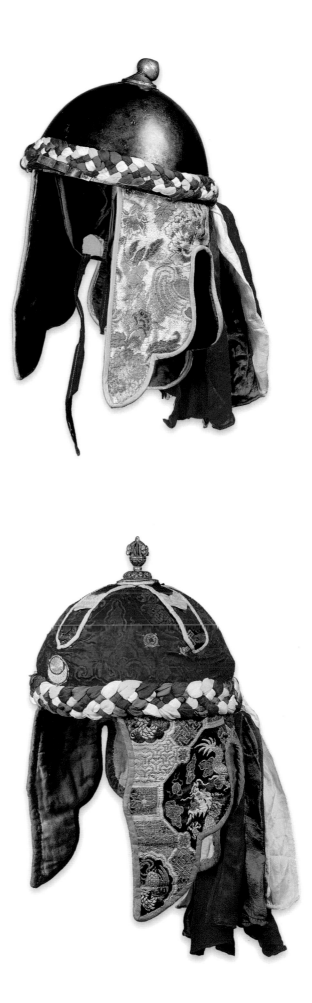

As frequent tours are a source of great expenditures for the people [patrons], from now on it is forbidden, except in case of transfer, for officials to go on tour even by one step under any pretext.

Only monks and laymen attached to the monastic community were exempt from these taxes. Beyond the taxes, all aspects of social life were also regulated by the Code of Laws which was in use until recently: inheritance, trade, crime and punishment, behaviour of monks and officials, the use of tobacco, etc.

Organization of the administration and the dual system of government (chösi)

No systematic account of the organization of government is given in the Bhutanese sources, and it has to be deduced from scattered mentions in different texts. It is well known however that all high-ranking officials were monks. The government took its definitive form in the late 1640s, just before the death of the Shabdrung. Before entering in retreat, the Shabdrung wanted to set up a strong government which could replace him effectively. The Shabdrung was head of the theocratic state. As Father Cacella wrote: "He was the King and at the same time the Chief lama", meaning that he combined religious and secular powers.

To look after his personal matters, the Shabdrung had a chamberlain, the 'Drung' Damchö Gyeltshen (1602–72). Born near Ralung, he had followed the Shabdrung in his flight from Tibet. He served as the Shabdrung's chamberlain until his death in 1651. He was always close to the Shabdrung and able to exercise considerable influence. Another person in daily contact with the Shabdrung was his 'chief of meals' (sölpön). The incumbent was named Saga, and he held this post until 1700.

The monk-body was organized on the model of Ralung monastery. There was a 'head-abbot' (je khenpo), who looked after the monks and ensured the discipline and purity of the teachings (chö). The first Je Khenpo was Pekar Jungne (1604–72), nominated at an unknown date, maybe sometime after 1646. He went to Ralung at a very young age and then escaped with the Shabdrung. He was from the family of the Chöjes of Changangkha, descended from Phajo's son Nyima.

The administration of political affairs (si) was given to the Desi. The incumbent of this post also looked after the properties and wealth of the monk-body. The first Desi was Tenzin Drugye (1591–1656) of the Obtsho family who had been the *umdze* in Ralung. He took the title of Desi in 1651, only after the Shabdrung entered in retreat, but he had been looking after political matters since long before. If Father Cacella is to be believed, as early as 1627, he was already "the whole government of the King".

This system of government with two persons responsible for different fields, was known as *chösi*, 'religious and political matters', or *chösi nyiden*, 'dual system of government'. Other important posts of the central government were that of 'chief of protocol' (drönyer), who was also the chief justice, and of 'minister' (kalön), who passed the orders of the Shabdrung to the other civil servants.

The country was divided into three large regions each with a 'universal lama' (pchila), who was also called 'governor' (pönlop). The three regions were Tongsa, Paro and Dagana. When the jurisdiction of a *pönlop* was too big, *drungpas* served as deputies in certain areas. Another post of importance was that of 'chief of the *dzong*' (dzongpön). The first *dzongpöns* were those of Punakha, Thimphu and Wangdi Phodrang. At a lower level, there were the 'elders' (gup), who looked after several villages and transmitted orders from the *dzong* to the people. This structure of government remained intact until the monarchy in 1907.

The retreat and death of the Shabdrung

Towards the end of his life, the Shabdrung devoted himself to the fabrication of 100,000 *tsatsa* (miniature images moulded in clay) of each of the 115 main deities of the Drukpa school and he wanted to consecrate them. As this activity was taking more and more of his time, he delegated some of his powers to the Umdze Tenzin Drugye and to the Drung Damchö Gyeltshen, but the final decisions always remained his.

On the tenth day of the third month of the Iron-Rabbit Year (1651), the Shabdrung entered strict seclusion in the Punakha Dzong. He was never to reappear. His death, however, remained concealed for fifty years until 1705 and, although today this may seem quite incredible, it can be understood in the context of the period. It was quite normal for high lamas to go into meditation for many years, and their longevity was believed to exceed that of normal persons. This belief in miracle, and the fact that occasionally orders were given in the Shabdrung's name, were enough to silence any doubts. It was almost normal practice to conceal the death of an important person, in order to give time to his entourage.

Parallels exist: Pema Karpo's death is said to have been concealed from the Drukpa of Ralung, and the Tsang Desi Phuntsho Namgyel's death was hidden for three years. From 1682 to 1697, the 5th Dalai Lama's death was also kept secret.

In fact the Shabdrung had ordered his entourage – most probably the Drung Damchö Gyeltshen, the Desi Tenzin Drugye and the Sölpön Saga – to keep his death a secret for twelve years, but circumstances were such that fifty years passed before the death of the Shabdrung was officially revealed.

If in 1651 the Drukpas controlled western Bhutan, they were campaigning to extend and consolidate their position in central and eastern Bhutan. Moreover the Tibetan government, still hostile to the Shabdrung, was following with interest and attention the evolution of the situation in Bhutan. The death of the Shabdrung occurred at this crucial time and the government was faced with the problem of his succession. By tradition, the Drukpas were not keen on succession by reincarnation and, as the Shabdrung's son Jampel Dorje was not in good health, following the Shabdrung's will, they decided to keep his death secret for twelve years.

The unification of central and eastern Bhutan [13]
The Drukpas had very little religious or political hold on these regions although there had in the past been occasional visits by senior Drukpa monks. Ngagi Wangchuk, the Shabdrung's great grandfather, had established small *dzongs* at Tongsa and Jakar; Tenpe Nyima, the Shabdrung's father, was the ancestor of three Drukpa Chöje families in eastern Bhutan. By and large, though, the central and eastern regions followed the Nyingmapa religious school and it appears that large areas were under the influence of the Tibetan administration which at that time was dominated by the Gelugpas (also called 'Gandenpas' in the Bhutanese texts).

The Shabdrung's ambition was to unify the whole country under his rule, but until 1646 he had concentrated his efforts on the western region. Although he travelled once to eastern Bhutan, he had no real opportunity to impose his rule on these areas which had such a different socio-religious pattern. In 1646, a quarrel between two parties in eastern Bhutan gave him the pretext to intervene in these regions, which were finally brought into the Drukpa political fold. By this year, Drukpa rule extended up to Tongsa Dzong and the Shabdrung had appointed Minjur Tenpa (1613–80) as the Tongsa Pönlop.

A Drukpa lama called Namse Dorje fled from eastern Bhutan after a dispute with the King of Khaling. The Shabdrung took him into the monk-body and gave him teachings. When Lama Namse requested the Shabdrung to send an armed force to subdue the eastern region, the Shabdrung replied: "Since there is a prophecy that in the future my teachings shall flourish and increase in that realm of the Eastern Province by means of the dual system, at that time you must act according [to the prophecy] without losing courage." [14] With that promise from the Shabdrung, Lama Namse returned to Tongsa.

Three years later, the governor of Tongsa, Minjur Tenpa, was offended by the Chökhor Pönpo who was the chief of Bumthang. He gathered a large force from western Bhutan and the Tongsa region, and himself went to Bumthang as commander while Lama Namse was second-in-command. With the help of the Chökhor Pönpo's officers who had been won over, they captured the *dzong* and the Chökhor Pönpo fled to Tibet. The result of this operation was that the four districts of Bumthang were brought under Drukpa rule.

While the army was resting in Bumthang, an incident occurred at Kurilung (Kurtö). The king of Ragsa was killed by the kings of Kyiling and of Phagdung. His widow and his officers wanted to take revenge so when they heard that the Drukpa forces were in Bumthang, they sent a messenger requesting them to come and help. The Drukpa armies came to Kurilung and, defeating the two kings, took over the whole region. After this victory, Lhuntshi Dzong was built. The armies then set off for the region of Tashiyangtse where the people paid allegiance to them and built the fortress. On their way back to Zhongar (Mongar), they defeated the rulers of this region.

Until now the Drukpa armies had advanced without much problem; in eastern Bhutan they were to encounter much resistance. The Drukpa forces stayed at Zhongar Dzong while Lama Namse advanced to Udzarong with a small detachment. From there he sent messages to the people of Tsengmi, Tashigang, Kanglung and Khaling asking them to submit. The king of Tsengmi surrendered. The king of Khaling at first refused to do so because of his past grievance against Lama Namse and tried to convince the Udzarong people not to help the Drukpas. Nevertheless, the Udzarong people decided to submit and the Khalingpas, Kanglungpas and Tashigangpas were left with no choice but to surrender as well. When Lama Namse returned to Zhongar, he presented his commanders with the gold, silver and other items that had been collected during this campaign and they decided to stop the campaign there.

On the way back to Tongsa, the Drukpas went through Kheng where among the Dung and chiefs of the region "some bowed down with devotion and reverence, some were subdued in terror and fright, while some bowed down at the fearful sound of rumours."[15] The whole of Kheng thus fell under the power of the Drukpas. Then the army returned to Tongsa and was given a warm reception by the Tongsa Pönlop Minjur Tenpa. Everybody received a gift and the army was disbanded.

Since eastern Bhutan was now under the Drukpas, Lama Namse thought after some months that it was time to check if the oath of allegiance that the eastern Bhutanese chieftains had taken was respected, and to levy some taxes. The eastern Bhutanese deeply resented the imposition of the new taxes. Lama Namse had to send his people to collect taxes by force. Hearing this, several petty kings decided to rebel. Lama Namse went to eastern Bhutan with an army and quelled the rebellion so that the power of the Drukpas was more firmly established in the region.

The story of the Drukpa campaign in central and eastern Bhutan is very detailed in the chronicle, the *Logyu*, but no date is given for the year of final victory. However it is known that Tashigang Dzong was built in 1656 on a site called Bengkhar and this could not have happened if the Drukpas were not in total control of eastern Bhutan at the time.

The conquest of central and eastern Bhutan concluded the unification process of Bhutan. The country was constituted as it is nowadays and unified under Drukpa political rule; in its religious affiliation, eastern Bhutan nevertheless remained largely Nyingmapa.

THE FIRST THREE DESIS

The 1st Desi Tenzin Drugye (1591–1656; r. 1651–56)
Tenzin Drugye was a son of the Obtsho family of Gasa which arrived in Bhutan from Tibet in the early thirteenth century and had always been loyal Drukpas. In 1601 he went to the monastery of Ralung in Tibet; he became *umdze* in 1610. When the situation in Tibet became dangerous for the Shabdrung, Tenzin Drugye suggested that he take refuge in Bhutan. In 1616, when the Shabdrung did flee, the Obtsho family was the first to welcome him and give him support.

All his life Tenzin Drugye was very close to the Shabdrung, and when the Shabdrung died in 1651, he must have been one of the few to know. He had been appointed by the Shabdrung at an unknown date, sometime after 1646, to look after state matters. His nomination to the position of Desi was only made in 1651, the very day the Shabdrung went into retreat. Tenzin Drugye was the logical choice because of his friendship with the Shabdrung and his knowledge of the political situation. His reign lasted only five years but was marked by the Drukpa expansion in central and eastern Bhutan, commanded by Minjur Tenpa, the Tongsa Pönlop, who would become the 3rd Desi. As Desi, Tenzin Drugye also carried out the instructions of the Shabdrung and saw to the effective establishment of the administrative structures of the government. He particularly followed the Shabdrung's orders concerning the grooming of young Tenzin Rabgye as heir to the throne. Tenzin Rabgye was the son of the Shabdrung's first consort and his cousin Tshewang Tenzin. Faced with the illness of his own son, the Shabdrung had always treated him as his 'direct spiritual and temporal heir' (thugs sras).

The 2nd Desi Tenzin Drugdra (1602–67; r. 1656–67)
Tenzin Drugdra, the half-brother of the Shabdrung, received a complete monastic education and became a scholar of traditional medicine. However he was destined to be an administrator, and in 1646 he became the first Paro Pönlop. After the death of Tenzin Drugye, who had nominated him as his successor, he ascended the throne of Desi. The beginning of his reign was marred by the sixth major Tibetan invasion of 1657, which was successfully repelled. He then devoted most of his time to restorations and building; he also followed closely the education of Tenzin Rabgye, to whom he talked at length about the importance of his future responsibility.

The Desi Tenzin Drugdra died suddenly in 1667. Because he had had no time to appoint a successor and Tenzin Rabgye was still too young, the chamberlain (*drung*) Damchö Gyeltshen forged a letter in the name of the Shabdrung appointing the Tongsa Pönlop Minjur Tenpa as the 3rd Desi.

The 3rd Desi Minjur Tenpa (1613–80; r. 1667–80)

Born in Tibet, Minjur Tenpa had a monastic education. He had behind him the prestige of his victorious campaign in central and eastern Bhutan and long years of experience as Tongsa Pönlop.

His first important decision as Desi was to give Tenzin Rabgye a rank as high as his own in the hierarchy and the title of 'Lama Tripa', 'Lama on the throne [of the Shabdrung]', which means that he recognized officially the importance of the young man.

He also continued the policy of Drukpa expansion that he had carried out as Tongsa Pönlop. First, in 1668, Bhutanese troops advanced in the direction of Sikkim where the Lepcha chief Achok requested the Tibetans for help, and Minjur Tenpa had to face the seventh Tibetan invasion. After a truce was declared, the calm lasted until 1675, when trouble started again in the same region. Minjur Tenpa then had to repel the eighth Tibetan invasion, which was the largest with five simultaneous fronts. At the same time, there was a reinforcement of political and religious ties with other regions. In 1673, Damchö Pekar went to Nepal where he was authorized to set up a Drukpa monastery. In Ladakh, because of the Drukpa faith of the kings, the Bhutanese were granted several estates and monasteries. In 1678, Minjur Tenpa sent a representative to look after the estates which had been given to the Bhutanese around Mount Kailash in western Tibet. Minjur Tenpa restored and enlarged numerous dzongs and monasteries, in particular Simtokha, Tongsa and Jakar.

In 1680 his reign ended abruptly and sadly with the revolt of the Punakha Dzongpön, Gedun Chöphel, who thereby inaugurated the internal strife which was to last for two centuries. The reasons for this revolt are not clear, but it is said that Gedun Chöphel resented the fact that Minjur Tenpa had elevated one of Gedun Chöphel's ex-servants, Norbu to the high rank of 'chamberlain'. It also appears that during the Tibetan attack of 1676 Gedun Chöphel was in command of the Bhutanese force in Lingshi, and that when he was defeated, he was reprimanded by Minjur Tenpa, against whom he decided to take revenge. His coup of 1680 did not give him supreme power, but he seems to have been a resentful and ambitious man as in 1694 he also ousted the 4th Desi Tenzin Rabgye and became the 5th Desi.

Minjur Tenpa retired to Cheri in 1680 and died there the same year. As Jampel Dorje, the Shabdrung's son, was most probably already dead, Tenzin Rabgye ascended the throne of Desi and started his reign as 'successor' (gyeltshab) of the Shabdrung.

The reigns of the first three Desis were a period of consolidation and expansion of Drukpa power. They were also reigns of transition between the Shabdrung and his designated successor Tenzin Rabgye. The first three Desis, in total contrast to the Desis of the eighteenth and nineteenth centuries, really stand out for their obedience to the Shabdrung's instructions and their apparent lack of personal ambition. Able men, they devoted themselves to the task of consolidating Drukpa power and defending the newly-formed nation against external aggression. They strengthened the administration, built and enlarged dzongs and temples, established links with other countries and, above all, followed the steps of the Shabdrung.

TENZIN RABGYE: THE LOGICAL HEIR (1638–96)

Because of his illness, Jampel Dorje could not ascend the Drukpa throne, but there was another blood relation of the Shabdrung who could, and who had even been groomed to do so: Tenzin Rabgye. It might well have been that the twelve years during which the Shabdrung was thought to be alive were a transitory period to maintain the cohesion of the state until the majority of this boy who was only fourteen years old in 1651.

Tenzin Rabgye, belonged to a collateral branch of the Gya family of Ralung whose ancestor Drung Dorje Rabgye was the younger brother of the eleventh and twelfth hierarchs of the Drukpas. Drung Dorje Rabgye's grandson was the famous divine madman Drukpa Kunle. Drukpa Kunle's grandson Tshewang Tenzin was thus a distant Bhutanese cousin of the Shabdrung.

Tshewang Tenzin, who resided at Tango monastery, married and had a son who became a monk, and was known as Jinba Gyeltshen. He was installed as abbot of Taktsang and Brangyekha in Paro valley and did a lot for the propagation of the Drukpa school in western Bhutan. Tshewang Tenzin later married Damchö Tenzin, the daughter of the Changangkha Chöje who had been the consort of the Shabdrung. From this union was born a daughter, Rinchen Pelzom, in 1634. This caused great concern to Tshewang Tenzin who was now sixty and who would have liked to have a son to perpetuate

his lineage. The Shabdrung told him not to worry because an heir would be born soon. [16]

In 1638, when Tshewang Tenzin was sixty-five and his wife thirty-three, a son was born. Both Tshewang Tenzin and the Shabdrung were delighted with the news which they heard while on tour. The Shabdrung must have seen in this son the possibility of an heir to the Drukpa throne: they were related by blood, belonging to the same Gya family, and therefore this son could, according to the Drukpa system of succession, ascend the throne. As the Shabdrung was away, it was Jampel Dorje who gave the baby the name of Tenzin. As soon as he came back to Cheri, the Shabdrung ordered Tshewang Tenzin to bring his son there so that he could start his religious education. When the boy was three, he was already exceptionally bright and he had such foresight that people started to say he was a reincarnation.

Hearing this rumour, the Shabdrung said to Tshewang Tenzin: "As for me, it is enough that this boy is your direct descendant. It is no need to see if he is somebody's reincarnation."[17] This clearly demonstrates how important it was to the Shabdrung that the child was a blood relation and not a reincarnation.

Tshewang Tenzin died in 1643, and after his funeral the Shabdrung told his widow to have her son enter the clergy. In 1645, the Shabdrung himself performed the ritual of hair-cutting for the boy, who was called Tenzin Rabgye. His education was entirely paid from the state treasury, the Shabdrung wishing to repay the kindness of Tshewang Tenzin who had offered him his monastery of Tango. The Shabdrung kept Tenzin Rabgye with him all the time and looked after his religious education. According to the biography of Tenzin Rabgye (folio 49b), he was treated as his 'direct spiritual and temporal son', which means that the Shabdrung regarded him as his successor.

When the Shabdrung entered meditation in 1651, he left instructions concerning Tenzin Rabgye. His will said:

Umdze Tenzin Drugye, you will look after Tshewang Tenzin's son in the same way as you do for my son Jampel Dorje. Give him from the Treasury whatever he needs and do not feel guilty towards the others. When he is mature enough, you must give him entire responsibility for all important and unimportant monastic affairs.[18]

In 1656, Tenzin Drugdra, the natural son of Tenpe Nyima, the Shabdrung's father, became the 2nd Desi, and he was

fully conscious of the privileged status of Tenzin Rabgye. When Minjur Tenpa became 3rd Desi in 1667, he made a very meaningful decision. He told Tenzin Rabgye, who was then thirty years old:

I am an old man and the Drung Damchö Gyeltshen, too. It is not acceptable on any account that you remain as if you have no responsibility and that you, an irreproachable descendant of the Drukpa order, are without activity. Now you must shoulder the entire responsibility for religious affairs and act as the master of all three actions, that is maintenance, protection and propagation of the precious teachings.[19]

And Minjur Tenpa gave Tenzin Rabgye a rank as high as his own along with the title 'Lama Tripa', 'Lama on the throne [of the Shabdrung]'. At the same time, Tenzin Rabgye left the monastic order so that he could marry and perpetuate his lineage.

From 1672, it was Tenzin Rabgye who presided over all the ceremonies of the central monk-body. In 1680, the 3rd Desi Minjur Tenpa was obliged to retire because of the revolt of the Punakha Dzongpön, Gedun Chöphel. Immediately after this event, Tenzin Rabgye was installed as *gyeltshab*, 'successor', and representative of the Shabdrung. He had the highest official position in the government. Because of his blood relation to the Shabdrung and because he was groomed so carefully to take a position of authority, nobody ever contested Tenzin Rabgye's enthronement as *gyeltshab*. He did not appoint a new Desi, but officiated himself as 4th Desi. His most trusted man was his chamberlain, Drung Norbu, who was also Thimphu Dzongpön. He was a former servant of Gedun Chöphel and the latter resented the fact that his servant had become more powerful than himself. Although Gedun Chöphel retired from his post of *dzongpön* in 1688, he was just waiting for an occasion to take revenge.

The task of Tenzin Rabgye was also to perpetuate his lineage. First he married a lady from Kabe (in the upper Thimphu valley), but the son and daughter he had with her died young. He remarried one of his mother's relatives, but had only one daughter, 'Lhacham' (Princess) Kunle, born in 1691. She was his last child, so Tenzin Rabgye was the last male descendant of the Gya lineage.

In the summer of 1694, Tenzin Rabgye became seriously ill and stayed in Thimphu instead of following the central monk-body to Punakha in the tenth month. A rumour spread that Tenzin Rabgye was dead. That was the occasion for

Administrative document and pencase. The document in cursive script and affixed with seals is Bhutanese paper made of Daphne bark, famed for its durability and flexibility. The ink used was made of soot and hide-glue. The document is a list of boxes and loads sent with the annual move of the Thimphu monk-body to Punakha at the beginning of the winter. The pen case (ngudro) is a fine example of metalwork. (E.L.)

which Gedun Chöphel had waited. On the twenty-first of the tenth month, he sent his men to surround Thimphu Dzong, and the Drung Norbu who was trying to flee was killed. Already weakened by illness, Tenzin Rabgye was deeply affected by this event and decided to retire to Tango without resisting, thus ending his long reign. Gedun Chöphel then realized his life-long ambition to become Desi.

Tenzin Rabgye lived one and a half years in Tango and died, without an heir, on the twenty-fifth day of the fourth month of 1696. His death brought to an end the Gya tradition of succession through blood descendants. This tradition had been observed for fifteen generations since the thirteenth century and had assured the cohesion of Drukpa rule while the Gya were in Tibet. Tenzin Rabgye started a lineage of reincarnations, which is now extinct, who were called 'Lama Tripa', or 'Lam Trip' in the vernacular.

Tenzin Rabgye was a broad-minded person who always maintained a tolerant attitude towards the Nyingmapas and the Sakyapas, the two non-Drukpa schools in Bhutan. He was, for instance, the one who offered the place for the Nyingmapa Gangte Trulku's winter residence at Pchitokha. His benevolence towards the Nyingmapas certainly won him the approval of a large part of the population of central and eastern Bhutan which remained by and large faithful to this

religious school. In western Bhutan, Tenzin Rabgye gave back to the Sakyapas the territories around their monasteries which had been confiscated earlier. In this way, he certainly contributed greatly to the acceptance of the Drukpa theocracy at a political level.

Another of Tenzin Rabgye's achievements was the establishment of the monk tax throughout Bhutan beginning in 1681 / 82: every family with more than three sons was obliged to provide one to the monk-body. This guaranteed a continuous recruitment of monks. From 500 in 1682, the number of monks in the monk-body increased to 800 at the end of Tenzin Rabgye's reign. Tenzin Rabgye also restored many temples and monasteries, including Tango, Taktsang and Kuje. In 1676 he built Daling Dzong on the western border, and that same year restored Gasa and Lingshi Dzongs.

The death of Tenzin Rabgye marked the beginning of almost two centuries of political turmoil and internal strife when Desis, *dzongpöns* and *pönlops* vied for political power. The whole period was marred by a lack of leadership, due firstly to the problem of finding a reincarnation for the Shabdrung Ngawang Namgyel whose death was only announced in 1705 / 7, and secondly to the fact that the Shabdrungs who ascended the throne afterwards were more inclined towards religious than political activities.

In 1744 Sherab Wangchuk (1697–1765) became the 13th Desi and Shakya Rinchen, one of the greatest scholars in Bhutanese history, became the 9th Je Khenpo. During their reigns Bhutan once again experienced a certain stability. The theory of the triple incarnations of the Shabdrung was most probably officially accepted at that time. The theory of multiple incarnations is well-known in Tibetan Buddhism and frequently used to represent the Buddha, bodhisattvas and great religious masters. In this case, it is explained as follows by the 10th Je Khenpo, Tenzin Chögyel, in his *Lho'i Chöjung* (folio 66b) printed in 1759:

> *When the secret of the retreat of the Shabdrung was revealed and when the Shabdrung went out of his meditation, three rays of light emanated from his body, his speech and his mind. They fell on Sikkim, Dagana in Bhutan and Dranang in Tibet.*

The reincarnation of the Shabdrung's body was born in Sikkim and died before 1746; this reincarnation was never found. No lineage of reincarnations of the body of the Shabdrung therefore ever existed in Bhutan. The first reincarnation of the Shabdrung's speech, the 'Shabdrung Sungtrul' was Chogle Namgyel. In 1746 the reincarnation was Shakya Tenzin, born at Dagana. This lineage would also be known as the 'Chogle Trulku'. The lineage which was to become the most important was the reincarnation of the Shabdrung's mind, the 'Shabdrung Thugtrul'. In 1746 the reincarnation was Jigme Dragpa born in Tibet. This is this lineage that would be known simply as 'Shabdrung Trulku', 'the reincarnations of the Shabdrung'.

NOTES

1 Tucci (1973: 33–59); Chayet (1994: 21–95).

2 Aris (1979: xxiii).

3 From the *rGyal rigs* (dated 1728), translated in Aris (1986: 12–85).

4 The best source to date is the *sMyos rabs* written by Lama Sangnga, who provides a fascinating account of Pema Lingpa's lineage.

5 The *Lo rgyus*, written in the eighteenth century, has been translated in Aris (1986: 88–120).

6 Aris (1979: 205–32).

7 Aris (1986, pp.170–86).

8 Ibid., pp. 172f.

9 Ibid., pp. 174f.

10 Ibid., p. 182.

11 Aris (1979: 214)

12 This code has been translated in Aris (1986: 122–68).

13 The history of this period is found in the *Lo rgyus*, translated in Aris (1986).

14 Aris (1986: 93), and *Lo rgyus*, folio 6a–6b.

15 Ibid., pp. 102f, and *Lo rgyus*, folio 13b.

16 Biography of Tenzin Rabgye, folio 15a.

17 Ibid., folio 23a.

18 Ibid., folio 52b.

19 Ibid., folio 69b.

REFERENCES

Aris, Michael. 1979. *Bhutan: The Early History of a Himalayan Kingdom*. Warminster: Aris & Phillips; New Delhi: Vikas.

—— 1986. *Sources for the History of Bhutan*. Vienna: Wiener Studien zur Tibetologie und Buddhismuskunde, Heft 14. Universität Wien.

Chayet, Anne. 1994. *Art et archéologie du Tibet*. Paris: Picard.

Imaeda, Yoshiro. 1987. *La constitution de la théocratie 'Brug pa au dix-septième siècle et les problèmes de la succession du premier Zhabs drung*. PhD diss., University of Paris VII.

Pommaret, Françoise. 1989. *History of Bhutan (7th–20th century): A Resource Book*. Unpublished mss. Thimphu: Education Department.

Tucci, Giuseppe. 1973. *The Ancient Civilization of Transhimalaya*. London: Archeologia Mundi.

The titles of Bhutanese works are given here
in their short form which is the best known.

dGe 'dun Rin chen (69th rJe mkhan po, 1926–97). 1972. *Lho'i chos 'byung gsar pa*. Tango edition. 192 folios.

Ngag dbang. 1728. *rGyal rigs*. 54 folios.

Ngag dbang. n.d. *Lo rgyus*. 24 folios.

Ngag dbang bstan 'dzin (1580–?). 17th century. *Pha jo 'brug sgom zhig po'i rnam par thar pa'i thugs rje'i chu rgyun*. 44 folios.

Ngag dbang lhun grub (6th rJe mkhan po, 1670-1730). [Biography of the 4th Desi bsTan 'dzin rab rgyas]. *mTshungs med chos kyi rgyal po rin po che'i rnam par thar pa bskal bzang legs bris 'dod pa'i re skong dpag bsam gyi snye ma*. Tango edition. 383 folios.

bsTan 'dzin Chos rgyal (10th rJe mkhan po, 1701–67). Written 1731–57, printed 1759. *Lho'i chos 'byung*. Norbugang edition. 151 folios.

Padma gling pa. 16th century. *Bum thang gter ston Padma gling pa'i rnam thar 'od zer kun mdzes nor bu'i 'phreng ba zhes bya skal ldan spro ba skye ba'i tshul du bris pa*. Autobiography incorporated in vol. PHA of his collected works. 254 folios.

Bla ma gSang sngags. 1983. *sMyos rabs*. Thimphu. 494 pp.

sLob dpon gNag mdog. 1983. *'Brug dkar po*. New Delhi. 242 pp.

sLob dpon Padma Tshe dbang. 1994. *'Brug gi rgyal rabs*. Thimphu. 625 pp.

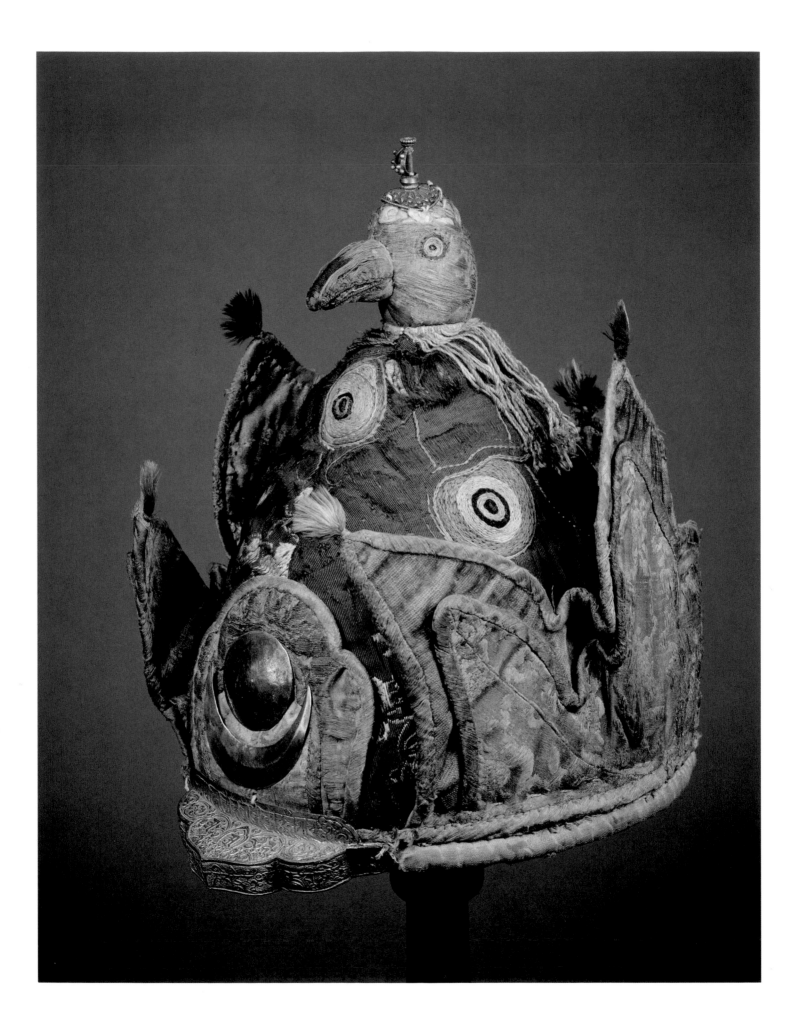

The Way to the Throne

Françoise Pommaret

THE NINETEENTH CENTURY: A NEW ERA
ENCOUNTER WITH THE BRITISH AND THE AGE OF
JIGME NAMGYEL

The history of Bhutan before the eighteenth century is known almost exclusively through Bhutanese and Tibetan sources. The nineteenth century, though, is very poorly documented by those same sources if we except the biographies of the Shabdrungs. The last biography was that of the 13th Desi Sherab Wangchuk, and his reign coincided with a period of stability. His forty-two successors are known through comments in other texts, but the available information about them rarely exceeds a page. As for the Je Khenpos of this period, only a few biographies exist and as these also deal almost exclusively with their religious works, they do not greatly assist the historian. New sources for this period do, however, appear: these are the narratives of the British missions to Bhutan which, though they can be biased and subjective, supplement the Bhutanese sources.

Opposite: The Raven Crown of Jigme Namgyel (1825–81) was worn as a helmet by the father of the first king Ugyen Wangchuck in the 1865 war with the British and became the model for the future royal crowns of Bhutan. (E.L) It takes its form from the raven-headed protective deity Legön Jaro Dongchen (Las mgon bya rogs gdong can), a form of Mahakala, the protective deity of the Shabdrung Ngawang Namgyel, and later of the monarchy, as depicted (right) on this 19th century wall painting from the ground floor of Dungtse Lhakhang in the Paro valley. (F.P. 1982)

This century was marked by two characteristics. Externally, Bhutan came into contact with the British power in India for the first time. At the same time Bhutan continued to have relations, sometimes difficult and marred by skirmishes, with its traditional commercial and cultural partners: Tibet, Ladakh, Cooch Bihar, Sikkim and Nepal. Internally, instability was rampant with incessant strife between *dzongpöns* for the post of Desi, and between the Desis themselves. Plagued by these struggles, the central government was weakened and gradually lost its authority to the Pönlop (Governor) of Tongsa, Jigme Namgyel.

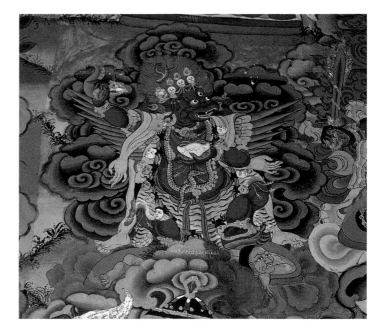

Bhutan and the British (1772–1926)

The first missions

At the end of the eighteenth century, the East India Company controlled virtually the whole of India and understood relations only in terms of commercial profit. Warren Hastings, the Governor-General of the Company in India, wrote to his headquarters in London about the prospect of an exploratory mission to Bhutan. The Company replied in 1771:

> *It having been presented to us that the Company may be greatly benefited in the sale of broadcloth, iron and lead and other European commodities by sending proper persons to reside at Rungapore [Rangpur] to explore the interest of parts of Bhutan …*[1]

With the closure of the old Nepal–Tibet trade route because of the Gurkha conquest of Nepal, this commercial interest also included the possibility of a new trade route to Tibet via Bhutan. Besides, because of its strategic position not only as a buffer state between British India, and Tibet and China, but also as a link on the turbulent northeastern frontier, the British were anxious to have Bhutan as a peaceful neighbour and ally.

The political scene suddenly changed in December 1772. For centuries the Bhutanese had made incursions into Cooch Bihar and now, during one such incursion, they captured the king. The Cooch Bihar regent requested the help of the East India Company. Seeing an opportunity to establish a protectorate in Cooch Bihar, the Company sent four companies of soldiers who fought the Bhutanese at the fort of Bihar. After considerable losses, the Company troops were victorious and reinstalled the king. At the same time a treaty was signed by which, in effect, the Company became the real ruler of Cooch Bihar. From now on, the Bhutanese would no longer be raiding the lands of a petty king, but the properties of the powerful East India Company. The year 1772 is therefore considered the official opening of relations between Bhutan and British India.

In May 1774, the British sent the first goodwill mission to Thimphu. Apart from the visit to Bhutan of the two Portuguese Jesuit priests in 1627, this was the first time in the history of Bhutan that Westerners were allowed inside the country. The mission was headed by George Bogle accompanied

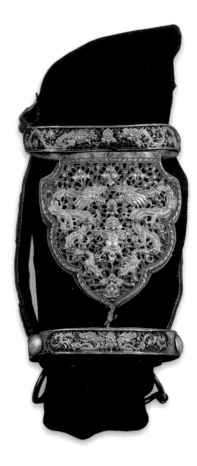

by Dr. Alexander Hamilton. After Bhutan, they were to proceed to Tibet. The purpose of the mission was to report on the country, to establish commercial links between Bhutan and Bengal and, more importantly in the eyes of the British, to explore the possibility of a trade route through Bhutan to Tibet.

While he was waiting for permission to proceed to Tibet, George Bogle was held up for a few weeks in Thimphu. He was finally allowed to proceed, but with just four other people. They only went as far as the monastery of Tashilhunpo (near Shigatse). Here Bogle held discussions with the 3rd Panchen Lama, Lobzang Palden Yeshe (1737–80), who supported his plans of increasing trade between Tibet and India via Bhutan. When he came back to Bhutan, Bogle managed to persuade the Desi of the advantages of this new trade; only Indian and Tibetan merchants, no Europeans, would be allowed to cross through Bhutan. Moreover, in addition to the yearly Bhutanese caravan to Rangpur, the Bhutanese would be allowed to sell their horses anywhere in Bengal. At last all duties would be abolished.

Although George Bogle's mission was hampered by many delays and problems, it was on the whole politically successful, and his report about Bhutan is very favourable

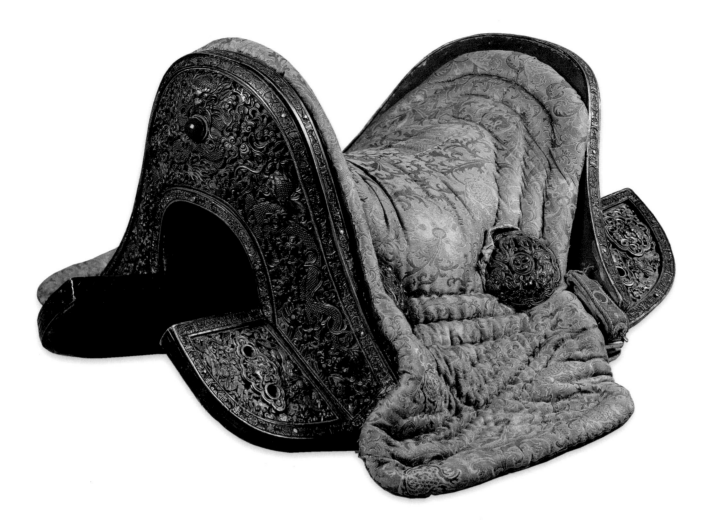

to the country and its people. He wrote:

> *The more I see of the Bhutanese, the more I am pleased with*
> *them. The common people are good humoured, downright*
> *and I think thoroughly trusty. The statesmen have some-*
> *thing of the art which belongs to their profession. They are*
> *the best built of race I ever saw; many of them are very*
> *handsome with complexions as fair as the French.*[2]

These comments are in sharp contrast to those made by other missions in the nineteenth century.

In 1776, Dr. Hamilton returned alone to Bhutan to strengthen the links between the two countries, and to examine the Bhutanese claims to Ambari Fallacota and Jaipelsh (in present Jalpaiguri District). In order to conciliate the Bhutanese, he recommended the permanent return of

Above: Part of the tack for the royal horse, this saddle, bridle and bridle plate (left) are embellished with gold-plated silver intricately worked in tendrils, dragon, phoenix and jachung (a mythical animal often associated with Guru Rinpoche). (E.L.)

these districts, a proposal accepted by the Governor-General Warren Hastings. However, Dr. Hamilton found that the Bhutanese were placing many obstacles in the way of merchants crossing their territory, with the result that hardly anybody passed through Bhutan. In 1777 Dr. Hamilton went to Bhutan once more, this time to congratulate the new Desi, the Tritrul Jigme Sengye, on his accession to the throne.

In the meantime, new problems arose because Cooch Bihar would not recognize the 1774 treaty, and would not revert the promised territories to the Bhutanese, who complained to Warren Hastings. The Governor-General decided to send

another mission to Bhutan. From there, the mission would proceed to Tibet. In 1783, Captain Samuel Turner accompanied by Samuel Davis (who was to sketch the country) left for Bhutan in order to settle these problems.

During his stay in Bhutan, Turner held numerous friendly and informal talks with the 18th Desi, the Tritrul Jigme Sengye, and witnessed a rebellion of the Wangdi Phodrang Dzongpön which was rapidly quelled. It appears that some of the high officials were not prepared to befriend the British, as is obvious from the letter sent by the retired 13th Je Khenpo, Yonten Thaye, to the Desi:

The barbarian demons have disturbed your mind, Holy Being, to the extent that you are enamoured of the goods of the English ...[3]

Turner's mission to Bhutan was successful in the sense that it consolidated Bogle's work, but it did not achieve any new breakthroughs in Bhutanese–British relations. Davis' sketches, however, were to become famous and bring Bhutan to the notice of the outside world.

Sour relations: First half of the nineteenth century
Relations began to deteriorate in 1792. Bhutan closed its door to merchants from the East India Company territories who wanted to travel to Tibet. Minor disputes kept on arising along the border and in 1808 culminated in a major incident at Maragahat. This was a large area comprising eight districts which had formerly belonged to Cooch Bihar, but which had been given to the Bhutanese by the 1774 treaty. In 1792, a Bhutanese party killed five people in this region, and a British detachment had to be sent to restore order. The British Collector of Rangpur, the supreme authority in the area, ordered the Bhutanese to return Maragahat to Cooch Bihar. They refused. There were skirmishes in the area again in 1811 and the Bhutanese once again refused to surrender Maragahat, or to accept any boundary demarcations that would be to their disadvantage.

In 1815, the British decided to send Kishan Kant Bose, an Indian from the East India Company, to gather information on the state of affairs in Bhutan. His report covered most aspects of Bhutanese life and politics. However he could not settle any further agreement between the British and the Bhutanese.

In 1828, the British occupied Assam and now had a long common border with Bhutan. Until this date the seven Assam

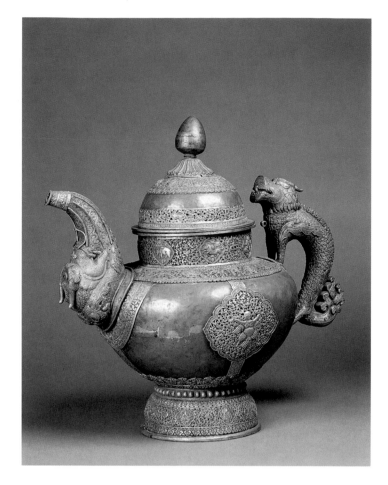

Made of copper ornamented with silver bands and medallions, this large teapot of royal provenance is a fine example of the art of the metal worker. The handle is formed by a dragon while the spout is a horned makara, a mythical animal associated with the ocean. (E.L.)

Duars (southern approaches) had been occupied and exploited by the Bhutanese who had paid a land tax and tributes to the Assamese. An official appointed by the Desi was even in charge of this area. It was obvious that with the increase of points of friction between the British and the Bhutanese (eighteen Duars in all: eleven Bengal Duars and seven Assam Duars), the tension would only escalate.

When the British took over Assam, they became the legal masters of the seven Assam Duars. When the next Bhutanese tribute was paid shortly afterwards, the goods were substituted with others of inferior quality by the middlemen working for the British, and the value of the goods was ultimately far smaller than the amount that should have been paid. This led to much resentment on both sides and in 1828 the Bhutanese attacked a frontier post in the Buriguma Duar, killing the Indian officer and taking captives. They justified the raid by saying they wanted to recover the looted goods. However the British counter-attacked

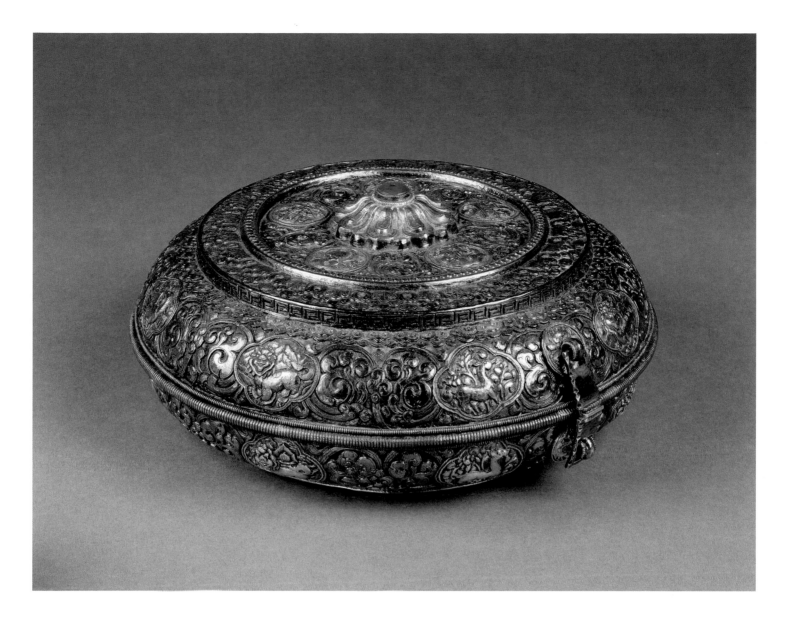

An elaborate betel leaf and areca nut box (bata) of this quality would have been used by the nobility and high clergy. Bhutanese are very fond of chewing betel, but in the past only the wealthy could afford this habit. (E.L.)

with troops, and the Duar was confiscated. It was later returned in 1834, after the Bhutanese had paid a fine of Rs. 2,000 for their previous aggression. Meanwhile, petty incidents kept occurring in the Bengal Duars, for which the Raja of Cooch Bihar was, apparently, much to blame. Border demarcations were yet to be fixed and, faced with a troubled situation along their entire border, as well as with the breakdown of communication with Bhutan, the British decided to send another mission to Bhutan.

Captain Pemberton was the head of this new mission. Since there was no answer to the British letter informing the Bhutanese of the mission, it left without receiving any travel authorization from the Bhutanese. In order to discover more about the eastern part of the country, its route would be different from that of earlier missions. The mission reached Deothang in early January 1838. Because of internal disturbances, it had to wait there for a whole month for permission to proceed from the Desi. The mission then followed the route: Tashigang–Tashiyangtse–Kurtö–Jakar–Tongsa–Punakha, which it finally reached on 1 April 1838. Captain Pemberton stayed in Punakha for one month trying to convince the government to sign an agreement with the British. The agreement included clauses about the extradition of criminals, free circulation between the two countries, and payment of the tribute arrears. The 36th Desi Dorje Norbu and the Shabdrung Jigme Norbu (who was then eight years old) were quite inclined to sign, but were prevented from doing so by the Tongsa and Paro Pönlops. After the mission failed, Captain Pemberton returned to India via Thimphu and Buxa Duar, which was the normal route.

Although Captain Pemberton's report is full of useful information, his distaste for the Bhutanese is only too apparent. This is in striking contrast to previous as well as subsequent reports on Bhutan. Politically his mission did not achieve anything, but contributed greatly to further deterioration of relations between the two countries.

The escalation of tension

Incidents along the border continued over the years following Pemberton's mission, and blame was shared between the two countries. Moreover, the British complained that the tribute the Bhutanese had to pay them for the occupation of the Assam Duars was always late, and never corresponded to the exact amount owed. Once again, this was due to the British practice of auctioning the goods received. But the goods which reached the auction were not the originals sent by the Bhutanese: they were products of inferior quality substituted by middlemen. As for the cash tribute, the British refused to accept Bhutanese currency. Because this currency had much less value than the rupee, once the conversion was made the agreed sum was never met. All these episodes built up resentment as each party had the impression it was being cheated by the other. The troubled political situation inside Bhutan did not help to lessen the problems.

The situation came to a head in 1840, and the British decided to annex two Assam Duars in the Darang region. At the time they stated they would pay compensation to the Bhutanese for the loss of revenue. In May 1841, the Shabdrung and the 36th Desi wrote to the British:

> *The Bhutanese government is ready to pay arrears of the tribute and requests the British government to return the annexed Duars ... please send an envoy in the cold season.*[4]

Lord Auckland, the Governor-General, replied that the situation in the Duars was extremely disturbed and that if the Bhutanese continued their raids the British would take over all the Assam Duars. This happened on 6 September 1841. However, the British agreed to pay a yearly compensation of Rs. 10,000 to the Bhutanese and did so up until the 1864 war.

The Bhutanese pleaded in vain until 1851 for the return of the Assam Duars, and annexation did not prevent further incidents. In 1845, seven people were taken captive by a party organized by the Deothang Dzongpön. In retaliation, the Banska Duar was once more taken over by the British until the captives were returned. In 1854, the Bhutanese government sent a mission to Gauhati to ask for an increase of the compensation to at least Rs. 12,000. The Agent of the Governor-General could not accede to their demands, so on their way back to Deothang the Bhutanese took revenge by plundering the Banska Duar. After a long exchange of letters and serious threats from the British to annex the Bengal Duars as well, the Tongsa Pönlop, whose jurisdiction extended as far as Deothang, apologized to the British government in July 1856. The revenue of the Duars was paid, minus the value of the property plundered.

The situation in the Bengal Duars was no better than in the Assam Duars. It further deteriorated after 1850, when Colonel Jenkins, who was already the Governor-General's Agent for Assam, also became responsible for the Bengal Duars. Until this date, the Bhutanese had the support of Dr. Campbell who since 1840 had been the Superintendent of Darjeeling and who had often settled litigious cases in their favour. Dr. Campbell had been a strong advocate of boundary marks, but because the two parties never seriously attempted to solve this problem nothing much had been done. Bhutan's permanent internal unrest, and Colonel Jenkins' belief in the annexation of the Duars, did not create favourable conditions for a settlement. Colonel Jenkins wrote:

> *... if we possess the Duars, the source of their subsistence, the Bhutanese government would in a short time become entirely dependent on us.*[5]

The Ashley Eden mission: 1864

Incidents continued and the Government of India decided that a mission would be the most appropriate course. In 1862 a messenger was sent to arrange the visit of the British envoy. The Bhutanese temporized and replied that the time was not convenient for a mission. They added that they would send messengers to invite a mission in due course. No messenger came. The British decided to go ahead with the mission and in 1863 dispatched letters to the Shabdrung and the Desi announcing the arrival of a mission and requesting them to make all the necessary arrangements. In fact, no Bhutanese messenger could have come because the country was in the midst of another internal conflict, and there was no official reply to the letter announcing the arrival of a mission.

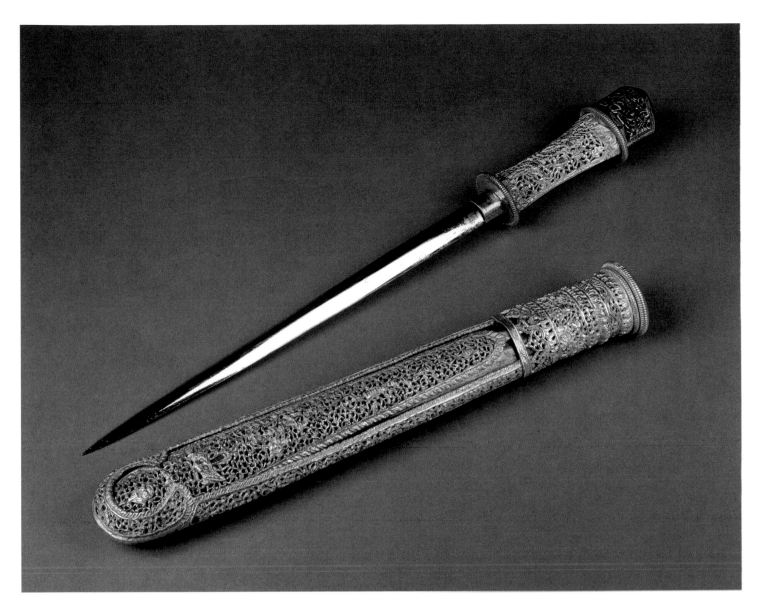

Gold-plated silver dagger with intricate metal work of probable royal provenance. Short straight knives are traditionally carried by Bhutanese men but most of them have simple wooden handles and scabbards. The knife or dagger is tucked under the belt within the large pocket made by the fold of the robe. (E.L.)

Ashley Eden, the Secretary of the Government of Bengal, was appointed to lead the mission. He was to explain to the Bhutanese government why Ambari Fallacota had been occupied and that this territory would be given back as soon as the properties and people plundered by the Bhutanese were returned. Inquiries into the litigious cases would be made as well. Eden was also to explain the situation of the protected states of Sikkim and Cooch Bihar and point out to the Bhutanese their interests in cooperating with the British. Last, he was to try to obtain permission to station a permanent Political Agent in Bhutan and to have free trade between the two countries. All these points were ultimately

to be formalized as a treaty, of which Eden carried a draft copy to serve as a basis for discussion.

On his arrival in Darjeeling, Ashley Eden heard that Bhutan was in a state of turmoil but he decided to proceed anyway with his escort. They met with many problems because the Bhutanese officers along their route had received no notice of their visit, and had no orders from the central government to receive them. The mission was first held up at Daling Dzong near Kalimpong. There the coolies deserted, understanding that the Bhutanese government would not be cooperative. In Sibsu, faced with the prospect of being short of supplies, Eden decided to continue his trip with a reduced escort without waiting any longer for the Desi's approval. On the road they soon met messengers from Punakha bringing orders from the Desi that the mission go back to Darjeeling. Eden refused and continued his journey. Descending from the Chelila pass into Paro, the mission met

another party sent to stop them. Eden once again refused to obey and proceeded to Paro. The Paro Pönlop, who was not on good terms with the Tongsa Pönlop and the new Desi, stopped them for a while but finally allowed them to proceed to Punakha, thinking this might later turn to his advantage.

When the mission arrived in Punakha, they were left waiting for many days before being ordered to meet with the Council of State. They were then subjected to various humiliations but part of the responsibility fell on Eden who had acted in a clumsy and undiplomatic manner. First, he had really forced his way into a country which was in political turmoil and which had made it clear that his visit was not convenient. Then, instead of sensing the mood of the Bhutanese and starting to discuss the various issues with an open mind, dropping some of them if necessary, he handed over the draft treaty as if it were a definitive document, whereas it had been given to him only as a guideline.

The Tongsa Pönlop Jigme Namgyel did all the negotiating for the Bhutanese, proving he was the real ruler of the country. His main concern was to get back the Assam Duars. The talks were inconclusive, and the mission decided to leave before things got worse. Before the mission left, however, the Tongsa Pönlop sent a letter which Eden had to sign as a treaty giving back the Assam Duars and agreeing to the payment of compensation for each year of occupation. Naturally Eden was not willing to sign, but decided to do so for the mission's safety believing this was the only way to escape unharmed. This treaty ultimately turned out to be worthless because Eden did not have the Government's approval to sign it, and because he had added to it the words "under duress". But he did not mention these two points to the Bhutanese, who thought they had a *bona fide* agreement. After further delay the mission finally left and at the end of April 1864 reached India after rigorous marches for fifteen days. Eden's report was, of course, negative towards the Bhutanese, and he was especially scornful of their military skills, a judgement which would be proved wrong during the Duar war the following year.

The Duar War: 12 November 1864 – 11 November 1865

Ashley Eden was severely reprimanded by London and by the Governor-General, who wrote:

> In our opinion it would have been well had Mr. Eden given up his mission, particularly after he arrived in Paro ... [6]

He also wrote to the Bhutanese government to denounce the agreement Eden had signed. Further he said that in retaliation for the outrages to British subjects, no revenues would be paid for the Assam Duars and Ambari Fallacota. The Governor-General added that these territories would be permanently annexed to the British Crown, as would all the Bengal Duars if the British-Indian captives were not released. The Bhutanese government replied that they would fight any aggression and that, in turn, they were offended that the British had denounced the treaty Ashley Eden had signed.

On 12 November 1864, the British issued a proclamation of war in the form of a declaration annexing the Duars. The Assam Duars and Ambari Fallacota were permanently annexed, as were the Bengal Duars and:

> ... so much of the hill territory including the forts of Dalingcot, Passakha (Buxa) and Dewangiri as may be necessary to command the passes, and to prevent hostile or predatory incursions of Bhutanese into the Darjeeling district or into the plains below. [7]

The first British attacks and victories

As soon as war was declared, without waiting for a Bhutanese reaction, the British began their advance. Except for the officers, the troops concentrated on the border were Indian soldiers and numbered about 5,000. The British force was divided into four, with two columns on the inside and two on the outside. The Force Commander, Brigadier-General W. E. Mulcaster, commanded the two right hand columns. The extreme right column was to take the forts of Deothang (Dewangiri), and the centre right column headed for Bishensingh which commanded the Sidli (Tsirang) and Bijni Duars. The columns on the left were commanded by Brigadier General H.F. Dunsford. The extreme left column was to occupy the fort of Daling near Kalimpong and Chamurchi (Samtse), and the centre left column Buxa and Bala Duars.

On 5 December 1864, Daling Dzong was taken with great loss of life. On 7 December, Buxa Duar fell. Bala (Tazagong) stockade, and then Chamurchi stockade were taken at the end of December 1864. The centre right column occupied Bijni and Sidli Duars during the last days of December 1864, and Bishensingh, its main objective in Bhutan, was taken without problem on 8 January 1865. As for Deothang, the extreme left column took the fort on 11 December after a

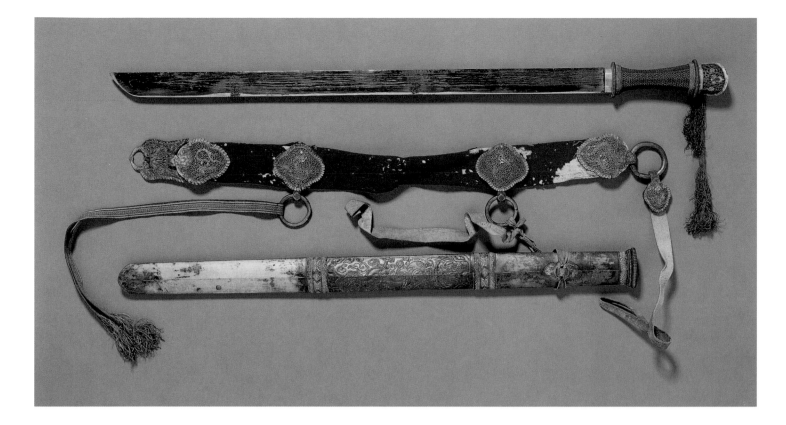

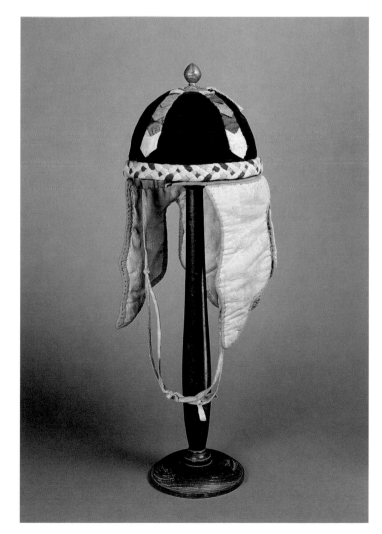

Swords are worn attached to a thick felt belt ornamented with fine silver buckles. Previously worn as a prestigious symbol of the nobility, today only those who are knighted as Dasho (Senior Officer) by the King are allowed to carry one. See also p. 163. (L.M.) The small chain mail helmet covered with velvet (right) comes from Wangduchöling palace in Bumthang. (E.L.)

short fight. The annexation of the Bengal and Assam Duars was completed by mid-January 1865, and the British thought the campaign was over. They felt confident enough to reduce their forces in all the places they had taken over, and to start establishing a civil administration in the Duars.

The British dismissed intelligence reports which warned of a Bhutanese counter-offensive, and a similar threatening letter from the Tongsa Pönlop. The Bhutanese attack took the unprepared and weakened enemy totally by surprise. Later, the British would marvel at the skill, coordination and unity shown by the Bhutanese. It appeared that the Tongsa Pönlop Jigme Namgyel was the man behind this victorious counter-offensive which took place simultaneously along the whole border. The offensive ended in total disaster for the British, especially at Deothang, which was attacked by a force commanded by the Tongsa Pönlop on 29 January 1865. The British evacuated the fort on 4 February leaving everything behind, including their cannons and the wounded. The British troops also had to abandon Bala on 2 February and

Bishensingh on the 24th. Chamurchi, too, was evacuated. Daling was the only fort the British could hold.

The final British attack and victory

In the face of this rout which was a blow to their prestige, the British government reacted swiftly. New commanders were appointed: Brigadier-Generals Tytler and Tombs replaced Brigadier-Generals Dunsford and Mulcaster. Regiments were brought up to the border as reinforcements, and the counter-attack started in mid-March 1865. On 15 March, Bala stockade was reoccupied, followed by Chamurchi on 28 March. However, it was the recapture of Deothang that was the decisive event in the Duar war. There the British were hoping to regain their lost prestige, but the slaughter by Sikhs and Pathan soldiers of 120 Bhutanese who had surrendered was an ugly act which the commanders could not prevent, and which only brought them dishonour. A British force of 1,500 men commanded by Brigadier-General Tombs attacked Deothang from the Darang pass on 2 April and recaptured it after fierce resistance from the 3,000 men guarding the fort. Every building was destroyed by the British as if to erase their previous defeat. Deothang was evacuated on 6 April 1865 because the British knew it was an untenable position.

The last stages of the war and the Treaty of Sinchula: 11 November 1865

In April 1865, plans were made for an invasion of Bhutan, at the proposal of Brigadier-General Tytler. One column was to invade Punakha from Buxa and another was to march to Tongsa from Deothang, but the British were reluctant to continue operations in an inhospitable and mountainous country, and were keen to finish the war. Negotiations lasted for the whole of the rainy season; at the same time, most probably as an intimidating measure, preparations for the invasion were made from August. However both parties reached an agreement before it was necessary to take this drastic step and, on 11 November 1865, the Treaty of Sinchula was signed.[8]

By this ten-article treaty, the Bhutanese surrendered all the Bengal and Assam Duars including Ambari Fallacota, Daling (Kalimpong), the hill tract between the rivers Tista and Jaldhaka, and Deothang. Moreover, they were to release all their captives and give back the treaty signed by Ashley

Eden in Punakha in 1864. The goods imported into each country would be duty-free and the Bhutanese would refer to the British in case of disputes with Sikkim and Cooch Bihar. However the British agreed to pay a compensation of Rs. 25,000 to the Bhutanese the first year on the fulfilment of the terms of the treaty and the return of the two guns captured at Deothang. This compensation was to increase every year until it reached Rs. 50,000; the Bhutanese were, nevertheless, losing 7,124 km^2 of precious arable lowland. This treaty was to lay the ground for the Treaty of Punakha of 1910, as well as the treaty between India and Bhutan in 1949.

The last armed incident occurred in February 1866 when the Bhutanese delayed the return of the two captured British guns. The column which was to receive the guns marched to the Manas bridge where the guns were to be handed over. For some reason, the British were fired upon. They immediately attacked and overran the Bhutanese. The war was over.

Consolidation of relations

After signing the Treaty of Sinchula in 1865, relations between Bhutan and the British improved, although minor incidents still occurred on the border. The border was demarcated in Bengal in 1867–68, and in Assam in 1872–73.

In 1888, the Bhutanese took a neutral stand in the dispute between the Tibetans and the British, a gesture the latter appreciated. Moreover, during the Younghusband expedition to Lhasa in 1904, the Bhutanese, and more particularly the Tongsa Pönlop Ugyen Wangchuck, provided valuable help to the British. The British recognized Ugyen Wangchuck's services by conferring on him the insignia of Knight Commander of the Indian Empire (KCIE). In 1905 John Claude White, the Political Officer in Sikkim, was sent to Bhutan to present the insignia to the Tongsa Pönlop. He received a wonderful welcome and the two men developed a strong friendship which only enhanced the good relations between the two countries.

In 1904, the political relations which had been looked after by the Government of Bengal were transferred to Colonel Younghusband, who dealt directly with the central

The exquisite appliqué work of the Bhutanese is demonstrated by this throne cover (thrikheb) of probable royal provenance. A phoenix in the central medallion is surrounded on each side by four kinnara, musicians who are part man, part bird, playing cymbals. No overtly religious motifs are used. See also p. 123. (E.L.).

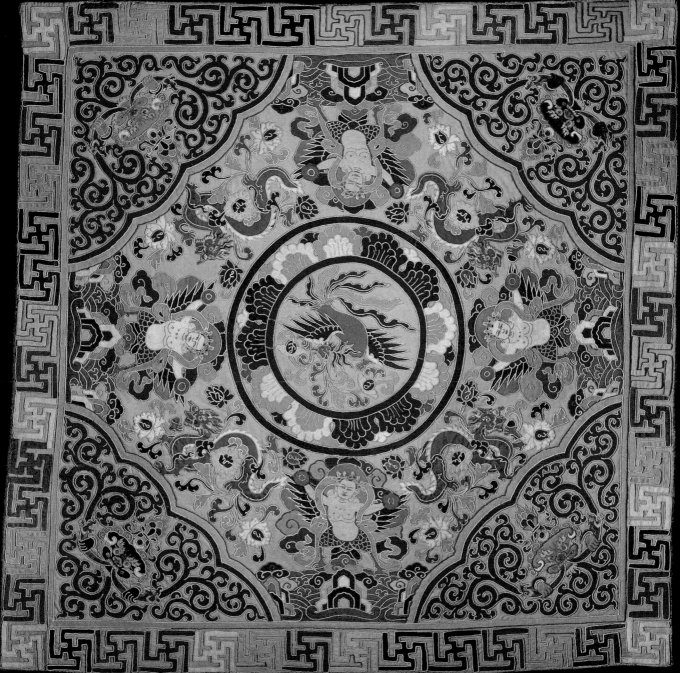

government. At the end of his expedition to Tibet, the political relations between Bhutan and the British government were transferred to the Political Officer in Sikkim who also looked after Tibet.

In 1906, Ugyen Wangchuck travelled to India to meet the Prince of Wales, the future George V, and received a very warm welcome. Besides, Ugyen Wangchuck took a keen interest in what he saw in India and it helped him to broaden his vision of the world. In 1907, John Claude White, still Political Officer in Sikkim, travelled to Bhutan for the second time in order to attend the coronation of Ugyen Wangchuck as the first king of Bhutan. The British were naturally delighted with the choice of the Bhutanese, as this coronation was a guarantee of stability in Bhutan and of future good relations between the two countries.

To further consolidate these ties, as well as to ward off any hegemonic attempt of China which had tried on several occasions to claim rights in Bhutan, it was agreed in 1910 to sign a new treaty. Known as the Treaty of Punakha, it was signed on 8 January 1910, at Punakha by H.M. Ugyen Wangchuck and Charles Bell, the then Political Officer in Sikkim (later Sir Charles Bell). The yearly allowance was increased to Rs. 100,000, and the British Government undertook to exercise no influence in the internal administration of Bhutan. For its part, the Bhutanese Government agreed to be guided by the British Government in regard to its external relations.

It appears that after signing this treaty, for fear of losing its independence, Bhutan tried as far as possible to avoid issues that could cause problems with the British. Relations between the two countries remained excellent but distant. The Political Officers based in Sikkim visited Bhutan from time to time and were very supportive of active aid to the country. In 1914, the first Bhutanese boys to receive a western education were sent to school in Kalimpong and Ha, and Kazi Ugyen Dorje played an important role in promoting education. In 1921, the British provided training in various fields.

Thus the Treaty of Punakha and subsequent British assistance provided the basis for the treaty of friendship signed in 1949 between Bhutan and independent India. At that time, as a goodwill gesture towards its neighbour, India returned the Deothang region to Bhutan.

The age of Jigme Namgyel

Jigme Namgyel had emerged as a figure of national importance on the troubled scene of Bhutanese politics since 1850, when he was appointed Tongsa Drönyer. In 1853, he became Tongsa Pönlop. He was from the family of the Dungkar Chöje in Kurtö (Lhuntshi). He was a descendant of the religious figure Pema Lingpa through the latter's son, Kunga Wangpo. Jigme Namgyel's father Gonpo Wangyel, better known as Pila, had served the central government under the Shabdrung Jigme Dragpa II (1791–1831) to whom he was related. When Pila came back to Dungkar, he married a girl called Sonam Pelzom from the village of Jangsa. They had five children and the middle one, born in 1825, was called Samdrup, better known as Jigme Namgyel.

One of the stories related in Bhutan says that when he was still very young, Jigme Namgyel had a dream in which a man appeared and told him to go to the Bumthang and Tongsa regions, where the Tongsa Pönlop would be good to him. He therefore joined the retinue of the Tongsa Pönlop, the Tamshing Chöje Ugyen Phuntsho. Tshokye Dorje, a descendant of the fourteenth-century saint Dorje Lingpa from Ugyenchöling, later became the Tongsa Pönlop, and Jigme Namgyel served him too, faithfully and diligently. Tshokye Dorje remembered that a few years earlier, he had received a prophecy saying that when he became Tongsa Pönlop, he would meet a man called Jigme from Dungkar and that the country would greatly benefit from their association. Jigme Namgyel was rapidly promoted. He occupied the posts of both *darpön* ('flag officer') and *zimnang* ('junior chamberlain'), looking after the different rituals of Tongsa Dzong and Bumthang. He was also responsible for all the trade of the *dzong*.

In 1841, Jigme Namgyel headed the team from Tongsa sent to restore Punakha Dzong after a fire. When the Tongsa Pönlop Tshokye Dorje came to Punakha, Jigme Namgyel saved him from an assassination attempt. In gratitude, Tshokye Dorje promised to give him the post of Tongsa Pönlop when he retired, thus bypassing his own son, Tsondru Gyeltshen, who was then the Jakar Dzongpön. Meanwhile at the age of twenty-four Jigme Namgyel was promoted to the post of Tongsa Zimpön.

In those days, the jurisdiction of the Tongsa Pönlop covered only Jakar, Lhuntshi and Shemgang. Tshokye Dorje wanted to extend it throughout the east. In 1850, the eastern

forces which sided with the central government, gathered at Mongar with the intention of waging war against the Tongsa Pönlop. Jigme Namgyel was appointed Tongsa Drönyer and sent to the east at the head of an army. He was victorious and took over all the *dzongs* in eastern Bhutan: Tashiyangtse, Tashigang, Zhongar (Mongar), and Dungsam (Pemagatshel/ Samdrupjongkhar). Thus the whole of eastern Bhutan came under the control of the Tongsa Pönlop.

A few months later in 1851, a civil war started in the western region. Chakpa Sangye had been enthroned as the 40th Desi, but the ex-Paro Pönlop Agye Hapa wanted to oust him and requested military back-up from the Tongsa Pönlop who sent a small troop commanded by Jigme Namgyel and his relatives Dungkar Gyeltshen and Kyitshelpa Dorje Namgyel. They killed Migtholma, the strongman of the Desi's party, and then fled back to Bumthang via Gasa, Laya and Tibet.

In 1853, faithful to his promise, Tshokye Dorje made Jigme Namgyel the Tongsa Pönlop. An agreement with his son, Tsondru Gyeltshen, stated that Jigme Namgyel would relinquish his post after three years. Jigme Namgyel was then called by the central government to mediate between the two Desis, Damchö Lhendup and Jamyang Tenzin, the latter being the reincarnate lama of Si'ula monastery known as the Jamgön Trulku. Jigme Namgyel's talents as a mediator started to become known. In recognition of his services to the state, he was allowed to keep part of the land-taxes collected by Tongsa Dzong and, more importantly, to appoint the *dzongpöns* of eastern Bhutan without referring to the central government.

In 1856, the Thimphu Dzongpön Uma Dewa requested Jigme Namgyel's help in becoming Desi (even though this position was already occupied by Kunga Palden). Jigme Namgyel sent him a small troop and Uma Dewa became Desi; he was, however, assassinated soon after on the order of the former Desi, Kunga Palden.

In early 1858, a fight broke out between Jigme Namgyel and the Jakar Dzongpön Tsondru Gyeltshen. More than three years had passed since the appointment of Jigme Namgyel, and Tsondru Gyeltshen wanted to become Tongsa Pönlop. In 1857, a friend of Tsondru Gyeltshen, the Tongsa Drönyer, was killed by the Zhongar Dzongpön, who was close to Jigme Namgyel. This provided the pretext for hostilities. The Jakar Dzongpön was assisted by some of Desi Kunga Palden's troops, but their joint force could not defeat Jigme Namgyel. To celebrate his victory at the battle of Shamkhar in Bumthang, Jigme Namgyel built the palace of Wangduchöling.

Meanwhile, many officials intervened to bring about peace between the two parties and an agreement was finally reached. The Jakar Dzongpön was promoted to the rank of Pönlop, and the eastern regions were divided between the two *pönlops*.

When Nadzi Pasang became the 45th Desi in 1861, his nephew, the Punakha Dzongpön Darlung Tobgye, expected to become the Wangdi Phodrang Dzongpön. When this did not happen, he rebelled. Darlung Tobgye called on the Jakar and Tongsa Pönlops for help. A battle took place in Lungtenphu near Thimphu, and Jigme Namgyel's party won. Darlung Tobgye was then appointed Wangdi Phodrang Dzongpön and a relative of Jigme Namgyel, Khasa Tobgye, became Thimphu Dzongpön. The 45th Desi's life was spared but he had to resign in 1864. With Jigme Namgyel's support, Tshewang Sithub, the Thimphu Dzongpön, became the 46th Desi.

Jigme Namgyel was clearly emerging as the strongman of Bhutan. In 1862, his wife Pema Chökyi, the daughter of the ex-Tongsa Pönlop the Tamshing Chöje Ugyen Phuntsho, bore him his second child, Ugyen Wangchuck.

In 1864, Jigme Namgyel was present at Punakha when the mission led by Ashley Eden tried unsuccessfully to hold talks with the Bhutanese government. Jigme Namgyel appears to have been the main figure with whom the British dealt, which says much about his importance in Bhutan at the time. When the Duar war broke out in 1865, the Tongsa Pönlop and the Jakar Pönlop were sent to fight in the Dungsam region which was under their jurisdiction. During a clash with the British, the Jakar Pönlop Tsondru Gyeltshen, was killed. When Jigme Namgyel reached Deothang, which had been occupied by the British, he fired on some officers taking them by surprise, and the British troops fled. As a result, the Bhutanese not only recaptured Deothang but also got hold of two British cannons. In 1866, Jigme Namgyel retired from the post of Tongsa Pönlop, appointing his elder brother Dungkar Gyeltshen in his place. He appointed Samdrup, the Ugyenchöling Chöje, as Jakar Pönlop.

However, this was by no means the end of his political career. In 1867, he was called on to help the party of the Punakha Dzongpön, who was fighting with Jigme Namgyel's ex-ally, the Wangdi Phodrang Dzongpön Darlung Tobgye. Darlung Tobgye had killed the Thimphu Dzongpön Khasa Tobgye (a relative of Jigme Namgyel), and replaced him with Kawang Mangkhel. Jigme Namgyel came to Thimphu with a small troop, but the monk-body intervened and an agreement was reached, after which Jigme Namgyel

went back to Bumthang. However, the conflict inevitably flared up again, and in 1867 Jigme Namgyel came back to Wangdi Phodrang with the Tongsa Pönlop Dungkar Gyeltshen. Negotiating began with Darlung Tobgye, but then Darlung Tobgye was assassinated.

As no strong Desi was emerging from these endless personal conflicts for power, a consensus was reached, and Jigme Namgyel was asked to become the 50th Desi. He was enthroned in 1870, at the age of forty-six. He immediately started repairing Thimphu Dzong, which had been damaged by a fire.

In 1872, Jigme Namgyel faced a rebellion by the Paro Pönlop Tshewang Norbu. Tshewang Norbu finally surrendered after a mediation, and was even permitted to keep his post. The Thimphu Dzongpön Kawang Mangkhel who seemed to be playing a double game, was killed.

In 1873, trouble started brewing in Bumthang between Jigme Namgyel's brother Dungkar Gyeltshen, who had been appointed Tongsa Pönlop in 1866, and the Jakar Pönlop Pema Tenzin, the son of the Tamshing Chöje Ugyen Phuntsho and Jigme Namgyel's brother-in-law. The reason was that Dungkar Gyeltshen was supposed to turn over the post of Tongsa Pönlop to Pema Tenzin after three years but had not done so, much to the ire of Pema Tenzin.

Jigme Namgyel retired in 1873. He appointed his relative, Kyitshelpa Dorje Namgyel, who had served him faithfully for many years, as the 51st Desi. However Jigme Namgyel retained a lot of power which probably fuelled what appears to have been a general rebellion in the western region that same year. The Punakha Dzongpön Nedup and his relative the Paro Pönlop Tshewang Norbu rebelled against the new Desi and Jigme Namgyel: they killed Jigme Namgyel's representative in Paro. Jigme Namgyel, his son Ugyen Wangchuck, his foster-son Phuntsho Dorje, the Desi Kyitshelpa, and Lam Tshewang went to Paro where they captured the Ta Dzong and established a garrison. In the meantime, the Wangdi Phodrang Drönyer assassinated the Wangdi Phodrang Dzongpön Kawang Sangye who had long been associated with Jigme Namgyel, and took over the post himself. As for the Punakha Dzongpön Nedup, he appointed the Chogle Trulku Yeshe Nedup as the Desi. Moreover, Jigme Namgyel's brother and former ally, the Tongsa Pönlop Dungkar Gyeltshen, also decided to side with the rebellion and sent troops to Punakha.

Jigme Namgyel understood then that the situation in Thimphu and Punakha was more serious than in Paro, and he rushed to Punakha with Lam Tshewang, leaving Ugyen Wangchuck and Phuntsho Dorje to look after the Ta Dzong. Learning this, the ex-Punakha Dzongpön Damchö Rinchen who had earlier been defeated by Jigme Namgyel, saw an opportunity for revenge. He went to Paro and, saying that he wanted to meet with his nephew Phuntsho Dorje, he entered the *dzong* and captured both Ugyen Wangchuck and Phuntsho Dorje. Hearing this news, Jigme Namgyel took Damchö Rinchen's family hostage and imprisoned them in Mendegang. He then asked Damchö Rinchen to choose between the life of Ugyen Wangchuck and the lives of his whole family. Damchö Rinchen immediately released Ugyen Wangchuck and Phuntsho Dorje, so his family could be set free.

In the meantime, the Desi Kyitshelpa managed to capture the water-supply tower of Paro Dzong. The *dzong* surrendered and the Paro Pönlop Tshewang Norbu fled to India. The Punakha Dzongpön realized that Jigme Namgyel's forces were very strong, and he too finally fled to India, while the Chogle Trulku took refuge in the Talo monastery. Jigme Namgyel reconquered Punakha Dzong and then proceeded to Wangdi Phodrang Dzong which he surrounded. The *dzongpön*, Adruk, wanted to burn down the *dzong* but, because of the crafty intervention of the Yangpe Lopön Sangye Dorje, he was captured and killed. The rebellion was finally suppressed and Jigme Namgyel emerged victorious and more powerful than ever. In order to consolidate his political position, he called his elder son Trinle Tobgye, who was studying at Lhalung monastery in Tibet, and appointed him Wangdi Phodrang Dzongpön. His second son, Ugyen Wangchuck, was appointed Paro Pönlop; Phuntsho Dorje, whom Jigme Namgyel always considered his son, became 'state chief of protocol' (*zhung drönyer*); Lam Tshewang, who was Kawang Mangkhel's brother, became Thimphu Dzongpön. Jigme Namgyel himself retired to Simtokha but he had *de facto* control over Bhutan.

In 1879 his loyal relative, the Desi Kyitshelpa, died. The new Desi Chögyel Zangpo had long been associated with Jigme Namgyel. When Chögyel Zangpo's uncle, the 44th Desi Uma Dewa, was assassinated, Chögyel Zangpo and his brother Kawang Sangye had killed the murderer and taken refuge with Jigme Namgyel, then Tongsa Pönlop. When the latter became Desi, he appointed Kawang Sangye as Wangdi Phodrang Dzongpön. Chögyel Zangpo was appointed as *zhung drönyer*; Jigme Namgyel was also the force behind his nomination, later, as Desi. The 52nd Desi died only two years later in 1881, and so did Jigme Namgyel. He fell from a yak at Hongtso near Dochula and died at Simtokha.

On his death bed, Jigme Namgyel called Trinle Tobgye, Ugyen Wangchuck, Phuntsho Dorje and Aloo Dorje (Lam Tshewang's nephew and adopted son, his father Kawang Mangkhel having been killed by Jigme Namgyel). He told them that they were all his sons and that they should help each other and always remain friends without fighting.

THE WAY TO THE MONARCHY

Ugyen Wangchuck (1862–1926), the first king of Bhutan

The consolidation of Jigme Namgyel's work
Ugyen Wangchuck was born in 1862 at the Wangduchöling Palace in Bumthang. His mother was Pema Chökyi, the daughter of the former Tongsa Pönlop, the Tamshing Chöje Ugyen Phuntsho. When he was nine years old, his father put him to work with the servants and had his attendants (*chankhap*) train him in rules and etiquette. When Ugyen Wangchuck was fifteen, Jigme Namgyel took him everywhere with him; he appointed him Paro Pönlop when he was seventeen. Ugyen Wangchuck was only the second son, but it was evident that he was being groomed to succeed his father as his elder brother Trinle Tobgye was originally destined to be a monk in Lhalung monastery in Tibet. In 1882, after the death of his father and of the 52nd Desi, Ugyen Wangchuck appointed Lam Tshewang (who had served his father) as 53rd Desi. Only two years later, in 1884, Lam Tshewang passed away.

In 1882, Ugyen Wangchuck had also to deal with the chronic conflict between his paternal uncle, the Tongsa Pönlop Dungkar Gyeltshen, and his maternal uncle, the Jakar Pönlop Pema Tenzin. Pema Tenzin wanted to become the Tongsa Pönlop and requested the help of Sengye Namgyel from Punakha, promising him the post of Tongsa Drönyer if they succeeded. They won but when Pema Tenzin became the Tongsa Pönlop, instead of keeping his promise to Sengye Namgyel, he gave the post of Tongsa Drönyer to his young brother-in-law. Sengye Namgyel was furious, assassinated Pema Tenzin and became Tongsa Pönlop. Pema Tenzin's sister, Pema Chökyi, requested her son Ugyen Wangchuck to avenge his uncle's death. Sengye Namgyel was killed during a meeting in the Jakar Dzong, and Ugyen Wangchuck replaced him as Tongsa Pönlop. His brother Trinle Tobgye was installed at the same time as Wangdi Phodrang Dzongpön and Paro

Pönlop, but he died prematurely after falling from his horse on the Paro Dzong bridge in 1883. To replace him, Ugyen Wangchuck appointed his cousin Dawa Penjor as Paro Pönlop. He also appointed his first cousin Chime Dorje, Pema Tenzin's son, as Jakar Dzongpön. Jakar thus became the seat of a *dzongpön* once again; the post of *pönlop* was abolished there. Moreover, to strengthen his alliance, Ugyen Wangchuck married Chime Dorje's sister, Rinchen Pemo, and gave his own sister, Dechen Chöden, to Chime Dorje. Then, after the death of his mother in 1884, he offered them the estate of Wangduchöling. The same year, in accord with his father's testament, Ugyen Wangchuck appointed Phuntsho Dorje as Punakha Dzongpön and Aloo Dorje as Thimphu Dzongpön. All these appointments suggest that Jigme Namgyel's power fell quite naturally into the hands of his son Ugyen Wangchuck. However, Ugyen Wangchuck's political stature was in the way of the personal ambitions of many of his contemporaries, and a strong opposition to him rapidly emerged.

In a first gesture of rebellion against him, just a few months after their appointment, Phuntsho Dorje and Aloo Dorje appointed Gawa Zangpo as the 54th Desi. Then, they planned to assassinate Ugyen Wangchuck. They sent a letter with some money to the Tongsa Drönyer, asking him to kill Ugyen Wangchuck. At the same time they sent a nice letter and a gift to Ugyen Wangchuck himself. Cleverly, the Tongsa Drönyer simply presented both letters to Ugyen Wangchuck who felt betrayed by his two former friends and became very angry. However he decided to try to settle the situation peacefully, and requested the two *dzongpöns* to come and meet him in the Shar region. They agreed to do so. When Ugyen Wangchuck reached the place, however, he found no one there, nor any message; this was very insulting. Ugyen Wangchuck realized that the two *dzongpöns* were intent on war, so he went back to Bumthang to prepare his troops.

In February 1885, he marched towards Punakha with some 2,000 men. The Paro Pönlop Dawa Penjor and the Wangdi Phodrang Dzongpön accompanied by the Je Khenpo and the four *lopöns* met him to settle the issue peacefully, but Ugyen Wangchuck was too upset and refused to negotiate. As for the Desi Gawa Zangpo, who had been nominated by Aloo Dorje and Phuntsho Dorje, he did not do anything to help his mentors.

In the meantime, Ugyen Wangchuck advanced up to Mendegang where the first indecisive battle took place. Then, the Punakha Dzongpön Phuntsho Dorje's men were defeated in Bjiligang and the *dzongpön* fled to Thimphu. When Ugyen

Wangchuck arrived at Simtokha, he overpowered the small party guarding it and occupied the *dzong*. A battle took place at Lungtenphu and, when the strongest men of the Thimphu Dzongpön's party were killed, his troop fled. Once more, the Je Khenpo proposed arbitration and this time both parties agreed to it. Ugyen Wangchuck's representative was the Paro Pönlop Dawa Penjor and Aloo Dorje's was the Punakha Dzongpön Phuntsho Dorje. They met at Changlimithang in Thimphu and had a meal together, but then a quarrel arose and, in the ensuing fight, thereafter called the battle of Changlimithang, Phuntsho Dorje was killed by Dawa Penjor.

At this point Aloo Dorje and his party decided to abandon Thimphu Dzong and flee to Tibet. There they requested military help, but the Tibetans and Chinese preferred to settle the question peacefully instead. A conference was held in 1886 at Galing in the Chumbi valley but produced no results.

After the battle of Changlimithang, Ugyen Wangchuck took over Thimphu Dzong and requested the Desi Gawa Zangpo to resign. In 1886, he appointed the Yangpe Lopön Sangye Dorje as the 55th Desi. Lopön Sangye Dorje had been very helpful to his father Jigme Namgyel during the revolt of the Wangdi Phodrang Dzongpön Adruk in 1873. He would serve as Desi for eighteen years, one of the longest and most peaceful tenures of all the Desis. Ugyen Wangchuck, in addition to being Tongsa Pönlop, became *gongzim*, and nominated his cousin Kunzang Trinle, the son of his paternal uncle Dungkar Gyeltshen, as the Thimphu Dzongpön.

The year 1885 is a turning point in the history of Bhutan. It marks the beginning of the first years of internal peace Bhutan had known since the end of the seventeenth century. The peace must be credited to Ugyen Wangchuck who, after his father's death, managed not only to remain the strongman of Bhutan, but also to emerge slowly as the undisputed leader of the country. His political achievement can probably be attributed to two main factors. First he developed a strong network of allies, some inherited from his father; many were his relatives, appointed to key posts and supporting him. Second he also had a superior and dedicated military force which allowed him to crush rebellions and intimidate potential enemies.

The way to the throne

In 1890, Kunzang Tenpe Nyima, Ugyen Wangchuck's maternal uncle and the 8th incarnation of Pema Lingpa, died in his monastery of Lhalung in Tibet. Ugyen Wangchuck went there for the funeral ceremony. There, he received a prophecy from both Khyentse Rinpoche and Kongtrul Rinpoche: he was to make a huge statue of Guru Rinpoche at the Kuje temple in Bumthang. This statue would guarantee the prosperity and stability of Bhutan. Ugyen Wangchuck had the statue built; it was consecrated in 1894.

Ugyen Wangchuck's wife was Ashi Rinchen Pemo, the daughter of his maternal uncle Pema Tenzin, and sister of the Jakar Dzongpön Chime Dorje. They had two daughters known as the 'Pelri Ashis' or 'Lame Gompa Ashis', but no son. In 1900, Ashi Rinchen Pemo died near Kunga Rabten in the Tongsa region.

In 1897, Ugyen Wangchuck met Kazi Ugyen Dorje, a Bhutanese living in Kalimpong who became increasingly important and advised Ugyen Wangchuck on international policy matters. In fact they were related as their grandfathers had been brothers. Ugyen Wangchuck called him to Bumthang and started to work with him. His first task was to go to Tibet to mediate with Aloo Dorje who had been trying to persuade the Tibetan regent and Chinese representative in Lhasa to help him regain power in Bhutan. Finally in 1898, as a result of Ugyen Dorje's efforts, a representative of the Tibetan government and two Chinese came to Phari in the Chumbi valley where they signed an agreement with the Bhutanese government representatives, the Paro Pönlop Dawa Penjor and the Zhung Drönyer. The regions under the jurisdiction of Ha Dzong, Gasa Dzong and Lingshi Dzong were to be given to Aloo Dorje to administer until his death. Aloo Dorje, who was settled in the Chumbi valley, apparently died not long after. His family was allowed back to their private estates in Bhutan but Ha, Gasa and Lingshi regions returned to the government complying with the agreement.

In 1900 Ugyen Wangchuck, who felt that he needed someone reliable to look after the southern regions, appointed Kazi Ugyen Dorje as 'border commissioner' (*gyadrung*), also known to the British as 'the Bhutanese Agent'. Kazi Ugyen Dorje had been living in Kalimpong, knew Indian languages, and had many contacts. In the royal command, it was written that he was the Bhutanese representative from Amartala in the east to Daga in the west. He was to make sure that taxes were paid to the Tongsa Pönlop. Although the order was signed jointly

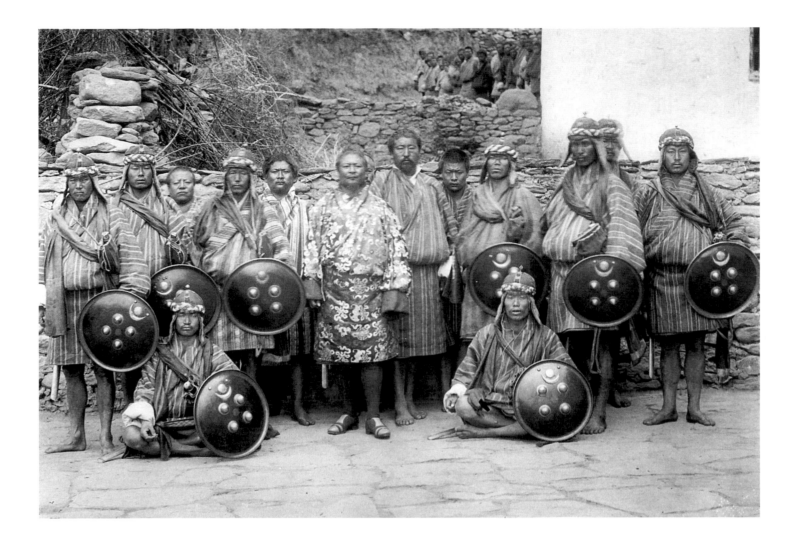

Ugyen Wangchuck, the Tongsa Pönlop and future first king of Bhutan, is seen here with his bodyguards and, on his left, with Ugyen Dorje, his confidant and representative in Kalimpong, at Tongsa in 1905. (Photo: John Claude White, private coll.)

by the Tongsa Pönlop, the Shabdrung, the Desi and the Wangdi Phodrang Dzongpön, it stipulated that if the representative did not do well the order of appointment would be withdrawn by the Tongsa Pönlop. This proved once more that real power resided with Ugyen Wangchuck.

In 1904, the British decided to send an armed expedition to Tibet as they wanted to expand their trade and influence there. They would force their way to Lhasa via the Chumbi valley. When rumours of the expedition reached Kalimpong, Ugyen Dorje's father, Sharpa Punchung, aware of the British military strength, advised the Tibetan government to settle the problems through negotiations. In 1901 the British had sent Kazi Ugyen Dorje to Lhasa with a letter from the Viceroy to the Dalai Lama but the letter had come back unopened. It was clear that the Tibetans did not want conciliatory advice. Instead they requested the backing of the Paro Pönlop Dawa Penjor who agreed to deploy soldiers on his border with the Chumbi valley.

Ugyen Wangchuck had already assessed the power of the British. In 1888–89, when the Tibetans occupied a small strip of land in Sikkim, Ugyen Wangchuck made sure that no assistance was given to them; the Tibetans were subsequently expelled by the British. Later, in 1903, he was invited to meet Colonel Younghusband to discuss the Tibeto-British situation. He decided to play his cards very carefully and instead of going himself, he sent his cousin the Thimphu Dzongpön Kunzang Trinle. There were many reasons for his choice.

He was very wary of giving the British the impression he was siding with them. For historical reasons, Tibet was still the country with which the Bhutanese had most ties. Moreover, Ugyen Wangchuck had just managed to bring about internal peace in Bhutan, and he knew that the Chinese stationed in Lhasa supported the Paro Pönlop and had sent him a seal in 1891. Kunzang Trinle received a very warm welcome, and it seems that this led Ugyen Wangchuck to propose his help to the British in their negotiations with the Tibetans in June 1904. However by that time the military mission to Lhasa had been decided upon so the British requested him to accompany them and try to convince the Tibetans that it was useless to fight.[9]

The central monk-body and the members of the government were strongly opposed to the idea of letting the Tongsa Pönlop go to Lhasa. They thought it was too dangerous. Nevertheless, Ugyen Wangchuck decided to go and act as a mediator. He therefore joined the British mission headed by Colonel Younghusband at New Chumbi in Tibet. From the start, he got on well with Younghusband, who said that the Tongsa Pönlop was "straight and possessed of a natural authority".[10] Even though Ugyen Wangchuck was there to mediate, naturally it was difficult for the Tibetans to consider him as totally impartial; nevertheless they respected him and preferred to deal with him first.

The British mission really valued his services. The party reached Lhasa in August 1904 after two battles in which the Tibetans were roundly defeated. The 13th Dalai Lama fled and the British had to deal with the Regent and the Assembly. A new treaty, humiliating for the Tibetans, was finally signed at the Potala palace on 7 September 1904, after much wavering on the Tibetan side. This was largely due to the constant efforts of three people: the Chinese representative in Lhasa, the Nepalese representative Jit Bahadur, and the Tongsa Pönlop Ugyen Wangchuck.

In 1903, Ugyen Wangchuck had remarried, taking as his wife Ashi Lemo, a wealthy woman from Khoma village in Kurtö. Two years later they had a son, Jigme Wangchuck, the future second king. That same year, in recognition for his services during the British expedition, the British presented him with the insignia KCIE (Knight Commander of the Indian Empire). John Claude White came to Bhutan to present the decoration to Ugyen Wangchuck, whom he already knew, and received a warm welcome from him. In 1903, White had taken the post of Political Officer for Sikkim and Bhutan and accompanied the British expedition, during which he had enjoyed the company of the Tongsa Pönlop. Kazi Ugyen Dorje was also awarded the title of 'Raja' in recognition of his services. Later he was appointed 'Ha Drungpa', administrator of the Ha region, by Ugyen Wangchuck.

After his trip to Bhutan, White suggested that Ugyen Wangchuck should attend the ceremony held by the Prince of Wales in Calcutta in 1906. Kazi Ugyen Dorje and a party of Bhutanese officials accompanied Ugyen Wangchuck to Calcutta. After the ceremony, the Sikkimese and Bhutanese officials were invited to tour India. Ugyen Wangchuck showed great interest during all these visits.

The coronation: 17 December 1907

From 1885 Bhutan enjoyed internal peace and stability. In 1903, the Desi Sangye Dorje passed away after being on the throne for eighteen years. The Chogle Trulku (the reincarnation of the Speech of the Shabdrung) Yeshe Nedup became the 56th Desi. When he retired in Paro in 1905, no new Desi was nominated. The Shabdrung Jigme Chögyel had died in 1904, and a new Shabdrung had not yet been recognized. It might have been this political vacuum which prompted Kazi Ugyen Dorje, most probably with the agreement of Ugyen Wangchuck, to write a petition to the State Council asking him to consider making Ugyen Wangchuck the king of Bhutan.

This petition was discussed and it was unanimously decided to elect Ugyen Wangchuck as the King of Bhutan, and to make the title hereditary. A grand ceremony was prepared and took place in Punakha Dzong on 17 December 1907.

With utmost respect: There has been no hereditary king in our country of Bhutan, and the Desis have been elected from among the Pönlops of the different regions, counsellors, Je Khenpos and Lopöns of the Central State Monastery. Now we, the Je Khenpo, Lopöns, and the whole monk-body, the State Counsellors, the Pönlops of the different districts with all the subjects have discussed and unanimously arrived at the unchanging and ever-lasting contract as follows.

We the above mentioned, all having discussed and agreed, elect the Tongsa Pönlop Ugyen Wangchuck, Governor-General of Bhutan, hereditary King of Bhutan, in the Palace of the Great Bliss in Punakha which is the second Potala, on this auspicious day which is the 13th day of the eleventh month of the Fire-Sheep year of the 15th Rabjung cycle, which corresponds to the 17th of December 1907 AD.

We now declare our allegiance to the King installed on the Golden Throne and his heirs, and undertake to serve him and his heirs. Should anyone have any bad intention or second thoughts, and not abide by this contract by saying this and that, he shall be expelled from our company. In witness thereof, we affix our seals.

Two copies of the document were prepared, signed and sealed. The British mission present at the ceremony was composed of John Claude White, the old friend of Ugyen Wangchuck, and other British officers (Major Rennick, Captain Campbell and Captain Hyslop), accompanied by twenty-five men of the 62nd Punjabis.

After the signing of the oath of allegiance, John Claude White presented the new king with the Viceroy's document which recognized him as the official ruler of the country. White was extremely pleased with the coronation, not only because Ugyen Wangchuck was a friend, but also for political reasons. In his congratulatory speech he said: "I have known Bhutan for many years; and with an intimate knowledge of the political questions relating thereto, I am convinced you have taken a wise step in thus consolidating the administration of the state. Ugyen has been my friend for many years and you could not have made a better choice. His integrity, uprightness and firmness of character commend him to everyone and his accession to Maharajaship is not only a gain to Bhutan but also is of great advantage to the British government which will henceforth have a settled government with a man of strong character to negotiate with." [11]

It is entirely to the credit of Ugyen Wangchuck to have understood the power of the British; he not only became their friend, but also gained their respect.

The King

After the coronation, in April 1908 King Ugyen Wangchuck decided to reward Kazi Ugyen Dorje for his services. Thus he appointed him Chief Chamberlain (*gongzim*), the post closest to head of state, and made this position hereditary.

In the early years of the twentieth century, the first Nepali immigrants arrived in Bhutan as labourers for the logging activities. Some came via Darjeeling and Sikkim where they were employed by the British in the tea gardens, while others came directly from Nepal. The lowlands of Bhutan were very fertile but unhealthy and the Bhutanese, used to living at higher altitudes, would not go and settle there.

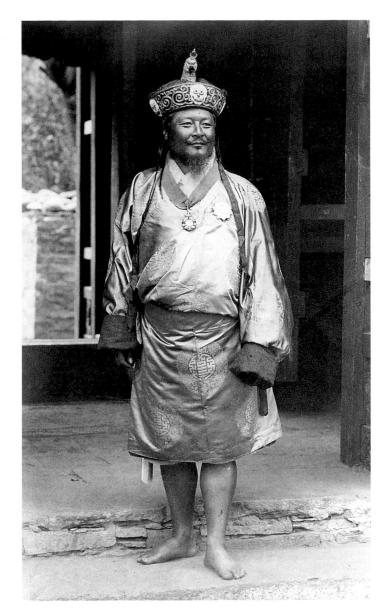

King Ugyen Wangchuck on the occasion of his presentation with the order of Knight Commander of the Indian Empire (KCIE) at Punakha in 1905 in recognition of his services in negotiating a settlement between the British and the Tibetans following the Younghusband Expedition of 1904. (Photo: John Claude White, private coll.)

Sometime in 1908 or 1909 – sources are not available – the 6th reincarnation of the Shabdrung Thugtrul was recognized in the village of Dagpo Domkhara in Arunachal Pradesh. The boy was called Jigme Dorje and had been born in 1905 of Bhutanese parents who had migrated to the other side of the border. He was to be the last official incarnation of the Shabdrung.

In 1907, the British had proposed a new treaty to replace the old treaty of Sinchula, but it was not finalized until the end of 1909. The signature took place on 8 January 1910, at

Punakha. The annual British contribution went from Rs. 50,000 to Rs. 100,000, and Bhutan was to be guided in its external affairs by the advice of the British government in India. The British were not to interfere, however, in internal matters. No British resident was to be stationed in Bhutan; the Political Officer resident in Sikkim would interact with Bhutan on behalf of the British.

In December 1911, on the invitation of the Viceroy, King Ugyen Wangchuck accompanied by Gongzim Ugyen Dorje, went to Delhi to meet with the King-Emperor George V who was presiding over a coronation ceremony. The visit to India was of great interest for the two men, and gave King Ugyen Wangchuck further exposure to the international world as well as to ideas for development in Bhutan.

He particularly appreciated the importance of western education and decided to start schools in Bhutan. One was set up in Ha and one in Kalimpong, and in 1914 the first forty-six Bhutanese students were enrolled. Gongzim Ugyen Dorje supervised the education and welfare of the children. In Bumthang the king also started a small school for the crown prince Jigme Wangchuck and some of his attendants.

Around 1915, as a mark of friendship and confidence, the king appointed Sonam Tobgye, Gongzim Ugyen Dorje's son, as Ha Drungpa. In 1916, Gongzim Ugyen Dorje passed away and King Ugyen Wangchuck felt deeply the loss of his friend and advisor. In 1917, he appointed the Ha Drungpa Sonam Tobgye Dorje as *gongzim* but as Sonam Tobgye was still young, his tutor was Wangmo, the late Kazi Ugyen Dorje's sister.

In the last ten years of his reign, the king concentrated on the welfare of his country. Internal trouble disappeared. The Paro Pönlop Dawa Penjor was being drawn more and more to the British side. When the Paro Pönlop died in 1918, the king appointed Tshering Penjor, the son of his daughter Pedön, as Paro Pönlop.

The king's second wife, Ashi Lemo, died in 1922. Besides Crown Prince Jigme Wangchuck, born in 1905, the royal couple had three other children: Dasho Gyurme Dorje born in 1912, Ashi Koncho Wangmo born in 1915, and Dasho Naku born in 1918.

King Ugyen Wangchuck was very religious. He patronized many monasteries and temples in Bhutan as well as Tibet. He also contributed to the restoration of the stupa of Swayambunath in Nepal. He spent the last years of his life in central Bhutan and died in August 1926, giving orders to be cremated at Kuje Lhakhang.

THE CONSOLIDATION OF THE MONARCHY

The second king, Jigme Wangchuck (1905–52)

When Jigme Wangchuck became the king of Bhutan in 1926, he was twenty-one, only two years older than the monarchy itself. He had been groomed by his father to become king, but had also served him along with other attendants. He had received a strict, traditional education in Buddhism but also in English and Hindi.

In 1922, he was appointed Tongsa Drönyer and then married his cousin, Ashi Phuntsho Chöden of Wangduchöling. In 1923, he became Tongsa Pönlop and official heir to the throne. In 1928, she bore him a son, Jigme Dorje Wangchuck, who would become the third king.

Jigme Wangchuck was crowned in Punakha on 14 March 1927, but the beginning of his reign was not without trouble. His father, King Ugyen Wangchuck, had already expressed some concern regarding the smooth transition of power to his son but the enthronement went well in presence of the Shabdrung Jigme Dorje and the Paro Pönlop prostrated three times in front of the king. In fact, trouble came not from the Paro Pönlop but from the family of the Shabdrung who wanted him to vie with the king in temporal matters. When the Shabdrung issued an edict concerning grazing rights in favour of Tibetan subjects, the king was not pleased and slanders were exchanged. Matters came to a head in 1931 with the Shabdrung's brother's trip in India where he is alleged to have sought Gandhi's help in restoring the Shabdrung's temporal powers. Shortly afterwards, in November 1931, the Shabdrung died in Talo monastery.

After this troubled early period, Jigme Wangchuck's reign was marked by stability and reorganization inside the country. In 1932, the king took his wife's sister Ashi Pema Dechen as his second consort and she gave him four children, a son and three daughters. As both his wives were religious, the king spent time attending rituals, restoring temples, inviting high lamas from Tibet for teachings, as well as sending pupils to Tibet for monastic studies.

The king had a firm hand on all matters of the kingdom. In winter he would shift from Wangduchöling in Bumthang to Kunga Rabten Palace in Tongsa, which he built in 1928. With him he had a handful of trusted men who could man-

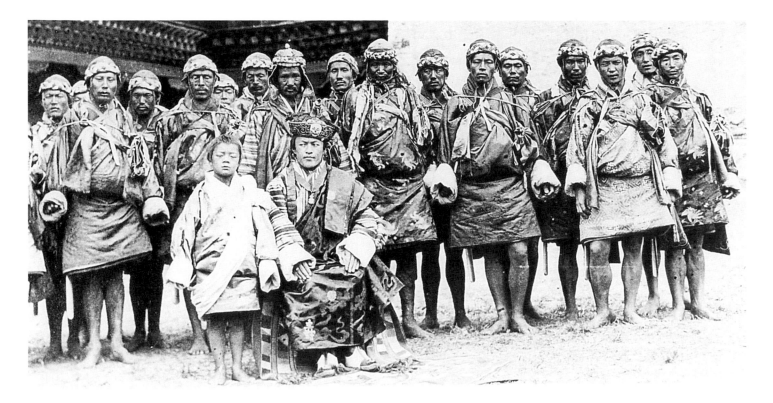

Above: Coronation photograph of the second king, Jigme Wang-chuck at Punakha in 1927. (Photo: F.M. Bailey, The British Library)
Below: The king aged twenty-eight wearing the Raven Crown at Bumthang in July 1933. (Photo: G. Sherriff, Museum of Mankind)

age the kingdom and kept impressive and accurate archives regarding political and financial matters such as taxes. The court comprised around two hundred people who moved with the king, and who were paid in kind according to their rank. They served the king until they died when, often, a son took over the charge of his father.

One of Jigme Wangchuck's first tasks was to reform and centralize the administrative system; the lack of centralization had caused much strife in the previous century. He set up a direct line of authority over which he had absolute control; all power, religious and temporal, was in his hands. The king appointed the Je Khenpo on the suggestion of the central monk-body. A central cabinet with four officials was to assist him: the 'state minister' (*zhung kalön*), the 'chief of protocol' (*zhung drönyer*), the 'chamberlain' (*zhung gongzim*) and, depending on the season, the Thimphu or Punakha Dzongpön. The chamberlain resided mostly in Kalimpong and was a kind of Political Agent or ambassador dealing with the British.

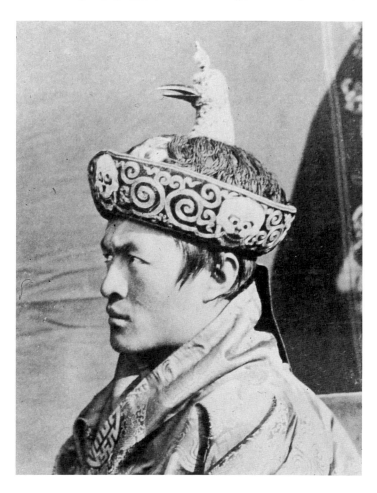

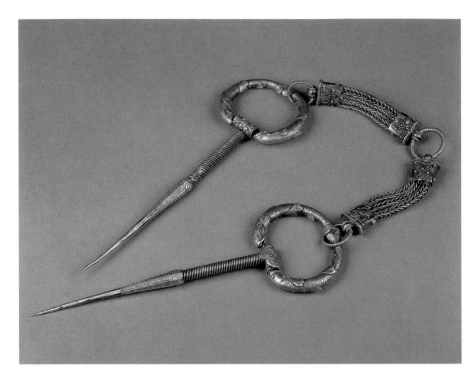

Silver fibulas called tinkhab, of royal family provenance. Made of solid silver, they were to fasten the ladies' dress (kira) at the shoulders but could also, if necessary, be used as effective weapons. They are replaced today by silver buckles (koma). (E.L.)

The queens of the first and second kings wore finely woven cotton and silk dresses called kushüthara which originated from the royal homelands of Kurtö. Jackets made of Chinese brocade and embroidered woollen pillbox hats completed the queens' outfits. (E.L.)

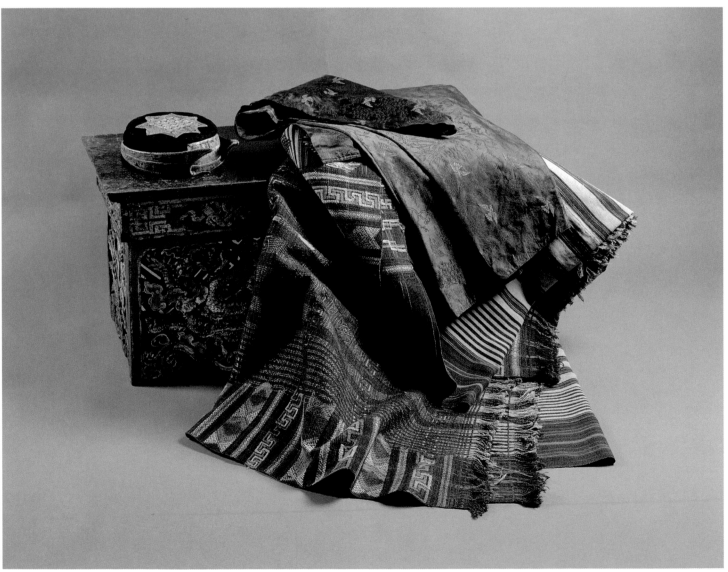

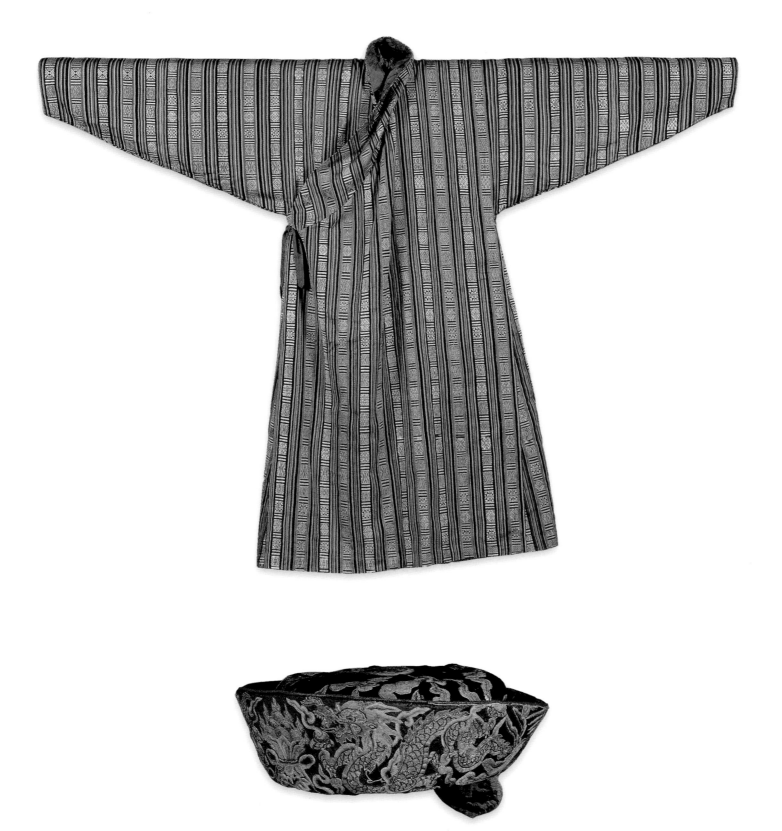

Above: Robe of the second king in menzimathra (silk patterning on a red ground), given to one of his attendants. Below: Hat of the nobilty from Kurtö embroidered in silk and gold thread, worn on ceremonial occasions. (E.L.)

The king also made all other high official appointments, and officials were required to deal with him directly. He abolished the post of Dagana Pönlop, reduced the powers of the Punakha, Thimphu and Wangdi Phodrang Dzongpöns, and himself appointed such officials as *zimpön* and *drönyer* who served under the *dzongpöns*, thus effectively cutting down their influence. Moreover, as the other *dzongpöns* died, their posts were not filled and gradually the regions came under the king's control (e.g. Paro, whose *pönlop* died in 1949).

This trimming down of the administration served three purposes: one was to keep tight control on a limited number of officers to avoid insurrection, the second was to have a responsible and accountable administrative cadre, and the third was to reduce the tax burden because the greater the number of officials, the heavier was the burden of taxes on ordinary people.

Taxes were paid mostly in kind, including labour, and each household had a record in the official account books kept by a high official called the *nyerchen*. The king paid great attention to this record. The taxes were not the same for all districts; some districts such as Bumthang and Kurtö were heavily taxed. There were a firewood tax, a labour tax, a land tax, a transportation tax, a grass fodder tax for animals, a cloth tax for eastern Bhutan, a butter tax based on the number of cows a family owned, and even a soot tax for making ink in the *dzong*. The king tried to establish a more equitable system by abolishing some of the taxes. He reduced the number of officials, thereby alleviating the amount of taxes for the people. He also gave to landless people lands made vacant by the death of their owners, though the taxes still had to be paid by the community. One form of tax was the military service by which peasants had to leave their farms to go and fight for a particular faction. The king established the first military detachment, thus paving the way for a regular army.

In the domain of education children were selected and sent to the modern schools in Kalimpong and Darjeeling in India. A few schools were also opened in Bhutan itself, especially in Bumthang, and the Ha school continued under the supervision of Gongzim Sonam Tobgye Dorje who also looked after the children sent to India.

Bhutan did not get involved in the Second World War but made a small contribution to the British, and also closely followed the evolution of politics in India. Good relations were maintained with British India, especially through the activities of Gongzim Sonam Tobgye Dorje. In 1935, the king and the royal family went on a trip to India at the invitation

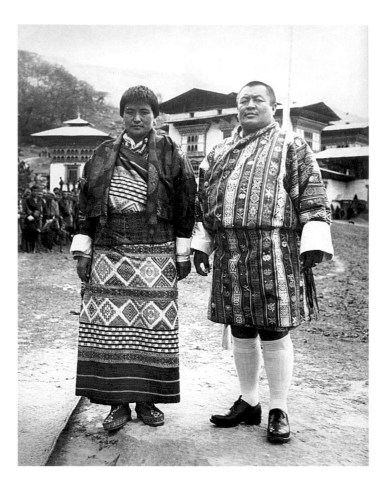

King Jigme Wangchuck with Queen Phuntsho Chöden, the elder of the two sisters whom he married and who is still alive today, at Kunga Rabten Palace south of Tongsa Dzong in 1949 where he died three years later. (Photo: G. Sherriff, Royal Botanic Gardens, Edinburgh.)

of the British Government. The king was extremely concerned about the international status of Bhutan which was ambiguous in the eyes of the British. In 1947, Bhutan participated in the conference of Asian Relations held in Delhi. When India became independent that same year, many semi-independent states were incorporated in the Indian Union but Bhutan retained its independence as a sovereign state. In 1948, a Bhutanese delegation went to India to discuss the future relations of Bhutan and India. The discussions led to the Treaty of 8 August 1949, which founded the relations of friendship and assistance between Bhutan and India. The territory around Deothang (Dewangiri) in southeast Bhutan was given back to Bhutan, and the annual subsidy from India increased from Rs. 100,000 to Rs. 500,000.

However, as early as 1948, conscious of Bhutan's vulnerability, the king started to look into the possibility of becoming a member of the United Nations. The admission of Bhutan to the UN would have to wait until 1971.

When the king died in 1952, he left to his heir a stable, unified and independent country where reforms were gradually taking place. With such firm foundations, it was to be the task of the third king, Jigme Dorje Wangchuck, to open Bhutan to the world and launch it on the path of development.

The third king, Jigme Dorje Wangchuck (1928–72): The father of modern Bhutan

Like his father before him, Jigme Dorje Wangchuck was groomed to become king from an early age. Born in Tongsa in 1928, he was educated with other children in Buddhist studies, English and Hindi but he was also taught the etiquette of the court and the administration of the country. His father, the king, appeared to have been a strict disciplinarian and the young prince was not spared punishment.

He was appointed Tongsa Drönyer at fifteen, but the king thought that in the fast-changing world, the heir had to broaden his view and see the West. Soon after his appointment, therefore, the prince was sent to England for six months to complete his education and gain knowledge. On his return, he worked as attendant to his father and was therefore well prepared to take over the kingdom when his father died in 1952. Before his father's death, he married Ashi Kesang, the daughter of Gongzim Sonam Tobgye Dorje. Five children were born from this union, four girls and a boy, Jigme Singye Wangchuck who was the crown prince.

The queen's brother, Jigme Palden Dorje, inherited the office of Gongzim from his father, who also died in 1952. He was a friend of the new king. Like their fathers and grandfathers before them, the two young men were bound by friendship, but also had a vision for Bhutan. The king made Jigme Palden Dorje his Prime Minister (lönchen), and they worked in close association until the assassination of Jigme Palden Dorje in 1964. His death was deeply mourned by the king who had lost a trusted advisor, friend and brother-in-law.

Like his forefathers, the new king was determined to preserve the independence of his country. He knew that without strong international links, his country could be in danger and that self-imposed isolation had to end. Throughout his life, he steered his activities in three directions: recognition of Bhutan on the international scene, development of its infrastructures, and socio-economic and constitutional reforms.

In 1962, Bhutan joined the Colombo Plan, an organization for the development of Southeast Asian countries, and

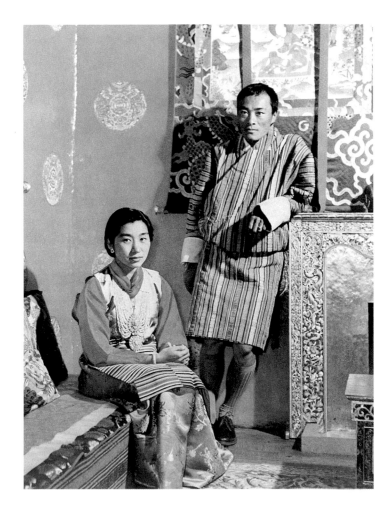

King Jigme Dorje Wangchuck with Queen Kesang Chödrön Dorje at the palace in Thimphu, 1957. (A.H.)

it received technical assistance as well as equipment and scholarships. In 1969, Bhutan became a member of the International Postal Union, and started to print stamps which were highly valued by collectors; for a long time the sale of stamps abroad was one of the country's most important sources of foreign exchange. Finally in 1971, Bhutan became a member of the United Nations, and opened missions which functioned as embassies at the UN in New York, and in New Delhi in India.

India, to which Bhutan was linked by a treaty, was to play a very important role in the development of Bhutan. In 1958, the Prime Minister Jawaharlal Nehru visited Bhutan with his daughter Indira Gandhi and, after consultation with the king, agreed to help Bhutan modernize and establish its infrastructure. India's assistance included the construction of roads, the setting up of a telecommunication system, manpower, as well as the training of an army and a police.

In 1961, development had barely touched Bhutan. Everything needed to be done. The first five-year development

plan started in 1961 and involved key sectors such as agriculture (in a country where 95% of the population were still farmers and pastoralists), forestry, health, education, power and roads. This plan was to be implemented with Indian assistance and would be followed by others that would increasingly involve the rest of the international community, especially UN agencies.

Early in his reign, the king realized that his country needed important socio-economic reforms if it was to develop. In 1956, he abolished serfdom and proceeded to a redistribution of land. The ceiling on land holdings was fixed at 25 acres, and lands above this ceiling were given to landless people who were also exempted from taxes. Government revenue from land taxes dropped but with development was replaced by other sources of income. Later, most of the land holdings of the monasteries were also redistributed, and the monks were paid a stipend by the government.

These structural changes were accompanied by important constitutional reforms. In 1953, the king established a National Assembly (*tshogdu*) with 150 members. The Assembly was to meet twice a year and discuss all kind of matters of national importance as well as enact laws. Out of the 150 members, 105 were elected representatives of the people, twelve represented the monk-body, and thirty-three were nominated representatives of the government.

In 1965, the Royal Advisory Council was constituted with nine members: six representatives of the people, two representatives of the monk-body and one nominee of the king. The council members' task is to advise the king but also to verify the implementation of the laws passed by the Assembly. They hold office for three years. A modern judiciary system with codified laws was also established and a High Court started to function in 1968 as the highest Court of Appeal. The final power of decision rested with the king.

Until this time the written language of Bhutan was Chöke, written classical Tibetan. The king felt that Bhutan should have its own written language following the national language, Dzongkha. He entrusted this task to eminent religious figures and started a school in Simtokha for the training of Dzongkha teachers.

Bhutan was in dire need of manpower. The Bhutanese educated in India were not enough to cover the immense needs of a nation. In 1963 a modern education system was started, and English became the medium of instruction.

In spite of faltering health from a relatively young age, the king was an extremely active man and he travelled extensively and often in the country to meet the people and judge by himself the progress of the projects. As the man who put Bhutan on the path of development and modernization, in Bhutan the third king is rightly known as "the father of modern Bhutan". When he died at the early age of forty-four in 1972, he left a country that had experienced tremendous changes and was on the path of development.

Although he was only seventeen, Crown Prince Jigme Singye Wangchuck immediately ascended the throne. The formal coronation took place two years later, on 2 June 1974 in the presence of dignitaries and ambassadors from all over the world.

NOTES

1 Collister (1987: 8).
2 Markham (1971: 51).
3 Aris (1982: 120). Excerpt from a letter from folio 123b of the biography of Yon tan mtha' yas (13th rJe mkhan po 1724–84).
4 sLob dpon Padma Tshe dbang. (1994: 440).
5 Collister (1987: 80).
6 Ibid., p. 114.
7 British proclamation regarding the annexation of Bengal Duars cited in Hasrat (1980: 211f).
8 Sinchula is situated east of present-day Phuntsholing.
9 Collister (1987: 138).
10 Fleming (1984: 199).
11 Collister (1987: 162).

REFERENCES

Aris, Michael. 1982. *Views of Medieval Bhutan: The Diary and Drawings of Samuel Davis, 1783*. London and Washington, D.C.: Serindia and Smithsonian Institution Press.
—— 1994. *The Raven Crown: The Origins of Buddhist Monarchy in Bhutan*. London: Serindia Publications.
Collister, Peter. 1987. *Bhutan and the British*. London: Serindia Publications.
Fleming, Peter. [1961] 1984. *Bayonets to Lhasa*. Hong Kong: Oxford University Press.
Hasrat, Bikrama Jit. 1980. *History of Bhutan*. Thimphu: Education Department.
Markham, Clements R. (ed.) [1876] 1971. *Narrative of the Mission of George Bogle to Tibet and of the Journey of Thomas Manning to Lhasa*. [London: Trübner.] Repr. New Delhi: Manjusri.
Pommaret, Françoise. 1989. *History of Bhutan (7th–20th century): A Resource Book*. Unpublished manuscript. Thimphu: Education Department.
sLob dpon Padma Tshe dbang. 1994. *'Brug gi rgyal rabs*. Thimphu.
Ura, Karma. 1995. *The Hero with the Thousand Eyes*. Thimphu: Karma Ura / Helvetas.

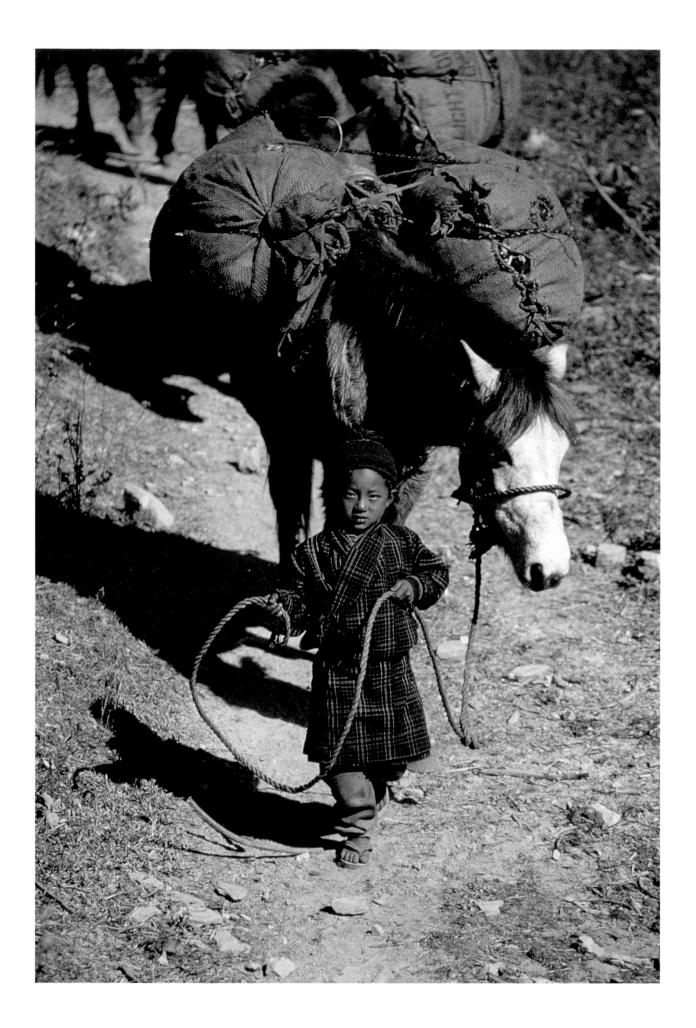

A Nation on the Move

Above: A British Aerospace 146 jet of the national airline, Druk Air, landing on a winter's day in front of Paro Dzong. (F.P. 1990) Opposite: Young boy leads his mules carrying dried chillies for the market. Much of the country is still inaccessible by road. (J.W. 1994)

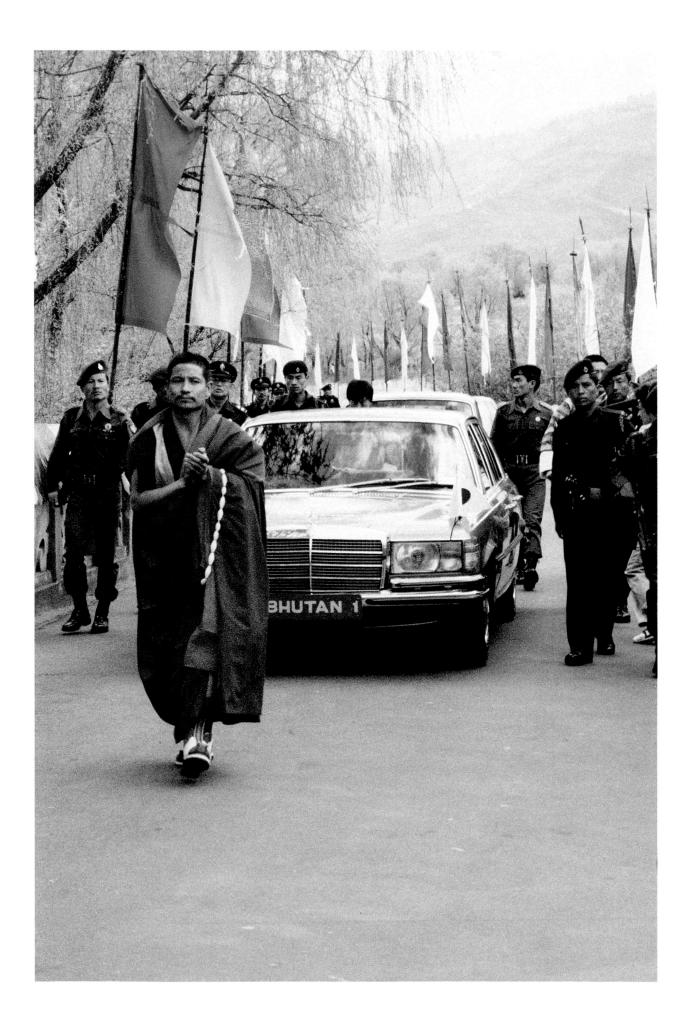

Tradition and Development

Karma Ura

INTRODUCTORY REMARKS

The impact of the West on Bhutan's material conditions and 'philosophy of life' is gradually being felt, even in the remote mountains and among the migratory cattle-herders in the deep forest. Its general influence is quite relentless and strong along the highways and in towns, and a traveller may already notice some signs of homogenization and blurred cultural identities. Imports of both artifacts and ideologies of Western origin are on the rise. Barely forty years ago, the kingdom was pervaded by a Buddhist state ideology, codes of courtly behaviour, indigenous institutions and knowledge, and non-market economies. Bhutan's closed traditional economy of agro-pastoralism, which developed as a sophisticated, sustainable and sensitive response to the fragile Himalayan ecosystem and micro-climate, is being gradually diversified and expanded, perhaps in the direction of a Buddhist welfare state.

The average Bhutanese observes the above-average living standards of the elite, and is becoming better informed about goods and services that may broaden his or her consumption. The elite are in turn aware of the greater privileges enjoyed by Europeans or Japanese. Income can hardly

Traditional etiquette requires that the motorcade bearing state guests arriving at Tashichödzong for an audience with the King are preceded by dancers and monks. (F.P. 1987)

keep up with expectation. Yet expectation is bound to escalate in the full flood of optimism that rises steadily like Bhutan's forest cover. Expectations and desires are aroused by the global flow of information, and by the national development plans which try to alleviate and meet them.

At the same time, like those who discount their own blessings and exaggerate the good life of others, the Bhutanese are liable to take for granted what they have and an average European or Japanese may lack. They have lived amidst ample space and environmental richness, with a reasonable sense of individual security ensured by a network of community members and a benevolent government. All these things provide a moderate basis for feeling happy and secure, but these boons may be too familiar to be appreciated consciously.

Individual expectations may ideally be fostered and directed to fit a lifestyle that reflects a balance between tradition and development. After nearly four decades of development experience, Bhutanese policy makers and development practitioners continue to display an intense fervour for maintaining such a balance. This contribution attempts to give an account of how and why Bhutan strives to maintain a balance between tradition and development.

However, what constitutes balance, and how to define it conceptually in order to guide practical affairs, is by no means easy to articulate. Nor can a strict criterion of what defines policy success be offered. An idea of goodness is intrinsic to the concept of balance: a balanced position conveys an impression of equilibrium and coherence, whereas one of imbalance is presumed to be unstable and

chaotic. In a dynamic social and economic situation, balance can only be maintained with assiduous effort; shifts in the ground caused by rapid modernization can periodically upset its careful cultivation.

VISION AND BALANCE

In developed and developing countries alike, economic planning was historically concerned with the stimulation and satisfaction of material needs, and associated predominantly with the creation of the material basis of 'good life'. The content and purposes of good life were to be defined by each individual. High levels of material possession and consumption have generally come to be seen as the end or purpose of development planning. By conventional definition and ranking of countries by per capita income, both are necessary conditions for a nation to be called developed. However, this notion of development planning is at odds with the vision of development for Bhutan which is not focused only on material or external development. Investing in the country's culture and traditions, and in the spiritual well-being of the individual, i.e. inner development, is also an important part of the development strategy.

In the Bhutanese cultural context, the original meaning of development differed from the conventional interpretation. It had much to do with the acquisition of education with respect to morality, intellect, knowledge, so as to rise above our own inborn prejudices and ignorance of the world.[1] Those who possessed such wisdom and intellect were considered developed.

The scope of education is usually culturally and socially defined, and is not universal. In Bhutanese Buddhist cultural belief, development is ultimately interpreted as spiritual development or education leading to progress in a person's 'karmic evolution'. It focuses on overcoming delusions arising from ignorance, aggression and the cravings of one's own mind, which also leads to the possibility of gaining selfless wisdom. Buddhist enlightenment education is essentially a matter of taming the mind "if [one] is to perceive the true nature of being and thereby overcome the mental clinging which leads to suffering".[2] It has more to do with transformation in the psychology of the person and, just as development is understood as changes in the psychological aspects of the person, so too is underdevelopment a spiritual and psychological phenomenon. The traditional Buddhist view sees the causes of underdevelopment and associated suffering "within the human spirit".[3] Transformation of the society towards balance and sustainability requires previous changes at the psychological level to embody Buddhist values and concerns.[4] Central to this particular development vision is development of the individual, not an exclusive focus on the surrounding infrastructure. Seeing oneself as part of all other life forms or 'sentient beings', and a contented and enlightened life that can be led with a minimum of materialistic support system are also central to the Buddhist vision of a good society.[5] The quality of relationship between people and other sentient beings is more important for true well-being than the relationship between people and things. The aim of such development is linked to spiritual enhancement and happiness.

Much has already been said in the media about the concept of 'Gross National Happiness', a phrase coined by His Majesty the King.[6] Welfare is perceived to accrue not only from material goods but also from man's (unquantifiable) spiritual and emotional well-being. In Bhutan, an important goal of development is the harmonization of spiritual and material aspects of life. Almost all decrees issued by the king stress both increasing prosperity (*peljor gonphel*) and happiness and peace (*gakid*). Of the two, peace and happiness is to be ranked higher; Gross National Product is regarded as less important than Gross National Happiness. As a desired end, happiness has been discussed by many Western thinkers from Plato to Mill. In economics, happiness has come to be associated, if not identified, with a range of concepts like utility, desire-fulfilment, satisfaction of pleasure or preference, and hedonism.[7] But the moral constraints and the methods of seeking happiness according to Buddhism are as different from those of utilitarianism as the reasons for them, embedded in the different philosophical streams.

If Bhutan's development path diverges significantly from the vision stated above, the country will be modernized with costs as well as benefits. Consumption and production have to increase exponentially to catch up with the constantly rising living standards of admired peers. Much of production is actually extraction from nature. Globally, there is mounting evidence of excessive extraction from nature and destruction of the environment. Though ultimately consumer goods originate from nature, their indestructibility and non-degradability do not enable them to merge once again back into nature to be the basis of renewal of life. To become

modernized is like marching towards an industrial and technological society that generates a serious and often irreversible impact on the environment. In its development strategies, the Royal Government attempts to counter the negative aspects of modernization. It attempts to take the country from being a late starter in modernization to a sustainable society – a post-modern or post-industrial society.[8] How far the course can be kept remains to be seen.

CAUSES OF RAPID DEVELOPMENT

Bhutan developed rapidly since 1961, when five-year plans were started. The achievements are particularly remarkable when one keeps in mind the modest base levels from which the process began. To give a picture of conditions prevailing before 1961, "there were only four hospitals with inadequate facilities, eleven dispensaries and a leprosy colony … functioning under untrained staff."[9] In the field of modern education, only 59 primary schools were built before 1971. The first historic batch of 20 Bhutanese pupils completed high school in Bhutan as late as 1968.[10]

This is not to say that there were no education or health services: the monastic education system, and indigenous medical knowledge flourished, as they do today, as parallel systems to Western education and health services. The monastic education system, one of the glories of traditional Bhutan, gave long-term education to a substantial number of men.[11] It strove to give the Bhutanese an enlightened education that included ethics as much as handicrafts, poetry as much as history, ritual as much as philosophy. Monastic enrolment at that time was, however, much lower than the present school enrolment of more than 80,000 students, who will gradually step up the pressure for white collar employment.

The rapid development can be attributed to several distinct causes. The first is the strong and dynamic leadership of the present and the previous king of Bhutan. They provided stable government which promoted rapid development. Both visionaries, they had immense capacity and energy for work to realize their strategic ideas. During a phase of rapid development strong coordination and clear direction are prerequisites. The advocacy for strong leadership that often goes hand in hand with centralized system of governance will be treated with skepticism abroad, and may be taken as a covert admiration for paternalism. In Bhutan's case, policy drifts have

been prevented because of the existence of a disciplined vertical command structure. Continuity and cohesiveness in policies probably could not have been maintained without the benign but decisive authority of the kings.

In practice, the Bhutanese monarch cannot be a mere figurehead; circumstances demand that the monarch be an active policy author and administrator. The burden of expectation and responsibility on the ruler remains heavy, which means that the monarchy needs to be fully functional rather than a mere institution. The pivotal role of the present king in promoting development has made the people fully internalize the value of monarchy as an active agency of development as well as tradition.

The second powerful cause of rapid development is that Bhutan, unlike many other developing nations, possesses rich resource endowments such as hydropower and minerals, combined with low population density. Bhutan has about 72% forest coverage. Because of the value of the forest, which goes beyond its timber stock, the government's conservation policy discourages commercial logging. Hydropower is the main area of commercial investment and exploitation. The fast-flowing perennial rivers of Bhutan, swollen by monsoon rain, provide vast potential for energy. Unlike thermal power stations which use fossil fuel, there is no emission of greenhouse gases from hydropower. Its electrical energy can replace the wood, kerosene, coke, coal and diesel used by households for cooking, heating and lighting. Exploitation of hydropower in Bhutan for export could reduce greenhouse emissions in the energy-hungry areas of India and Bangladesh, and perhaps one day in the Tibetan plateau. Reciprocity between India and Bhutan is realized through Indian investment in the construction of hydropower stations in Bhutan, and the use of Bhutanese energy by Indian industries as far away as Orissa.

With a population of some 600,000, Bhutan has the lowest population density in Southeast Asia at 13 persons per km^2. There is no labour surplus, a feature of many developing countries. Bhutan's low population seems to be an outcome of epidemics (e.g. smallpox, malaria), high morbidity caused by dysentery and diarrhoea, and occasionally wars, through which Bhutanese population growth was periodically contained. The existence of celibate monks also contributed to the stability of the population. Since the factional battle at Changlimithang in 1885, no Bhutanese have gone to war. Primary health services combined with water and sanitation programmes have improved public health. Owing to these

and other factors, the population growth rate has begun to climb sharply from 2.6% in 1984 to 3% in 1994.[12]

While low population and rich resource endowments are apparently important factors in development, a well-functioning administrative set-up and community organizations are not usually acknowledged factors of development. The presence of a well-developed administrative machinery and cohesive community organizations should be considered as the third cause of rapid development. In many other countries, donors' frustrations with corrupt and unstable governments, and the consequent investment in civil service reforms, capacity building, improvements in management efficiency, testify to the importance of this organizational factor in development. The calibre and integrity of both the administrative set-up and community organizations are essential conditions for rapid development to occur. The former is an instrument of delivering goods and services, the latter one of receiving and utilizing them. A delivery mechanism in the form of a responsive administrative set-up and receiving mechanisms in the form of well-defined community organizations have been put in place. In today's development terminology, there was sufficient 'institutional capacity'.[13]

The fourth cause, also often insufficiently stressed, is the primacy of Bhutanese culture as a criterion of evaluation and means of perception. As a country which historically escaped occupation by Tibetan troops in the seventeenth century, as well as by the British in the nineteenth, an assertive culture was built up. It is a source of defining and asserting development strategies of one's own choice and pace. As an extreme example, the way a lama sees the world is different from the way an international banker does. Against the banker, the lama may not have much free rein in strategic decision-making, though he may deserve a place in the forum of development planning.

Bhutanese development strategy has relied on local decisions, rooted in local perceptions and implicit local criteria of proposal evaluation, though there is no written doctrine of these (a shortcoming only as strange as the oral transmission of knowledge of certain esoteric Buddhist sects). In past decades, culture as a criterion of evaluation and perception was embedded in the mores of high official circles. Its unifying grip may, however, be weakened as new generations move up the official hierarchy and as the administrators, professionals, business people and industrialists who influence strategy, engage in superficial interests in culture. The mooring in culture may not exceed the penchant for pictur-

esque attire and the capacity to ingest vast quantities of chillies! The deeper aspect of culture consisting of distinct perspectives and values may be supplanted.

Were it not for the strengths and primacy of Bhutanese culture, it would be difficult not to be overwhelmed by the many development models and strategies from abroad. To a large extent, the adoption of stereotypical ruling strategies and policies has been averted, and the decision-making process in Bhutan has insisted on its own terms of development collaboration. This could be achieved primarily because of the self-assurance and confidence of Bhutan's assertive culture, which helped to deflect conventional strategies found in many countries, as well as the tendency of donors, consultants and international organizations to globalize generally. There is a proliferation of advice, offered in good faith, not only on how, but also on what policies and strategies to formulate. Such expert and professional opinions are greatly conditioned by their own, broader cultural backgrounds. The less one thinks originally, the greater is the propensity for unquestioned acceptance of such general strategies and policies, which neglect the peculiarities of local conditions and visions.

The last, but crucial, cause of rapid development is the long-term support of the various donors. To my knowledge, not a single donor, whether a multilateral agency or country, which has come to participate in Bhutan's development has so far withdrawn from Bhutan. This has to do with the high accountability, efficiency and transparency of utilization of aid, and the realization of intended purposes. The commitments of high per capita grant aid spanning decades has helped Bhutan plan over a longer period. India, Switzerland, Japan, Denmark, the Netherlands, Austria, Germany and other countries of the European Union are the leading donors who have participated in development programmes in Bhutan. Almost all multilateral agencies of the United Nations' family of organizations have also made significant long-term contributions. India, a partner of development in Bhutan since the inception of five-year plans, still ranks highest in terms of size of assistance, although other bilateral and multilateral sources are becoming increasingly important.

PHASES OF CHANGE

Looking briefly at the investment pattern since 1960, it is possible to delineate some key features of the experience of economic development. The years 1961–73 were a period of road construction, and development of international relationships between Bhutan and the world. Investment in this period was heavily concentrated in building a single axis motor road across the country. The coming of motor roads has stimulated both a socio-economic development and a sense of national economic integration among a people who often lived with a strong orientation to their valley communities with their own dialects. In spite of the extensive layout of motor roads now totalling 3,300 km, the network is still sparse. Motor road accessibility is restricted by settlement patterns, with villages scattered over high mountains. The ancient arteries of mule-track highways will never be totally substituted as the majority of Bhutanese live beyond a day's walking distance from the motor road. The sight of children walking ten kilometres to and from schools in a day, through corridors in forests harbouring wild animals, is likely to remain a feature of education in Bhutan.

During the same period, a broadening of international relationships between Bhutan and other countries took place. An old country, whose ancient independence had until then existed without diplomatic links and participation in the international community, it now conducted deft manoeuvres which led to international recognition of its state sovereignty. Bhutan exchanged ambassadors with India in 1968, and was admitted to the UN in 1971. Diplomatic exchanges with many nations were to follow, contributing substantially to the sense of collateral security as well as to the diversification of sources of development assistance. The significance to Bhutan of such international relationship cannot be adequately appreciated without understanding the geopolitical history of Himalayan Buddhist nations which have tended to disappear. Bhutan has endured, both politically and culturally, between China and India, countries which are on the way to becoming the two most important entities of the next century, and which are both experiencing demographic transitions. Bhutan's population of 600,000 is an insignificant 0.00049% of the population of China, and 0.00064% of the population of India. The external demographic pressure can sometimes be seen vividly with the new settlements butting against the boundary posts. In 1865, when Bhutan's southern corridors – now turned into tea gardens – were lost to the British, the country physically shrunk. In the north, the Sino-Bhutanese boundary is being demarcated.

Once the problems of inaccessibility were partly overcome, and the delivery of goods and services became more cost-effective, the establishment of health, education and agricultural extension services expanded rapidly between 1971 and 1983. This period was characterized by the expansion of social services and the attendant growth of personnel to man them. The expansion in the social infrastructure as well as other economic services led directly to increases in the maintenance budget. The need to augment revenue naturally led to the next phase of development – revenue-generating investment. The exploitation of hydroelectric and mineral potential (e.g. for production of cement) became the main focus.

The period between 1983 and 1987 was one of high growth rate fuelled by the construction of the 336-megawatt Chukha hydropower station. Construction related to the project represents the biggest lump sum investment so far. Recurrent budget self-sufficiency is a strongly advocated fiscal target in Bhutan, and in the 1990s the gap between recurrent budget and internal revenue has not been allowed to fluctuate above 10%. The underlying trend of growth was boosted to new heights during the construction of the Chukha hydro-project. The output of electricity started a chain of industrial enterprises. This pattern of growth dependent on construction of hydro-stations and power production has become a main attribute of the economy. Similar peaks in growth are expected from the construction of further hydropower projects.

The period after 1988 is characterized by expansion of air-links and telecommunications networks. Air services connect this once inaccessible and unapproachable country to Bangkok, Delhi, Calcutta, Dhaka, Kathmandu and, in early 1997, to Rangoon. The district headquarters or *dzongs*, where the monks also reside, are linked by faxes and telephones based on the latest digital communication technology. Computers are almost a norm in project offices. Rumblings of the arrival of Internet can be heard in Thimphu. National media in the form of *Kuensel*, the weekly newspaper, and BBS (Bhutan Broadcasting Service) give substantial coverage to foreign news, leading us to the edge of the transnational or globalized world. These are harbingers of the age of electronic media and information which will bring in messages in sounds, images and texts from all parts of the world at great speed. The distance between Bhutan and the outside world has begun to collapse.

One of the main national goals is economic self-reliance. The direction towards this goal is broadly indicated by an increase in domestic saving over investment, internal revenue over recurrent expenditure, and export over imports. There has been steady progress with respect to all these financial indicators. Revenue in 1983/84 was 88% of the recurrent expenditure, but rose to 97% in 1993/94. From negative gross domestic saving in the early 1980s, it rose to Nü 2,885 m, or 29% of GDP, in 1993/94. As a percentage of investment (gross domestic saving plus net capital inflow), gross domestic saving amounted to 65%. Imports continued to exceed exports. In 1980, the difference between exports and imports was Nü 257 m. With the increasing volume of trade this increased to Nü 885 m in 1995. The drive for economic self-reliance should remove dependence on foreign aid in the shortest possible time. In 1993/94, only 38% of the total government expenditure was met out of domestic revenue. There is still a long way to go before total government expenditure can be financed completely out of domestic revenue.

Privatization, disinvestment and corporatization are some of the means of increasing revenue-generation. Another option is the introduction of a user's fee in the social service sectors, although this has been minimal due to equitable and comprehensive coverage, particularly universal primary school enrolment which the Royal Government wishes to attain by 2005.

The main threat to meeting economic self-reliance is unabated population growth which will lead to unaffordable government expenditure in the social services and maintenance of infrastructure. Taking a twenty-year perspective, the population of Bhutan is likely to grow from the current 0.6 m to 0.931 m in 2017. This scenario does not purport to be a prediction, but is useful for enabling us to see the general contour of changes that might occur. The demographic change is predicated on a drastic decrease in the rate of population growth: 3.1% in 1994, 2.43% in 2002, 1.63% in 2011, and 1.3 in 2017. The fertility rate must drop correspondingly from the present level of 5.3 to 2 in 2017. Such a quick reduction in growth rate in a twenty-year period cannot be achieved without serious efforts in family planning. The contraception prevalence rate for women between the ages of 15 and 49, was estimated to be 19% in 1994, but 22.7% if the age group is narrowed down to those between 20 and 44 years of age.[14] There is already a vigorous programme to increase this.

If economic output grows at a long-term rate of 4.5% per year – which is on the conservative side – the present per capita income of Nü 5,181 (at 1980 prices) will double to Nü 11,800 in 2017.[15] Doubling of income is estimated at 1980 prices; so in nominal price it will be obviously much higher, depending on the inflation rate in the intervening years. However, by that time, a new measure of quality of life might be instituted which would show that Bhutanese enjoy a much higher standard of life than that conveyed through the measurement of per capita income.

Government provision of health and education services will require the revenue base to be expanded. As a result of population increase to 0.931 m by the year 2017, the number of students enrolled in primary and junior high schools could shoot up from the present 76,000 to 156,000 by 2017.

Food deficit, especially in terms of rice and wheat, is expected to increase due to shrinking man:land ratio. In 1992, per capita consumption was estimated to be 62 kg of rice and 42 kg of wheat. In 1992, the domestic production level for rice and wheat was 33,000 tons and 11,000 tons, respectively. Provided that this level does not increase and the per capita consumption level does not change, the import of rice and wheat will have to increase steadily. Import levels for rice and wheat will reach 54,000 tons and 36,000 tons, respectively. Due to the steepness of the terrain, the scope for expansion of land for cereal cultivation is generally presumed to be limited. However, orchard cultivation, especially of apples, oranges and cardamom, does not seem to be curtailed by terrain. The main constraint is accessibility for marketing and transportation. Horticulture is spreading rapidly on land close to the highways. Investment in apple and orange orchards is taking place on an unprecedented scale. Apples and oranges are the top two exports to Bangladesh, whereas the top three exports to India are, in descending order of magnitude, electricity, calcium carbide and cement. The possession of an acre of apple or orange orchard has come to be an indicator of membership in the economically successful middle class.

In general, increase in population will exert pressure on the environment and agricultural land and, if the standard of living does not rise fast enough in rural areas, will also intensify rural–urban migration. Concern for the potentially adverse impact of increased economic activity and population

on the fragility of the mountain ecosytem has led the Royal Government to raise the preservation of environment as an important national goal. Bhutan is normally regarded as an environmental leader, its soil and air not yet contaminated by harmful emissions and pollution. The quality of the environment is rather outstanding with the exception of wood smoke in the kitchen,[16] and some micro-biological impurity in drinking-water supply,[17] which show up as respiratory infections and waterborne diarrhoeal diseases. They are the second and third most common diseases referred to the Basic Health Units and hospitals. Skin infections, possibly caused by poor cleanliness, ranks as the main cause of morbidity. A concerted effort to raise the level of sanitation was boosted by the Royal Decree on Sanitation issued in 1992. The environment surrounding Bhutanese villages is an enviable one, yet the immediate ambience of the village environment, where livestock and people mingle, and where there is no well-established sewerage system, poses some risk to human health.

Bhutan is one of the ten global 'hot spots' with an outstanding concentration of plants and animals within the confines of a small country. Lifestyles of previous generations did not reduce the carrying capacity, and on the whole the environmental legacy is considered unmatched in this part of the world. Constant interactions with the fragile mountain ecosystem have enabled the people in Bhutan to accumulate considerable knowledge about and institutions relating to environmental protection and sustainable use of natural resources. Only some of the older practices such as bush-fallow cultivation and migratory grazing are frowned upon by modern agronomists, although the scientific basis of criticism against them have been proven not entirely correct.

Bhutan's environmental legacy can be explained by the presence of the following: (a) indigenous institutions for managing common property resources like irrigation water, leaf litter, wood lots, grazing land; (b) a strong culture of conservation and Buddhist ethics; and (c) enforcement of legislation enacted mostly between 1969 and 1981. These elements reflect the conservative ethos and are mainly responsible for the sustainable resource use. Both farming and breeding practices show keen understanding of the need for renewal of soil nutrition, crop rotation and livestock management, and are adapted to the micro-climatic conditions. For example, the clockwork precision of seasonal livestock migration, especially of cattle and yaks, across different ecological zones exhibits a keen understanding of the nutritional opportunities afforded by plants growing and dying at different times. In order to be at the right place at right time and thus relieve environmental pressure, movement is crucial. Plants of many kinds provide much of the varied livestock fodder; 308 species of grass have been identified in Bhutan. Research in alpine regions indicates that exotic species cannot substantially increase fodder production, and the emphasis must be on improving grazing management.[18] Besides, the rules of division of communal pastures, which appear to contain inbuilt checks on overgrazing, show concern for equitable division among their owners.

Aspects of local culture such as language, knowledge, beliefs and institutions, may reflect a great deal of knowledge about the ecosystem within which they have evolved. Knowledge and institutions relating to a particular niche or ecosystem are always localized. The dissolution of institutional arrangements for resource management and utilization between communities, and their replacement with borrowed institutions is a source of concern. There are those who believe that erosion of local institutions leads ultimately to environmental degradation. Traditional institutions of sustainable resource use may have developed partly because of the need for cooperation among competitive users, but also because of the long periods over which the communities relied on themselves, without the intervention of the state. These indigenous institutions have to some extent been legally recognized, though Western standards of soil, crop and livestock management are being rapidly diffused.

To preserve Bhutan's pristine environment in a period of modernization, the Royal Government has enacted a series of environmental laws, starting with the Forest Act of 1969, which has now been superseded by the 1995 Forest and Nature Conservation Act. Other important laws which have direct bearing on the environment are the Land Law, 1979; Notification on Reserve Forest and Wildlife Sanctuaries, 1974; National Assembly Resolutions; Pasture Land Law, 1979; Mines and Mineral Management Act, 1995. More environment-related rules and regulations are being added to the body of laws to prevent and control pollution by industries. The Forest Act of 1969 decreed that more than 60% of the country be under perpetual forest cover. The Royal Government does not look upon forest as a source of revenue but emphasizes its conservation and ecological roles above that of revenue generation. Knowing the tendency of private companies to overexploit forest resources, limited logging is the monopoly of the public sector corporation – Forest Development Corporation.

From a Buddhist point of view, nature is not only to be exploited and conquered for human benefit. The principle of respecting life in all its forms extends to all wildlife because of the interconnectivity of life between various species and the blurring of species distinction. Not all Bhutanese are entirely pacifist, however. Some people cull yaks commercially, go fishing, or keep chicken farms. In general, however, reverence for life in all its forms leads logically to the protection of the natural environment in which wildlife occurs. To further create a harmonious natural order in which man and other beings live together interdependently, the Royal Government has declared 26% of the country as wildlife sanctuaries and forest reserves.

The Bhutanese have seldom been keen on trapping, hunting and shooting animals and birds. Hunting has never been regarded as a sport and is prohibited by law. The law goes to extraordinary lengths to give safe conduct to wild boars, for example, which have become the most common pest in the country. They inflict great loss on farmers not only through feeding, but trampling, uprooting and wallowing. Wild boars may be killed inside or within 50 m of the perimeter of the field being destroyed, and a fatal device has to be used. But farmers rarely have guns and wild boars continue to trot away scot-free. A survey conducted in 1996 on crop damage by wild boars shows that methods of guarding, especially at night, would not in any way endanger wildlife. Among the farmers surveyed, 29% shouted at the wild boars, 29% drummed empty tins, 20% erected scarecrows and 19% lit bonfires. 65% of the farmers expressed themselves unwilling to kill for various reasons, including lack of weapons and fear of committing a sin.[19]

The third important national goal is to stimulate a regionally balanced development. According to neoclassical economics, regional imbalance is a short-term disequilibrium to be removed by the adjustment process through free movements of factors of production. If competitive market conditions obtain, growth is diffused. As such competitive markets favouring free movement of factors of production are unlikely to exist in reality, disparities are likely to emerge without deliberate policies to correct them. The objective of balanced development provides for equitable services and infrastructure throughout the country. The aim is to avoid the emergence of backwaters, as more and more parts of the country are brought into the economic mainstream. Social infrastructures are almost uniformly distributed, but economic forces do not on their own create even growth

throughout the country. For this, communication facilities are recognized as a key input. Communication infrastructure has had an enormous impact on trade and commercial growth, as can be deduced from bustling growth around a western axis between Phuntsholing and Thimphu–Paro, and an eastern axis between Tashigang and Samdrupjongkhar. These places are relatively densely populated due to urbanization. Higher growth along these routes explains the importance of good communications and effective demand in the generation of wealth.

The fourth important national goal is to encourage community responsibilities and decentralization by stimulating local institutions. Bhutan tries to maintain local institutions regulating natural resource use, collective and reciprocal work relationships and conflict resolution. In older villages where social and economic institutions are deeply rooted, there are unwritten and largely internalized rules governing the uses of natural resources and social relationships. These institutions bind people together as a community; the people could not exist as members of the community without them. Their intangible and elusive quality, however, makes them remote from the planners and researchers, and leads to their marginalization.

A well-functioning society needs a range of organizations and institutions which exist outside the state machinery, but which cooperate with it. Such institutions lying between the state and the family are true indicators of the self-organizational capacity of the community. Historically, they played a vital role between: (a) the machinery of the state, which was devoted to mobilization of labour and taxes and the defence of the country, and (b) the family, which functioned as the basic unit of society, and bridged the gap between the two. They were self-regulated through competition, cooperation and control within the community. When these elements of cooperation, competition and control are present in a balanced way, one may consider the community to be democratic. The smallness of the community structure and the web of kinship connection among the members were additional factors that made it democratic, although some institutions sometimes fell captive to centres of influence and power.

On an administrative and political plane, a systematic decentralization of authority began in 1981 as a process initiated by the present king to devolve authority to the district and block (gewog) levels. The process of decentralization led to the establishment of local bodies both at the

district and block levels. It also created participatory forums for community representatives to make decisions affecting their area, ranging from social, religious to economic issues. There are 560 members in twenty District Development Committees (Dzongkhag Yargay Tshogchung), and about 2,589 members in 196 Block Development Committee (Gewog Yargay Tshogchung). The elected members of these committees participate actively in the formulation and monitoring of the five-year plans. Further, through the establishment of the block-level bodies, the villagers are increasingly linked to the broader national decision-making process.

Alongside the decentralization of certain decision-making powers to local bodies, the latter are also being asked to organize, construct and maintain their own facilities. They are also being asked to build up the necessary skills to deal with new construction materials and imported technologies and create cash funds to buy maintenance equipment. Organizationally, this leads to the creation of beneficiary or user groups. The management of certain facilities like newly built drinking-water supply schemes, primary schools, and irrigation canals by the communities also reinforces the sense of ownership necessary for renewed care.

While development is being ushered in, by far the most ambitious national goal is that of cultural preservation. Globally, lifestyles may be imploding or converging rather than diversifying. The Bhutanese too are becoming oriented to Western culture, which by and large represents global culture. Traditional values and cultures get relativized, recomposed or submerged under the weight of global culture. The diffusion of transnational culture can set in motion forces of silent dissolution of local languages, knowledge, beliefs, customs, skills, trades, institutions and communities. Globally due to broad homogenization, linguistic, organizational, cultural and institutional diversities are being reduced; lifestyles, political orders, and economic markets are imploding. The melting-pot process on a global scale undoes the mosaic of lifestyles, languages and bio-diversity which provide human beings with fundamentally broader choices and options.

If left to themselves, these changes will subdue rather than enhance the cultural distinctiveness of Bhutan. During a period of cultural absorption, a society delves into its heritage in search of cultural specificity. In order to reconstruct or reconceptualize selfhood, it becomes necessary to find out what constitutes us as a people, a community, or a country, in terms of our respective identities. It is a quest to define oneself as a historical continuity.

Politically, Bhutanese culture is regarded as indispensable for unique national identity. National identity is in turn connected with sovereignty and security of the nation. Therefore, Bhutanese culture is seen as a necessary condition for the nation state to flourish. The implicit assumption is that the structure of the state and the nation will be endangered if culture is not maintained. Culture is asserted as an anchor in a sea of change. That anchor consist of values and institutions deemed desirable for the solidarity of a nation, despite its different subcultures. A desirable set of values and institutions must serve an integrative function among the people.

The concept of 'three foundations' (*tsawa sum*) comprising the nation, the people and the king, has gained currency as a contemporary focus of nationalism. It is reminiscent of the holy trinity of Buddhism (Buddha, dharma and sangha). The religious concept was appropriated to secular purpose.

One aspect of culture being revived since the mid 1980s was *driglam namzha*. At a fundamental level, it can be understood as a 'the way (*lam*) of conscious (*namzha*) harmony (*drig*)'. At a popular level, it emphasizes the observation of a distinctive culture as indicated in such outward forms as architectural style, dress, manners, official etiquette. It came to be interpreted as a system of rules of physical conduct and external forms, applied on an individual basis to forge a sense of nationhood. One meaning of *drig* can be found in everyday use in song and dance. A song and dance troop must cultivate harmony (*drig*) in its music and movements. Harmony is a matter of individuals not upsetting the choreography dependent on group combination. Humility, a key Buddhist attribute, is directly concerned with group orientation and social harmony. Harmony is facilitated if individuals can subordinate themselves to the group, while the group can reconcile and balance its interests with those of its individual members.

As a set of values underlying the harmonious relationship between people, between man and nature and between present and future generations, the aim of cultural preservation is to maintain the basic values of Buddhism in the face of challenges from competing ideologies and ideas of social order. Buddhist ethics have always been a strong feature of Bhutanese society. Custom and law supported the moral code inspired by religion. Buddhist morality became influential socially and legally partly because it percolated down to the villages.[20] Of these values, the principle of *tha damtshig le jude* has gained currency and finds mention in school textbooks. The boundary (*tha*) of morality (*damtshig*)

and causes and effects of actions (*le jude*) are reasserted in this concept, which should limit our actions to what accords with morality. This kind of ethical constraint is meant to bind all of us, and the freedom we should enjoy is to live in a way becoming to Buddhists. As we make a transition from an insular agrarian society to an industrial society, competition will become a vaunted value. People's behaviour will be driven by competition for various goods and services and pursuit of narrow individual well-being. However, Buddhism also teaches concern for others. The idea of concern for others or altruism can be seen as a broadened welfare function, which does not only include people, but also other beings that constitute the environment.

Despite the emphasis on cultural preservation, there are inherent obstacles in planning for it. In the economic sphere, planners and policy makers usually have models and tools to change the existing system and achieve a desired state of the economy. However, technocratic development planners, who are increasingly in charge of the course of the nation, usually have a poor grasp of the cultural setting, as well as a dimly imagined vision of the cultural shape of the future society. Less is known about symbols, beliefs, values, ideology, hierarchy, and ethno-histories than about trends in income, mortality, nutrition, trade and price levels. The dynamic relationship between the changes in the economic system and the cultural sphere is not clearly understood. In neoclassical economics, the image of man is devoid of cultural leanings. Cultural factors are usually subsumed under economic motives of maximizing benefits, welfare and utilities. But this is a reductive approach.

The present economic system is driven by a vision of the future economic society to be attained. Unlike economic goals to be achieved, however, there is no clear image of the future cultural state of affairs, especially a shared one, to be attained. Broadly speaking, it is suggested that all societies are converging towards Western liberal democracy and free market economy, both held as world-wide models to be emulated. But Bhutanese society – as briefly discussed in the section 'Vision and Balance' – has the potential to be a society distinct from one based on borderless free market economy and liberal democracy, blending the spiritual, political and social heritage of Bhutan with elements of innovations and progress of the West.

PAST AND FUTURE

Several disjunctions between the past and the future will make striking a balance very difficult, as changes push us to the verge of a new era, breaking with the past. Modernity is characterized by technology, choice, urbanization and openness to the outside world. The past is characterized by subsistence agriculture, insularity, and village settlement. Clearly, we live in tension between these dichotomies and ambiguities of change. If it is not managed, we might see some of the bungled scenarios that have unfolded in many parts of the world.

The main factors of production that dominated in the past were land and labour, and as a result many institutions evolved to use labour from each household for various community and national tasks. There has not been much indigenous technological progress aimed at mass production, though farmers seem to have made innovations from time to time. The future will be dominated by technological and industrial modes of production; industrialists and mercantilists, as much as the farmers of horticultural plantations, will constitute the emerging dominant group. Technology comes from outside, and success will depend on how closely one can link up with the right sources. Technological innovation will be needed to sharpen the edge of market competitiveness. Choices concerning industry and technology will be extraordinarily important.

In terms of share of economic output, modernization implies transformation of the main basis of the economy from agriculture to industry and services. Formerly, a child became a good farmer and breeder through long practical experience. Industrial employment requires training which the family cannot offer. But industry will not train employees if they are unlikely to show lifelong loyalty to the industry. It is, however, easy for family members to be deeply committed to the family farm and invest in their training as farmers.

The past demanded villagers to be multi-skilled individuals. They worked as farmers, herders, carpenters, foresters, masons, tailors, tanners, smiths and masked dancers. The future compels people to specialize in order to cope with a set pattern of daily responsibilities and leads to the impoverishment of the joys associated with the diversified experiences of such multi-faceted individuals. In an industrial society, the

young, the old and functionally illiterate cannot be employed, as they would be in a village subsistence economy. The village economy employs everybody, exploiting the capabilities of each person, including children. Although rural areas will continue to offer work, though at low levels of labour productivity, there will be a flight of young people, especially able males, to urban areas. The only way to tackle this problem and make it less intractable is to establish an infrastructure in the rural areas covering everything from electricity to village sewerage systems, as the Royal Government aspires to do.

The past was characterized by close-knit rural communities which could contain social and civic problems. With the exception of occasional conflict and dissension within a community, traditional village society thrived on a web of social cooperation, friendship and reciprocal altruism. Such intangible aspects of village society are lacking in urban settlements where life is very individualistic and nucleated, with a reduced sphere of social life.

Urbanization is a part of modernity. Towns will continue to grow much faster than villages, drawing pools of people and resources. Already, a few small villages, which stood on the mule-track highway, have perished with the diversion of traffic to the motor roads. Incipient townships already manifest the inability to plan space as a visual unit. While stylistic decline is generally arrested through building codes, the consideration of space between objects is a weak aspect of urban settlement. Space has to be planned at a collective level while building style is a matter of individual responsibility. The constraints imposed by Bhutan's mountainous character mean that the urban population will reach a saturation point much faster than in any urban settlements in the plains. The problems of urban areas stemming from high density, large income disparities and environmental problems of mixed land uses (industrial, residential, commercial, administrative and agricultural) demand a more systematic approach.

The past was probably characterized by conformity in a broad sense, which stemmed from the internal logic of insular and isolated communities. Precisely because of their isolation, such communities differed a great deal. Whilst there was conformity within communities, this was combined with distinctiveness, but never divisiveness, across them. Modernity and the future are associated with individual choice and options. Yet, as pointed out earlier, on a global level there is a paradox. What appears as a widening is really a convergence and narrowing of options and choices. The past was insular. The future holds prospects for openness to the outside world. In a mundane way, it can be seen operating through the principle of free trade which prises places open as markets, so that the country becomes increasingly integrated into regional and global economies and the people fulfil efficiently their economic quests.

Yet the question remains of what will happen in the process of a successful development planning delivering us from fundamental material needs. The view that modernization has done more than its share to recreate ruthless egocentric persons is echoed by many.[21] The possibility that it can take us into a social, political and economic system which creates increasing 'voidness' in us cannot be ruled out. The complexity of modern life may produce unanswerable doubts about the purpose and value of life and a sense of powerlessness over its course. The stimulus of modern mass entertainment and mass culture of songs and thrillers, and many other forms of sedatives and stimulants may draw us, in the moment of our need to forget and suppress emptiness.[22]

On the other hand, that peculiar Bhutanese faculty to follow a holistic path of development of both materialism and spiritualism could remain alive. We could continue to strive to maintain the enlightenment that is within all of us, in the midst of the information revolution. Efforts in this direction are so far are quite encouraging, but also hang in the balance.

NOTES

1 See Thurman (1995: 1–45).

2 See Aris (1990: 94).

3 Ibid., p. 86.

4 See Sivaraksa (1992: 61).

5 See Ura (1995).

6 It was sometime in late April 1987 that John Elliot of the London *Financial Times* wrote a travel piece on Bhutan. This was the first time that the phrase coined by HM the King of Bhutan occurred.'Gross National Happiness' appeared as the headline of the article.

7 There are several substantial criticisms of utility, desire-fulfilment, preference-satisfaction or happiness-based moral approaches detailed in the theoretical literature. See Sen 1982, 1984 and 1987.

8 See Ura (1995).

9 Royal Government of Bhutan *Third Five Year Plan 1971–76*, p.51.

10 Royal Government of Bhutan *Second Five Year Plan*. Vol. 1, 1971: 29.

11 See Dungkar (1993).

12 See Ministry of Health and Education (1996: 25).

13 Capacity does not exist in the narrow sense of being able to formulate plans in a given format in English, and to produce lengthy progress reports for donor agencies. This kind of criterion allows most Bhutanese organizations to be disqualified as lacking institutional capacity.

14 Ministry of Health and Education (1996).

15 Ministry of Planning (1996b, vol. 1, main document, p. 22).

16 No study has measured the density of smoke in kitchens. In 1986 a smokeless stove programme was started. By 1995, about 16,000 smokeless stoves were installed, though it is likely that by now a substantial number of these are defunct.

17 A survey conducted in 1995 established that 59% of tap-water samples collected in rural areas were contaminated. The mean faecal coliform content per 100 ml in the sample was 14. The official standard is to keep pollution levels at sources below 10 faecal coliform per 100 ml. In the same survey, water samples were also collected from springs, streams and canals used by those who had no tap water; 77% of the samples were contaminated and the mean faecal coliform per 100 ml was 19. This poses low risk to human health. Contamination increases with storage of water in the house.

18 See Roder (1990: 7).

19 See Choden and Namgay (1996).

20 See French (1995). For a discussion between Buddhism and Law see especially part 2.

21 See Menzi (1995).

22 See Margyari-Beck (1993).

REFERENCES

Andorka, Rudolf. 1993. 'Cultural norms and values – the role of the intellectual in the creation of a new democratic culture in Hungary.' AULA. *Society and Economy, Quarterly Journal of Budapest University of Economic Science*, vol. XV, no. 5.

Aris, Michael. 1990. 'Man and nature in the Buddhist Himalayas'. In (eds) N.K. Rustomji and C. Ramble, *Himalayan Environment and Culture*. Shimla: Indian Institute of Advanced Culture and Delhi: Indus, pp. 85–101.

Central Statistical Organization. 1996a. *National Accounts Statistics 1980-1995*. Thimphu.

—— 1996b. *Statistical Yearbook of Bhutan, 1994*. Catalogue no. 101. Thimphu.

Chapela, Lenardo. R. 1992. 'Buddhist guidelines on economic organization and development for future Tibet: Interviews with His Holiness the XIV Dalai Lama and Prof. Samdhong Rinpoche. *The Tibet Journal*, vol. XVII, no. 4.

Chmielewski, Adam J. 1995. 'Rationality, values, traditions: liberalism – communitarian debate in the context of transition in central Europe.' AULA. *Society and Economy Quarterly Journal of Budapest University of Economic Science*, vol. XVII, no. 5, pp. 89–101.

Choden, Dechen and Namgay, Kunzang. 1996. *Report on the Findings and Recommendations of the Wild Boar Survey*.

Chomsky, Noam. 1994. 'World order and its rules: variation on some themes.' *Scandinavian Journal of Development Alternative*, vol. 13, no. 3, pp. 5–27.

Drucker, Peter F. 1993. *Post-Capitalist Society*. Oxford: Butterworth Heinmann

Dungkar, Lobzang Tinley. 1993. 'Development of the monastic education system in Tibet.' *The Tibet Journal*, vol. XVIII, no. 4.

European Commission. 1995. *Bhutan: Evaluation of Rural Water Supply and Sanitation Project*. EC REF. NO NA/84124. Draft Report.

Featherstone, Mike (ed.) 1990. *Global Culture, Nationalism, Globalization and Modernity*. London: Sage

French, Rebecca. 1995. *The Golden Yoke. The Legal Cosmology of the Buddhist Tibet*. Ithaca: Cornell University Press.

Gluck, Ron. 1996. 'The private Dalai Lama'. *Asia Week*, 10 May 1996, pp. 34–38.

Margyari-Beck, Istvan. 1993. 'Culture and the market (An essay on culture and the drugs called culture.) AULA. *Society and Economy, Quarterly Journal of Budapest University of Economic Sciences*, vol. XV, no. 5.

Menzi, Marten. 1995. 'Quo vadis? Reflections about development cooperation.' Lecture given at Anniversary Celebration NADEL/SFIT (ETH) Zurich, 24 Nov. 1995.

Ministry of Agriculture, Planning and Policy Division. 1991. *Report on Baseline Survey in Lhuntshi, Mongar, Tashigang and Pemagatshel*. Thimphu.

Ministry of Health and Education. 1996. *Report on National Health Survey*. Thimphu. (Survey conducted June 1994.)

Ministry of Home Affairs. 1995. *Evaluation of Rural Water Supply Schemes, Smokeless Stoves and Latrine Programme*. Thimphu.

Ministry of Planning. 1996a. *Population Projection of Bhutan: Total and Sectoral Implications of Population Growth on the Economy and Strategies to Achieve Desired Demogaphic Goal*.

Ministry of Planning. 1996b. *Eighth Five Year Plan, 1997–2002*. 2 vols. Thimphu.

Nagel, Thomas. 1979. *Mortal Questions*. Oxford University Press.

Ohmae, Kenichi. 1990. *The Borderless World*. London: HarperCollins.

Payutto, P.A. 1992. *Buddhist Economics: A Middle Way for the Market Place*. Bangkok: Buddhadhamma Foundation.

Roder, Walter. 1990. *A Review of Literature and Technical Reports on Grassland and Fodder in Bhutan*. UNDP, FAO. Thimphu.

Scitovsky, Tibor. 1978. *The Joyless Economy: An Inquiry into Human Satisfaction and Consumer Dissatisfaction*.

Sen, Amartya. 1982. *Choice, Welfare and Measurement*. Oxford University Press.

—— 1984. *Resources, Values and Development*. Oxford University Press.

—— 1987. *Commodities and Capabilities*. Oxford University Press.

Sivaraksa, Sulak. [1981] 1992. *Seeds of Peace: A Buddhist Vision of Renewing Society*. Bangkok: Thai WatanaPanich.

Thurman, Robert A. F. 1995. *Essential Tibetan Buddhism*. London: HarperCollins.

Trungpa, Chögyam. 1988. *The Myth of Freedom and the Way of Meditation*. Boston: Shambhala.

Tucci, Giuseppe. 1980. *The Religions of Tibet*. London: Routledge and Kegan Paul.

UNDP. 1993. *Human Development Report*.

UNDP/FAO. 1990. *Accelerated Food Production Programme: Project Findings and Recommendations,* vol. II. Thimphu.

Ura, Karma. 1992. 'Environmental legislation in Bhutan: Review and proposal.' Unpublished.

—— 1993a. 'Ends of development: A discussion paper on 1993 Human Development Report with reference to Bhutan.' Unpublished.

—— 1993b. 'Land tenure and food security.' Unpublished. August 1993.

—— 1993c. 'The nomads' gamble, pastoralists of northern Bhutan.' *South Asia Research,* vol. 13, no 2., pp. 81–101.

—— 1993d. 'Gambling for sustainability - local institutions for pasture managment in Bhutan.' *Forest Trees and People Newsletter* (FAO Community Forest Unit), no. 22, pp. 12–17.

—— 1994. 'Development and decentralization in medieval and modern Bhutan. In (eds) Michael Aris and Michael Hutt, *Bhutan: Apects of Culture and Development*. Gartmore: Kiscadale Asia Research Series no. 5, pp. 25–50.

—— 1995. 'Central themes of sustainable development planning.' *Kuensel,* 11 March 1995.

Wade, Herbert A. 1995. *Zhemgang Energy Study*. Thimphu.

World Bank. 1994. *Bhutan Country Economic Memorandum*. Washington, D.C.

Wright, Robert. 1995. 'The evolution of despair'. *New York Times,* August 28, 1995 .

Zhemgang Dzongkhag Administration. 1995. *A Natural Resources Inventory of Zhemgang Dzongkhag.*

Employees at the National Library in Thimphu learn to use computers. (F.P. 1986)

Women in the City

Kunzang Chöden

The emergence of cities in Bhutan is a new experience, of no more than thirty years. Today, at least 10% of the female population of the country lives in the cities. In an effort to draw a holistic picture of Bhutanese women in the city, it is imperative to study the subject within a broader frame of reference. Besides focusing on women in the cities, this approach will also enable us to trace and develop an understanding of the process of urbanization and urbanism in the Bhutanese context, and to gain an insight into the first generations of Bhutanese women in the city.

WOMEN IN BHUTANESE BUDDHIST SOCIETY: PAST AND PRESENT

A historical perspective on the position of women in Bhutanese society is confined to inferences and speculations in respect of the earlier periods. There is no concrete evidence available on the role and status of women in pre-Buddhist Bhutan. The significant presence of women participants in some surviving Bön rituals suggests that women had prominent positions – either real or symbolic – based on religion and ritual.

After the introduction of Buddhism to Bhutan in the eighth century, the country's traditions and culture seem to have evolved around Buddhist philosophy and principles. Like many other aspects of the society, norms, attitudes and behaviours relating to women have been grounded in religious origins. Unfortunately, various interpretations of the original Buddhist texts have, over the centuries, attributed to the position of women negative connotations, such as the implications of inferior birth. Guru Rinpoche, who introduced Buddhism to Bhutan and is revered as the second Buddha, 'lavishly and extensively' praised the dharmic accomplishments of Khandro Yeshe Tshogyel, his enlightened consort and a great Buddhist teacher. Of women and religion he said:

> The human body is the basis of the accomplishment of wisdom,
> And the gross bodies of men and women are equally suited,
> But if a woman has strong aspiration,
> She has higher potential.
>
> (Gross 1989: 17)

In a context where celibacy was widespread, it was surely not women's inferior birth, but the vulnerability to pregnancy that kept many female aspirants from reaching the highest levels of religious accomplishment. Given the very close and often inseparable interrelationships between religion and politics, women's absence, in Bhutanese history, from politics, is hardly surprising. Written history gives us the name of a single woman, Tshokye Dorje, the daughter of Jampel Dorje son of the Shabdrung, who "seems to have been influential in Bhutanese politics for a short period" after the death of Shabdrung and the ensuing period of secrecy marked by feuding among successors (Aris 1980).

If there were no common secular role models for Bhutanese women to turn to, they drew their inspiration and guidance from the exemplary lives of well-known Buddhist women, divine and often miraculous personalities. The lives of extraordinary women such as Khandro Yeshe Tshogyel, Ashi Nangse (known as Nangsa Obum in Tibet),[1] Gelongma Palmo,[2] and many others were common sources of inspiration to women everywhere. Both Khandro Yeshe Tshogyel and Ashi Nangse suffered, in the early parts of their lives, in the ways that many women do in marriage and unhappy familial circumstances; their lives were easy to identify with. Bhutanese women narrated and listened to stories about these exemplary figures; they sang songs and composed verses (*tsangmo*) about them. While they may have secretly, or even unconsciously, drawn their inner strengths from the tremendously powerful role models (like the terrifying manifestations of Palden Lhamo,[3] and the triumphant, provocative, and wild, dancing images of Machig Labdrön),[4] they conformed to the socially more desirable feminine attributes of humility, gentleness and demure domesticity.

As in all traditional agrarian societies, Bhutanese women's significant economic roles as viable producers must be recognized. While the men entered the monasteries for religious education and practice, or served the ruling lords of the region – later the kings, and feuded and fought for power, the women continued to work the crop fields, weave fabrics, keep family hearths ablaze, and feed and nourish the children. The *dzongs*, traditional seats of religion and government, were naturally considered men's domains where women's presence was restricted. Village households were often headed by the 'mother of the house' (*mailiama* or *chim gi ama*). This may have had a lasting effect on Bhutanese society, leading to the tradition of female inheritance of property prevalent in some parts of the country. It may also explain why the number of women in the civil service is comparatively lower than that of men, and why women are underrepresented at the higher levels of government.

Located in a geographical region where prejudice against women is common, Bhutanese women are known to enjoy some aspects of egalitarianism; they have been spared from much of the gender-related discrimination found in neighbouring countries. Bhutan accords the same legal rights to both men and women, and gender discrimination is claimed not to be a significant social problem. Bhutan is a signatory to the UN's Convention on the Elimination of all Forms of Discrimination Against Women.[5] In principle, both men and

women have equal status and opportunities. There are no sharply defined male/female domains, which eases the task of mainstreaming women in the developmental process. At the household level women are neither subordinate, nor is their access to resources limited. On a very general scale most major decisions regarding household and family matters are jointly made.

Notwithstanding the favourable situation of women in Bhutanese society, we cannot completely ignore some of the realities. The rate of maternal mortality is 3.8 per 1,000, considered to be one of the highest in the world (Inayatullah 1993). Some discrepancy between the sexes in education is widely acknowledged. The female literacy rate is estimated to be around 20%, and the number of women who complete higher education still lags behind their male counterparts. The fact that men traditionally went into religious education may explain why they had a head start in modern western-style education: for men, going to school was simply a transition from one system to another, whereas for women, it was a pioneering effort. The government is aware of these discrepancies and serious efforts are being made to narrow the gaps.

FROM RURAL SETTLEMENTS TO URBAN CENTRES

Although indigenous urban life was never the common Bhutanese experience, the concept of town or city is not totally new to the Bhutanese. The fact that Bhutanese knew about and travelled to neighbouring cities in India is recorded by Ralph Fitch in 1583, and J.P. Tavernier between 1631 and 1668, both of whom claimed to have met Bhutanese traders in the cities of Cooch Bihar and Patna respectively (Olschak 1979).[6] Traders and pilgrims, men as well as women, travelled to the holy Buddhist centres located in the ancient and bustling cities of Benaras in India, Kathmandu in Nepal, and Lhasa in Tibet, and savoured the experience of city life. Back home they were content to go back to their rural lives.

In the Bhutanese context, *throm* (the closest Bhutanese equivalent to 'city' or 'town') constituted not permanent structured areas for trade and commerce, but temporary settlements which sprung up spontaneously whenever and wherever people gathered for specific purposes, often for religious congregations and festivals. These were the special occasions when women dressed in their best clothes, usually heirlooms used only once or twice a year, and

adorned themselves with amber and corals which they had acquired from the cities in India and Tibet, and went to *throm she*, literally 'to the roam the town'. Even today it is common to talk of a *throm* springing up during religious gatherings and festivals. Traders quickly set up their shops and brisk business is conducted. Aside from the occasional temporary *throm*, over the centuries Bhutanese settlements continued to be essentially agrarian and rural in nature.

Perhaps the first non-religious gatherings of people for the sole purpose of entertainment and commerce, and for many surely the first experience of anything remotely resembling a town, were the fairs which were held annually in the grounds of Wangduchöling Palace in Bumthang. The fair, which lasted for a week, was initiated by the second king of Bhutan in 1937 to celebrate the completion of Domkhar Palace. "Men and women came from as far as Haa, Trashigang and Tibet, particularly from Lhodrak Karchung. There may have been two to three thousand people at the fair", writes Karma Ura (1995) in his historical novel recording the life and views of a royal courtier. In the same book he lists the stalls and shops which were set up for various commodities, "all were named and numbered as if they were permanent establishments".

According to the National Report to Habitat 11 'The City Summit' in March 1996, the phenomenon of urbanization commenced with the introduction of a planned development process since 1961 (RGOB 1996). The Works and Housing Department does not have a standard definition of a city/urban area, but considers all district headquarters as urban centres or potential urban centres. The same report states that: "Unlike many other countries, where the establishment and growth of towns and cities has been influenced by their economic potential, their development in Bhutan has mostly resulted from the establishment of administrative centres."

Presently there are twenty *dzongkhag*. Many of the district headquarters are located in the *dzongs*, which were built from the seventeenth century onwards. For strategic reasons *dzongs* were built on hilltops and narrow ridges. These locations are often not conducive to the growth and expansion of urban centres, a process nowadays accelerated by rural–urban migration. Furthermore, the unfortunate absence of any comprehensive planning strategy or evaluation of total land available for building, has led to growth of urban centres in a "haphazard and piecemeal manner" (RGOB 1996).

Women in the city of Thimphu – five portraits

After a brief introduction to the city of Thimphu, I will present a profile of five women who live there. I will consider the impact on women's lives of urbanization and urbanism and how these, in turn, are influenced by women's presence and activities. While these women were carefully chosen to represent a cross-section of women in the city, the selection is not proportional in any way to the population of the city. Fictitious names have been used to safeguard the women's privacy and identity.

The urban population of Bhutan is said to be 14.5% of the national total of 0.6 million, with an estimated annual increase of 7–10% for Thimphu (RGOB 1996). Increase is particularly noticeable in larger towns such as Thimphu. Being the largest city and the centre of the Bhutanese government, Thimphu serves as a useful case study of urbanization and urbanism in the Bhutanese context.

Located in northwestern Bhutan, Thimphu is a narrow valley oriented in a north–south direction, with steep mountainsides to the east and west. The valley width rarely exceeds one kilometre. In 1774, the British emissary George Bogle described Thimphu as, "covered with rice fields and well peopled with villages scattered on the brow of the hills". Thimphu remained unchanged until 1962 when the reconstruction of the *dzong* was initiated by His Majesty King Jigme Dorje Wangchuck, the third hereditary monarch of Bhutan. At that time, a small village called Chang Jangsa with six houses and two ruins stood at the same site where Thimphu's city centre is located today (*Kuensel*, 3 October 1992). The rice fields mentioned by Bogle are still there, but they are now concentrated to the south of the valley while the emerging city sprawls in the central portion. In 1984, the population was estimated at about 14,000; in the last ten years it has doubled to between 30–35,000 (RGOB 1996). While there are no statistical indications on the actual numbers of women in the city, we can assume that about half of the population is female.

Individual circumstances more than choice brought the first generation of city women to Thimphu. Today, Thimphu's female population is composed of a wide spectrum of women adding to the potpourri of different occupations, social classes, cultural backgrounds and interests, and enhancing its vitality, excitement and enterprise.

Dechen Wangzom: A society in transition

Today there are 2,180 females in the government representing 17% of the civil service; many of these women work in the central government. While most of them may hold stereotypical clerical positions, some work at professional levels.

Dechen Wangzom is a highly educated professional and is well regarded by her superiors and colleagues alike. She is young, single, and holds a managerial position in the government, and is no different from any upwardly mobile female professional anywhere in the world. She represents the gradually emerging, but still small, segment of professional women in the city. She dresses simply but with care, and has the look of the professional cosmopolitan sophisticate, conveying an air of competence, eloquence and confidence. With her educational background, experience and exposure, she says she feels comfortable at any international forum attending meetings and conferences at least two to three times a year.

Dechen Wangzom feels at ease among her male colleagues, especially now that they know and respect her sensitivities. She has learnt to accept what she calls the 'joking relationship' between men and women, which is common in Bhutan. She says that, as a single woman, her social life is somewhat constrained by the 'small town atmosphere'. When she doesn't have to attend official or other social functions she enjoys going home to cook for her parents, and spends her time quietly reading or watching the occasional video with them. She misses the anonymity of the big cities which she experienced and enjoyed during her university days abroad. She points out that Thimphu offers little in terms of recreation and leisure.

Leisure time is a new experience for the urban women. In the subsistence communities of traditional Bhutan women rarely had free or leisure time.[7] Today city women have a comparatively easier life as most of them have access to water and electricity; some even have access to electric rice cookers, washing machines and other kitchen gadgets which reduce the time and drudgery of women's work. Some city women engage in *thagla bela*, 'work related to wool and weaving' traditionally considered a highly desirable womanly attribute, but the majority of the urban population prefer to buy the cheaper and readily available factory-made fabrics and clothes.

What then do city women do with their free time? While many keep themselves busy in meaningful and profitable ways, a few ostentatious lifestyles have contributed to the impression that city women have too much leisure time and do not know what to do with it. Some groups of women, clearly not constrained by economic conditions, engage in gambling sessions with venues shifting from one home to another. They rationalize that there is no problem with this form of leisure, as they play for small stakes. Getting together for card sessions is a good way, they believe, to meet and interact with other women; most importantly it is a good way to ward off boredom. Some older women engage in the traditional game of *yam* or dice. It is known that some women indulge in excessive use of alcohol. *Kuensel*, Bhutan's national newspaper, listed housewives, among others, as "regular users of soft drugs available in Thimphu" (4 May 1996). Whether these lifestyles are brought on by boredom or by other social conditions is yet to be determined, but a lack of facilities for women and a lack of ingenuity on their part does exist.

Younger women do, however, participate in many organized sports: basketball, table-tennis and even martial arts and archery. The only cinema house in the city, which a generation ago used to be the favourite hangout for the youth, is now heavily patronized by lower income families. For the economically better off, it is the place to be seen at only if a home video is not owned. Video-watching is a very popular pastime for many in the city, and as it is the women who are most likely to be home all day they spend more time in front of the screen. Tear-inducing love stories and violent drama seem to be the most popular themes.

Dechen Wangzom views the increasing urban adolescent dilemma as a serious social problem which needs immediate attention. She thinks that the city should have more avenues to help young adults utilize their energies in more creative and productive ways. Echoing her concerns, *Kuensel* (14 September 1996) writes: "A common complaint among Bhutanese urban youth, in recent years has been the absence of 'healthy recreation' in the evenings". She also thinks that 'urban drift' could lead to serious problems, particularly for women who come to the city to search in vain for better lives.

Asked to elaborate on the phenomenon of 'urban drift' in the context of Thimphu, an official from the Works and Housing Department said that propelled by individual circumstances and decisions, there is a constant trickle of migrants to the city. The most significant groups of migrants were the families of masons, carpenters and other skilled and unskilled labourers who came to work on the reconstruction of Thimphu *dzong* in the early 1960s, and the retired ex-army personnel who have opted to settle in the city. They are attracted by the better medical facilities at the biggest and best equipped hos-

pital in the country, options of various schools for their children, and the conveniences that city life has to offer. Many of these people live in semi-permanent houses, or share housing, and have low incomes. Many of their menfolk earn little or nothing, and the task of supplementing, often sustaining, the family's livelihood falls on the women, which they do through weaving, producing home-brewed alcohol, gardening and other ingenious ways. "Ours is a society in transition and we cannot escape some of the social problems associated with the process of urbanization", says the official from the Works and Housing Department.

Education, Dechen Wangzom feels, is the key to empowering women, through the expansion of their choices and options. Education is indeed taken very seriously by all Bhutanese. Between 1984 and 1993, the enrolment of girls in primary to high school increased by 68%, as compared to only 11% increase for boys (Wangchuk 1994). Yet, female literacy is estimated to be only 20%, and a very high percentage of women never complete higher education (Ehsan 1993). "The proportion of girls attending schools tends to be higher in urban than in rural areas", wrote Lhadon Pema in 1989 which, she supposed, correlated with higher incomes in urban areas. Parents' attitudes in urban areas were also influenced by greater exposure to a wider range of factors, and contrasted with traditional rural attitudes that prevented girls from attending schools. She anticipated that increasing urbanization would, "help to increase the number of women who would be diverted from their traditional roles as housewives."

Irrespective of their educational background, women seem to look to the city as a place of opportunities and better livelihoods through employment or favourable marriages. While women with higher education often find employment, many are caught in a situation of no return. Among those who do not qualify for the more prestigious jobs, preferably with the government, there is a definite rush for the coveted position of working as a maid with expatriate families living in the city, with comparatively attractive wages and a workload believed to be minimal.

Some women turn to friends and relatives for help, but others fall into a state of limbo, with nowhere to go and no one to turn to, thus creating a group of trapped and downwardly mobile women. In response to questions about crimes by, and against, women, the Crime Bureau of Thimphu Police said that their dealings with women and crime are insignificant in terms of numbers reported. Of those reported, women's crimes are usually confined to petty thefts and there

are no reports of crimes against women. Prostitution, which is illegal in Bhutan, is not yet seen as a major problem although it is reported to be on the rise. According to a *Kuensel* report (19 October 1996) there are about twenty women in Thimphu who solicit customers on the streets or make arrangements in small hotel rooms. The same report observed that, "Getting prostitutes to adopt health safety measures has, so far, proven to be an uphill task, both because of low awareness among them and the social pressures which force the women to seek anonymity".

Dolma Yangchen: The family comes first

Education has definitely expanded the choices and options of those women who have had the opportunity to attend good schools. Dolma Yangchen, an executive in a highly successful private enterprise, says, "It was during my school days that I learnt to be optimistic, confident and to strive for success and perfection." She heads an enterprise with about forty employees and regrets the fact that so few women work for her. Dolma Yanchen comes from a family of modest background from a rural area not far from Thimphu. She came to Thimphu at the age of six and grew up during its period of urbanization. Now in her late thirties, she says, "I am here because of my work. I could not operate my business from anywhere else in the country". She is in a highly competitive business and has to work extremely hard to stay in the business and do well. She says that as an entrepreneur in a city she did not encounter any special problems or advantages because she is a woman. She attributes her success to hard work, luck, her reliability, together with firm and sound decisions. Asked how she feels about being a role model for the younger generation of women, she says she would like be seen as a hardworking woman with a comfortable and happy family life, "I am not a fashionable glamorous woman with a busy social life that young women today yearn for".

Dolma Yangchen is aware that society in Thimphu is becoming increasingly fashion conscious, "… women of all ages and social status are pouring into the local saloons, armed with the latest fashion magazines, to express their own fancies" (*Kuensel*, 24 August 1996). She dresses tastefully in comfortable clothes, wears subtle make-up and prefers a simple hairstyle that compliments her good looks. She is confident that both the people from the government and the private sector recognize her as a reliable and successful business-person.

Although her business has been highly successful, she

says her family's happiness and well-being come first. She entertains guests and business associates for lunch at restaurants but reserves the evenings for the family. She helps her school-going children with their homework. She doesn't like to "cook and do all sorts of housework", so she employs domestics. She would like to "guide" her children to become independent, and encourages them to pursue their goals with full confidence. "Exam time in school is stress time for the entire family", laughs Dolma Yangchen, but it is a well known fact that many parents are extremely ambitious for their children and equate education with success.

Because of the high value placed on education, along with the social reality of living in nuclear family settings, without the ever-present grandmothers, aunts, elders sisters and other relatives of the traditional extended families, always available for childcare, pressure is put on the schools. Schools often say that parents go to any lengths to make their children seem older than they actually are to qualify them for admission. The lack of crèche or daycare facilities are apparent as teachers complain, "We are teachers, not baby-sitters!"

Dolma Yangchen is aware that she represents a very small privileged group of city women and that there is a growing disparity between the privileged and underprivileged city women. Women are pressured to come to the city in search of better livelihoods and get a "taste of it … the material comforts".

Ani Yeshi: The city is good to the poor and the elderly
Yet the material comforts of the city are often elusive for women. Ani Yeshi, who has been living in Thimphu for the last twenty years or so, is a seventy-eight year old nun who has shifted her dwelling place some seven or eight times. She has lived with relatives, in people's garages, and in huts that she has constructed from cast-off materials – flattened tins, pieces of wood and cardboard. The Works and Housing Department acknowledges that there is a housing shortage in the city which has led to sharing of houses and construction of unauthorized shelters. *Kuensel* (30 March 1991) highlighted the problem, "The acute housing shortage in Thimphu and the spiralling rent are major dilemmas faced by the authorities and residents in the capital."

Ani Yeshi's last home had to be dismantled as it was an unauthorized hut built on government land. Now she has squeezed into a one-room house which belongs to a man who works as a night guard in an office building and spends his days doing small carpentry jobs. He uses it more as a store than a house, and rarely lives in it. Ani Yeshi did not know the man but he offered her his room when he heard of her plight. Thimphu is still a very humane and caring city, without much evidence of the typical urban ills of alienation and despondency. She has the second key to the house and has access to it any time.

The one-room house has an altar cluttered with pictures of Buddhist teachers, living and dead. The whole room is decorated with framed pictures of the king and sacred Buddhist symbols cut out of newspapers and old calendars. In one corner of the room is a bed with a thin mattress and the blankets folded neatly to one side. All her meager clothing is hung on nails on the wall and covered with a sheet of plastic paper. Next to her bed is an old tea chest upon which is her kerosene stove, one aluminum pot and an earthen pot. Another smaller wooden box holds all her other provisions. Light comes into this dark room from a window frame with broken glass that is tinged yellow-brown from the cooking fumes. Ani Yeshi is grateful for this house. She has reasons to be grateful for there are known groups of elderly and handicapped people who live out in the open in "enclosures of rags, cardboard and wooden boxes and jute material" within the municipality of Thimphu city (*Kuensel*, 11 February 1995).

As a person who circumambulates the *chörten* on a regular basis, Ani Yeshi is one of the few who receive a nominal stipend from the government. She claims that she uses most of the cash she gets for butter lamps in the *chörten*. She has no other income and lives on the goodwill and donations from her well-wishers. She says that she never begs for cash, although she knows that her other colleagues do. Once a month or so she does, however, go begging for vegetables at the vegetable market, and the vendors give generously.

Living alone in the city is not so easy, but if I would go back to my rural home, I would not know any peace. I would not be able sit idly and watch the others work on the farm. Here I am independent and my only obligation is to pray and circumbmambulate the chörten which I can do at my own pace. I would say that elderly people who want to be independent and dedicate their time to prayer should come to the city.

She says that her age, her shaven head and her wrinkles give her strength and confidence. Her femininity is no longer at threat, although, occasionally "shameless old men", even

while going around the *chörten* try to tease and touch her. On occasions she has slapped the miscreants and told them who she is, "an old nun".

Aï Lhadön: The family hearth is missing

Aï Lhadön is a sixty-six-year-old grandmother who would have liked to have the independence of the "old nun"; instead she has to divide her time between her daughter and grandchildren in Thimphu, and her own home in eastern Bhutan. Her daughter is a primary school teacher married to a civil servant. Their marriage was arranged by their parents who wanted their children to marry into the right families. Although Bhutanese society is not stratified along class or caste lines, the concepts of *rig* and *jüba* (terms which roughly translate as 'origin' and 'lineage') were serious considerations, and important criteria for matrimony. Among the elite an untainted genealogy was carefully maintained through planned matrimony. Members of the aristocracy, and the *lama chöje* (religious nobility) were quite distinct from the *trelpa* (tax-payers) and the *dab* (bonded labourers who were given *toshing* or tenured land by their feudal masters) and the *zab* (serfs who were given daily food or monthly rations for their labour). Homogeneity within these groups was an important societal norm. Today, both men and women in the city choose their partners without any restrictions, as marriages are based more on tangible economic status than on such abstract concepts as *rig* and *jüba*. Interestingly, more women than men in the city have married foreigners, either oblivious to, or openly defiant of, traditional codes of conjugality.

The grandmother feels some sense of ambivalence towards the city and talks rather disapprovingly of the way city women dress and behave. She laments the fact that there is little harmony between her old valued ways and the modern ways. She is especially concerned that modern women have so little time for religion. She is quick to quote from the biographies of religious women, especially Ashi Nangse, and compares her life situation to theirs. It would probably sadden her to realize that many younger women no longer look to these exemplary Buddhist women, turning instead, as we move closer to global homogeneity, to the world at large for role models.

Aï Lhadön's daughter has two children of her own living with her and various nieces and nephews. She often despairs for she suspects that, with only two children, the young couple may have used permanent family planning measures; she would like to see more grandchildren.[8] For her, living space

is definitely not a serious consideration. About eight to thirteen people already live in their apartment: a fairly large flat with all the basic amenities the city offers.

Their home is rather typical of the buildings in the city. Many rental apartments and houses in the city have lost not only the traditional architectural styles, but also some of the most attractive characteristics of traditional Bhutanese homes. In traditional Bhutanese homes the main room contains the hearth. This is usually the largest and warmest room, in which the family gathers to eat, work, talk, and often sleep together, in an atmosphere of relaxed ease. A typical scene in a traditional family kitchen would be the mother, father or one of the older children cooking at the hearth and everybody helping. Modern kitchens, especially those built in the early phase of urbanization, are a far cry from the traditional kitchens. They are usually small, dark, concrete affairs with a gas or a kerosene stove placed on a table in one corner. The person cooking, nearly always a woman, must do so standing without the company or the help of the rest of the family who are probably gathered together around the video screen, mesmerized, watching movies picked up from the multitude of video parlours in the city. Utensils and stores are stacked on shelves stuck randomly into the walls at inconvenient heights. Seen in the light of what it has done to the family structure, the contrast between the warmth of the hearth and the cold unfriendly kitchen is tremendous. Traditionally the division of labour based on gender was blurred, and it may be pertinent to consider what effect the change in family structure will have on the position of women in the city.

The grandmother says, "In my daughter's previous house there was not even a small garden space for a single chilli plant. Now, thanks to her husband's relative, we have a big house for a reasonable price and enough garden space for vegetables." Kinship is highly valued by the Bhutanese, and relatives are expected to help each other. The modern houses, which on the whole were built for nuclear families, are often crammed because of live-in relatives, visitors and acquaintances from the rural areas. Urban families are obliged to adopt aspects of rural lifestyles, and of extended family systems.

The city administrator or *thrompön* cautions that although Thimphu is the biggest city in the country we have to look at it in a purely Bhutanese context, for it is a city "dominated by rural settings".[9] The rural setting is a result of the beliefs, attitudes, lifestyles, skills and expertise that rural migrants bring to the city, even as they come in search of

new lives. The men work for their salaries and many women have to work hard to supplement the family income by drawing on their rural experience and expertise.

Dawa Zangmo: The weaver in the city

Weaving, which is traditionally considered an exclusively female activity, has turned out to be one of the most reliable skills for supplementing livelihoods in Bhutan, be it in the city or in the village. Many women are excellent weavers. Some women weave and market their own products while others are contracted by enterprising entrepreneurs in the city. *Kuensel* (29 May 1993) reports that, "Thimphu lures weavers from all parts of the country, and people at all levels of the society depend on weaving for a living", and that, "… housewives who weave part-time often earn more than their husbands who may be senior officials in the civil service".

Dawa Zangmo is a weaver in Thimphu. Her employer says that she is the best among the eight to ten weavers she employs. This forty-six year old weaver and mother of five children thinks that she has been weaving for the last thirty odd years. She lives on the outskirts of Thimphu city in a traditional Bhutanese house which her employer has arranged for her. She came to Thimphu about thirteen years ago from the Kheng area. There are two looms in the house. An exquisite *kushüthara* hangs on one loom, and a woman's belt on the other.[10] She explains that she works on the *kushüthara* during the day for her employer. At night when her eyes are tired and the light is not so good, she works on the belt which sells for about Nü 450 per piece. Being in the city with a bigger market potential helps her to sell these belts. She is quick to point out that the belts are of *tshongthag* quality, 'good only for selling', but the *kushüthara* is of *hingthag* or 'heart-woven' quality fit for heirlooms. She can complete a belt in about four to six weeks, but it takes her a year to complete the *kushüthara* .

She puts on her thick eye glasses as she begins to weave. Her younger children hang on to her and she chides them gently, the older ones play nearby. She is fortunate because her employer helps her whenever she is in need and is conscious of her welfare. Other employers in Thimphu are said to be demanding and very insensitive to the weavers' needs and general well-being. Sadly it is often those women in advantaged positions who exploit the weavers.

Save for the bright-coloured fabrics on the looms, the house is devoid of any decorations. Crudely fixed bare bulbs hang from the smoke-blackened ceilings. The floors have been swept, but the house has a severe utilitarian atmosphere. If the appearances of the houses and the way they are decorated can be taken as a reflection of the values of the people who live in them, women of the higher income group seem to devote substantial amounts of time and effort to decorating their homes. In recent years women, especially those of the higher economic group, have taken to having potted flowers and decorative plants in their homes. Many homes have pleasant displays of multitudes of flowers and plants that have been raised with care and pride. For the lower income groups, home decorating is not an important priority, and time and garden space are more often used for vegetables. Although most Bhutanese housewives always like to have both annual and some perennial flowers to offer at the altar, Dawa Zangmo's garden is full of vegetables; there are no flowers.

Dawa Zangmo supports her four younger children and her husband. Her oldest daughter is twenty-three years old and married; she refused to learn to weave. Fortunately her son-in-law is a salaried man, and her daughter's family survive on his salary. Her own husband and father of the three younger children has never been able to hold a steady job because of his alcohol problem.[11] At the time of interview he had not yet found the job he was "thinking of". Dawa Zangmo plans to teach her second daughter to weave so that she has something to fall back on if she fails in school.

Dawa Zangmo appears to experience some effects of urban alienation. Even after thirteen years in the city, she said she would be too shy and too afraid to go anywhere beyond her neighbourhood and doesn't know anyone well enough to ask for help in times of hardship. Her mobility is limited because she is "afraid of the taxi fare". She feels alone, and yet she would not go back to her village, "I went to my village for one month some time ago but for some reason I was very restless and unhappy. I wanted to come back to Thimphu". She thinks life is still easier in the city than in the rural villages. She explained that in the city she could sell her products for a price any time but working for several months in the fields gives no guarantee that the crop will translate into food or income. Crop production is largely dependent upon weather conditions and wild animals.

Women in Retailing

A 1993 UNFPA report states, " The most lucrative and bustling activity for women is in the urban phenomena of retailing and real estate speculation, this in large measure is due to the inheritance of property being through the female" (Inayatullah 1993). The *thrompön's* office says that land ownership is approximately fifty-fifty for males and females. Women dominate in retailing and real estate speculation because the civil service rules do not allow government servants (mostly male) to engage in business.

The most recent phenomenon in retailing is selling foreign goods. Many stores sell electronics, fabrics, fashion garments, shoes and other merchandise from Thailand, Bangladesh and Nepal. To obtain their goods, today's young and confident women retailers have no qualms about boarding the national airline, Druk Air, to any of these destinations. They dress in fashionable clothes and many drive their own vehicles. These women have come a long way from the days when most of the stores in Thimphu sold groceries and were run by men, and women rarely travelled on their own without a translator-cum-guide. One middle-aged woman in retailing comments that although the buying power of the general population has increased, all retailers sell more or less the same goods and competition is stiff. Besides the licensed retailers there is yet another group of women entrepreneurs in the city: women and children vendors who eke out a living selling *doma* or betel nut, the country's favourite indulgence, and other snacks.

Thimphu is a small town and nearly everyone in the business community knows everyone else, yet there has been a conscious efforts to form smaller groups called *kidu*.[12] These groups are made up of various people who share certain things in common. For instance there is a *kidu* made up of Tibetans married to Bhutanese, and another *kidu* for the old Tibetans or those traders who were in Bhutan prior to the Chinese takeover of Tibet, and so on. The various *kidu* are structured differently but quite formalized and their main objective is to help members in times of trouble and suffering. The idea seems to be modelled on traditional village communities and the principle of reciprocity which brings people together in times of hardships and trouble. A woman retailer who is a widow said that these *kidu* are very helpful especially at times of illness and death. During times of illness the members take turns to look after and keep vigil over the sick, and take food to the hospital. If there is a death the *kidu* members help to organize everything from getting a lama to do the *phowa* (transference of the soul at the moment of death), performing all the death rituals – usually up to the forty-nine days after death, even pooling resources to help the bereaved. As a woman alone in a city with only her young children she said she would have been completely lost without the *kidu*.

MOVING INTO THE 21ST CENTURY

"What do we know? We live in the *gigu* ['corner' referring to the village]. They are from the *throm* [town or city] who have seen it all and know it all." This is what a village woman would say when comparing herself to the woman in the city. Generally women from rural Bhutan look upon the city women with awe, wonder and a tinge of envy. They consider city women to be better educated, economically better off, to have relatively easier lives. On the contrary, city women often tend to be rather patronizing to their rural sisters, "Poor thing, what can she know? She is only a villager."

Despite these attitudes and sentiments, the majority of city women still maintain their rural links and nobody is totally alien to rural life. Whether from the city or from rural areas, women relate to each other effortlessly, their common bond being that they are "Bhutanese women".

Today, Bhutanese women in general, and the women in the city in particular, are at the crossroads of traditionalism and modernity; it is important to realize that one does not have to be relinquished for the other. It is hoped that the choices women make today will be prudent and wise. As the first generation of women in the city, they will have a far-reaching impact on generations to come. Today's visions, dreams, actions, choices and decisions in all aspects of women's lives can either erode women's traditional heritage of relatively favourable egalitarian status, or further raise their status and empower them to impart an rich legacy to the children. This responsibility rests upon each individual woman but the the responsibility rests heavier on the women in the city who are seen as better educated, who have had better opportunities, wider exposure, and are in positions influence.

Rural women may continue to be the custodians of the traditional Bhutanese women's ways, while the women in the city have the responsibility of sifting through all that

comes through outside contact and exposure and what the powerful global media projects. Today's women can either follow blindly the ways of other developed countries, or cautiously scrutinize and then adapt and adopt ideas, behaviours and customs, and build upon what they have, to enhance, empower and enrich their lives and their well-being.

NOTES

1 Ashi Nangse is a Tibetan woman of the eleventh century, a devotee of Tara, the popular female form of the Buddha (Allione 1984). Ashi Nangse's biography is of the genre of Tibetan tales concerning the *delog* ('das log), women who return from the nether world well known throughout Bhutan. Older women sometimes get together and randomly open the pages of the biography and read passages to see how their lives relate to hers.

2 Gelongma Palmo, an Indian princess who was afflicted with leprosy is believed to have meditated in Bhutan (Allione 1984). In Bumthang, caves in Thowadra Gompa in Tang, and Gongkhar Gompa in Chökhor, are revered as her meditation caves.

3 The Tibetan Buddhist version of the Hindu Godess Kali. All over Bhutan she is widely revered as a deity. She has unlimited powers, and she is often depicted in terrifying forms.

4 Machig Labdrön is one of the most renowned and beloved of Tibetan women mystics. She is said to be an incarnation of Khandro Yeshe Tshogyel, the eighth-century consort of Guru Rinpoche. She was an integral part of the great Buddhist renaissance which occurred in Tibet in the eleventh century. Machig Labdrön developed the ritual practice of *chö* (gcod) which is commonly performed in many households in Bhutan (Allione 1984).

5 This Convention was opened for signature, ratification and accession on 18 December 1979. Bhutan signed on 17 July 1980. The Convention went into force on 3 September 1981 (Buringa and Tshering 1992).

6 "The best kind and the greatest quantity of musk comes from the kingdom of Bhutan from whence it is conveyed to Patna, the principal town of Bengal. All the musk which is sold in Persia comes from thence, and the merchants who sell musk prefer that you give them in exchange yellow amber and coral rather than gold and silver because they make great profits out of these two commodities." (Olschack 1979: 146f)

7 Save for the annual festivals, traditional Bhutanese societies had no standardized free days or holidays. For some years now the rural populations have observed the 15th and 30th of every Bhutanese lunar month as holy days, and therefore free days. In urban Bhutan the government's working days follow the international system of weekends in addition to special holidays.

8 Bhutan has a very dynamic family planning programme that reaches all sectors of the population. Generally urban couples have fewer children than their rural counterparts.

9 The *thrompön* is a woman who was assigned to this challeging and important position after many years of outstanding government service.

10 *Kushüthara* is an elaborately brocaded fabric used as a woman's dress. Weaving experts suggest that the method of weaving these fabrics may be uniquely Bhutanese.

11 Two of the older children were born out of wedlock and the fathers have never acknowledged them. Now there is a law that compels the father to share in the expenses of raising the children up to the age of eighteen years.

12 *Kidu* (skyid sdug) translates literally as: peace (*ki*, skyid) and (*du*, sdug) suffering.

REFERENCES

Allione, Tsultrim. 1984. *Women of Wisdom*. London: Routledge and Kegan Paul.

Aris, Michael. 1980. *Bhutan: The Early History of a Himalayan Kingdom*. Warminster: Aris and Phillips; New Delhi: Vikas.

Buringa, J., and Tshering, L. 1992. *Education and Gender in Bhutan: A Tentative Analysis*. Thimphu: National Women's Association of Bhutan and SNV.

Ehsan, N. 1993. *Women and Rural Development in Bhutan: A pilot time-allocation survey report*. Thimphu: UNIFEM/UNDP and Ministry of Agriculture, RGOB.

Gross, Rita. 1989. 'Yeshe Tshogyel: Enlightened consort, great teacher, female role model'. In (ed.) J.D. Willis, *Feminine Ground: Essays on Women and Tibet*. Ithaca, New York: Snow Lion Publications, pp. 11–32.

Inayatullah, A. 1993. *Women in Development: A review of the Bhutan effort*. Thimphu: United Nations Fund for Population Activities/Women in Development Report.

Kuensel (national weekly newspaper): dates as indicated in the text.

Olschak, Blanche C. 1979. *Ancient Bhutan: A Study on Early Buddhism in the Himalayas*. Zurich: Schweizerische Stiftung für Alpine Forschung.

Pema, Lhadon. 1989. *Women in Development: Bhutan*. Country Briefing Paper. Thimphu: Asian Development Bank.

RGOB (Royal Government of Bhutan). 1996. *National Report to Habitat 11, 'The City Summit'*. Thimphu.

Ura, Karma. 1995. *The Hero with the Thousand Eyes*. Thimphu: Karma Ura/Helvetas.

Wangchuk, Namgyel. 1994. *National Report for the Fourth World Conference on Women in Beijing, China*. Thimphu.

Glossary

Note on spelling
The editors have attempted to standardize the transcription of Bhutanese terms throughout the book. For the convenience of non-Bhutanese readers, we have tried to keep as close as possible to the Bhutanese pronunciation, which is given in italics (pronunciation may, however, vary according to region and speaker). Proper names appear in roman type. An *e* at the end of a word (e.g. Dorje) is pronounced like the French *é*; *ö* is pronounced as in 'bird'; *tsh* is an aspirated *ts*. Where the Dzongkha or Tibetan spelling is also provided, it is given in brackets in roman type, following the Wylie system of transliteration.

ani, anim (a ni, a ni mo) female religious practitioner, nun.

ashi (a lce, a zhe) honorific title used for women of the royal family.

bangchung (bang chung) double basket made of bamboo and used to carry food.

beyul (sbas yul) 'hidden country'; regions believed to have been hidden by Guru Rinpoche (Padmasambhava) to be rediscovered at a later date.

bodhisattva (Skt.) enlightened being; Dz./Tib. *changchub sempa* (byang chub sems dpa').

Brokpas ('brog pa) also called 'Bjop'; (1) semi-nomadic herders; (2) people of Merak Sakteng.

chagzö (phyag mdzod) treasurer.

cham ('cham) religious dance.

changkhap ('chang sgar pa) personal attendant.

chim (khyim) house.

chimi (spyi mi) elected member of the National Assembly.

chö (chos; Skt. dharma) religion, i.e. Buddhism.

chöje (chos rje) head of a religious lineage, often married.

chöke (chos skad) 'language of religion', i.e. classical Tibetan.

chörten (mchod rten; Skt. stupa) Buddhist commemorative monument.

chösham (mchod bshams) altar, shrine room.

chösi (chos srid) religious and temporal rule.

chunidom (bcu gnyis bsdoms) 'every twelfth'; labour tax applied to every group of twelve people in a household.

dab (*grwap) bonded labourer, but who can also own land.

Dakpas (dwag pa) semi-nomadic herders of eastern Bhutan.

darpön (dar dpon) 'flag officer'; head of bodyguards.

dasho (drag shos) non-hereditary senior official; honorific title given by the king in recognition of services; also honorific title used for men of the royal family.

Depa (sDe pa) or Deb Raja; see Desi.

deshing (de shing) daphne plant, the bark of which is used to make paper.

Desi (sDe srid) title of Bhutan's temporal ruler; the British used the title 'Deb Raja'.

dezo (de bzo) paper-making; one of the thirteen traditional crafts.

dobchu (gdob cung) bracelet.

doma (rdo ma) quid made of areca nut, betel leaves and lime.

dona (rdo nag) black slate.

dorje (rdo rje; Skt. vajra) 'thunderbolt'; ritual implement used in Tantric Buddhism; symbol of the male element, and of compassion.

dozo (rdo bzo) masonry or stonework; one of the thirteen traditional crafts.

dralha (dgra lha) warrior god.

driglam namzha (sgrig lam rnam bzhag) 'basic rules of disciplined behaviour'; official etiquette.

drönyer (mgron gnyer) 'guest master', chief of protocol.

Druk Yul ('Brug yul) 'Land of the Dragon', 'Land of the Drukpas'; Bhutanese name for Bhutan.

druk ('brug) thunder, dragon.

Drukpa ('Brug pa) school of Buddhism, offshoot of the Kagyu tradition; also refers to the people of Bhutan.

drungpa (drung pa) deputy of *pönlop*; subdistrict officer.

dung (gdung) 'bone', clan; honorific title used for nobility of Bumthang and Kheng.

dzo (mdzo) cross between a yak and a cow.

dzong (rdzong) fortress-monastery housing the civil administration and the Drukpa religious body.

dzongdag (rdzong bdag) district head, officer.

Dzongkha (rdzong kha) 'language of the fortress'; national language of Bhutan.

dzongkhag (rdzong khag) district; Bhutan has twenty districts.

dzongpön (rdzong dpon) 'lord of the *dzong*'; old term for *dzongdag*.

garzo (mgar bzo) blacksmithy; one of the thirteen traditional crafts.

gewog (rged 'og) 'block'; administrative division of several villages within a district.

go (gos/bgo) man's dress.

gomchen (sgom chen) male lay religious practitioner; sometimes married.

gompa (dgon pa) Buddhist monastery.

gongzim (gong gzim) chief chamberlain.

gung chim (gung khyim) family house.

gungda ula (gung grang 'u lag/'ur la) form of labour service or tax, discontinued in 1995.

gup (rgad po, rgap) 'elder'; head of a block or *gewog*; local representative.

gyadrung (rgya drung) border commissioner.

gyelpo (rgyal po) king.

gyeltshab (rgyal tshab) representative.

hingthag (hing 'thag/snying 'thag) 'heart weaving'; name given to the finest textiles with intricate patterning. See also *tshongthag*.

je khenpo (rje mkhan po) head abbot of Bhutan.

je pön (rje dpon) chief, lord.

jinda (sbyin bdag) lay patron, benefactor.

jinzo ('jim bzo) pottery, clay arts; one of the thirteen traditional crafts.

kalön (bka' blon) chief minister.

katrim (bka' khrims) Code of Laws.

kera (sked rags) belt.

kidu (skyid sdug) term used to refer to local mutual aid or assistance groups; also grant from the king.

kira (dkyi ra/dkyis ras) woman's wraparound dress, fastened at the shoulders with two brooches.

koma (ko ma) woman's dress fastener; usually made of silver.

Kuensel (Kun gsel) national weekly newspaper published in English, Dzongkha and Nepali.

kunre (kun ra) monks' assembly hall in a *dzong*.

kushung (skud shung) a cotton tunic cut like a poncho with brocade patterns, worn in Kurtö.

kushüthara (skud shud 'thag ras) brocaded dress with white background; originally from Kurtö.

kyelha (skyes lha) birth god.

kyilkhor (dkyil 'khor; Skt. mandala) cosmic or symbolic diagram used for visualization and initiation.

la (la) mountain pass.

lagchung (lag cung) small basket used mainly for serving cooked rice.

lama (bla ma, Skt. guru) religious master; can be married.

lama khag nga (bla ma khag lnga) the 'five groups of lamas' opposed to the first Shabdrung.

langdo (sp.?) share of dry land kept by mother; also unit of measure for a field.

lha (lha) broad term used to refer to a variety of deities, gods or spirits. See also *dralha*, *kyelha*, *pholha*, *yulha*.

lhakhang (lha khang) Buddhist temple.

lhami (lha mi) 'god men'; men who represent indigenous non-Buddhicized deities.

lhazo (lha bzo) religious painting; one of the thirteen traditional crafts.

lho (lho) south; used in the various ancient names of Bhutan: *lho jong, lho jong men jong, lho mön, lho mön kha shi, lho yul*.

Lhopus or Lhops (lho pa) known also as Doyas; 'southerners' living in Samtse district.

Lhotshampas (lho mtshams pa) 'people of the southern border'; generally people of Nepalese descent settled in southern Bhutan.

lönchen (blon chen) prime minister.

lopön (slob dpon) 'master'; term of address for educated persons and monks.

lu (klu) subterranean or serpent deity; associated with the Indian 'naga'.

lugzo (lugs/blugs bzo) casting of bronze, silver or gold; one of the thirteen traditional crafts.

lukhang (klu khang) dwelling place for subterranean deity.

lyönpo (blon po) minister.

mandala (Skt.) see *kyilkhor*.

Menla (sman lha) Medicine Buddha.

Mön (mon) name for regions south of Tibet.

Mön or Mönpas (mon pa) term used for a number of different ethnic groups of the Himalayan region, including some of the peoples of south-central Bhutan.

neljorpa (rnal 'byor pa; Skt. yogi) male practitioner of yoga.

ngagpa (sngags pa) Tantric practitioner.

Ngalong (sna slong) generic name for the people of the five valleys of western Bhutan.

ngultrum (dngul tram) Bhutanese currency; 1 US$ = 36 Nü (1997).

nyerchen (gnyer chen) storekeeper in a *dzong* or monastery.

pakhi (sp.?) wraparound garment of nettle fibre worn by Lhopu and Lepcha men.

pangthag (spang 'thag) backstrap loom.

parzo (par bzo) carving of wood, slate or stone; one of the thirteen traditional crafts.

pawo/pamo (dpa' bo/dpa' mo) male and female oracles.

pchila (spyi bla) 'universal lama', i.e. governor.

See also *pönlop*.

pholha (pho lha) god of the male lineage.

phurbu (phur bu) ritual implement in the shape of a dagger; the deity associated with it is called Phurpa.

pönlop (dpon slob) 'lord teacher'; historical title of regional governors of Paro, Tongsa and Daga. See also *pchila*.

pönpo (dpon po) ruler of a region, chieftain.

rapse (rab gsal) room with largest number of windows; architectural feature.

rig (rigs) family, lineage.

rigpa (rig pa) science, learning, craft.

rinpoche (rin po che) 'precious one'; term of address for a reincarnate lama.

samsara (Skt.) cycle or wheel of existence.

sang (bsangs) incense offering for local deities; also called *lhasang*.

satham (sa khram) land record or register.

shabdrung (zhabs drung) 'at whose feet one prostrates'; title of the unifier of Bhutan and his reincarnations.

shagzo (gzhag bzo) craft of wood-turning; one of the thirteen traditional crafts.

shaptolemi (zhabs tog las mi) work undertaken by households on village projects for the state.

Sharchopas (shar phyogs pa) 'easterners'; inhabitants of Bhutan's eastern region.

shidag (gzhi bdag) 'owner of the earth'; category of local deities.

shingkha (shing kha) woman's sleeveless tunic; no longer worn except in Kurtö on ritual occasions; and as women's dress in Merak and Sakteng.

shingzo (shing bzo) carpentry; one of the thirteen traditional crafts.

shugpa (shug pa) juniper wood.

si (srid) politics, political affairs.

sogshing (srog shing) 'life wood' of a statue or a *chörten*.

sölpön (gsol dpon) 'food master' or 'chief of meals' of high dignitary.

stupa (Skt.) see *chörten*.

terma (gter ma) concealed religious treasures, especially texts, awaiting rediscovery at a later time; many *terma* are said to have been hidden by Guru Rinpoche (Padmasambhava).

tertön (gter ston) religious treasure revealer; person predestined to discover religious texts or objects.

thabsang (thab tshang) kitchen.

thagzo ('thag bzo) weaving; one of the thirteen traditional crafts.

thagla bela ('thag las/la' bal las/la') work re-

lated to weaving and wool.

thangka (thang ka) religious scroll painting on cloth.

thrithag (khri 'thag) pedal loom from Tibet.

throm (khrom) market, town.

thrompön (khrom dpon) mayor.

torma (gtor ma; Skt. bali) moulded ritual dough offering or sacrificial cake; in rituals, each deity is represented by a different *torma*.

trelpa (khral pa) taxpayers.

tröko (spros rko) silver, gold and copper work; one of the thirteen traditional crafts.

trulku (sprul sku) reincarnate lama; can be married. See also *rinpoche*.

tsawa sum (rtsa ba gsum) the 'three foundations' of country, people and king.

tsen (btsan) category of local deities residing in the human realm and often represented as warriors.

tsenkhang (btsan khang) abode of local deity or spirit.

tseri (sp.?) land used for shifting cultivation.

tshazo (tshar bzo) bamboo and cane work; one of the thirteen traditional crafts.

tshechu (tshe bcu) 'tenth day'; festival in honour of Padmasambhava.

tshemzo ('tshems bzo) craft of embroidery and sewing; one of the thirteen traditional crafts.

tshogdu (tshogs 'du) National Assembly.

tshongthag (tshong 'thag) commercial weaving. See also *hingthag*.

ula ('u lag, ur la) labour service or tax.

umdze (dbu mdzad) choir master; important position in religious hierarchy.

utse (dbu rtse) central tower of *dzong*, usually housing the most important temples.

wangyön (dbang yon) 'initiation fee'; taxes levied for the *dzong*.

yathra (ya khra) striped woollen cloth from Bumthang with supplementary weft patterning.

yulha (yul lha) god of locality; generic term for local deities.

zab (bza' pa/bza'p) 'the one who eats [the master's food]'; serf.

zee (gzi) highly valued agate stone with white markings.

zhung (gzhung) state, government.

zimnang (gzim nang) junior chamberlain.

zimpön (gzim dpon) chamberlain.

zope (bzo pa) senior master carpenter or mason.

zopön (bzo dpon) master craftsman.

zorig chusum (bzo rig bcu gsum) the thirteen traditional crafts.

zung (gzungs) rolls of prayers and precious objects inserted in a statue or *chörten*.

Select Bibliography

Aris, Michael. 1979. *Bhutan: The Early History of a Himalayan Kingdom.* Warminster: Aris and Phillips, and New Delhi: Vikas.

—— 1982. *Views of Medieval Bhutan: The Diary and Drawings of Samuel Davis, 1783.* London and Washington D.C.: Serindia and Smithsonian Inst. Press.

—— 1986. *Sources for the History of Bhutan.* Vienna: Wiener Studien zur Tibetologie und Buddhismuskunde, Heft 14.

—— 1994. *The Raven Crown: The Origins of Buddhist Monarchy in Bhutan.* London: Serindia Publications.

Aris, Michael, and Hutt, Michael (eds.) 1994. *Bhutan: Aspects of Culture and Development.* Gartmore: Kiscadale Asia Research Series no. 5.

Bose, Baboo Kishen Kant. [1865]. 'Account of Bootan (1815)', in *Political Missions to Bootan,.* [Calcutta: Bengal Secretariat Office]. Repr. New Delhi: Manjusri 1972, pp. 337–58.

Brauen, Martin. 1994. *Irgendwo in Bhutan; Wo Frauen (fast immer) das Sagen haben.* Frauenfeld: Verlag im Waldgut.

Choden, Kunzang. 1993. *Folktales of Bhutan.* Bangkok: White Lotus.

—— 1997. *Bhutanese Tales of the Yeti.* Bangkok: White Lotus.

Collister, Peter. 1987. *Bhutan and the British.* London: Serindia Publications.

Department of Works, Housing and Roads. 1993. *An Introduction to Traditional Architecture of Bhutan.* Thimphu.

Dogra, Ramesh C. 1990. *Bhutan.* Oxford: Clio.

Dowman, Keith. 1980. The Divine Madman. The Sublime *Life and Songs of Drukpa Kunley.* London: The Dawn Horse Press.

Eden, Ashley. [1865]. 'Report on the state of Bhutan and on the progress of the Mission of 1863–1864', in *Political Missions to Bootan.* [Calcutta: Bengal Secretariat Office.] Repr. New Delhi: Manjusri 1972, pp. 1–137.

Fletcher, Harold R. 1975. *The Quest for Flowers: The Plant Explorations of Frank Ludlow and George Sheriff Told from Their Diaries and other Occasional Writings.* Edinburgh University Press.

Gerner, Manfred.1981. *Bhutan: Kultur und Religion im Land der Drachenkönige.* Stuttgart.

Grieder, Susanne. 1995. *Gesponnen gewoben getragen: Textilien aus Bhutan.* Zurich: Völkerkundemuseum der Universität Zürich.

Griffiths, William. [1865]. 'Journal of the Mission to Bootan in 1837–38', in *Political Missions to Bootan.* [Calcutta: Bengal Secretariat Office.] Repr. New Delhi: Manjusri, 1972, pp. 276–336.

Hutt, Michael (ed.) 1994. *Bhutan: Perspectives on Conflict and Dissent.* Gartmore: Kiscadale Asia Research Series no. 4.

Inskipp, Carol and Tim. 1995. *An Introduction to Birdwatching in Bhutan.* Thimphu: World Wildlife Fund.

Markham, Clements Robert (ed.) [1876]. *Narrative of the Mission of George Bogle to Tibet and of the Journey of Thomas Manning to Lhasa.* [London: Trübner & Co.] Repr. New Delhi: Manjusri, 1971.

Myers, Diana K. and Bean, Susan S. (eds.) 1994. *From the Land of the Thunder Dragon: Textiles Arts of Bhutan.* London: Serindia Publications, and Salem: Peabody Essex Museum.

Nakao, Sasuke and Nishioka, Keiji. 1984. *Flowers of Bhutan.* Tokyo: Asahi Shimbun Publishing .

Padma Tsewang, Khenpo Phuntshok Tashi, Butters, Chris and Saetereng, Sigmund. 1995. *The Treasure Revealer of Bhutan: Pemalingpa, the Terma Tradition and Its Critics.* Kathmandu: Bibliotheca Himalayica.

Parmanand. 1992. *The Politics of Bhutan: Retrospect and Prospect.* Delhi: Pragati Publications.

Pemberton, Capt. R. Boileau. [1865]. 'Report on Bootean (1837–38)', in *Political Missions to Bootan.* [Calcutta: Bengal Secretariat Office.] Repr. New Delhi: Manjusri, 1972, pp. 151–275.

Political Missions to Bootan, comprising the reports of the Hon'ble Ashley Eden, 1864; Capt. R.B. Pemberton, 1837, 1838, with Dr. DW. Griffiths journal; and the account of Baboo Kishen Kant Bose. Calcutta, 1865. Repr. New Delhi: Manjusri, 1972.

Pommaret, Françoise. 1994. *Bhutan.* Hong Kong: Odyssey Guides.

—— 1996. *Bhutan Insight Pocket Guide.* Singapore: Apa.

Rennie, D.F. [1866]. *Bhotan and the Story of the Dooar War.* London: John Murray; repr. New Delhi: Manjusri, 1970.

Rose, Leo E. 1977. *The Politics of Bhutan.* Ithaca N.Y., and London: Cornell University Press.

Singh, Amar Kaur Jasbir. 1988a. *Himalayan Triangle: A Historical Survey of British India's Relations with Tibet, Sikkim and Bhutan, 1765–1950.* London: The British Library.

—— 1988b. *A Guide to Source Materials in the India Office Library and Records for the History of Tibet, Sikkim and Bhutan, 1765–1950.* London: The British Library.

Solverson, Howard. 1995. *The Jesuit and the Dragon: The Life of Father William Mackey in the Himalayan Kingdom of Bhutan.* Outremont: Robert Davies.

Stapleton, Chris. 1994. *Bamboos of Bhutan.* London: Kew Royal Botanic Gardens.

Turner, Samuel. [1800]. *An account of an Embassy to the Court of the Teshoo Lama in Tibet; Containing a Narrative of a Journey through Bootan and part of Tibet.* London: Bulmer; Repr. 1971 New Delhi: Manjusri.

Ura, Karma. 1995. *The Hero with the Thousand Eyes.* Thimphu: Karma Ura/Helvetas.

—— 1996. *The Ballad of Pemi Tshewang Tashi.* Thimphu: Karma Ura.

White, John Claude. [1909]. *Sikhim and Bhutan, Twenty-one Years on the North-East Frontier, 1887–1908.* Repr. Delhi: Vivek, 1971.

—— [1914]. 'Castles in the air: Experiences and journeys in unknown Bhutan', *National Geographic Magazine* , 25, no. 4, pp. 365–453.

Williamson, Margaret D. 1987. *Memoirs of a Political Officer's Wife in Tibet, Sikkim and Bhutan.* London: Wisdom.

List of Objects Illustrated

94 Brick tea from China in banana leaves, L: 53 cm, D: 10 cm, Museum für Völkerkunde, Vienna

100 Trinle Gyeltshen, detail from a Bhutanese thangka, appliqué and embroidery, early 20th century, Paro Dzong

105 Table, wood, H: 34 cm, L: 71 cm, W: 35,5 cm, Ugyen and Norzom Namgyel

105 Chest, painted wood, iron fittings, H: 38,5 cm, L: 65 cm, W: 30 cm, Françoise Pommaret

108 Vaisravana, Guardian of the North, slate, gold colour, 20th century, H: 36 cm, L: 31 cm, Anthony Aris

108 Virudhaka, Guardian of the South, slate, gold colour, 20th century, H: 39 cm, L: 31 cm, Anthony Aris

108 Dhrtarastra, Guardian of the East, slate, gold colour, 20th century, H: 36 cm, L: 30 cm, Anthony Aris

108 Virupaksa, Guardian of the West, slate, gold colour, 20th century, H: 36 cm, L: 31 cm, Anthony Aris

111 Drukpa Kunle, Bhutanese thangka, 20th century, 129 cm x 111,5 cm, Anthony Aris

115 Lidded container for ceremonial offerings (yangtro), bronze, H: 19,5 cm, D: 17 cm, National Museum, Paro

119 Amulet case (gau), silver, fire-gilding, turquoise, H: 17 cm, L: 12 cm, W: 5,5 cm, National Museum, Paro

120 Drinking vessel, bamboo, brass, leather, H: 37,5 cm, D: 14 cm, Völkerkundemuseum der Universität Zürich

120 Drinking vessel, bamboo, brass, leather, H: 22,5 cm, D: 12 cm, Völkerkundemuseum der Universität Zürich

121 Basket with cover (bata), bamboo, H: 11,5 cm, D: 34 cm, Museum für Völkerkunde, Vienna

123 Throne cover (thrikheb), wool, silk, cotton, L: 152 cm, W: 70 cm, private collection

125 Boots of a lay religious practitioner (gomchen), silk brocade and damask, satin, cotton, leather, H: 51 cm, L: 28 cm, W: 10,5 cm, Museum für Völkerkunde, Vienna

125 Boots of a senior official (dasho), napped wool, silk brocade, cotton, leather, H: 49,5 cm, L: 27 cm, W: 10 cm, Museum für Völkerkunde, Vienna

130 Ceremonial textile (chagsi pangkheb), hand-spun silk, L: 306 cm, W: 94 cm, Völkerkundemuseum der Universität Zürich

133 Printing block for prayer flags, wood, H: 64 cm, L: 39 cm, B: 5 cm, Françoise Pommaret

136 Buddha Sakyamuni, copper, fire-gilding, ca. 18th century, H: 46 cm, Thimphu Dzong

136 Stupa, copper, silver, fire-gilding, coral, turquoise, emeralds, rubies, 17th century, H: 77 cm, Thimphu Dzong

136 Prajnaparamita text, cover: wood, sheet copper, fire-gilding, leaves: paper with writing in gold, silk cloth for protection, 19th century, H: 24 cm, L: 69 cm, W: 20 cm, National Museum, Paro

145 Set of five ritual objects for a fire offering ceremony (gangzar ganglu), blades: burnished iron with copper inlay, handles: gilt silver, stems: nielloed iron with silver and gold applications, knobs: silver or copper with gilding, box: wood, velvet, L: 94 cm, W: 26,5 cm, Punakha Dzong

145 Double-sided drum (damaru), bone, snakeskin, silver, silk, silk velvet, cotton, coral imitation, resonance box: 9 cm x 6,5 cm, private collection

145 Ritual dagger (phurbu) with container, dagger: copper haft, iron blade, container: copper, L: 26 cm, private collection

147 Altar of a Bhutanese prayer hall with ten clay figures and weapons for the tutelary deities, 19th century, H: 270 cm, L: 380 cm, W: 70 cm, Penjo Dasang Dorji

149 Butter lamps (chökong), gold, late 19th century, H: 21,5 cm, Paro Dzong

150 Green Tara, copper, fire-gilding, some painting, turquoises, 19th century, H: 23 cm, Penjo Dasang Dorji

150 The Arhat Hashang, bronze, painting, 17th century, H: 24 cm, National Museum, Paro

150 The Arhat Gopaka, bronze, painting, 17th century, H: 24,5 cm, National Museum, Paro

151 Amitayus, partly fire-gilt silver, painting, corals, turquoises, ca. 16th century, H: 35,5 cm, National Museum, Paro

152 Torma for granting longevity (tshetor), partly fire-gilt silver, corals, turquoises, late 19th century, H: 38 cm, L: 19,5 cm, Paro Dzong

152 Portable altar (gau), silver, fire-gilding, copper back, H: 17 cm, L: 15 cm, W: 7,5 cm, National Museum, Paro

152 Ritual vessel (drubphor), silver, fire-gilding, H: 12 cm, D: 8,5 cm, private collection

153 Ritual vase (bumpa), partly fire-gilt silver, peacock feathers, 19th century, H: 46 cm, Paro Dzong

154 Hat of a lama of the Nyingma school, silk damask, silk brocade damask, cotton lining, H: 25 cm, W: 29 cm, National Museum, Paro

154 Hat of a lama of the Drukpa school, silk satin with gold paper designs, silk damask, silk taffeta, starched cotton cloth, H: 29 cm, W: 42 cm, National Museum, Paro

154 Hat of a lama, silk damask, lining of napped wool, cowrie, H: 27 cm, W: 18 cm, National Museum, Paro

162 Swords, blades: iron, handles: silver, brass, scabbards: wood covered with animal skin, covers: wool, cotton, L: 93 cm, Penjo Dasang Dorji

163 Tsen deity, unfired clay, painting, H: 38 cm, Museum für Völkerkunde, Vienna

163 Tsen deity, mask, wood, H: 34 cm, W: 29 cm, National Museums & Galleries on Merseyside, Liverpool

163 Hat of a priest showing a tsen deity, silk brocade with gold thread design, appliqué, cotton, H: 31 cm, W: 28 cm, National Museum, Paro

Index

Numerals in italics refer to illustrations

Illustration Sources

The General Editors and publisher thank the following individuals, museums and institutions for granting permission to reproduce copyrighted materials in this book.

Anthony Aris (A.A.): pp. 30, 54, 55, 71, 157

Henry Ausloos/WWF: p. 38

F.M. Bailey, Trustees of the British Museum: p. 229

Philip Denwood (P.D.): p. 64

Robert Dompnier (R.D.): pp. 19, 21, 22, 41, 44, 46, 84, 160

Marc Dujardin (M.D.): pp. 64, 67, 71, 75

Armin Haab (A.H.): p. 233

Erich Lessing (E.L.) and Museum für Völkerkunde, Vienna: pp. 15, 17, 24, 26, 45, 52, 57, 79, 90, 91, 92, 93, 94, 100, 108, 111, 115, 119, 120, 121, 123, 125, 130, 133, 136, 145, 149, 150, 151, 152, 153, 154, 162, 163, 165, 167, 168, 172, 173, 175, 177, 178, 192, 193, 195, 197, 199, 205, 208, 210, 211, 212, 213, 215, 217, 219, 230, 231

Liverpool Museum (L.M.): p. 217

Gerald Navara (G.N.): p. 29, 33, 36, 37, 68, 134-135

Françoise Pommaret (F.P.): pp. 28, 32, 35, 38, 129, 138, 141, 189, 209, 237, 238, 252

Jaroslav Poncar (J.P.): p. 21

Sammlung für Völkerkunde, St. Gallen (S.F.V.): p. 12

Christian Schicklgruber (C.S.): pp. 21, 46, 50, 77, 86, 87, 95, 142, 147, 158, 161, 169, 170

George Sherriff, Museum of Mankind, London: p. 229

George Sherriff, Royal Botanic Gardens, Edinburgh: p. 232

Guy Van Strydonck (G.V.S.): pp. 21, 23, 34, 51, 56, 118

Jon Warren (J.W.): pp. 8-9. 21, 42, 48, 60, 68, 69, 73, 75, 77, 78, 89, 96, 103, 110, 112, 113, 116, 117, 121, 122, 124, 126, 128, 132, 139, 171, 176, 236

P. Weimann/WWF: p. 38

Lieut-Col. J.L.R. Weir, Courtesy of the Trustees of the Royal Geographical Society, London: p. 56

John Claude White, Private Collection: pp. 225, 227.